The Beginnings of the
Cinema in England

Frontispiece William Kennedy-Laurie Dickson (1860–1935): inventor of the Kinetograph and Kinetoscope, the first practical method of cinematography. *(Barnes Museum of Cinematography)*

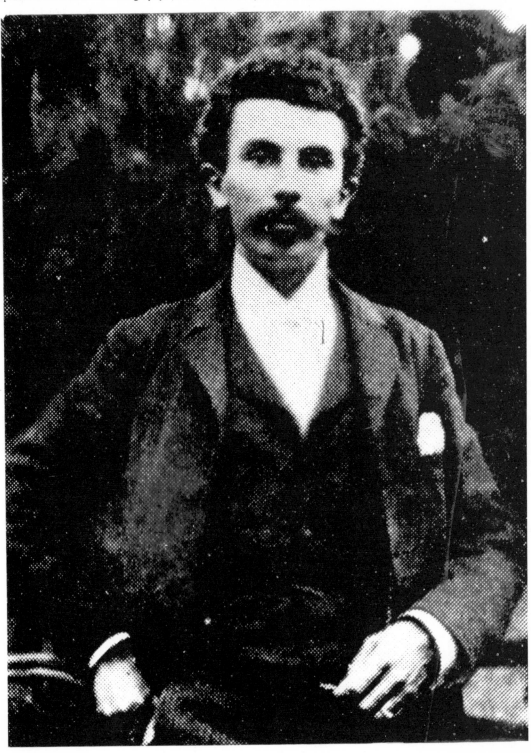

The Beginnings of the Cinema in England

John Barnes

DAVID & CHARLES
Newton Abbot London Vancouver
BARNES & NOBLE BOOKS . NEW YORK
(a division of Harper & Row Publishers, Inc.)

To Txiki

© John Barnes 1976

ISBN 0 7153 7089 8 (Great Britain)
ISBN 0 06 490317 6 (United States)
Library of Congress Catalog Card Number: 75 41576

Set in 10 on 12 pt Times Roman
and printed in Great Britain
by Clarke Doble & Brendon Limited, Plymouth
for David & Charles (Publishers) Limited
Brunel House Newton Abbot Devon

Published in the United States of America 1976
by Harper & Row Publishers, Inc.
Barnes & Noble Import Division

Published in Canada
by Douglas David & Charles Limited
1875 Welch Street North Vancouver BC

Contents

Foreword

The extensive literature on the development of the cinema has been in the past at its least adequate when dealing with the introduction of cinematography. Frequently, writers with little or no practical experience of the technical aspects of film have taken the existence of a patent as proof of actual accomplishment (which it is not), or have relied upon the reminiscences of elderly people whose recollections were often confused or biased. So far, little serious research has been done in this country using the contemporary sources still available to us. Buried in the photographic and other journals of the 1890s is a considerable amount of information about the early days of film. To be of value, this material requires careful extraction and interpretation by someone experienced with the kind of apparatus and processes concerned, with the technical knowledge to be able to judge between rival claims. John Barnes is such a person, and as Curator of the remarkable Barnes Museum of Cinematography has a special qualification for the task of unravelling the tangled story of the introduction of cinematography to Great Britain. By combining information gathered from the literature of the time with that obtained by direct examination of surviving apparatus and films in his own and other collections, Mr Barnes has pieced together the fascinating story of the vital two years during which the modern motion picture was born. The key parts played by Robert Paul and Birt Acres, for so long overshadowed by the often spurious claims of other inventors, are clearly established, and they show that this country was in the forefront of the development of cinematography.

The preservation of films for their content has long been accepted as proper, and many film archives throughout the world are concerned with this important task. Mr Barnes's book highlights the importance of the complementary collection of apparatus and other relics which, with the documentary evidence, may make possible a better understanding of the work of the early film-makers. Several collections already exist in Great Britain, notably the Barnes Museum of Cinematography, the Science Museum, London, and the Kodak Museum, together with several fine private collections. However, much material of importance has been and is being lost to this country, especially now when old apparatus is being sought more for its cash value than its historic significance. We look forward eagerly to the day when the imminent loss of a precious piece of early equipment is greeted with the same outcry and remedial action as follows the proposed sale abroad of a Vermeer or a Rubens.

Brian Coe
Curator, Kodak Museum

Introduction

The cinema, as we know it today, began with the invention of the Kinetograph and Kinetoscope. These two instruments represent the first practical method of cinematography.

The Kinetograph (or camera) recorded the action on a strip of photo-sensitised celluloid or cellulose-nitrate film, which was accurately perforated down each side so that the picture frames were equally spaced throughout its length, thus ensuring exact registration of one frame with the next when subsequently reproduced. This negative strip of film was then developed and a positive print was taken from it on a similar strip of film of the same width and with identical perforations. In fact, both the negative and positive film strips were almost identical to the standard 35mm film in use today, the only significant difference being the rate at which the individual pictures were taken. The positive film strip was then viewed in the Kinetoscope and the spectator witnessed a lifelike representation of the original action. The whole procedure thus involved a strip of photographic film, a perforator, a motion-picture camera, printer, and reproducer—all the essential requirements of the modern cinema. The only modern feature which had not been accomplished at this stage was the projection of the pictures upon a screen.

No previous attempts at cinematography had achieved all these requirements. Professor E.J. Marey, who perhaps came closest to the result, failed to achieve the ultimate goal. He managed to film a series of consecutive phases of motion, but he did not realise the exact registration of one picture with the next, and could only achieve a chrono-photographic record of the action which could not be faithfully reproduced except by an imperfect stroboscopic method like the picture strip in a Zoetrope, or Phenakisticope disc.

Although the films taken with the Kinetograph were quite capable of being projected on a screen, the method first adopted for viewing them was by transmitted light in the instrument called the Kinetoscope. The film projector had not then been invented, but the problem of projection, once tackled, was relatively simple of solution. A projectable film was already available and the principle of intermittent picture projection had also been formulated and demonstrated (ie by such devices as the Choreutoscope (British Patent No 13372, 9 October 1884, W.C. Hughes) and an apparatus invented by A.B. Brown (US Patent No 93504, 10 August 1869)). The subsequent replacement of the Kinetoscope viewer with the film projector was thus the next logical step in the perfection of the process. This was soon accomplished and the cinema as we know it today was born. The Kinetograph and the Kinetoscope can therefore be regarded as the true beginnings of modern cinematography.

The Kinetograph and Kinetoscope were the invention of W.K.-L. Dickson, an Englishman who had gone to America and taken

7

employment with the Edison laboratories at West Orange. Thomas A. Edison had been intrigued with the idea of recording movement ever since his invention of the phonograph and he desired to do for the eye what the phonograph did for the ear. The problem was given to Dickson, who after a period of experimentation arrived at a practical solution; but since his work was done as an employee of the Edison establishment, it was Edison's name which became associated with the invention.

This history of the beginnings of the cinema in England commences with the English debut of the Kinetoscope on 17 October 1894, and covers the period up until the end of 1896 when film performances had become an established form of entertainment throughout the country.

The dominant figure in the early history of the cinema in England was undoubtedly Robert W. Paul, or 'Daddy Paul' as he was later affectionately referred to in the trade for, above everyone else, he can be truly regarded as the father of the British film. Soon after the Kinetoscope had been introduced into England, Paul was commissioned to construct replicas of the machine which was at that time available only from Edison agents and was in short supply. Since the apparatus had not been patented in England, Paul was at liberty to make as many copies as he desired. The new venture had prospects of becoming a lucrative business, but the drawback was a lack of films for use in the instrument. Those films that were available were restricted to bona fide users of original Edison machines and were also subject to international copyright. Paul was left with no alternative but to make his own. He thus set himself the task of inventing a camera which would provide his Kinetoscope customers, and others, with a supply of films. By the end of March 1895, with the help of a professional photographer named Birt Acres, he succeeded and was able to take films comparable in quality to those of Edison. This camera, the first to be made and invented in England, I have named the Paul–Acres camera.

Elsewhere, the Kinetoscope had also stimulated interest in the new cinematography, particularly in France where the brothers A. and L. Lumière were early in pursuing the subject. Their objective, however, was not to make films for the Kinetoscope, but to present them as projected pictures on a screen. The result was the Cinématographe-Lumière, the first successful film projector to appear, and one which also served as camera and printer combined. Their first public screen performance was an immediate success and the days of the Kinetoscope peepshow device were already numbered.

Paul, who had also been toying with the idea of projected pictures, heard of the Lumières' success and promptly set about inventing a projection apparatus of his own. But in the meantime, his former collaborator, Birt Acres, who was also by then producing his own films, set himself a similar task and succeeded in making an apparatus which enabled him to give the first documented screen performance

in England. Within a few weeks Paul too gave a successful performance with his own projector. From then on, the race to exploit the new medium began.

The Cinématographe-Lumière was brought to London, and when it began its triumphant run at the famous Empire Theatre of Varieties in Leicester Square, all London flocked to see the so-called living photographs. The other London music-halls, not to be outdone, immediately clamoured for the new invention. The Lumière machine was exclusive to the Empire Theatre and the only other apparatus available in England at that time was Paul's, which had just been put into commercial production. For several months, Paul had almost a monopoly in London and was very soon penetrating the provinces as well as the foreign market. So successful an enterprise could not long remain the preserve of one man, and others started to enter the field. A steady trickle of new machines and films from home and abroad began to appear, so that before the year ended the cinema had established a temporary home in practically every major music-hall in the country.

This, then, in brief, is the story of the cinema's beginnings in England. The following chapters describe in detail these tentative steps that were to lead to a major industry and a new art form, and which the English pioneers played a not unimportant part in bringing about.

St Ives John Barnes
Cornwall
1974

9

1 The Kinetoscope

Cinematography was born in America in 1892. It was the culmination of numerous experiments and inventions spanning several centuries and involving many minds in almost as many different countries, for invention, like organic life, is a process of evolution. The invention was finally brought to fruition by William Kennedy-Laurie Dickson (frontispiece)[1] in the laboratories of Thomas Alva Edison, at West Orange, New Jersey. The story of its birth has been told by the American historian of the cinema, Gordon Hendricks, in a definitive work on the subject called *The Edison Motion Picture Myth.*

Dickson, under the aegis of Edison, began experimenting with the idea of moving pictures in about 1889, and by October 1892 had achieved a practical method of photographing and reproducing consecutive phases of motion. The camera for taking the action was called the Kinetograph, and the apparatus for exhibiting it was called the Kinetoscope.

The Kinetograph need not concern us here, for it is only incidental to our story of the beginnings of the cinema in England. Those wishing to pursue the subject further are referred to Hendricks. The Kinetoscope, on the other hand, played a very important role in the subsequent development of cinematography, not only in England, but in every other country where the subject was pursued. It is from the Kinetoscope that all subsequent motion picture invention is derived, including the work of the brothers A. and L. Lumière in France,[2] R.W. Paul and Birt Acres in England,[3] as well as other pioneers not mentioned in this history.

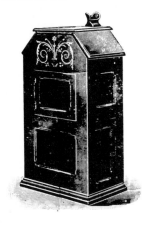

1 R.W. Paul's Kinetoscope, wood-cut illustration from the original wood-block used by Paul. *(Cambridge Scientific Instruments Ltd)*

Briefly, the Kinetoscope consisted of a wooden cabinet, in the interior of which the mechanism was assembled (1). The film was not projected but was viewed by transmitted light through a magnifying lens contained in an eyepiece at the top of the case. It was, in fact, a peepshow device which permitted only one spectator at a time to view the pictures inside. The film passed continuously under the inspection lens at the rate of about forty or more frames per second,[4] and ran in an endless loop carried on a spool bank. A shutter revolved between the eye and the illuminant which was a low-voltage electric lamp (2). The film for use in the apparatus was similar to the standard 35mm film in use today, and an original Kinetoscope film can still be projected on a modern machine. Each film was about 40ft in length before being joined at its ends to form the loop. It was driven by a sprocket-wheel engaging with the perforations on each side, and was powered by an electric motor.

In America, the Kinetoscope, in its commercial form, was placed on the market early in 1894, and was soon being installed in parlours throughout the states (3).[5] It was mostly operated on the coin-in-the-slot principle and was powered by electric current from the mains, or from accumulators.

2 Replica of the Edison
Kinetoscope, made by Robert
W. Paul: details of interior
mechanism. *(Conservatoire
National des Arts et Métiers,
Paris)*

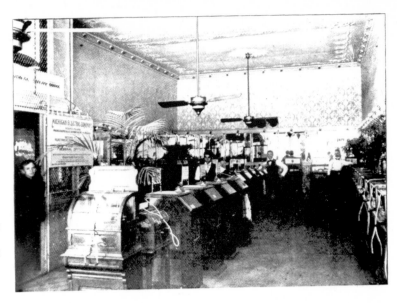

3 Typical American Kinetoscope parlour: 184 Woodward Avenue, Detroit, opened 11 November 1894; manager: Charles Urban. Urban came to England in 1898 and subsequently became one of the most influential figures in the early British film industry. *(Science Museum, London; Crown copyright)*

4 Front cover of the Dicksons' booklet, *History of the Kinetograph, Kinetoscope and Kineto-Phonograph* (New York, 1895), overprinted with the name and address of the Continental Commerce Co. *(Barnes Museum of Cinematography)*

News of the Kinetoscope had reached England before the apparatus was exhibited here. An illustrated account of the invention by W.K.-L. Dickson and his sister Antonia had appeared in the June 1894 issue of *The Century Magazine*, an American publication which was widely distributed in England by the London publisher, T. Fisher Unwin.[6] This was not the only reference to the invention to appear in this country; a minor report had been published in *Cassell's Family Magazine* as long ago as September 1891.[7] Several other accounts had also appeared before the Kinetoscope's English debut, and *Chambers's Journal of Popular Literature, Science and Art* reported in April 1894: 'It is said that Mr Edison has completed his "Kinetoscope", about which various absurd reports have been current during the past year.'[8]

The Kinetoscope finally made its appearance in England on 17 October 1894, when it was exhibited at 70 Oxford Street, London.[9] This parlour was owned by Frank Z. Maguire and Joseph D. Baucus of the Continental Commerce Company, whose head office was at 44 Pine Street, New York.[10]

A small booklet by the Dicksons, based on their original article in *The Century Magazine*, had been published in America and this was reissued in England by Maguire and Baucus, with the name and address of the Continental Commerce Company overprinted on the front cover. It was entitled: *History of the Kinetograph, Kinetoscope, and Kineto-Phonograph*, by W.K.-L. Dickson and Antonia Dickson. Copyright and designed by W.K.-L. Dickson (4).[11]

The Oxford Street debut of the Kinetoscope marks the beginning of the cinema in England. It is from this inauspicious occasion, which received mixed notices in the daily and photographic press, that all subsequent motion-picture development in this country originated. The public opening of the Oxford Street parlour had been preceded

12

HISTORY of the KINETOGRAPH KINETOSCOPE and KINETO-PHONOGRAPH

BY
W·K·L·DICKSON
and
ANTONIA DICKSON

Copyrighted
AND
Designed by
W.K.L.DICKSON

by a private demonstration which took place in the evening of Wednesday 17 October, and to which members of the press were specially invited. Mr Maguire himself was in attendance, no doubt to explain technicalities and to make sure the enterprise was launched in a fitting manner to attract the widest publicity. Singled out for special mention by the press the next day, were *Blacksmith Shop, Cock Fight, Anna Belle Serpentine Dance, The Bar Room, Carmencita, Wrestling Match,* and *Barber Shop.*

According to the correspondent of *The Times*, ten machines were demonstrated and the audience was informed of Edison's intention eventually to synchronise the Phonograph with the Kinetoscope and to project the pictures life-size on a screen so that he would be able to give the world a startling reproduction of human life. Although *The Times* devoted several hundred words to the event, most of which were taken up with explaining the technicalities of the invention, the correspondent did not appear over-enthusiastic, merely commenting that 'The latest, and not the least remarkable of Mr Edison's inventions is the kinetoscope, of which a private demonstration was given last evening at 70 Oxford Street. This instrument is to the eye what Edison's phonograph is to the ear, in that it reproduces living movements of the most complex and rapid character.'[12]

The correspondent of *The Daily Graphic*, however, was decidedly more impressed and devoted almost a full column to the occasion, under the heading MR EDISON'S LIVING PICTURES. 'At scientific conversaziones,' he wrote, 'the visitor is used to finding pretty and wonderful things for him to see—the playthings of science—but hardly ever has anything more striking and pretty been shown than the kinetoscopes which Mr Maguire, acting as the European representative of Mr Edison, exhibited at the conversazione last night in Oxford Street.'[13]

Perhaps least enthusiastic, on the whole, was the photographic press; none more so than the periodical *Photographic Work*:

The exhibition of Mr Edison's kinetoscope in London is disappointing, as when it is announced that Mr Edison has 'invented' something, we at least expect that he will carry refinement, completeness and perfection of construction a long way beyond what has previously been done. Mr Edison should, perhaps, rather rank as a careful and laborious constructor than as inventor—that is to say, if a man may be called a constructor of articles which are made by others under his control.[14]

From information revealed by Hendricks,[15] it seems that there were possibly five Kinetoscope parlours operating in London by 9 November 1894. Two of these were run by the Continental Commerce Company, for in addition to the parlour in Oxford Street they had opened another in the Strand, on 9 November. Apparently, the other three were independent concerns.

It thus appears that the craze for peepshow movies was almost as great in London as it had been in the big cities of America, and consequently there arose a demand for Kinetoscope machines which could not be met by regular Edison agents. As the invention had not been patented in Europe, showmen were not slow in looking around for someone with the necessary skill and technical resources who could manufacture replicas. Robert William Paul (5) an electrical engineer and scientific instrument maker of 44 Hatton Garden, London, seemed a logical choice. The story of how Paul was approached by two Greeks with a request to manufacture copies of the Kinetoscope is already well known, the story having been told at least half a dozen times in the popular literature of the cinema.[16] The story first appeared in 1912 in the pages of Talbot's book *Moving Pictures*.[17] In writing the work, the author had approached several pioneers for their reminiscences, and Paul was no exception.[18] The story as related by Talbot is as follows:

Among those who saw the instrument at the World's Fair [Chicago] were two Greek visitors from London. One was a greengrocer, the other a toy-maker. With shrewd business instinct they perceived here an opportunity to make a fortune in England. The Kinetoscope was known only by name in London, and the search for novelty in regard to new forms of amusement inevitably brings a rich reward to the ingenious exploiter. The two men acquired a machine and brought it home with them, their intention being to make duplicates and instal them in public places, to work upon the penny-in-the-slot principle.

The two Greeks evidently were not animated by very lofty ideas of business integrity, for they did not trouble to ascertain if the Kinetoscope were patented in Great Britain.

Upon arrival in London they sought for a man who could duplicate the machine they had brought with them; and they approached Mr Robert W. Paul, an electrical engineer and scientific instrument maker, who at that time had his workshops in Hatton Garden. They brought the Kinetoscope to him. He had never seen it before, and was deeply interested in its operation. When, however, they suggested that he should produce copies of it to their order, he declined, for he felt sure that Edison never would have omitted to secure its protection in Great Britain. He pointed out to the Greeks that that both he and they would probably expose themselves to litigation and heavy damages for infringing a patent.

His clients expressed dissatisfaction at this decision and departed with the instrument. After they had gone, Paul was prompted to make a search at the Patent Office, and to his intense surprise he found that Edison had not protected his invention by taking out British patents. He was thus at liberty to build as many machines as he desired, and forthwith he set to work, not only for his Greek visitors, but also for his own market.[19]

15

5 Robert William Paul,
MIEE (1869–1943). *(National
Film Archive)*

In 1926, Terry Ramsaye published his history of the motion picture titled *A Million and One Nights*[20] in which is to be found a similar story of Paul's encounter with the two Greeks. Apart from embellishing the account with typical Ramsaye journalese, he is able to add a few particulars not recorded by Talbot. He gives the names of the Greeks as Georgiades and Trajedis (*sic*).[21] They had arrived in England with Kinetoscopes purchased in New York and opened an exhibition in a store in Old Broad Street in the City.[22] This enterprise was an immediate success. Wishing to extend the business and loath to pay $300 apiece for imported machines, they looked around for a machinist capable of making duplicates in England. A fellow countryman, one Melachrino, introduced them to a friend of Paul's named Henry Short, who managed to arrange a meeting with Paul. After some deliberation, Paul agreed to manufacture the required number of machines and at the same time decided to make others for himself, which he placed on exhibition at Earls Court, with great profit to himself.[23]

The only other version of this story that need concern us here is related by Paul himself in a lecture he delivered to a meeting of the British Kinematograph Society on 3 February 1936:

> My first contact with animated photography occurred by chance in connection with the business of manufacturing electrical and other scientific instruments which I had started in Hatton Garden in 1891. In 1894 I was introduced by my friend, H.W. Short,[24] to two Greeks who had installed in a shop in Old Broad Street, E.C.,[25] six kinetoscopes, bought from Edison's agents in New York. At a charge of twopence per person per picture one looked through a lens at a continuously running film and saw an animated photograph lasting about half a minute. Boxing Cats, A Barber's Shop, A Shoeblack at Work were among the subjects, and the public interest was such that additional machines were urgently needed. Finding that no steps had been taken to patent the machine I was able to construct six before the end of that year. To supply the demand from travelling showmen and others, I made about sixty kinetoscopes in 1895, and in conjunction with business friends installed fifteen at the Exhibition at Earl's Court, London, showing some of the first of our British films, including the Boat Race and Derby of 1895.[26]

Hendricks, in his history of the Kinetoscope, has little to add to the story, since he purposely confines himself to the American scene. He is, however, as to be expected, more specific concerning the Kinetoscopes bought in America by the two Greeks, whom he names as George Georgiades and George Trajedes (not Trajedis as Ramsaye states). The machines were acquired from the Holland Brothers.[27]

An earlier reference to Paul's Kinetoscope activities is to be found in a chat with the inventor published in *The Era*, a weekly newspaper

devoted to show business, and an invaluable source of reference for the early history of the cinema in Great Britain. In the issue of 25 April 1896, *The 'Era*'s special commissioner' has this to say:

> Mr Paul was greatly interested in the perfection and exploitation of the kinetoscope, of which he was in charge at the India Exhibition . . .
>
> Mr Paul was amazingly successful with his kinetoscopes. During the six months of the India Exhibition he disposed of the instruments at the rate of nearly a hundred a month, his relations with the Edison people being so friendly that they often exchanged subjects.[28]

This last statement seems extraordinary, to say the least, especially in view of what we have since learned of Edison practice through Mr Hendricks. That Edison was never one to allow others to encroach upon what he believed to be his own preserve, is evident from the amount of litigation in which he became involved. Though the Kinetoscope machine was not protected in England, the films were definitely Edison's copyright. This, however, did not prevent infringements from time to time,[29] and we have several instances of Edison films being illegally shown by exhibitors, including Paul himself, as we shall see in the course of this history.

Just how many Kinetoscopes were manufactured by Paul is not known. Paul himself puts the figure at around sixty-six, which includes the six he recalls having made in 1894. The claim that he was selling nearly 100 a month at the India Exhibition, Earls Court, must therefore be a gross exaggeration. Some of those he made were probably exported. Charles Pathé, for instance, in his autobiography, states that he acquired a Kinetoscope from London[30] which may very well have been one of Paul's machines.

The only Kinetoscope machine of Paul's manufacture known to be extant is the one preserved in the Conservatoire National des Arts et Métiers in Paris (2).[31] This was donated by another pioneer of the French cinema, Raoul Grimoin-Sanson, renowned for his invention of Cinéorama, a completely circular cinema, which was the precursor of Disney's Circarama and the Russian Circlorama. In his autobiography, published in 1926, Grimoin-Sanson claims to have purchased the first Kinetoscope to have arrived in Europe, at a cost of 650 francs. This machine he carefully preserved and it was still in his possession at the time he was writing.[32] It is obviously the one he subsequently donated to the Conservatoire National des Arts et Métiers. Gordon Hendricks, who has examined this machine, has found it to be one of Paul's replicas,[33] and although Grimoin-Sanson is in error concerning its origin, we are nevertheless indebted to him for preserving it. Incidentally, Grimoin-Sanson provides another example of a pioneer in the field of cinematography who acknowledges the Kinetoscope as the source of his invention.

18

2 The Paul-Acres Camera

Having been inducted into the Kinetoscope business late in 1894 by the two Greeks, Georgiades and Trajedes, Robert W. Paul must soon have been faced with a certain dilemma. The future success of the business would depend on a supply of films. The only films then available were those being shot in the 'Black Maria' studio back in New Orange,[1] and these were reserved for official operators of Edison machines. Unlike the Kinetoscope, which Edison had failed to patent abroad, the films were subject to international copyright by their registration in the Library of Congress at Washington. Such circumstances, rather than acting as a deterrent to Paul, provided him with the incentive to manufacture a camera of his own.

At that time, the Kinetograph was a closely guarded secret at the Edison works, at least until the patent was finally issued in 1897 (US pat no 589168). The Kinetoscope, on the other hand, was open to inspection for anyone who cared to look. The task thus confronting Paul, and other would-be inventors of cinematography (the Lumière brothers for example), was to analyse the available evidence and re-invent a camera which could produce a near replica of the Kinetoscope picture-strip. The problem, though formidable, was not as difficult as that which originally confronted W.K-L. Dickson, who had only the imperfect attempts at moving pictures made by his precursors to guide him.

The facts concerning the first cinematograph camera invented and made in England are somewhat obscure. This is not surprising when we realise that cameras generally are the least documented of early cinematographic equipment, since it was usually the practice of the first film-makers to supply films exclusively for use in projectors of their own make.[2] The camera was thus regarded as the fountainhead of their success and its details kept secret. This is equally true of Paul's first camera, which was made solely to supply films for his Kinetoscope customers. It was not until about the middle of 1896 that the first cinematograph camera was commercially produced. Just the contrary applied to the invention of the film projector, which called for immediate commercial production. The precedent had been set by Edison who, although he marketed over 1,000 Kinetoscopes, retained the camera—the Kinetograph—as the sole source of film production. Paul himself, when he commenced the commercial production of projectors, held back for some time before he manufactured a camera for the commercial market.

From a statement of Paul's, to be referred to later, it appears that trials with the first camera had taken place in February 1895, the same month and year in which the Lumière brothers patented their Cinématographe.[3] But since his statement was made long after the event, it cannot be upheld as a valid claim to priority. We have proof, however, that Paul had a workable camera ready by 29 March, for on

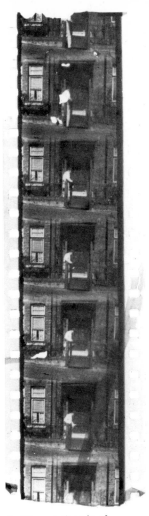

6 The sample strip of Kinetoscope film sent by Paul to Edison on 29 March 1895. *(US Department of the Interior, National Park Service, Edison Historic Site)*

19

The facsimile of the handwritten letter appears at the top of the page.

7 Letter from R.W. Paul to Thomas Edison, 29 March 1895. *(US Department of the Interior, National Park Service, Edison Historic Site)*

that date he wrote to Thomas A. Edison, enclosing a sample strip of cinematograph film. The film strip (6) and letter (7) are now in the Edison Museum at West Orange.[4] The letter reads as follows:

> Dear Sir,
>
> I have taken some interest in your Kinetoscope here, and have found that a demand existed for a greater variety of subjects that [*sic*] at present available. I have therefore commenced to manufacture films representing recent scenes and events here, and shall be pleased to hear from you if you think that our mutual interests would be served by an exchange of films.
>
> I enclose for your inspection the f* a small piece of the first film which I have made, thinking it might interest you although I expect to attain even better results with a little practice.
>
> In case you decide to entertain this proposal I shall be pleased to co-operate with you in stopping sundry attempts now being made here to copy your films—which, I take it, is an offence against the international Copyright Act.
>
> I am, Dear Sir,
> Yours faithfully,
> Robt. W. Paul

This letter was answered by Edison on 16 April, rejecting Paul's proposal.[5]

A further piece of this film is reproduced in Talbot's *Moving*

* Here 'the f' is written and crossed through. Evidently Paul intended to write 'the film' but changed his mind.

20

Pictures,[6] where it is captioned: 'The first kinetoscope film made in England' (8). It obviously forms part of the same strip sent to Edison, but records a later, or earlier, phase of the action. There is no reason to doubt that this was indeed the first successful film taken in England, for why else would Paul have kept it, unless it marked some significant event in his career?

In his BKS lecture already referred to, Paul told his audience: 'I am able to show a bit of kinetoscope film taken during a trial of our first camera in February, 1895.'[7] This lecture was delivered in 1936 and there is now no means of knowing what subject was represented on the film, but we can hazard a guess that it was yet another piece of the strip mentioned above, which Paul had retained as a keepsake. The scene shown on the former strips is the front of Clovelly Cottage, Barnet, the home of Birt Acres who was Paul's cameraman at the time. The name of the cottage is written on the lintel of the door, but is hardly legible in the illustrations (6, 8, 74). The identification of the scene with Clovelly Cottage is also attested by Birt Acres himself (9), who has recorded the fact in his personal copy of Talbot's *Moving Pictures*, now in the keeping of the British Film Institute. The book is annotated throughout in Acres's handwriting. Against the illustration facing page 36, which is captioned 'the first kinetoscope film made in England', Acres has written:

> This reproduction of a Kinetoscope film was taken by Birt Acres and is a view of the front entrance of his home, Clovelly Cottage, Barnet. The figure in white is his paid assistant Henry W. Short, and was taken at the rate of 40 pictures per second, 2400 per min.[8]

The consecutive phases of action recorded on these two strips clearly indicate that a practical cinematograph camera had been used to record them, and we know that the two men associated with this camera were Robert W. Paul and Birt Acres. Henceforth I shall refer to this camera as the Paul–Acres camera.

Paul's letter to Edison and the strip of film enclosed with it also cofirm that Paul had devised a satisfactory perforator and printer by 29 March 1895 for, as Hendricks has pointed out, the sprocket-holes are of the same size and location as those of the Edison film.[9] There must have been a certain amount of trial and error before such perfection was attained, and it seems likely that a February date for these trials would be a conservative one. Concerning the perforating of the films at this time, Paul has this to say: 'For perforating the film I made, for use in an ordinary fly-press, a set of punches, 32 in number, with pilot pins, to the Edison gauge.'[10] This use of hand punches as a first expedient to perforate the film seems to be borne out by a strip of film in the Will Day Collection of Historical Cinematograph and Moving Picture Equipment, which is claimed to be a piece of Paul's first film. I have not had the opportunity of examining the actual strip, but it is listed and described in the Will Day Catalogue, under item 300, as follows:

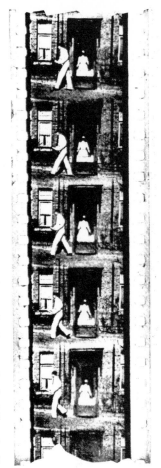

8 'The first Kinetoscope film made in England': from an illustration in Frederick A. Talbot, *Moving Pictures* (London, 1912). This is a further section of the film that Paul sent to Edison in 1895. *(Barnes Museum of Cinematography)*

21

9 Birt Acres, FR MetS, FRPS (1854–1918). *(Mrs Sidney Birt Acres)*

SMALL PORTION OF POSITIVE FILM, being the first film ever taken by Mr R.W. Paul in 1895, and showing a cricketer jumping over the garden gate of Mr Paul's own residence. The perforations are interesting in this film as they were carried out by the use of a 32-toothed hand punch, the film being placed upon a block of lead and the punch being driven through the film with a hammer. Hence the irregularity of the perforations.[11]

It is difficult to believe that such accurate perforating as is revealed by the sample strip of film sent to Edison on 29 March 1895 could have been effected by the manual method just described, and we are forced to believe that a more sophisticated method was by then in use, such as a rotary perforator of the kind now represented in the Science Museum, South Kensington, by a replica made from an original in the Will Day Collection which is ascribed to R.W. Paul, but to the year 1896 (10).[12] A reliable printer must also have been constructed

about the same time, although the Paul–Acres camera may have served the purpose in the initial stages. A Paul printer in the Science Museum is also ascribed to the year 1896 and may be contemporary with the perforator (11). It seems highly unlikely that Paul would suggest to Edison an exchange of films if his own were not of a comparable standard to Edison's, which they certainly would not have been if the perforations were as irregular as Will Day suggests was the case with the hand-punched film. It is reasonable to suppose, therefore, that both the rotary perforator and the printer mentioned above[13] are modified versions of models previously in use as early as March 1895.

What little information we have concerning the camera is meagre in the extreme, and we have largely to fall back on reminiscences given many years later, never a very reliable method of ascertaining the facts at the best of times, but, under the present circumstances, the only course left open to us. It will therefore be as well to begin our investigation with an examination of the later accounts, and then see how these tally with the few known facts ascertained from contemporary sources.

The story as told by Talbot, whose source of information was Paul himself, is as follows:

10 Paul's rotary film perforator, c1895-6; replica made from the original in the Will Day Collection. *(Science Museum, London; Crown copyright)*

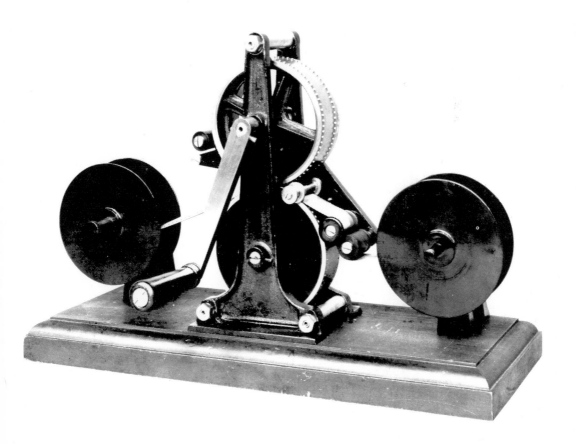

11 Paul's film printer, c1896.
*(Science Museum, London;
Crown copyright)*

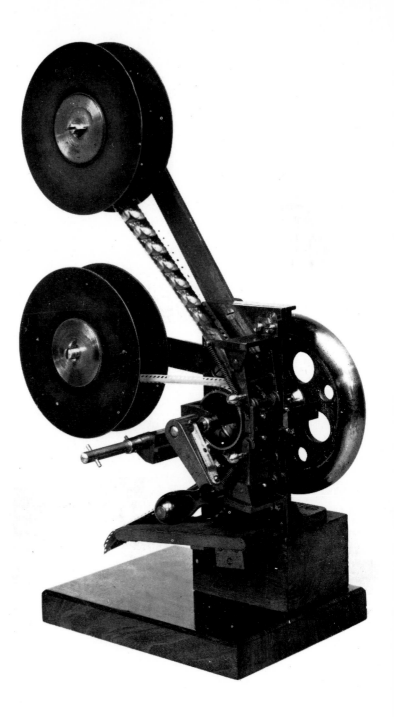

[Paul] was introduced to another inventor, Mr Birt Acres, at that time in the employment of a firm engaged in the manufacture of dry plates and bromide papers. Acres had conceived a mechanical means of printing on bromide paper from glass negatives a number of copies of a subject at a very rapid rate, and had committed to paper his crude suggestion. He submitted his drawing to Paul. The negative was to be set in a frame, beneath which the bromide paper travelled over rollers in a continuous length. The coil of paper was to move a certain distance—the length of the negative, in fact—and then to pause; when a flat pad, carried at the end of a lever beneath the paper, was to rise up and press the latter flatly and tightly against the negative. When the exposure had been made the clamping device, as it was called, fell back, and permitted the paper to travel another short distance to bring a fresh unexposed surface beneath the negative, when the same cycle of operations was repeated.

When Acres brought his sketch to Paul, the latter was wrestling with the problem of photographing objects in motion. It was imperative to perfect a camera in order to defeat the machinations of the Americans bent upon the capture of the English film market. In this task, however, the most satisfactory means of securing intermittent motion was the stumbling block. He thought for a time that Acres's ingenious method of printing bromide prints might offer a clue. Being a mechanical engineer, Paul recognised the inefficiency of Acres's idea as far as its application to cinematography was concerned, because the clamping device was not actuated by a positive drive. But the rough drawing which Acres had made of his bromide printing process set Paul thinking, and gave birth in the end to an entirely different project.

... it was not long before he produced a camera working with an intermittent motion. With this camera some excellent films were obtained, and in the first instance these were employed with the Kinetoscope. The purchasers of the Paul machines consequently experienced no difficulty whatever in getting all the films they wanted, and the American product was ignored.[14]

Terry Ramsaye's account, partly based on Talbot, includes a short extract from a letter he received from Paul dated 23 July 1924, written in response to an enquiry on the subject:

I find that on March 29, 1895,[15] I made an agreement with Birt Acres for him to take films for the Kinetoscope with a camera made by me. It has an intermittent movement of the film, effected by clamping and unclamping the film at the 'gate' while under tension provided by a spring jockey-roller. This gave unsteady pictures and within a few weeks (I think, days) was replaced by a sprocket, 7 pictures in circumference, actuated by a finger wheel and a 7-point star based on the idea of a Maltese cross.[16]

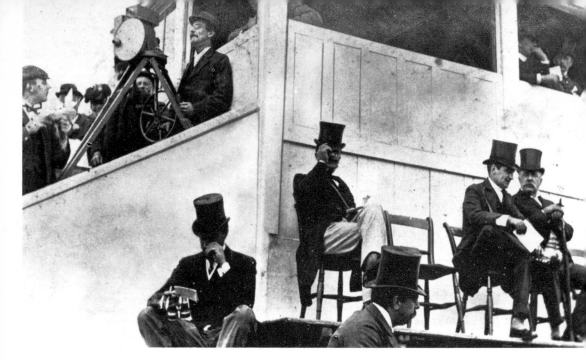

12 Birt Acres filming the Derby of 1895 with the Paul–Acres camera. The gentleman in the immediate foreground is Lord Derby and the central figure seated on the platform is Lord Marcus Beresford. *(Mrs Sidney Birt Acres)*

In his lecture to the British Kinematograph Society in 1936, Paul had this to say:

> We had no information to guide us in designing a camera, but I worked out an idea due to Acres. The film was drawn, under slight tension, from an upper spool, past the light opening, or gate, to another spool below. A clamping plate, intermittently actuated by a cam, held the film stationary in the gate during each exposure. A shutter, whose opening synchronised with the cam, revolved between the lens and the gate.[17]

The only contemporary evidence we have concerning this first camera is supplied by a remarkable photograph which has since been published several times, although wrongly interpreted (12). It is reproduced in C.W. Ceram's *Archaeology of the Cinema*,[18] where it is captioned 'Birt Acres with his camera filming the Derby'. The photograph also appears in Jacques Deslandes, *Histoire Comparée du Cinéma*.[19] Here it is placed within the passage of the text relating to Paul's film of the Derby of 1896, and the inference is that the picture shows the filming of that event. The caption wrongly states that the apparatus used is the 'Animatographe' of R.W. Paul. The same photograph had previously been published in the *Amateur Photographer* for 18 April 1956, to illustrate an article on Birt Acres written by his son Sidney.[20] Here the photograph is captioned: 'In this picture Birt Acres is seen photographing the Derby in 1895. Mounted on a massive tripod is his Kinetic Camera. This is a copy from an old and faded print.'[21]

We know that Birt Acres was granted a patent for his 'Kinetic Camera' on 27 May 1895 (pat no 10474), only two days before the Derby of 29 May 1895, and it might be supposed that it was this

26

camera which is depicted in the photograph, with Birt Acres himself shown at the controls. There is no difficulty in identifying the man with his hand on the crank-wheel as Birt Acres, nor the *locale* as the race-course at Epsom. What is in question is the identity of the camera being used, and the date when the photograph was taken. I now propose to show that the camera is not the Birt Acres camera patented on 27 May, but the Paul–Acres camera already mentioned. Also that the date of the photograph is 29 May 1895.

Our clue is supplied by a photograph published in *The Strand Magazine* for August 1896 (13).[22] This photograph shows R.W. Paul posing behind his camera in the act of 'turning' a film. The similarity between this camera and the one shown with Birt Acres at Epsom (12) is truly remarkable, and although the cameras are not identical, they both have the same 'look' and obviously emanate from the same designer or designers. Moreover, both cameras have distinctive features in common. Unfortunately, the *Strand* photograph is not very clearly reproduced, but on close examination the following features are revealed. The most striking is the large circular casing enclosing the camera shutter, which extends conspicuously beyond the edge of the camera at one side. It is almost exactly the same as the one shown on the camera in the Birt Acres photograph. The view-finders on each camera, too, are almost identical, although mounted in slightly different positions. Both cameras are turned by large, six-spoked crank-wheels which, although identical, are mounted in different positions. On the camera shown in the Birt Acres photograph, the crank-wheel is awkwardly mounted below and at right angles to the camera itself, no doubt to be in a truer and more convenient position to actuate the unsatisfactory[23] clamping and unclamping device of the intermittent movement, which Paul informs us that the first camera had. The camera in the *Strand* photograph, however, shows the crank-wheel in the normal position for operating a Maltese-cross type of intermittent mechanism, where the driving spindle would run at right angles to the mechanism, that is, from side to side of the camera, with one end protruding to carry the crank-handle or, as in this case, the pulley on which the driving belt connects to the crank-wheel.* These details exactly correspond with Paul's description of the second camera, in which he says that a seven-point star wheel based on the Maltese cross was employed.

The form or shape of the two cameras under examination is also similar, and the position of the objective lens, in the centre of the front camera-panel, is also the same in both cameras. There can be little doubt that the two photographs show (1) Birt Acres operating the first camera, ie the Paul–Acres camera, and (2) Paul with the second camera, the first which he made independently.

There now remains only the question of the date when the two

* Note the position of the driving shaft in the drawing of the Birt Acres camera (27). Here the shaft extends from the rear of the camera and occupies a similar position to that of the Paul–Acres camera where the same type of intermittent clamping device was used.

13 Paul's Cinematograph Camera No 1, used by R.W. Paul to film the Derby of 1896. Paul is shown with his hand on the crank-wheel. (From an illustration in *The Strand Magazine,* August 1896.) This camera was probably contructed by Paul in April 1896. *(Barnes Museum of Cinematography)*

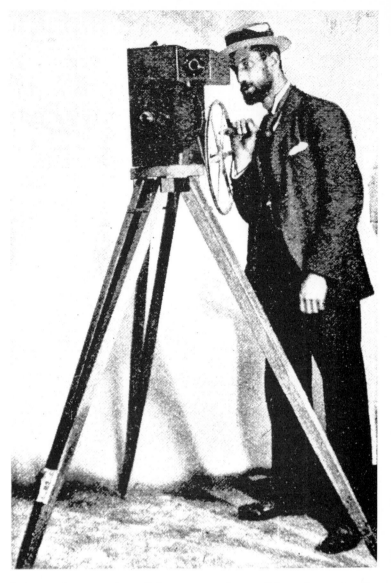

photographs were taken. It is at present impossible to determine the exact date of the *Strand* photograph, but this is relatively unimportant since it was published in the August issue of 1896, to illustrate a feature article on the filming, by Paul, of the Derby which was run the previous June, when the race was won by the Prince of Wales's horse 'Persimmon'. The article informs us that it was the camera used by Paul to film this event, which we know took place on 3 June. Since we have established that this was the first camera made by Paul independently of Birt Acres, the photograph which shows Acres with the former camera, the Paul–Acres camera, must have been taken at Epsom the previous year, that is on 29 May 1895, the date when the Derby for that year took place.

28

Shortly after this picture was taken, Birt Acres left for Germany to film the opening of the Kiel Canal, and the partnership or collaboration between the two men came to an end. The films which had been turned by Acres before the split, including the Derby of 1895, remained the property of both men, for both Paul and Acres later included them in their early screen performances.

During their collaboration, Birt Acres had been allocated the job of cameraman and was also in charge of the processing of the films, and no doubt he considered the films were as much his property as they were Paul's. In his lecture to the BKS, Paul had this to say about the arrangement: 'In Birt Acres I found a photographer willing to take up the photography and processing, provided I could supply him with the necessary plant, which I did early in 1895.'[24] It is always difficult, with a co-invention, to know how to apportion the credit due to each man. From the available evidence, it seems to me that Paul was the guiding hand and certainly the instigator of the first camera. My reading of the evidence so far may be summarised as follows.

Having achieved a measure of success with the manufacture of Kinetoscopes, Paul was faced with a shortage of films and came to the conclusion that he must make his own if the future success of the business was to continue. He therefore set himself the task of inventing and constructing a camera. His knowledge of photography at that time being wanting, he decided to enlist the services of a professional photographer to assist him. This brought him into contact with Birt Acres, who he knew was of an inventive turn of mind, having already taken out two patents relating to photographic matters.[25] Birt Acres was able to suggest a rather clumsy method of imparting an intermittent movement to the film by a clamping and unclamping device applied to the film in the gate of the camera. He also assisted with the optical and chemical side of the enterprise, being something of an expert in these matters.[26] It remained for Paul to put these theories into practice and to arrive at a satisfactory conclusion. The plans for the camera were thus drawn up and the work executed at his factory at 114–15 Great Saffron Hill, London, which was already equipped for the manufacture of scientific instruments and kinetoscopes. The result was the Paul–Acres camera, the first cinematograph camera to be made and invented in England. Birt Acres was put in charge of the camera, and it was he who turned the first films.

A disagreement then arose between the two men, probably over the patent which Birt Acres filed on 27 March for a 'Kinetic Camera'. This patent claimed the intermittent movement and other features previously incorporated in the Paul–Acres camera, which had not been patented, but which Paul felt was largely of his own invention. Acres, on the other hand, apparently considered that the major share of the invention belonged to himself. Subsequent events have proved that Paul was by far the more inventive of the two men. He went on to

design a number of other cameras, as well as several film projectors. He also made improvements in perforators and printers and other cinematographic equipment, all of which were manufactured at his own works. He was also instrumental in laying the foundations of the British film industry—an amazing achievement when we consider that he retired from the industry before 1910. It is little wonder that he was affectionately known in the trade as 'Daddy' Paul,[27] for he was indeed the father of the British cinema.

At this stage, it would be only fair for some account of the invention to be given from the point of view of Birt Acres, and we are fortunate in having a personal statement in the form of a letter that Acres addressed to the editor of the *Amateur Photographer*, which was published in the issue for 1 October 1897, under the heading 'The Inventor of the Cinematograph'. As the letter is rather lengthy, I will quote only that portion relevant to our text:

Sir,—I have just been reading your interesting article on the 'Cinematograph', and as it aims at being historical, I trust you will permit me to make some corrections. On page 263 you are good enough to say that 'on the appearance of the kinetoscope several inventors—of which Birt Acres, in England, and the Lumiere Bros., in France, were foremost—turned their attention to its conversion into a projection machine, etc.' Now I cannot speak for Messrs. Lumiere, but so far as I am concerned I had designed practically the same machine that I have used during the last two or three years before the Edison kinetoscope was heard of or at least before I had heard of it, namely, at the latter end of 1893, but I did not apply for a patent for it, until 1895, as until the commencement of the latter year my time was fully occupied otherwise. Further if you will search the patent records for the year 1893 I applied for a patent for a one-lens machine (my previous experiments with twelve lenses not satisfying my ideal) by which I could expose and project a number of separate plates or films in rapid succession, the advantage of this system being that an almost indefinite number of exposures could be made, so that the incident was not limited as in the Muybridge or Anschutz, or my own previous machine, and further, parallax was entirely avoided. Again, where do you get the information from that I ever tried such an absurd thing as to try and use the Edison kinetoscope as a projection machine? I am aware that some inventors (?) did by an arrangement of reflectors and a lens endeavour to project these pictures by means of a powerful electric light, but I cannot allow it to be stated as a fact in your widely read journal that I tried to do so, and I have very little doubt that Messrs. Lumiere will deny that they tried such a system.[28]

Such a letter would hardly be worth considering were it not written by one of our pioneers, and one who rightly holds an honourable place in the history of cinematography in this country. It is such a travesty

of the known facts, that almost every one of them can be refuted.

It really does seem extraordinary that, if Birt Acres had indeed designed at the end of 1893 'practically the same machine' as the one he says he had been using for the last two or tree years, the world never got to hear of it, especially since all his other activities were regularly reported in the pages of the *Amateur Photographer*. And it is equally extraordinary that this machine, which he says he invented before he had ever heard of the Kinetoscope, should have used film of the same size—a really extraordinary coincidence! His patent of 27 May 1895, which we have already mentioned, contained many of the features previously used in the Paul–Acres camera, and the one-lens apparatus which he patented in 1893 (pat no 23670) was not a cinematographic apparatus at all, but a method for 'exposing successive photographic plates, and for exhibiting magic lantern and other slides', akin to a rapidly changing slide carrier of the kind used in optical lantern projections.

We also have an article on 'Animated Photography' by Birt Acres, written at an earlier period for the same journal, and published on 9 October 1896, in which his claims are noticeably less extravagant:

> Without claiming to be the originator of animated photography I do claim to have been the first to have made a portable apparatus which successfully took photographs of ordinary scenes of everyday life. In March or April, 1895, I took a successful photograph of the Oxford and Cambridge Boat Race, and in the same year I photographed the Derby, in which I showed the course being cleared by the police, then the preliminary canter, followed by the race, and then the crowd surging over the course. I also took successful photographs of the opening of the Kiel Canal in July of the same year. Up to the time that I had taken these photographs *no successful* pictures had been taken of such a nature, the pictures shown in the Edison kinetoscope having been photographs of specially arranged scenes, such as a boxing match, dancing girls, etc.[29]

Here again he is at variance with the facts. We know from documentary evidence, a photograph of the actual occasion, that the camera Birt Acres used to turn the film of the Derby of 1895 was not the portable camera he had patented on 27 May, but the Paul–Acres camera. Similarly, the Boat Race, which took place the previous month, on 30 March, was also turned with this camera. As for the Kinetoscope films, choice of subject is irrelevant to the invention of cinematography, but is important only as regards film content, and in this respect Birt Acres was certainly the first in England to turn topical subjects, although under Paul's direction. However, the Lumière brothers in France were concurrently producing similar subjects.

Later writers have called the films of the Boat Race and Derby of

1895, and the Kiel Canal ceremony, the first news films;[30] but the term 'news' can hardly be applied to films which were not publicly shown until many months after the events took place, which was indeed the case with the films just cited.

Birt Acres was fortunate in having the support of the editor of the *Amateur Photographer*, who constantly espoused his cause. He was equally fortunate in the assessment of his work given by Henry V. Hopwood, whose book *Living Pictures* was the first important and authoritative work on the history of cinematography to be published in England. In referring to the work of Birt Acres in this field, Hopwood has this to say:

> While Messrs Lumière were triumphing over their difficulties in France, the problem was also being attacked on this side of the Channel. It is certain that Mr Birt Acres was working concurrently with Messrs Lumière, for he photographed the University Boat-Race with his *Kinetic Camera* on March 30th, 1895, only a few days after Messrs Lumière filed their French patent, and before the deposit of their English one. In fact, Mr Acres appears to have been beaten all through the race by a few days; his English patent is dated about five weeks after Lumière's, and he does not appear to have given a public exhibition until the early days of 1896. But this point is of little importance, for his apparatus was constructed on distinctly different lines to those adopted in the Cinématographe.[31]

What Hopwood failed to realise was that the Boat Race was not filmed with Acres's Kinetic camera (pat no 10474 of 27 May 1895) but with the Paul–Acres Camera which was the only one in existence at that time, for why else would Acres be using the Paul–Acres Camera a few days later at Epsom, where our illustration (12) shows him filming the Derby with that camera?

In a hitherto unpublished source, we have Paul's own comment on Hopwood's statement that Acres photographed the University Boat Race with his Kinetic Camera. It is to be found in Paul's personal copy of Hopwood's book, now in the Barnes Museum of Cinematography. The title-page is signed in Paul's own hand 'Robt. W. Paul' and the page is also embossed with his home address, '69 Addison Road, Kensington, W.'[32] Paul has made several annotations in the margin of the book, and against the statement just mentioned he has written 'With a camera made by R.W. Paul'. From a careful examination of the available evidence, we are fully in accord with Paul's claim.

The dispute between Birt Acres and R. W. Paul was publicly aired in an exchange of letters published in the *British Journal of Photography* during March and April 1896. These letters came to my notice after the foregoing part of this chapter was written and I am doubly convinced since reading both sides of the argument, put forward by the contestants themselves, that my former conclusions are just. In fairness to both men, I leave the reader to form his own

opinion by presenting the letters without further comment except to point out certain errors of fact ascertainable from outside sources. Each letter is addressed to the editor of the publication in which it appeared:

GENTLEMEN,—Referring to Mr G. R. Baker's notes on the projection of moving objects on the screen, I am quite willing to admit that to Messrs Lumiere belongs the credit of being the first in England to show the outside public such figures; but, at the same time, I think it is only fair to myself to point out that I successfully showed such pictures at the Royal Photographic Society on January 14, which antedates Lumiere considerably. I think it is only fair to point out that I was the first in Europe to *successfully* take photographs suitable for either the kinetoscope or the kinetic lantern (many of my *earlier* successful photographs, not being historical subjects, of course, bear no indisputable date); but it is well known that I successfully photographed the Oxford and Cambridge Boat Race last spring, also the Derby, in which is shown clearing the course, the race, and the rush across the course after the race; further, I took a series of photographs at the opening of the Kiel Canal in June last year. The photographs also of the Boxing Kangaroo, Tom Merry, lightning cartoonist, dancing girls, &c., as well as the magnificent wave picture at Dover, are also mine.

I have gone into this matter at some length, as it came to my knowledge that a certain individual had advertised himself as sole manufacturer of these films, whereas he had no more to do with the taking or making of these films than you, Mr Editor, have had. Now that projection lanterns are springing up like mushrooms all around, I think that it will be useful to know that Mr Friese Green holds what is really the master patent; and, as he has arranged with a syndicate to run his apparatus, I should not be at all surprised if he asserts his patent rights. I am informed that his claim is a good one, and so thoroughly am I convinced of his rights that I have already entered into an agreement with him, by which I have secured the right of working under his patent. I confess that I was entirely in ignorance of Mr Friese Green's work when I designed my apparatus, and, as a matter of fact, the principle on which I work is mechanically different to his, but his claim to passing a series of pictures on an endless band intermittently is original with him, and I have very little doubt that he will be able to uphold his claim.

It may seem a contradiction for me to claim that I was the first to successfully solve the difficulty in Europe in the face of what I have just written, but it is a fact that with my apparatus I am able to take pictures at almost any speed (I have gone as high as 100 per second) *accurately spaced*, which is the crux on which nearly every one has failed. Mr Friese Green's pictures were, I believe, accurately

spaced, but he did not contemplate such great rapidity as the kinetoscope involved.[33] Apologising for trespassing on your valuable space,—I am, your, &c.,

March 7, 1896. Birt Acres.[34]

GENTLEMEN,—Referring to Mr Acres' letter in yours of the 13th, stating that 'a certain individual had advertised himself as being sole manufacturer of these films,' and giving the impression that the successful manufacture in England was due to Mr Acres alone, it is due to me to state exactly what occurred, leaving your readers to form their own judgment.

In December 1894 I was manufacturing kinetoscopes, and my friend, Mr S., suggested that if I would construct a camera for taking the films he would introduce me to Mr Acres, who could undertake the photography. On February 4 Mr Acres called at my works, and agreed that, if I constructed the camera and tools at my own risk and expense, he would use it for taking films for me solely. He also handed me a sketch of an apparatus for photographic printing, and suggested that some of the actions of this might be utilised for the camera. I pointed out that this could scarcely be done, and of seven mechanical motions embodied two were abandoned, and the remainder replaced by different actions suggested by Mr S. and myself, only one unimportant piece being retained.

On February 5 and 6, 1895, I designed and constructed (with the co-operation of Mr S.) a working model. By March 16 I had made drawings of, and finished, a complete kinetograph, for which Mr Acres found a lens, but in designing the mechanism of which he took no part. Before this was finished, Mr Acres verbally undertook to share the patent with me. After the kinetograph was tried and found satisfactory, Mr Acres said he withdrew from this undertaking, and stated that he would purchase the camera, but claimed that he had a right to patent it himself.

On March 28, finding that Mr Acres insisted on this, and that during the delay the demand for films was rapidly falling off, I gave in upon this point, Mr Acres signing an agreement to produce films for me for a term of years from that date, and on March 30 our first saleable picture—viz., *The Boat Race*—was taken.

On July 12, 1895, Mr Acres stated that he was no longer in a position to make films without being financed, and the agreement was cancelled on his paying for the outfit and compensation. Since then I have constructed a kinetograph on an entirely new principle, which enables me to obtain increased accuracy in the manufacture of the films.—I am, yours, &c.,

44, Hatton-garden, London, E.C., Robt. W. Paul.
 March 17, 1896.

P.S.—Referring to the second paragraph of Mr Acres' letter, I have submitted the matter for the opinion of Mr Fletcher Moulton, Q.C., with the following result:—

. Mr Moulton is of the opinion that Mr Friese Green's patent is imited to the actual details of working described by him, in conunction with the use of the double lantern, none of which I, in any vay, embody in my system.

. Having submitted to Mr Moulton the specifications of all inetoscope projection apparatus, he states that my apparatus in 10 way infringes upon any of these.[35]

iir,—I have read the letter in your issue of the 27th ult. over the 1ame R. W. Paul, but I decline to enter into a wordy contest with 1im. I will therefore content myself with a few statements.

Towards the latter end of 1894, Mr H. W. Short (the Mr S. of 'our correspondent's letter), who was a constant visitor at my 10use, informed me that he knew a man who was making Edison inetoscopes, and who would do anything to get films, as the idison Company would only sell films to purchasers of their nachines. I believe that no patents were taken out on the Edison nachine, the Company relying on the difficulty of the successful naking of films, and, as machines were of no use without films, hey made it a stipulation with the sale of films that they were only o be used with their own machines.

Mr Short knew that I had invented an apparatus for taking (or rinting, the principle is interchangeable) a number of hotographs in rapid succession,* and suggested that, if I were greeable, he would introduce me to his friend, who would at his wn cost make any machine I required, provided that I would upply him with films. Accordingly, Mr Short introduced me to Ar Paul. Mr Paul admitted to me that he had no idea how to make uch an apparatus, but that he would work out my ideas for me. I ccordingly showed Mr Paul how the thing could be accomplished, nd made sufficient drawings to enable him to work the machine ut. From that date until the machine was finished I attended at Mr 'aul's workshop every evening, modifying and superintending the nanufacture of this machine. Mr Short was only present on rare ccasions.

I showed Mr Short Mr Paul's letter in your issue of the 27th ult., nd he seemed very surprised, and solemnly declared to me that he Mr Short) had not the faintest idea how to set about making such n apparatus before he saw my models and drawings, and he was qually certain that Mr Paul had not; and, further, that he (Mr hort) had had nothing to do with the designing of the machine.

Mr Paul's letter would give your readers the impression that a ind of partnership existed between Paul and myself, and speaks of ur first saleable picture.'

The truth is that, during the construction of the machine, Paul poke of putting a large sum of money into the manufacture of

* The patent specification shows that this was not a cinematographic or chronohotographic apparatus, but a method for rapidly exposing a series of hotographic plates or lantern slides.

35

films. I expressed myself willing, under such conditions, to give him a share in the venture, but, to my utter astonishment, when the machine was finished, Mr Paul claimed a half share in it, and this without the slightest intention of putting a sixpence into it. I very well remember Mr Short's surprise at this claim of Paul's. I finally agreed to appoint Paul agent, Paul agreeing to take a minimum number of films. Later on, Paul said he could not sell the minimum number, and so it became necessary for me to make other arrangements, which I accordingly did, having first cancelled the agreement with Paul.

If Paul thinks that he has any rights in the boat race or any other of my negatives, I would suggest that he makes copies of same in any shape or form, and publishes or makes any use whatever of such copies; we will then have an opportunity of deciding whose property they are.

In conclusion, I would only add that Mr Paul has never seen one of my negatives, and has no idea, so far as I am aware, how I print and develop my pictures (my printing machine, which is a special one, being exclusively designed by myself and made on my own premises), my methods of handling film also my own invention.

Apologising for trespassing on your space, but I could not allow such a letter to pass without laying the facts before you.—I am yours, &c.,

<div style="text-align:right">Birt Acres, F.R.Met.S., F.R.P.S.[36]</div>

3 Paul's Time Machine

The idea of film projection first seems to have occurred to R.W. Paul during the Empire of India Exhibition which was held at Earls Court, from 27 May to 26 October 1895. The article in *The Strand Magazine* for August 1896, previously referred to, reports that Paul 'made and exhibited the kinetoscopes there, and noticing the rush for these marvellous machines, he wondered if their fascinating pictures could be reproduced on a screen, so that thousands might see them at one time'.[1]

With this idea in the back of his mind, Paul happened upon a remarkable story by H.G. Wells which had recently been published, entitled *The Time Machine*.[2] The story has since become so well known and is so easily accessible, that only the barest outline need be recounted here.

> The inventor of the time machine travels into the future and visits stages in the evolutionary degeneration of life. He sees the stage when the evil, apelike Morlocks (the descendants of our age's industrial workers) live underground and farm and eat the beautiful, aristocratic Eloi. He witnesses, too, the stage when giant crabs are the only surviving living things, and the sun and the earth are dying.[3]

Paul visualised the story as a fantastic voyage through time and space which could be simulated in real life by mechanical contrivances, and by the use of moving pictures projected on to a screen. He knew that the project could not be realised immediately, but so convinced was he that the idea was possible of accomplishment within the very near future, that he committed the idea to paper. This was filed at the Patent Office on 24 October 1895 (pat no 19984), almost exactly four months before Paul gave his first official screen performance at the Finsbury Technical College.

In an interview with Paul, the correspondent of *The Era* outlined the scheme:

> He [Paul] had been reading that weird romance, 'The Time Machine,' and it had suggested an entertainment to him, of which animated photographs formed an essential part. In a room capable of accommodating some hundred people, he would arrange seats to which a slight motion could be given. He would plunge the apartment into Cimmerian darkness, and introduce a wailing wind. Although the audience actually moved but a few inches, the sensation would be that of travelling through space. From time to time the journey would be stopped, and on the stage a wondrous picture would be revealed—the Animatographe, combined with panoramic effects. Fantastic scenes of future ages would first be

shown. Then the audience would set forth upon its homeward journey. The conductor would regretfully intimate that he had over-shot the mark, and travelled into the past—cue for another series of pictures. Mr Paul had for a long time been at work on this scheme, and had discussed it here and there.[4]

The full text of Paul's patent, which received provisional protection only, is as follows:

A NOVEL FORM OF EXHIBITION OR ENTERTAINMENT, MEANS FOR PRESENTING THE SAME
My invention consists of a novel form of exhibition whereby the spectators have presented to their view scenes which are supposed to occur in the future or past, while they are given the sensation of voyaging upon a machine through time, and means for presenting these scenes simultaneously and in conjunction with the production of the sensations by the mechanism described below, or its equivalent.

The mechanism I employ consists of a platform, or platforms, each of which contain a suitable number of spectators and which may be enclosed at the sides after the spectators have taken their places, leaving a convenient opening towards which the latter face, and which is directed towards a screen upon which the views are presented.

In order to create the impression of travelling, each platform may be suspended from cranks in shafts above the platform, which may be driven by an engine or other convenient source of power. These cranks may be so placed as to impart to the platform a gentle rocking motion, and may also be employed to cause the platform to travel bodily forward through a short space, when desired, or I may substitute for this portion of the mechanism similar shafts below the platforms, provided with cranks or cams, or worms keyed eccentrically on the shaft, or wheels gearing in racks attached to the underside of the platform or otherwise.

Simultaneously with the forward propulsion of the platform, I may arrange a current of air to be blown over it, either by fans attached to the sides of the platform, and intended to represent to the spectators the means of propulsion, or by a separate blower driven from the engine and arranged to throw a regulated blast over each of the platforms.

After the starting of the mechanism, and a suitable period having elapsed, representing, say, a certain number of centuries, during which the platforms may be in darkness, or in alternations of darkness and dim light, the mechanism may be slowed and a pause made at a given epoch, on which the scene upon the screen will come gradually into view of the spectators, increasing in size and distinctness from a small vista, until the figures, etc., may appear lifelike if desired.

38

In order to produce a realistic effect, I prefer to use for the projection of the scene upon the screen, a number of powerful lanterns, throwing the respective portions of the picture, which may be composed of,

(1) A hypothetical landscape, containing also the representations of the inanimate objects in the scene.

(2) A slide, or slides, which may be traversed horizontally or vertically and contain representations of objects such as a navigable balloon etc., which is required to traverse the scene.

(3) Slides or films, representing in successive instantaneous photographs, after the manner of the kinetoscope, the living persons or creatures in their natural motions. The films or slides are prepared with the aid of the kinetograph or special camera, from made up characters performing on a stage, with or without a suitable background blending with the main landscape.

The mechanism may be similar to that used in the kinetoscope, but I prefer to arrange the film to travel intermittently instead of continuously and to cut off the light only during the rapid displacement of the film as one picture succeeds another, as by this means less light is wasted than in the case when the light is cut off the greater portion of the time, as in the ordinary kinetoscope mechanism.

(4) Changeable coloured, darkened, or perforated slides may be used to produce the effect on the scene of sunlight, darkness, moonlight, rain, etc.

In order to enable the scenes to be gradually enlarged to a definite amount, I may mount these lanterns on suitable carriages or trollies, upon rails provided with stops or marks, so as to approach to or recede from the screen a definite distance, and to enable a dissolving effect to be obtained, the lantern may be fitted with the usual mechanism. In order to increase the realistic effect I may arrange that after a certain number of scenes from a hypothetical future have been presented to the spectators, they may be allowed to step from the platforms, and be conducted through grounds or buildings arranged to represent exactly one of the epochs through which the spectator is supposed to be travelling.

After the last scene is presented I prefer to arrange that the spectators should be given the sensation of voyaging backwards from the last epoch to the present, or the present epoch may be supposed to have been accidentally passed, and a past scene represented on the machine coming to a standstill, after which the impression of travelling forward again to the present epoch may be given, and the re-arrival notified by the representation on the screen of the place at which the exhibition is held, or of some well-known building which by the movement forward of the lantern can be made to increase gradually in size as if approaching the spectator.

Robt. W. Paul[5]

Although the project never materialised, it provides an interesting insight into Paul's motion-picture thinking at this time, and proves that he had entertained the idea of intermittent film projection more than two months before the Lumière brothers gave their first public screen performance in the basement of Le Grand Café, on the Boulevard des Capucines. Moreover, it can also be regarded as the precursor of another 'film journey' which first appeared in America in 1904 and was known as Hale's Tours. A history of this extraordinary exhibition has been written by Raymond Fielding, who sums up the object of the show as follows: 'It took the form of an artificial railway car whose operation combines auditory, tactile, visual and ambulatory sensations to provide a remarkably convincing illusion of railway travel.'[6] The 'travellers', seated in their vibrating carriage, witnessed a succession of films representing scenes from a moving train, which were projected on a screen in front of them. Hale's Tours was eventually brought to London and opened at 165 Oxford Street, under the management of Gilbert Large;[7] just across the street from where the first Kinetoscope parlour in England had been opened in October 1894.

Hale's Tours proves that Paul's original idea was not so fanciful as must have been supposed at the time. Even so, he soon realised that equally wondrous journeys could be undertaken by his audiences by letting them identify with the fanciful happenings which trick photography could provide. Paul later became very interested in the making of trick films, possibly being influenced by Georges Méliès, and he produced some very clever examples, such as *The Motorist*, which he made in 1906.[8]

4 The Theatrograph

R.W. Paul had visualised the idea of film projection when formulating his scheme for his 'journey through time', discussed in the previous chapter, and no doubt he had turned over in his mind the means by which this could be accomplished. The idea was lying dormant in his mind when news reached him of the success of the Cinématographe-Lumière in Paris and the plans afoot for its imminent exhibition in London.[1] Paul immediately realised that he must act or be forestalled.[2]

That Paul had a wonderfully fertile brain is apparent from the many technical accomplishments to his credit, both in the field of cinematographic equipment and in his regular work as an electrical engineer and scientific instrument maker.[3] His solution to the problem of film projection was speedily resolved, and his first projector was ready not later than 20 February 1896, when it was exhibited at the Finsbury Technical College.[4] Paul later claimed that he had given many private shows with his projector at his factory at Saffron Hill prior to this,[5] and it is reasonable to assume that this was so, for it is very unlikely that he would arrange an official performance without first trying it out a few times. The Lumière exhibition in Paris, which had prompted Paul into action, was presumably that held in the basement of Le Grand Café, 14 Boulevard des Capucines, Paris, on 28 December 1895.[6] The Paul projector was thus designed, manufactured and equipped with a lens, all within the amazingly short period of eight weeks or less!

A notice of Paul's first projector, which was called the Theatrograph, appeared in *The English Mechanic* for 21 February 1896, under the section headed 'Scientific News'. As this is probably the first notice of the projector to appear in a scientific journal, it is worth quoting in full:

> The Theatrograph is a new mechanism for throwing on a screen, so as to be visible to an audience, theatrical scenes or events of interest, with their natural motions and in life-size. The apparatus is simple, and can be adapted to any lantern, and the films containing the instantaneous photographs which produce the effect, and of which there are about 800 to each scene, are of the same size as those used in the kinetoscope. The first public exhibition of this apparatus was [*sic*] to take place at the Finsbury Technical College on the 20th inst., on the occasion of the annual conversazione. Mr Paul, of Hatton-garden, is introducing it.[7]

It was clearly Paul's intention at this time to manufacture the Theatrograph projector for the commercial market, and an illustrated description of the apparatus was printed, which was circulated to the leading photographic journals. Although no original

copy of this press handout seems to have survived, it is possible to arrive at a reasonably accurate transcription of the contents from the accounts subsequently published in the various journals. Much of the matter was recorded verbatim, and by selecting the passages common to each most, if not all, of the text can be restored. In following this procedure, it is found that the account published in the April issue of *The Photogram* appears to be an exact transcription of the original, and it is this which is given below:

THE THEATROGRAPH is an ingenious apparatus for projecting moving figures upon a lantern screen. The apparatus is strongly constructed of steel, gun-metal, and aluminium, and of such size as to go between the condenser and objective of an ordinary lantern. The film containing the instantaneous photographs[8] is drawn from the spool at the top of the instrument, and passes under the rollers and pressure-pad in front of the oblong aperture through which the light shines, then under an aluminium sprocket-wheel to a second spool, on which it is automatically wound up. Each turn of the horizontal shaft, which is driven from a small hand-wheel, actuates a cam which instantaneously shuts off the light, and at the same time the sprocket-wheel is acted on by a steel finger, causing it to move forward the space of one picture; the film is then locked in position for projection; the shutter opens and allows the picture to be projected. In this way the film is at rest the greater part of a revolution, giving a bright image. The rapid revolution of the shaft causes successive pictures to appear without discontinuity, as in the Kinetoscope, until the whole scene has been presented. A special series of subjects is in preparation, but any Kinetoscope film, of which fifty subjects are already published, may be used. The apparatus is supplied separately or complete with lanterns, or fitted to clients' own lanterns if desired. The films or subjects are interchangeable, and supplied separately, and any number may be used with each apparatus. It may be seen in action daily at the address of the maker, Robert W. Paul, 44 Hatton Garden, London, E.C.[9]

The *Photographic News*[10] and the *British Journal of Photography*[11] were the first journals to publish extracts from Paul's circular, in their issues for 28 February, the latter journal commenting: 'We witnessed the theatrograph in actual operation and the projected images, with the lifelike motions of the figures, were successfully shown. If the theatrograph, together with series of kinetoscopic photographs, is available at reasonable prices, it should supply an extremely popular addition to the resources of the lantern lecturer.' The *English Mechanic*[12] also printed an extract in its issue for 6 March, stating that the description given had been published by the 'sole maker' (who was, of course, Paul), and that 'this device was exhibited at the Royal Institution last week, and is shown in the illustration annexed'.

Each of the journals mentioned reproduced an identical illustration of the apparatus, as did the *Photogram* (14a). The *Optical Magic Lantern Journal*[13] published the description in its April issue, and in addition to the illustration printed in the other journals a second one was included which represented a single frame of perforated film (14c). The *Journal* also added that 'this instrument is now being exhibited at Olympia, and is creating a great sensation'.

The same press handout was also received by the editor of the *Amateur Photographer*, but instead of a verbatim report of the apparatus, the information was digested in an article on 'Lantern Projection of Moving Objects'.[14] This journal, under the editorship of A. Horsley Hinton, was invariably biased in favour of Birt Acres as far as cinematographic invention was concerned, and was also rather hostile in its attitude to the new 'animated photography', being decidedly conservative in its views on photography in general. A similar bias is also apparent in the editorship of the *Optical Magic Lantern Journal* (edited by J. Hay Taylor), which consistently championed the claims of Friese-Greene as the true inventor of cinematography.[15] The absurdity of this claim has already been conclusively established by Brian Coe, curator of the Kodak Museum at Harrow.[16]

The *Amateur Photographer* article is illustrated by one additional figure showing the intermittent movement of Paul's Theatrograph, the other two figures being identical to those published in the other two journals. As the *AP* illustrations are more clearly reproduced, it is from these that our own have been taken (14a, b, c). We will quote only that part of the article pertinent to Paul's machine. (The original figure numbers have been changed to those used in our text.)

In Messrs Lumiere's Cinematograph [*sic*] (how fond modern inventors are of long words) now being exhibited at the Marlborough Gallery, Regent Street, we have an excellent exhibition, probably the best thing of the kind which has yet been done, if we except the apparatus shown the other night at the Royal Photographic Society's rooms by Mr Birt Acres. In this latter contrivance the motion of treating waves was so beautifully reproduced that one had an inclination to step backward to avoid getting wet. Mr Birt Acres has arranged to give public exhibitions of his apparatus shortly at a large hall at Piccadilly Circus; the details of its mechanism have not yet been published. In the meantime another inventor, Mr R.W. Paul, electrician, of Hatton Garden, has shown a neat piece of apparatus called the 'Theatrograph', in the library of the Royal Institution, with some success, but it must be owned that in its present condition the registration of the pictures on the screen is not so perfect as in Lumiere's arrangement. Mr Paul has not kept his method in any way secret, and he has been wise in this respect, for by courting inquiry he obtains that blessed thing called free advertisement. In

fig [14a] we have a representation of the entire apparatus. The spool at the top contains some hundred feet of pictures printed on a ribbon of celluloid, which ribbon, as will be seen by reference to fig [14c], is provided on both sides with punched apertures. A large fly-wheel, not shown here, gives motion to the sprocket wheel mechanism [14b] which it will be readily seen will cause the ribbon to be fed forward in jerks, first a downward movement, and then a pause, such movements occurring at the rate of about 15 per second. The holes at the sides of the film are to accommodate spokes in the sprocket-wheel drum which engage therewith and thus pull the ribbon forward.

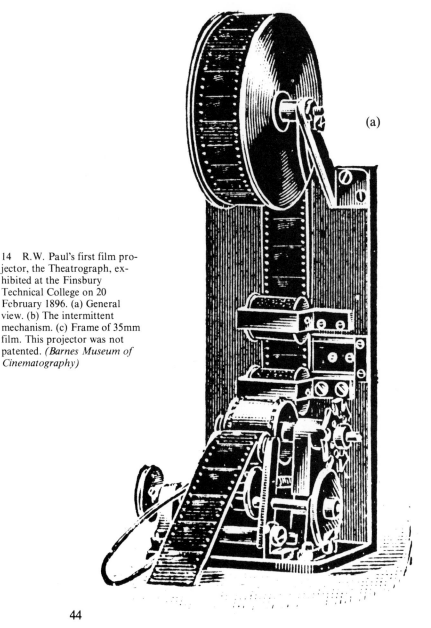

(a)

14 R.W. Paul's first film projector, the Theatrograph, exhibited at the Finsbury Technical College on 20 February 1896. (a) General view. (b) The intermittent mechanism. (c) Frame of 35mm film. This projector was not patented. *(Barnes Museum of Cinematography)*

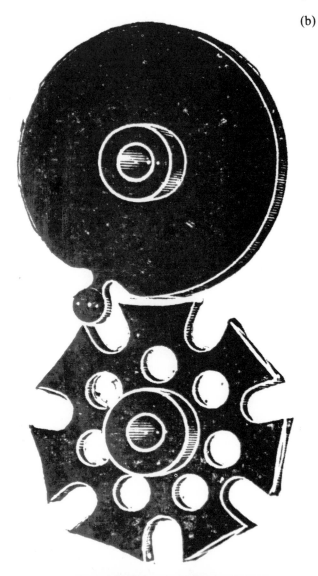

(b)

(c)

It is a grave question to our minds whether this old method of solving the problem of projecting these moving images is the correct one; we are of the opinion that it is wrong in principle. At any rate, we may say that the apparatus is as yet in its infancy, but will probably grow into vigorous youth before next lantern season opens. Many brains are at work upon it, much money is being spent in experiments, and the work is sure to result in something better than anything as yet available.[17]

We may disregard the haughty opinion of this editorial, and merely remark that the method employed was in fact entirely correct in principle, even to the rate at which the pictures were projected, which is almost exactly the standard speed subsequently adopted for silent pictures, ie sixteen frames per second. Paul's first machine imperfect as it may have been, was the prototype of the modern projector.

The first Theatrograph projector was not patented, and since no examples of it are known to be extant, the printed description and accompanying illustrations are the only reliable information we have concerning it. However, Paul did recall some of its defects, in the lecture to the BKS on 3 February 1936:

I first adopted a modification of the familiar Geneva Stop, as used in watches, to give an intermittent motion to the sprocket. Because the 14-picture sprocket of the kinetoscope had too great an inertia I made one in aluminium, one-half its diameter. My first projector is described in 'The English Mechanic' of February 21st and March 6th, 1896. It was intended to be sold at five pounds, and to be capable of attachment to any existing lantern.[18] The seven-toothed star wheel was driven by a steel finger-wheel which acted also as a locking device during the period when the shutter was open. The latter was oscillated behind the gate by means of an eccentric, and a safety drop shutter was provided. Four light spring pads pressed on the corners of the film, which was fed out into a basket. A fault, which I ought to have foreseen, was the unsteadiness caused by the inertia of the spool of films, and it became necessary to insert the films, 40 or 80 feet long, singly. So this model, with which I first saw a moving picture on the screen, was promptly scrapped.[19]

In most respects this account tallies with the original description of the apparatus which, it will be remembered, was supplied by Paul himself as the 'sole maker'. But in the matter of the take-up spool, Paul's memory is at fault when he recalls that the film was fed out into a basket, for according to the original description this was not the case. Moreover, the illustration clearly shows a pulley wheel on the driving shaft, and a belt which obviously connects to a take-up arm. The oscillating shutter and safety drop shutter cannot be vouched for, since they are not mentioned before, nor shown in the illustration, and must therefore remain a matter for conjecture. That the

apparatus was promptly scrapped, as Paul says, is not so. We have conclusive evidence that it was used at the performances given at the Finsbury Technical College on 20 February,[20] at the Royal Institution on 28 February,[21] and at Olympia from 21 March.[22] We have reason to believe that it may also have been used for a few performances at the Alhambra, Leicester Square, from 25 March, as well as at other theatres in London.

The major defect of this first model, as Paul has pointed out, was the drag on the film caused by the weight of the top spool when overloaded with too much film. Since most of Paul's film subjects at this period were either 40 or 80ft long, only one or two subjects could be laced in the machine at one time. This was a decided drawback as far as public exhibition was concerned and Paul set about designing a second model, also called the Theatrograph (15), which he patented on 2 March 1896 (pat no 4686).[23] From an examination of contemporary reviews of Paul's early film performances, we have reason to believe that it was not until the end of the following month that this second model had been manufactured in sufficient quantities to replace all the old ones then in use.

Paul's first performance at the Alhambra took place on Wednesday, 25 March, and was written up in *The Era* the following Saturday. The correspondent noted that 'the apparatus did not work with the smoothness and regularity that might be expected after a night or two'.[24] This defect in performance had also been noted at the showing at the Royal Institution the previous month, when we know it was the first model that was being used.[25] The criticism levelled at the Alhambra performance would therefore seem to suggest that it was also being used at this theatre. Though the evidence is circumstantial, it appears to be corroborated by the review of the Alhambra programme published in *The Era* on 16 May: 'Mr Paul has much improved his animated pictures presented by means of his clever invention. The finish of the Derby of 1895 excites enthusiasm nightly.'[26] This certainly suggests that it was Paul's second model that was now being used. The improvement in the pictures could not have been due to improvements made to the camera, for the film under review was one of the earliest in the repertoire—the Derby of 1895.[27] The possibility exists, however, that an improvement could have been made to the perforator, for steady pictures are equally dependent on accurate registration of one frame with the next, which is possible only if the perforations in the film are regular and exact.

It is impossible to determine, from the evidence at present available, just how many examples of the first Theatrograph were manufactured, but it may be possible to account for six. If we accept the supposition that Paul's new model was not ready in sufficient numbers to replace all the old ones in use until the end of April, then it is reasonable to assume that some of the performances given before that date were with the first model. We have documentary evidence that public performances were given with Paul machines at six

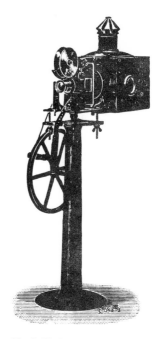

15 R.W. Paul's second projector, the Theatrograph No 2, Mark 1; wood-cut illustration from the original wood-block used by Paul. *(Cambridge Scientific Instruments Ltd)*

different venues before May. The performances at the Finsbury Technical College and Royal Institution were single performances only and need not be taken into account, since a single machine could serve both and then be transferred to any one of the venues where regular performances were given. These were as follows:[28]

Egyptian Hall, Piccadilly (from 19 March)
Olympia (from 21 March)
Alhambra Theatre of Varieties, Leicester Square (from 25 March)
Canterbury Theatre of Varieties, Westminster Bridge Road (from 27 April)
Paragon Theatre of Varieties, Mile End Road (from 27 April)
Wonderland, Whitechapel Road (three weeks in April)

The opening performance at the Canterbury Theatre was not up to scratch and was criticised in the following terms:

The introduction of the Cinematographe [sic][29] at the Canterbury on Monday evening was attended only with partial success. Difficulties of working had hardly been overcome, and one of the pictures was so blurred and indistinct that the audience did not hesitate to express their disapprobation.[30]

This echoes the criticism of the Alhambra show already referred to, and is further evidence for supposing that it was Paul's first model that was being used here. It thus seems probable that only about half a dozen examples of the first projector were actually manufactured, unless, of course, one machine served several theatres, which seems unlikely. It is not surprising, therefore, that it has become one of England's rarest projectors; not a single example is known to be extant. The Cinématographe-Lumière fared much better, and has survived in several collections.[31]

The verdict of contemporary opinion was that Paul's first Theatrograph did not provide the quality of projection attained by the Cinématographe-Lumière. Paul himself later admitted that the results obtained with the Lumière machine were 'superior in steadiness and clearness' to his own.[32] But in its defence it must now be admitted that Paul's machine was much superior in principle and provided the prototype for the modern film projector, whereas the Cinématographe was something of an oddity and proved eventually to be hybrid.

Paul's second Theatrograph projector was patented on 2 March 1896 (pat no 4686), a little more than a week after the first was exhibited at the Finsbury Technical College (20 February). Production of the first model had thus hardly got under way when Paul, realising its shortcomings, immediately set about designing this new machine. Although a marked improvement on the former, the second Theatrograph did not entirely satisfy Paul either and he later made

several minor modifications to its design. In his BKS lecture, Paul related the sequence of improvements which he carried out after the first Theatrograph had been completed and found wanting:

The next step consisted in duplicating the intermittent sprockets, the film being kept more or less taut between them. At that time the fact of liability to shrinkage in the film was not realised. The new mechanism had a revolving shutter in the form of a horizontal drum cut away in two opposite sides,[33] and a rewind spool was provided, driven by a slipping belt. A large hand wheel was belted to a small pulley on the finger-wheel spindle, the latter being coupled to the shutter spindle by spur gears. This machine is illustrated [in diagrammatic form only, of course] in my Patent Specification of March 2nd, 1896, and was supplied with its lantern as a complete projector, either on an iron pillar or with a combined carrying case and stand.

After a few of these projectors had been put into operation the need for larger spools, to contain a series of films, became evident. So additional sprockets were arranged to give continuous feed above and below the intermittent sprockets, and the masking device was improved. Of this model over 100 were produced, many being exported to the Continent and some to the United States. A precisely similar mechanism was used in the perforator and in the camera. An example of the camera of 1896, as used for taking many of my early films, is preserved in the Science Museum, together with the projector just described. These machines were decidedly noisy, an objection which was minimised by the fact that projection was usually from the back of the stage, through a translucent screen.[34]

The new Theatrograph was also briefly mentioned in the interview with Paul given in *The Era* for 25 April 1896:

Mr Paul is a manufacturer of the 'graph machines at eighty pounds a-piece. At present he has confined his attention to London and to foreign countries, whither a number of machines have been despatched. Eventually he proposes to open up a provincial trade. The important constituents of the machine are light, and occupy very little space. For the time the 'graph occupies attention mainly as a popular amusement, but its value and importance for many other purposes are great, and the details of its useful applications are without apparent limit.[35]

The impression given here is that production of the new model was just getting under way, and this is confirmed by Carl Hertz, a well-known American conjurer and showman, who was one of the very first to acquire one. In his autobiography, *A Modern Mystery Merchant*,[36] Hertz relates the circumstances leading up to the acquisi-

49

tion of the first of the new machines. Paul was reluctant to part with it, and since Hertz was about to sail for his tour of South Africa and Australia, and was bent on taking the new machine with him, he unscrewed it from the floor, thrust £100 into Paul's hand and departed with it. However exaggerated this story may be, it does provide an approximate date for the completion of this model, for we know Hertz sailed for South Africa on 28 March 1896, and we also know that he took one of Paul's machines with him (see Chapter 8).

This same Theatrograph projector, which once belonged to Carl Hertz, is claimed to be in the Will Day Collection of Historic Cinematograph and Moving Picture Equipment. Although the catalogue entry is inaccurate in other respects,[37] there is no reason to doubt that the machine listed as item no 129 is Hertz's actual machine. It is shown in the photograph reproduced in the catalogue as Plate 5a. Here it can be seen on the top shelf of the show-case exhibited at the Science Museum, where it was once on loan.[38] The apparatus is shown complete with its lantern, but without the iron pillar. The machine, it will be remembered, was supplied either on an iron pillar or with a combined carrying case which also served as a projection stand. The latter would, of course, be the more convenient arrangement for Hertz's purposes, since he had to take it with him on his various travels, and lightness and portability were factors to be considered. I have not had the opportunity of examining the actual apparatus, but a study of the photograph in the Will Day catalogue clearly shows it to be the first pattern, since there is no indication of the additional sprockets which Paul says were added in the modified version to provide a continuous feed to the film above and below the two intermittent sprockets. It should be noted that the provision for additional sprockets was made in the complete specification which was not deposited with the Patent Office until 30 November 1896.

Paul's second Theatrograph projector is also illustrated in *The Strand Magazine* for August 1896 (16),[39] where it is the first pattern that is again shown. A comparison with the model in the Will Day collection shows only a difference in the lantern. The one shown in the *Strand* photograph has a short cylindrical chimney surmounted by a rose-type cowl, whereas that in the Will Day photograph has an oblong cowl with a slightly curved top and, of course, no chimney. The variation was presumably dictated by the type of illuminant selected, the flat cowl being more suited to an electric arc lamp, and the rose cowl with chimney to limelight, both forms of illuminant being in use at that time. Be this as it may, the projection mechanism is identical in both cases.

16 Paul's Theatrograph No 2, Mark 1, from an illustration in *The Strand Magazine,* August 1896. *(Barnes Museum of Cinematography)*

A similar projector, donated by R.W. Paul, is in the Science Museum, South Kensington (17)[40] but is incomplete, although the missing parts have been replaced by replicas copied from the machine in the Will Day Collection at the time the latter was on loan to the museum. The replica parts include the lamphouse or lantern, driving handle, film spool and optical system. The details of this projector are

fully described and illustrated in the patent specification and corres-
pond exactly with the machine as made. The intermittent mechanism
comprises two seven-toothed star wheels based on the Maltese cross,
which are actuated by a centre wheel with two fingers at opposite
points of the circumference. These engage periodically with the teeth
of the upper and lower wheels which are directly connected with two
sprocket-wheels on the other side of the mechanism, so imparting an
intermittent motion to the film.

The diagram (18) shows the star-wheels in the locked position,
before the fingers re-engage to turn them both the required amount to

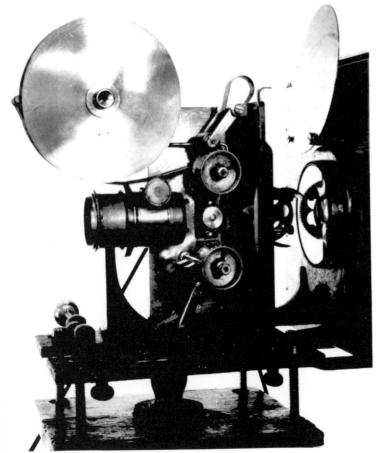

17 Paul's Theatrograph No 2,
Mark 1, presented to the
Science Museum by R.W. Paul
in 1913. *(Science Museum,
London; Crown copyright)*

advance the film by one frame. A similar intermittent mechanism was also employed in a new rotary perforator, which Paul constructed at about the same time as the projector (19).[41]

The second diagram (20) shows the modified version of the projector with the two continuous-feed sprockets added. In other respects, the mechanism is essentially the same, except for the re-positioning of the guide rollers necessitated by the inclusion of the additional sprockets.

Paul also states that improvements were made to the masking device, ie the picture rack adjustment. Although Paul says that over 100 of this model were produced, we have not been able to trace a single example. There exists, however, a variation of this projector which has a single continuous-feed sprocket placed above the two

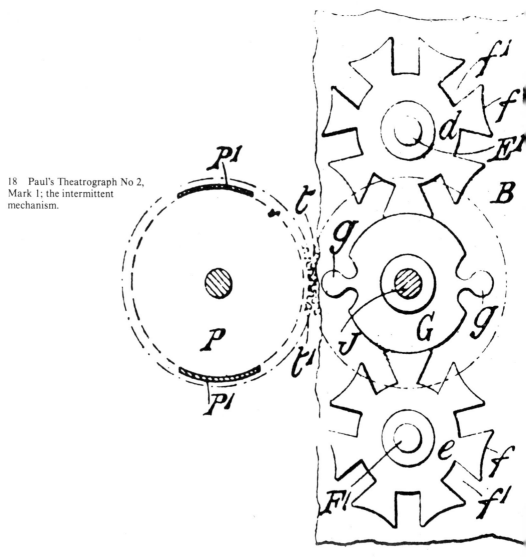

18 Paul's Theatrograph No 2, Mark 1; the intermittent mechanism.

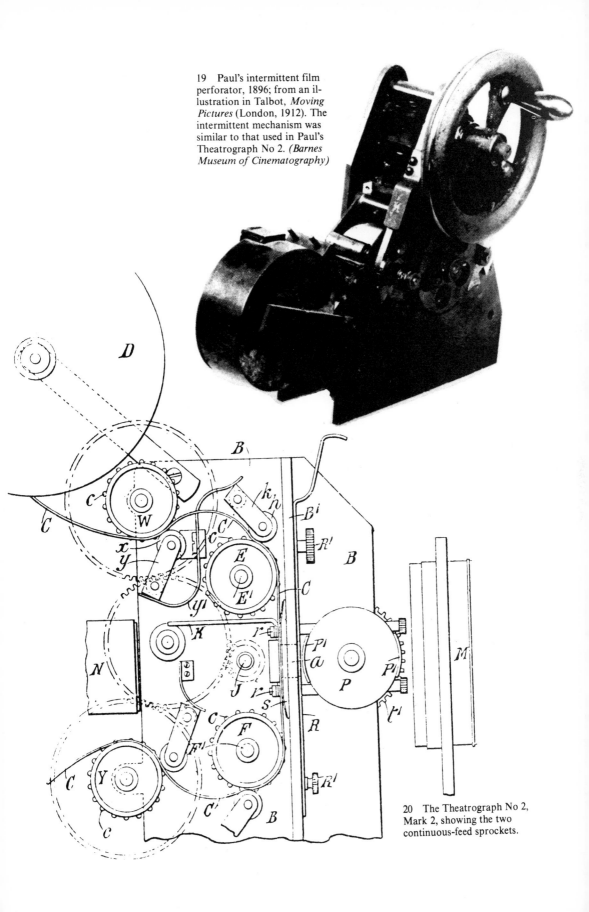

19 Paul's intermittent film perforator, 1896; from an illustration in Talbot, *Moving Pictures* (London, 1912). The intermittent mechanism was similar to that used in Paul's Theatrograph No 2. *(Barnes Museum of Cinematography)*

20 The Theatrograph No 2, Mark 2, showing the two continuous-feed sprockets.

intermittent sprockets but without the second lower one described in Paul's complete specification. The projector is preserved at the Cinémathèque Française in Paris, and although it is incomplete enough remains to indicate the features in question. Whether or not a second modification was subsequently made to incorporate two continuous-feed sprockets as indicated in the patent has not been established and it is a matter for conjecture whether indeed such a model was ever produced. Two continuous-feed sprockets were certainly a feature of a camera made by Paul at about this time, and the possibility exists that a similar arrangement was employed in a projector, as Paul claims. If so, such a machine has not, as yet, been traced. As to the date when a continuous-feed projector was first produced by Paul, this can be estimated to within a few months. We know that such a machine was not in existence before August,

21 Paul's Cinematograph Camera No 2, 1896. The intermittent mechanism is similar to that employed in Paul's Theatrograph No 2. Note the addition of the two continuous-feed sprockets above and below the intermittent sprockets. *(Science Museum, London; Crown copyright)*

because it is the first pattern that was illustrated in *The Strand Magazine* for that month. Judging from the date of the complete specification, 30 November, it seems unlikely that it was placed on the market before then. A December date would therefore seem to be the most likely one, shortly after the patent had been filed.

Extracts from the patent were published in *The Photogram* and the *Optical Magic Lantern Journal* during 1897.[42] Neither journal added matter not contained in the original specification, but *The Photogram* added that the apparatus 'was one of the most successful in last year's music-hall season'.

It may be as well at this point to discuss the new camera which Paul designed at this period, and which is also in the Science Museum (21).[43] This was the second designed and constructed by Paul after the original Paul–Acres camera and, as Paul himself noted, employed the same type of movement used in the new projector. It also employed the two additional continuous-feed sprockets which were a feature of the modified version described in the patent. The cylindrical shutter used in the projector is replaced by a flat circular disc, 9in in diameter, in which two segments have been cut away and which revolves in a metal casing screwed to the front of the camera. A direct-

vision view-finder is included at the top of the apparatus. Paul gives no clue as to the date when this camera was first in operation, but from an examination of his film production during 1896 it may be possible to arrive at a likely date.

The ideal method for dating early cameras would be to examine the actual films of the period and compare each one, noting any change in frame lines, masking or other peculiarities which might occur on the film. It would be preferable, of course, to examine the original negatives, but since these have rarely survived, an examination of the contemporary prints is the next best expedient. It is therefore imperative that film archivists should always retain the original copy for preservation; if this is not possible in the case where a film has become unstable, at least an effort should be made to preserve a few frames. In this way it might be possible not only to determine when a different camera has been used, but also to identify the actual camera with which a particular film was photographed. Unfortunately, I have not had the opportunity of applying this method in the present case and have had to rely entirely on circumstantial evidence.

The most likely date for the introduction of Paul's new camera would seem to be some time in September, when Harry Short was sent off on a five-week tour of Spain and Portugal and managed to secure a series of fourteen films which were first shown on 22 October. The camera in the Science Museum is a neat portable camera of the type admirably suited to a trip of this kind, and the venture itself was quite a distinct departure from previous practice, which would seem to indicate that, a new camera having been made, new projects were contemplated for it in order to exploit its full potentialities.

5 The Kinetic Camera
and Kineopticon of Birt Acres

After the break with R.W. Paul, sometime in June 1895, Birt Acres
(9) went his own independent way, and in the following six months or
so achieved some remarkable results in the field of cinematography
which have assured him a lasting place in the history of the British
film.

It seems that the last film he turned for Paul was the Derby of 29
May 1895, for toward the end of the next month we find him in
Germany, filming events connected with the opening of the Kiel
Canal,[1] which took place on 20 June (22). Some of these films were
later shown at his first 'official' screen performance at the Royal
Photographic Society in January of the following year. We cannot be
sure what camera was used by Acres for filming these historic events,
but it is unlikely that he made off with the Paul–Acres camera, which
surely belonged to Paul. Most probably it was the one he had
patented on 27 May 1895 (pat no 10474), which was more portable
although it employed a similar type of intermittent mechanism. It was
called the Kinetic Camera. That it was this camera which Birt Acres
took to Germany seems to be confirmed by a report in the *Amateur
Photographer* for 31 January 1896, which was published as a correc-
tion to an article in a German photographic journal quoted the
previous week. I will quote the latter first:

> The *Photographische Mittheilungen* gives some particulars of the
> taking of the series of consecutive views which Mr Acres showed at
> the meeting of the Royal Photographic Society last week. The
> apparatus has a massive metal base, which is necessary to reduce
> vibration, and a fly wheel under the camera secures steadiness of
> driving. In thirty-five minutes 700 views are taken, and a band of

22 Souvenir postcard of the
Kiel Canal sent by Birt Acres to
his family in England on the
occasion of the opening of the
Canal, 20 June 1895. *(Mrs
Sidney Birt Acres)*

film 250 metres long is used, this having been specially made by the English Blair Company. The *Mittheilungen* speaks enthusiastically as to the excellence of the results obtained.[2]

This was replied to as follows:

Some of the particulars given in our paragraph of last week, p. 70, on the authority of the *Photographische Mittheilungen*, require correction, as the heavy metal base, with a fly-wheel under it, does not form part of the camera, but apparently the writer in our contemporary had in mind the projection apparatus or lantern. The 700 pictures are taken in thirty-five seconds, not minutes, as stated. Mr Acres informs us that the camera proper is only as large as an ordinary portable 12 by 10 folded up, and as to weight it is certainly heavier than an ordinary modern tourist outfit, but during the Sedan festivities in Berlin Mr Acres carried it on its tripod for very considerable distances. The apparatus was shouldered musket fashion.[3]

The description hardly seems applicable to the Paul–Acres camera which, judging from the photograph (12), seems considerably more bulky than 'an ordinary portable 12 by 10 folded up'. Furthermore, the rate at which the pictures are stated to have been taken is considerably less than one would expect the Paul–Acres camera to be geared for, since it was specifically designed for taking films for the Kinetoscope, which operated at forty or more frames per second. The rate for the portable camera is given as only 700 in thirty-five seconds, which means it operated at twenty frames a second, a little in excess of the normal rate of sixteen per second subsequently considered adequate for silent films.

Further evidence for believing it was the newly patented Kinetic Camera which Birt Acres took to Germany, and not the Paul–Acres camera, is supplied by two films deposited by Sidney Birt Acres at the Science Museum, South Kensington. One is the film *Rough Sea at Dover* which shows the waves breaking over Admiralty Pier, and the other is the film of the *Kiel Canal* (24 and 25). *Rough Sea at Dover* was one of the films Birt Acres turned for Paul with the Paul–Acres camera (see p 202), before the relationship between the two men came to an end. The *Kiel Canal* film, on the other hand, was taken by Acres after the two men had parted and was made quite independently. An examination of the two films reveals a marked difference in the characteristics of the frame lines which clearly indicates that they were photographed with different cameras. Since we know it was the Paul–Acres camera which Birt Acres used to film *Rough Sea at Dover*, the camera used by him to film the *Kiel Canal* must therefore have been the Kinetic Camera, the subject of his recent patent.

The camera itself does not appear to have survived and, as far as I am aware, no photograph of it was ever published. We are therefore

23 *Tom Merry, Lightning Cartoonist, Sketching Kaiser Wilhelm II* (Paul-Acres, 1895), from the original negative in the Science Museum. *(Science Museum, London; Crown copyright)*

dependent on the printed specification with its accompanying drawing, for details of its mechanism (26). The film is driven by two continuously revolving sprocket-wheels and passes through a clamping device actuated by a cam which momentarily arrests the film for exposure. A pivoted spring roller deflects the film each time the clamp is released, thus drawing the film downward a distance of one frame.

What appears to be a working drawing for this camera has survived in a photo-copy now in the possession of Mrs Sidney Birt Acres (27). A comparison between this drawing and the one in the printed specification shows several minor differences in design, but a comparison of this sort, between a patent and the finished product, often reveals certain discrepancies. It is possible, however, that the working drawing just mentioned indicates modifications made to the original design at a later date.

The Birt Acres camera in the Science Museum (28)[4] which is said to be one of the earliest in the country and to date from 1894–5, is revealed on examination to be of much later date. It is obviously an experimental camera which has been hastily and crudely constructed, and not intended for regular use. I am of the opinion that it served as an intermediate step in the designing of the Birtac.

The Birtac was a sub-standard combined camera/projector (29) which Birt Acres patented on 9 June 1898 (pat no 12939). It was designed for use with film 17.5mm wide, obtained by splitting standard 35mm film down the middle, and was one of the first home movie outfits to be placed on the market. The date of the apparatus places it outside the scope of the present history, so I do not intend to enter into a detailed description except to point out the features that link it with the camera under discussion.

A comparison of the two machines reveals an identity of design which is not readily apparent because of the differences in size and overall appearance, yet the similarities between the two in other respects is most striking. The experimental camera, as I have chosen to call it, uses a centrally placed sprocket-wheel *with teeth (or pins) on one side only*, to provide a continuous feed to the film which is intermittently drawn through the pressure gate by a common beater or 'dog' motion. The film is held against the sprocket by two spring guide rollers. Exactly the same arrangement is employed in the Birtac.

There is nothing novel or original about the mechanism employed. The 'dog' movement had been used and patented by Georges Demeny as early as 1893,[5] and was commonly in use by the end of 1897, though mainly for projectors. The centrally placed sprocket-wheel which

24 *Rough Sea at Dover*, showing waves breaking over Admiralty Pier, photographed by Birt Acres with the Paul–Acres camera in 1895. Note the difference in the frame lines between this film and that of *The Kiel Canal* (25), indicating that these films were photographed with different cameras. *(Science Museum, London; Crown copyright)*

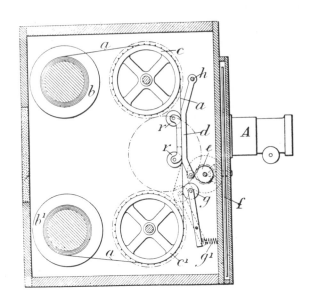

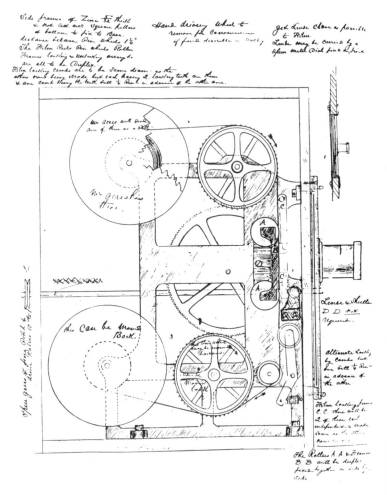

25 *(above)* *The Kiel Canal*, from original negative taken by Birt Acres with his Kinetic Camera in June 1895. *(Science Museum, London; Crown copyright)*

26 *(above right)* The Kinetic Camera of Birt Acres.

27 *(right)* Working drawing for the Kinetic Camera of Birt Acres, c1895. Note the position of the driving shaft, extending from the rear of the camera like that in the Paul–Acres camera where a similar type of intermittent clamping device was employed. *(Mrs Sidney Birt Acres)*

provides a continuous feed to the film above and below the gate, and so eliminates the need for two sprockets, was also widely in use in cameras at this time. But by some stroke of genius Birt Acres transformed those commonplace mechanics into a neat piece of simple machinery by which the amateur was enabled to take and project his own films in a most novel and original manner. There can be little doubt that the Birtac home movie outfit was the most successful of all Birt Acres's achievements.

My conclusions are that the experimental camera which we have been discussing paved the way for this success, and was constructed a little before the idea for the Birtac finally took shape, either at the end of 1897 or early 1898.

After this necessary digression, we must now return to the Acres Kinetic Camera and trace the developments which followed from it.

In the early stages, the Kinetic Camera also probably served as a projection apparatus, in the same manner as the Cinématographe-Lumière. Such a use is certainly suggested in the patent. However, the

28 The Birt Acres experimental camera, c1897–8. This camera probably served as the prototype of the Birtac, in which a similar mechanism was employed. *(Science Museum, London; Crown copyright)*

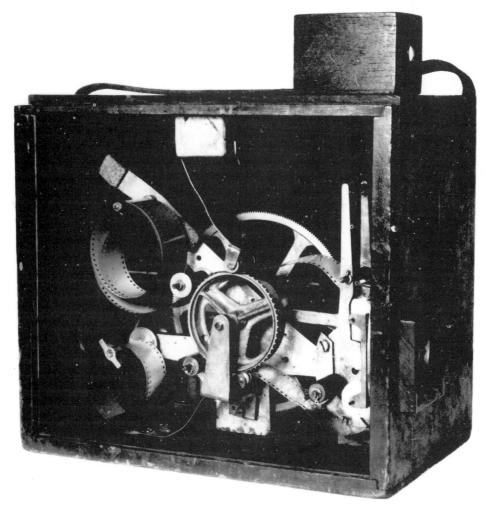

lapse of almost a year before Birt Acres gave his first public screen performance indicates that it was never very satisfactory in this role and needed drastic modification before it was ready for projection, by which time it had parted company with the camera and become a projector in its own right, under the name of Kineopticon. It was in this latter form that it made its public debut at 2 Piccadilly Mansions, Piccadilly Circus, on 21 March 1896.

In the meantime, it was known as the Kinetic Lantern and under this name it made its first official debut when it was exhibited at an important meeting of the Royal Photographic Society held at 12 Hanover Square on the Tuesday evening of 14 January 1896, not, as one would suppose, as the main item on the agenda, but rather as a diversion to the evening's more serious proceedings. Even so, according to the photographic press, it caused quite a stir. This

29 The Birtac, patented by Birt Acres in 1898. This was one of the first home movie outfits to appear on the market. It employed a sub-standard film 17.5mm wide. *(Science Museum, London; Crown copyright)*

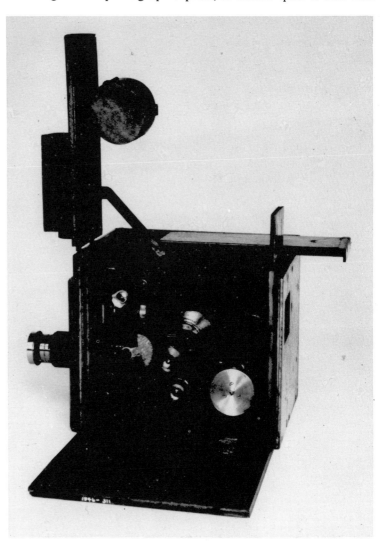

performance was another significant event in the history of the cinema in England, for it was the first screening of a cinematograph film ever to be given in this country, before an official audience.

A report of the proceedings was published in the *Amateur Photographer* for Friday, 24 January 1896, and since the occasion was such an important one it is worth quoting at length:

There was a goodly attendance at the Royal on the 14th inst. to hear Mr H.L. Aldis, B.A., describe his new stigmatic lens. In the absence of Sir Henry Trueman Wood Mr Spiller took the chair at rather a later hour than usual, the deliberations of the Council having somewhat delayed the meeting. We almost forgave them, however, for keeping us waiting when we learnt that they had conferred the Progress Medal upon Mr T.R. Dallmeyer for his inventions and improvements in lenses for telephotography. The announcement was received with acclamation, and I venture to think that the presentation will be one of the most popular that the society has made.

Mr H.L. Aldis' paper was of an extremely scientific nature, and he talked, I am afraid, far over the heads of the majority of his audience ...

The Chairman's invitation to the members to discuss the paper was not very hastily responded to, and probably the two gentlemen who did speak, Mr Dallmeyer and Mr Beck, were the only persons present capable of fully following the lecturer's remarks.

A pleasant surprise was in store for us, however, for, presumably by way of antidote to the knotty problems submitted to us earlier in the evening, the Chairman announced that Mr Birt Acres would give a demonstration with his Kinetic lantern ...

Mr Birtacres [*sic*], whose versatility and inventive genius are well known, fairly astonished us by the wonderful effects provided by his Kinetic lantern, which apparatus, he informed us, had taken him many years to perfect. The exhibition was of a most realistic nature. Lantern pictures were thrown upon the screen apparently in the orthodox manner, but with this difference—that the objects depicted, instead of being shown in the attitudes of arrested motion, common to so-called instantaneous photographs, appeared to be endowed with life itself. Nor was the effect confined to a mere repetition of the same movement, a whole sequence of events being in each case reproduced with lifelike fidelity. A regiment of soldiers, standing at attention, is seen upon the screen. Then, at the extreme end of the line, we see some moving objects; as they approach we recognise the familiar features of the German Emperor, attended by his staff. Occasionally he halts to scrutinise the accoutrements of a soldier, and again with martial mien marches on. Finally when he reaches the foreground and appears about to step out of the picture, he turns round, salutes, and the soldiers present arms—then the crowd of sight-seers press on, and the regiment is

lost to view. Skirt dancers, a boxing match, and the Derby were also shown, but the final slide—a study of waves breaking on a stone pier—was simply wonderful in its realistic effect. We all know how beautiful ordinary instantaneous effects of breaking waves appear on the screen, but when the actual movement of nature is reproduced in addition, the result is little short of marvellous. Very rarely indeed has such enthusiastic applause as greeted Mr Acres on the conclusion of his demonstration been heard at the 'Royal.'[6]

A notice in the *Photographic Journal*, without commenting on the success or otherwise of the demonstration, included some interesting particulars regarding the rates at which the films had been taken and projected:

The photographs for use in the lantern were taken in a somewhat similar apparatus also devised by Mr Acres—at the rate of about forty per second, although he could if necessary take as many as one hundred in a second, but the effect of motion was satisfactorily reproduced by projecting them upon the screen at the rate of about fifteen per second.[7]

A somewhat similar account was also published in the *British Journal of Photography*, which, although not committing itself on the merits of the performance, noted that 'the opinion of the meeting was unmistakably evidenced by the loud applause which greeted the various effects'.[8] *The Photogram*, on the other hand, confined its account to the films themselves:

All the actions of the German Emperor reviewing his troops, a pair of boxers in the prize ring, and several similar subjects were wonderfully well shown upon the screen; but the most successful effect, and one which called forth rounds of applause from the usually placid members of the 'Royal,' was a reproduction of a number of breaking waves, which may be seen to roll in from the sea, curl over against a jetty, and break into clouds of snowy spray that seemed to start out from the screen.[9]

The actual number of subjects shown is nowhere stated, but since no more than five films are ever singled out for mention by the various reviews, it seems reasonably safe to assume that only that number was shown. Considering that the average length of the subjects was about 40ft, the whole show must have been of very short duration, no doubt dictated by the late hour at which the performance was held, due to the evening's rather lengthy proceedings as reported in the *Amateur Photographer*'s account already quoted.

Of the five films mentioned, only one was photographed with the Kinetic Camera—the review of the troops by the German Emperor,

which was one of the films taken in Germany the previous year during the celebrations attendant on the Kiel Canal opening. The rest were photographed with the Paul–Acres camera: *Boxing Match, Dancing Girls, Derby of 1895,* and *Rough Sea at Dover*. This accounts for the high rate of forty frames per second at which the photographs are said to have been taken, since these films were originally intended for the Kinetoscope. Birt Acres was well aware of the abnormalities resulting from projecting films at a slower rate than the speed at which they had been photographed (and vice versa), and stressed this point at a meeting of the London and Provincial Photographic Association on 20 February, which was subsequently reported in the *British Journal of Photography:* 'Birt Acres considered it of utmost importance that the pictures should be taken at the same speed as they are shown, and explained the effect obtained by taking at forty per second and projecting at fifteen per second, and *vice versa*.'[10] The effects produced, of course, have since been termed 'slow-motion' (high speed cinematography) and 'speeded-action', the latter being much used in the early Keystone comedies. Neither effect seems to have been deliberately exploited during 1896.

The performance at the 'Royal' was a considerable achievement as it pre-dates Paul's first official screening by thirty-six days, and that of the first Lumière performance in England by the same amount. But after this initial success, Birt Acres was left behind as far as public exhibition of his apparatus was concerned. The Cinématographe-Lumière had its public debut at the Marlborough Hall, Regent Street, on 20 February, and Paul's Theatrograph on 19 March at the Egyptian Hall.

After the debut at the Royal Photographic Society, Birt Acres gave a similar performance the following evening, 15 January, at a meeting of the Photographic Club held at Anderton's Hotel, 162–5 Fleet Street. In addition to the films shown the previous night, one of a boxing kangaroo was included.[11] Acres was to have given a further performance, before the London and Provincial Photographic Association, on 20 February,[12] but cancelled the arrangement. However, he attended the meeting and personally gave the reasons for the non-appearance of his Kinetic Lantern. The explanation he gave was reported in the *British Journal of Photography.*

Mr Birt Acres, who had promised a display of his new kinetic lantern, apologised for its non-appearance, and explained his reasons for not showing the same. He had but just heard of a competitor from the other side of the Channel who had that day shown his apparatus in London, and he was not satisfied to show to the London and Provincial his original apparatus and take second place. He had machines in the hands of the best London mechnics, but unfortunately they were slow, and he was unable to show his latest improvements. He invited all present to a private view in Piccadilly-circus, where he intended to exhibit his machine...[13]

65

The cancelled performance was also noted in the *Optical Magic Lantern Journal* for April:

> Birt Acres had promised to show his arrangement at the London and Provincial Photographic Association, but hearing of the Marlborough Hall demonstration, he preferred to wait a little longer and perfect his instrument, rather than show it in an incomplete state.[14]

That plans had already been made to exhibit the Kinetic Lantern to the general public is apparent from the statement Birt Acres made on 20 February, to the London and Provincial, when he invited those present to a private view in Piccadilly Circus. In fact, according to a report in the *British Journal of Photography*, the debut was to have taken place on 2 March.[15] Although the exhibition failed to open on time, it is evident that preparations were going ahead, for the following paragraph appeared in the *Amateur Photographer* on 6 March:

> Over a doorway in Piccadilly Circus is a superscription, which, without attempting to record it literatively, still less pronounce it, we may say stands for Mr Birt Acres' really wonderful machine, with which he so moved to applause his audience at the Royal Photographic Society, and we understand that the Birt-Acres Kinetograph [*sic*] will there be permanently on exhibition ere long.[16]

The following week, the same journal referred to the matter again:

> Mr Birt Acres has arranged to give public exhibitions of his apparatus shortly at a large hall at Piccadilly Circus; the details of the mechanism have not yet been published.[17]

Things were still not ready when the columnist for the *British Journal of Photography*, G.R. Baker, made a visit to the premises later in the month:

> I should have liked very much to have written something this time about Mr Birt Acres' apparatus and its projections, but, having twice been to Regent-circus to try and see the 'Kineopticon,' and found the place closed and no announcement as to time of exhibition, I can only suppose that it is not quite ready for the public; or, perhaps we shall hear of it at the other large variety house, viz., the Palace, for, as I heard some one remark, it might be politic on the inventor's or agents part to 'hold his hand' for a while.[18]

Then on 19 March, *The Optician* announced that 'The Kineopticon is to open its doors to the public on Saturday next.'[19] So at last, on 21 March, the new apparatus, which Birt Acres and his mechanics had

been hastily perfecting, made its public debut in a small hall close to Piccadilly Circus, at 2 Piccadilly Mansions, situated at the junction of Shaftesbury Avenue, opposite the old Criterion Restaurant. The exhibition was duly noted in the photographic press. The *British Journal of Photography,* had this to say:

Mr Birt Acres, who, as our readers are aware, has recently demonstrated his Kinetic lantern before several of the photographic societies, and may claim to have been first in the field with a public exhibition of animated photography on the screen, has given his system the happily chosen title of Kineopticon, and is exhibiting it at a pleasant little hall in Piccadilly Circus, where we had an opportunity on Saturday last of witnessing the display.

The subjects on the programme included the arrest of a pickpocket, an exciting street scene; a carpenter's shop, showing work in full swing; a visit to the zoo; a boxing match; the German Emperor reviewing his troops; the 1895 Derby; a rough sea at Dover; and other attractive views. The realism and success of the views, particularly in the case of the horse race and the breaking waves, are remarkable, and should ensure the Kineopticon wide popularity.[20]

The account in the *Photographic News*, though short, was equally favourable:

THE KINEOPTICON. This is the name given by Mr Birt Acres to his system of screen kinetoscopy which is now being shown at Piccadilly Circus. Very successful and realistic are the pictures depicting the arrest of a pickpocket, a carpenter's shop, a visit to the zoo, the Derby, a rough sea at Dover, and other subjects.[21]

A short account also appeared in *The Optician*:

The capital 'living pictures' projected by Mr Birt Acres' 'Kineopticon' are now on view at No. 2 Piccadilly Mansions, Piccadilly Circus. W. Mr Acres has dispensed with extraneous assistance in the production of the films, and he intends to frequently vary the pictorial programme of the exhibition.[22]

As was to be expected, one of the most favourable reviews appeared in the *Amateur Photographer*:

In addition to the Cinématographe and the Animatographe, another exhibition of the same kind is now open in London at Shaftesbury Mansions [sic], Piccadilly Circus—the Kineopticon. Although presented to the public so late in the day, this was the first thing of the kind which was shown in this country, an exhibition having been given of the working of the instrument at one of the

meetings of the Royal Photographic Society in January last. We believe that the apparatus by which the negatives are taken and the adaptation of the lantern for showing the transparencies are the outcome of the ingenuity of Mr Birt Acres whose name is doubtless well known to all connected with photographic circles, although no name is mentioned on the programme furnished to each visitor to the show.

Those who have seen Edison's kinetoscope at work will be able to understand what these exhibitions are which are creating so much interest in London at the present time, when it is explained that they consist, practically, of similar series of pictures to those shown by direct vision in the kinetoscope, projected on to a screen some six or more feet in diameter in a similar way to that in which an ordinary lantern slide is shown by means of an optical lantern. The subjects shown by the kineopticon, however, have the advantage that for the most part they are natural sequences of events and not dramatic episodes rehearsed for the purpose of being photographed. A review of troops by the German Emperor is very good, but perhaps the most interesting of the series shown at the press views was that of the finish of the race for the Derby of 1895. Here we had the clearing of the course, the preliminary canter, the finish of the race itself, followed by the scramble over the course of the crowd, presented as those on the spot actually saw these events.[23]

The correspondent of the Monthly Supplement to the *British Journal of Photography*, who had already made two abortive attempts to see the Kineopticon, came away contemplating the need for its improvement:

Animated lantern pictures are still the rage, for not only are there four different machines or projection apparatus being publicly exhibited at the present time in London,[24] but these are being duplicated at the east and west ends, besides arrangements being in progress for provincial exhibitions. I had the opportunity recently, of seeing Mr Birt Acres' 'Kineopticon' at the hall in Piccadilly-circus (just at the junction of Shaftesbury-avenue), and the subjects shown were of a very effective nature, and point to a great future when the initial difficulties, inseparable from new inventions, are overcome.

It seems to me, in this class of apparatus, the ultimate success will depend on the co-operation of the film-makers and the perfection of material forming the base, whether it be celluloid or something yet to be manufactured. The great light necessary for the projection of the present size of kinetoscope designs, to make them visible life size on the screen, or of sufficient size to be seen by a large audience, is such that it makes apparent the slightest blemish in either film or support, and consequently pinholes, scratches, and marks, obtrude themselves, and are particularly noticeable in the

quick changes that have to take place to keep up the appearance of motion, or living photographs.

Mr Birt Acres, with a modesty very rare in these days of advertising, does not anywhere on his prospectus put his name, nor did he announce himself personally as the inventor, on the day I saw his exhibition, but contents himself with the following note at the end of the programme: 'Our apparatus is an English invention, and was the very first shown in England, an exhibition having been given, with great success, at the Royal Photographic Society, early in January last. An entirely new series of pictures is now being prepared, and we shall frequently vary our programme.'

I quote this more as a text, for, from the results of each projection I have seen, I feel that it is a great pity, after once the plan of projecting the kinetoscope designs was found practical, that a much larger photograph was not arranged for, and the ultimate success of the invention will depend on the taking and projection of photographs of at least double the size of the present small photographs, for it is too much to expect to get perfection in detail in such a limited space.

Considering the material available, the results were remarkably good, particularly in such subjects as the *Breaking Waves of a Rough Sea at Dover*; *The Derby Day*, with its concourse of people on the course, the actual race, and the crowd after the race; *The Boxing Kangaroo*, and the *Arrest of a Pickpocket*. One could see from the various results shown that a great deal of the success of the pictures depended on the position available for taking the photographs, for, in those where the subjects could be to a certain extent 'placed' or kept at a definite or fairly regular distance from the camera, the natural appearance was well maintained; while in others, such as the *Royal Review*, the exaggerated perspective had a most comical effect, the strides of the Emperor being in rapid succession Brobdingnagian and Liliputian [sic]; while the *Derby Day*, with the camera pointing nearly straight down the course, the horses, as they neared the end, and were thus close to the camera, were somewhat out of focus.

It is, of course, easy to criticise, and I only allude to these little matters in the hope that some of the workers on machines for this class of work will see their way, not only to arrange for larger films being used, but induce some film-maker to produce them with the utmost care. That something has already been achieved, is amply testified by the reception accorded to the projections of the Kineopticon and the Cinematograph [sic] daily, and, as I understand, in the modern patterns of the former instrument, it not only projects the subject, but can be used for photographing it, and it is so constructed that the same plan, with probably a little modification, could be used for subjects of a larger size. Further development may be expected when a further supply of machines is made.[25]

ANIMATED PICTUR&S

LIFE-LIKE MOTIONS!
LATEST SENSATION!

THE *1896*

NOW ON
VIEW.

Admission

Sixpence

Entire Set of

New

Pictures.

KINEOPTIKON

Showing from
2 p.m. to 6 p.m.

SEE THE TOWER BRIDGE IN WORK.

PICCADILLY CIRCUS,

30 Handbill advertising the Kineopticon of Birt Acres, which was exhibited at 2 Piccadilly Mansions, Piccadilly Circus, from 21 March 1896. *(Mrs Audrey Wadowska)*

The price of admission to the exhibition at Piccadilly Mansions was sixpence (30), and unlike that of Lumière or Paul, both of which formed part of a music-hall programme,[26] the Kineopticon was the sole attraction. In this respect it foreshadowed the 'nickelodeon' and one is tempted to refer to 2 Piccadilly Mansions as the first cinema in England, if we except Marlborough Hall where the Cinématographe-Lumière was shown. How long the Kineopticon remained on exhibition at Piccadilly has not been determined, but apparently the performances came to an abrupt end after a few weeks, for, according to a statement made by Birt Acres, it was burnt down through the carelessness of an assistant in his absence.[27]

Perhaps Birt Acres did not have the right temperament to make a successful showman, and preferred to leave this side of the business to others. Henceforth he contented himself giving lectures at various functions up and down the country.

He exhibited the Kineopticon at Cardiff's Art and Industrial Exhibition, which opened on Saturday, 2 May. The first performance there took place the following Tuesday afternoon, and thereafter at frequent intervals throughout each day, the performances being held in the upper storey of the Cardiff Town Hall. According to the *South Wales Echo*, the opening performance 'was a remarkable success, and all present declared themselves astonished with the series of pictures thrown upon the screen'.[28] These included: *Capture of a Pickpocket; The German Emperor Reviewing his Troops; The Derby of 1895; Rough Sea at Dover; Tom Merry, Lightning Cartoonist;* and *Beer time in a Carpenter's Shop.*[29]

On 27 June, the Prince and Princess of Wales and the Princesses Victoria and Maud paid an official visit to the Cardiff Exhibition, and Birt Acres availed himself of the opportunity to take a film of the royal party. This ultimately led to the first Royal Command Film Performance which Birt Acres was summoned to give at Marlborough House on 21 July, at which the film of the royal visit to Cardiff was shown.

On another occasion in Wales, Birt Acres filmed a military tournament, an account of which was given in the Cardiff *Evening Express* on Thursday, 3 September:

On Thursday next the 'Kineopticon' programme will consist of a complete military tournament, the following pictures being shown: Sword v. Sword, Sword v. Bayonet, Boxing Match, Cleaving the Turk's Head, Mounted Mule Battery, Maypole Dance, and Mounted Quadrille. The latter especially is a very fine picture, and in the photographs of the Mounted Mule Battery the action is shown with much better effect than the actual manoeuvres, the clouds of smoke being more susceptible to the lens than to the eye.

There is a treat in store for patrons of the 'Kineopticon,' in Old Cardiff. Those of our readers who attended the recent military tournament may have noticed an arrangement similar to a diminutive barrel-organ at work in front of the grand stand. This was Mr Birt Acres' kinetic camera, and, instead of grinding out popular tunes, was taking the infinitely more popular animated photographs. At each revolution of the handle twenty photographs were taken, and in all some 1,000ft. of pictures were obtained. The result is a magnificent series of films, which are equal to those taken by Mr Birt Acres on the occasion of the Royal visit to the Exhibition. The latter were shown at Marlborough House, and created such a sensation that Mr Acres was given facilities for taking photographs of the wedding procession on the lawn at Marlborough House and Buckingham Palace.[30]

Then followed a series of shows at the Royal Photographic Society's exhibition which opened on 25 September at the premises of the Royal Society of Painters in Watercolours, in Pall Mall. Performances were held every Monday, Wednesday and Saturday at 8.45 pm.[31] The busy itinerary continued with a performance on 27 October, in his home town of Barnet, at the Town Hall, given in aid of the Bell's Hill Mansion Building Extension Fund. By this time, Birt Acres's repertoire of films had increased considerably, as the following account taken from the *Barnet Times* reveals:

Mr Birt Acres briefly explained the apparatus, and then proceeded to throw upon a screen a series of animated photographs of a marvellous character. First came a view of Highgate Tunnel, on the G.N.R., and while the audience watched it smoke issued from the

opening and a luggage train rushed along the platform, on which Mr Birt Acres was observed walking up and down. Next came photographs of fishing-boats leaving the harbour. The boats were towed by tugs, which left in their wake a mass of foam. Then a party of lancers, dancing the 'Lancers' on horseback, were shown, and performed their evolutions in the most realistic manner. 'A south-western [*sic*] at Dover' showed great waves breaking on the shore, and one listened instinctively for the rustle of shingle. 'Children playing' was a most interesting view, the little ones romping with two nurses in quite a natural style. 'A corner of Barnet Fair,' shewing roundabouts in operation and people moving about, was next depicted, and the first half of the entertainment was closed with views of 'The Boxing Kangaroo,' 'The Capstone Parade, Ilfracombe,' and 'A Boxing Match.'

... Then came more of the Cinematescope [*sic*] pictures, the following being the order in which they were thrown on the screen: Return to Marlborough House, after the wedding of Princess Maud, and departure of the Bride and Bridegroom for Sandringham; the Emperor of Germany Reviewing his troops previous to the opening of the Kiel Canal; the Derby: (a) Clearing the Course, (b) Preliminary Canter, (c) Race and crowd surging on the course; Henley Regatta; Finsbury Park Station; T.R.H. the Prince and Princess of Wales arriving in State at Cardiff Exhibition. The photographs of the Royal Wedding and the arrival at Cardiff were taken, Mr Acres explained, by special command of the Prince of Wales. The whole of the pictures were of the most interesting nature, and as each scene concluded there was a tremendous outburst of applause. During the evening Mr Acres informed the audience that the first successful pictures taken with his machine were taken within a quarter of a mile of that hall.[32]

Two days later, on 20 October, Birt Acres fulfilled an engagement in Liverpool, where he gave a demonstration to the Amateur Photographic Association in St George's Hall.[33] The Hackney Photographic Society also secured his services for their Annual Exhibition held at Morley Hall, Triangle, Hackney, 17–20 November.[34] On 16 December, he was in Ramsgate lecturing and exhibiting at the Royal Assembly Rooms, for the Isle of Thanet Photographic Society.[35] In between these engagements, he had been busy filming the Lord Mayor's Show (9 November).[36] Other engagements during the year had included a performance at Louth Town Hall sometime during the summer,[37] and a performance at the Sheffield Literary and Philosophical Society's exhibition held in the Cutler's Hall.[38]

At the Liverpool meeting on 29 October, Birt Acres, speaking at a dinner at which he was entertained earlier in the evening, informed his hosts that 'he had now practically brought to completion improved mechanism, by which the unpleasant unsteadiness of the picture on the screen is avoided, and also the fact that ere long the

72

general public will be able to purchase the camera [*sic*] at a reasonable rate'.[39] Obviously the Kineopticon was not as perfect as one would have been led to believe, and as for the apparatus being available to the public 'ere long', an advertisement had previously appeared, on 27 June, stating that the machine was already on the market;[40] although it did not specifically mention the Kineopticon, we know it referred to this machine from a subsequent advertisement which appeared on 1 August, where it is mentioned by name.[41] The wholesale agents for the apparatus were the British Toy and Novelty Company Ltd, of 29 Ludgate Hill, London (31).

No details or illustration of the Kineopticon ever appear to have been published, as if Birt Acres deliberately intended to keep the details of its mechanism secret. In fact, he had stubbornly ignored requests by the photographic press for such information.[42] The suspicion naturally arises that perhaps the apparatus was not entirely of his own design. It certainly seems odd that no patent was issued, especially since he took the trouble to patent his other inventions. Maybe it still employed the old principle contained in his Kinetic Camera. The Liverpool statement clearly suggests that, as of 29 October, the apparatus had not appeared on the market, and considering the general lack of information concerning it, I am of the opinion that it was never in fact commercially produced, and that no more than three machines were ever manufactured.[43] A paragraph published in the *Amateur Photographer* on 16 October supports the Liverpool statement and shows that the advertisement of 1 August, stating that the Kineopticon was the 'simplest, cheapest and best

31 An advertisement for the Kineopticon from *The Era* of 1 August 1896.

ANIMATED PHOTOGRAPHS. —
The KINEOPTICON (Patented),
Simplest, Cheapest, and Best Projection Machine
on the Market.
ANIMATED PHOTOGRAPHS AT THE ROYAL WEDDING.
By command of H.R.H. the Prince of Wales Mr Birt Acres, F.R.Met.S., F.R.P.S., attended at Marlborough House to give an exhibition of his Kineopticon before H.R.H. and the Royal wedding guests on Tuesday, July 21st. A series of twenty-one beautifully-executed photographs was exhibited by means of this wonderful machine. One which interested the Royal party more particularly was a view of the Prince and Princess of Wales, the Princesses Victoria and Maud and their suite on the occasion of their recent visit to the Cardiff Exhibition, in which picture-portraits of the Royal group were faithfully represented. This was loudly applauded and repeated. At the close of the entertainment H.R.H. complimented Mr Acres on the successful exhibit, and honoured him by a special permission to photograph the Royal wedding on the following day.—The Era, July 25th, 1896.
N.B.—The Royal Films will only be Supplied to Purchasers of the Kineopticon.
Prices and particulars on application to the
Sole Wholesale Agents,
THE BRITISH TOY and NOVELTY COMPANY, LIMITED,
29, LUDGATE-HILL, LONDON, E.C.

projection machine on the market', was just a canard:

> Mr Birt Acres tells us that both the kinetescopic camera as well as the lantern for showing the pictures will shortly be placed on the market at moderate prices, so that this interesting method of entertainment will soon be within the reach of every one. Moreover, he adds in this letter, 'I have just perfected an apparatus on a new principle with which I hope to be able to show pictures at the R.P.S. before the close of the exhibition. I have entirely obliterated the jumping about, and have done away with the flicker entirely. The apparatus will not be expensive and will be extremely portable.'[44]

This was just another of Birt Acres's rash promises, for no apparatus of the sort was forthcoming until 1898 when the Birtac appeared on the market.

The highlight of Birt Acres's career during 1896 was undoubtedly the Royal Command Film Performance given at Marlborough House on 21 July, which is discussed in Chapter 11. This event, and the films he had taken at Princess Maud's wedding, were duly exploited with the intention of boosting the sales of the Kineopticon projector. The advertisements announced that 'the Royal Films will only be Supplied to Purchasers of the Kineopticon'.[45] Moreover, the name of the apparatus was changed and advertised as 'The Royal Cinematoscope—Exhibited at Marlborough House'.[46]

Concerning the change of name, Henry V. Hopwood in his book *Living Pictures* has this to say:

> Brought out in January, 1896, as the *Kinetic Lantern,* this term was abandoned the following March in favour of the name of *'Kineopticon.'* Being called to give an entertainment before the Prince of Wales in July, the inventor found, to his surprise, that the programmes issued under Royal auspices referred to his invention as the 'Cinematoscope.' What could a loyal photographer do except follow the same course as Mr Acres actually did? Cinematoscope it was by Royal dictum, and Cinematoscope it remains to this day. But as 'a rose by any other name would smell as sweet,' so has the Cinematoscope retained its good qualities under all its varied nomenclature.[47]

A machine by a similar name had already been exhibited by Fred Harvard prior to the Royal Command Film Performance, but whether it was the Kineopticon has not been determined; it seems unlikely. The machine was advertised as 'Harvard's Cinematoscope', and it was exhibited at the Star Theatre of Varieties in Liverpool on 2 June[48] and at the Tivoli, Leicester, on 15 June.[49] The name also appeared as the 'Cenematascope' but this may be merely a misspelling.[50]

The name 'Royal Cinematoscope' seems to have been peculiar to an exhibitor named Lewis Sealy, who exhibited the Kineopticon under this name following the royal performance[51] and continued to do so during some part of 1897. I rather fancy Sealy had the exclusive rights to the name, much in the same way as the management of the Alhambra called Paul's Theatrograph the 'Animatographe'. The fact that another exhibitor, T.C. Hayward, continued to exhibit the apparatus under its former name of Kineopticon seems to confirm this.[52] So much for the royal prince's misnomer!

The British Toy and Novelty Company Ltd, of 29 Ludgate Hill, dealers in grapho-phonographs, kinetoscopes, etc.,[53] did not long remain the agents for the Kineopticon, for in December their place was taken by the Dramatic and Musical Syndicate, of 19 Buckingham Street, Strand, who advertised the machine not as the 'Royal Cinematoscope', but as the 'Birt Acres Royal Cinematographe'.[54] It was still advertised as such in January of the following year, but with the rider: 'This was the first machine which was shown in England';[55] a somewhat inaccurate statement considering the modifications it must have undergone since that time. I am of the opinion that the Dramatic and Musical Syndicate acted as a theatrical booking agency for the machine and not as a dealer concerned with selling it, since no details of the apparatus, or price, are ever stated. This seems to substantiate the notion that the only apparatus of Birt Acres to be commercially produced was the Birtac of 1898.

While Birt Acres was personally exhibiting his Kineopticon at various clubs and societies in different parts of the country, its commercial exploitation was left in the hands of a few professional exhibitors. The general lack of information concerning these public performances seems to indicate that they were few and far between, and I have been able to find the names of only two men who can be connected with the apparatus. One was Lewis Sealy, of 46 Gray's Inn Road, and the other T.C. Hayward of Florence Terrace, Highbury. Sealy exhibited the Kineopticon under the new name of Royal Cinematoscope, whereas Hayward used the former name.

Sealy's first performance was probably at the Metropolitan Theatre on 24 August, on which *The Era* commented that it would be 'a distinct novelty in this part of London'.[56] Reviewing the show on 12 September, *The Era* wrote:

The Royal Cinematescope [*sic*], which was exhibited at Marlborough House on July 21st last before their Royal Highnesses the Prince and Princess of Wales, and the wedding party, has been brought to the Metropolitan by Mr Lewis Sealy, and it is not the slightest exaggeration to say that the pictures shown have proved a great draw. The series consists altogether of some seventeen or eighteen illustrations of most interesting and up-to-date subjects. The most popular of these are undoubtedly those

relating to the late Royal wedding, the scenes at Marlborough House being taken, so we are given to understand, by the express command of the Prince of Wales. Every loyal Britisher is interested in the domestic history of the reigning house, and it is therefore needless to add that loud cheers nightly ring throughout the large auditorium of Mr Henri Gros' fine house in the Edgware-road when the audience assist at the 'Departure of the Bride from Marlborough House,' at the 'Arrival after the Wedding,' and at the 'Going Away.' Neither is less interest shown in a subsequent picture of the Prince and Princess and their daughters Victoria and Maud. Of course, the Englishman's love of sport is appealed to in the Derby series—'Clearing the Course,' 'The Preliminary Canter,' and 'The Finish.' A very successful comedy scene is that enacted in 'A Surrey Garden,' where the watering operations are interrupted by a mischief-loving elf, who, however, gets hoist with his own petard. The departure of 'The East Coast Express' is a very realistic scene, and we hear the swish of the breakers in 'A Stormy Sea.' 'Henley Regatta,' 'The Falls of Niagara,' and 'Highgate Tunnel,' with the passage of a luggage train, are other clever examples of the entertaining powers of the Cinematescope. The director of the special entertainment is nightly called in front of the curtain amid considerable applause.[57]

This is undoubtedly the same music-hall entertainment referred to by the *Photographic News* in its issue for 4 September:

The Cinematoscope. This is the distinctive title given by Mr Birt Acres to his system of projecting animated photographs that now forms part of the entertainment of a London music-hall. Mr Acres is rather late in the field, but it is to be hoped that the pool has not been 'scooped' quite clear, as he certainly, by reason of having antedated Paul and Lumière with a public exhibition of animated photographs, deserves to reap some reward for his trouble and foresight.[58]

We next find Lewis Sealy exhibiting an apparatus at, of all places, the big department store of Swan & Edgar, at the corner of Regent Street. An advertisement in the *Lady's Pictorial* announces: 'Swan & Edgar's wonderful and gigantic bazaar, will open on Nov. 16, with Prof Lewis Sealby's [*sic*] Animatograph.'[59] It is not certain what apparatus was being used here, but the indications are that it was the Kineopticon or Royal Cinematoscope. The management probably chose the term 'Animatograph' as being more familiar to their clients. A subsequent advertisement in the same paper lists the titles of some of the films exhibited, and among them we recognise subjects similar to those of Birt Acres:

Animatograph performances twice daily, at 11.30 am and 4 pm.

Life-size animated photographs, showing realistic pictures of interesting and amusing subjects which create roars of laughter. Perhaps the most funny of these marvellous pictures is that of the *Scrambling Urchins*. There are many other scenes, such as Brighton Beach, Cycling in Hyde Park, and scenes from the Derby—the Course, the Race and Finish; also the Royal Wedding in which H.R. Highness Prince of Wales and all other members of the Royal Family can be distinctly recognised. Admission only by tickets to be had free upon application to the firm, who will in all cases do their utmost to give their little friends an enjoyable time.[60]

There followed an engagement at Collins's Music-Hall in Islington, a short review of which appeared in *The Era* on 12 December:

A very interesting item in the entertainment is Mr Lewis Sealy's Royal Cinematoscope. The series of animated pictures exhibited include familiar London scenes, but the last view takes us to Epsom Downs what time the great race is being run. These pictures are calculated to astonish country folks who have never seen anything more wonderful than an ordinary diorama, or magic-lantern show.[61]

The following year, Sealy continued for a while to exhibit the Royal Cinematoscope, with a return visit to the Metropolitan in Edgware Road,[62] and engagements at the Hammersmith Varieties[63] and the Standard.[64] Thereafter he disappears from the records, probably unable to compete with the host of new machines from home and abroad, which were then beginning to flood the market.

T.C. Hayward's performances are even more sparsely documented. On Saturday, 15 August, he fulfilled an engagement at the People's Palace in the Mile End Road, where he shared the bill with a Promenade Concert given by the Thames Iron Works Military Band. The entertainment took place in the Queen's Hall and two film performances were held during the evening at 7.30 and 9 o'clock. The printed programme, a copy of which is in the collection of the British Film Institute, has been reproduced in C.W. Ceram, *Archaeology of the Cinema*, though only in part. The section referring to the film show is headed: 'The Kineopticon, Invented and Patented by Birt Acres, Esq., F.R.met.S., F.R.P.S. Introduced by T.C. Hayward.' There follows an annotated list of ten subjects from which a selection was to be shown. The films listed are:

1. Sea Waves at Dover: The waves roll up in a most realistic manner, breaking against the Admiralty Pier, each wave as it breaks throwing up a great cloud of spray.

2. Golfing Extraordinary—5 Gentlemen: This is a Golf Scene, in which one gentleman in attempting to strike the ball misses

and falls headlong, much to the amusement of the bystanders.

3. Tom Merry, 'Lightning Cartoonist,' Sketching Gladstone.

4. Tom Merry, 'Lightning Cartoonist,' Sketching Salisbury: In these two pictures of Mr Tom Merry, the Lightning Cartoonist, is seen busy at work upon portraits of Mr Gladstone and Lord Salisbury.

5. Boxing Match or Glove Contest: Having an interval introduced, during which the combatants sit down for a brief rest, and are vigorously fanned by the two attendants, concluding in the last round with one of the boxers being floored.

6. Highgate Tunnel: A goods train issues from the tunnel and passes through Highgate Station; a gentleman, waiting for his train, strolls up and down the platform and watches the passing trucks.

7. Henley Regatta: This year's picture, showing the whole surface of the river crowded with boats, etc.

8. The Arrest of a Pickpocket: In which the man is pursued by a constable, runs right across the picture, they struggle together and the policeman's helmet is knocked off, then the pickpocket, by slipping out of his jacket, manages to escape, but runs full tilt into the arms of a sailor, with whose assistance he is finally secured, handcuffed, and marched off to justice.

9. Broadway—New York: A busy scene at Broadway, with carriages, trams, carts, and pedestrians moving about.

10. Prince and Princess of Wales at Cardiff, June 27th: A view of the Prince and Princess of Wales, the Princesses Victoria and Maud, and their suite, on the occasion of their visit to the Cardiff Exhibition, in which portrait pictures of the Royal group are faithfully reproduced.

The above subjects are the identical pictures exhibited before H.R.H. The Prince of Wales and the Royal Wedding Guests, at Marlborough House, on Tuesday, July 21, 1896. At the close of the entertainment, H.R.H. complimented Mr Acres on the successful exhibit, and honoured him by a special permission to photograph the Royal Wedding on the following day.

The Kineopticon enjoyed a return visit to the People's Palace in the

week commencing 24 August.[65] Thereafter, Mr Hayward also disappears from the records.

There is a printed programme on display in the museum of the Cinémathèque Française at the Palais de Chaillot which links the name of Birt Acres with a programme of films presented under the management of a Mr A. Jones. The preliminary blurb states:

The sensation of the nineteenth century. The Kinematograph ... now attracting crowded and enthusiastic audiences in both London and Paris. Further developments are being made daily by the celebrated English artist Birt Acres, Esq. The mechanical and electrical arrangements under the management of M.A. Jones. Please address T.M. Howard, 319, Hoe Street, Walthamstow.

There follows a list of eleven films, all but one of which we are familiar with in the Birt Acres repertoire. The exception is one called 'Yarmouth Sands'. The titles of the films suggest that the programme dates from the latter half of 1896, and the fact that the machine is simply referred to as the Kinematograph may indicate that it was not Acres's machine that was being used. The programme emanates from the Will Day Collection, now in the possession of the Cinémathèque, and is listed as item 464 in the catalogue; there the date 1896 is ascribed to it.

6 The Cinématographe-Lumière

We need only discuss the Cinématographe of Auguste and Louis Lumière in relation to the part it played in the history of the cinema in England. The story of its invention and exploitation in France has already been documented by the French historian of the cinema, Jacques Deslandes.[1] We will begin by giving a brief description of the apparatus, taken from the English patent of 8 April 1895 (no 7187), and the English edition of the official manual, published by Messrs Lumière at Lyons.[2]

The apparatus (32) is so designed that by a rearrangement of certain components it can be made to function as a camera, printer, and

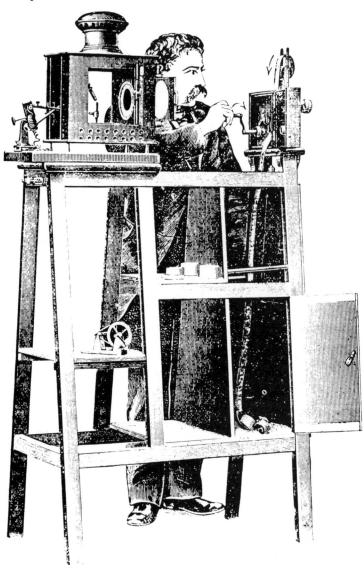

32 The Cinématographe-Lumière, first publicly exhibited in England at Marlborough Hall, Regent St, London, on 20 February 1896; from an illustration in the official manual published at Lyons in 1897. *(Barnes Museum of Cinematography)*

projector. In each case, the conversion is simply performed by adding and/or substituting the necessary parts, without any alteration to the actual mechanism, except to vary the opening formed by the angle of the segmented disc shutter. It is also necessary, of course, to employ a different lens for projection from that used for filming.

The film is drawn through the apparatus by an ingenious claw mechanism, supported on a vertically shifting arm, actuated by an eccentric cam. The claw, which is composed of two protruding pins, on reaching extremes of its upward and downward movement, is then acted on by two revolving arms which alternately cause the claw to engage and disengage with the perforations at the commencement of its upward and downward strokes, so imparting an intermittent movement to the film. In other words, the film is drawn downwards during the descending motion of the two pins and remains at rest during their ascending motion, the pins entering and retracting from the perforations at each stroke. The beauty of the mechanism is that the pins enter and leave the perforations at the dead points of the cam when their speed is nearly at zero. The pins thus enter and leave the perforations with the least possible amount of shock and consequently with the minimum of wear and tear on the film.

The film used is 35mm wide, but, unlike the standard Edison gauge, is perforated with two round holes, a pair to each frame at intervals of 20mm throughout its length (33). The film capacity of the apparatus is about 17 metres (approx. 56ft), and is normally taken and projected at fifteen frames per second. It is manually operated by a handle at the rear which the operator turns at a regular rate of about two revolutions in a second. The mechanism is enclosed in a walnut case and the whole apparatus, despite its rather awkward design, is cleverly made by the expert constructor Jules Carpentier, who deserves some credit for its commercial success.

The first model underwent several modifications and about four or five additions were made to the French patent, with the consequence that a further English patent, covering the improvements, was taken out on 13 April 1896 (pat no 7801). The modifications mainly consisted of refinements to the cam and claw mechanism. The complete outfit comprised the following accessories:[3]

1 *A frame box with two axles for obtaining positives* (A walnut film-box fitted to the top of the apparatus for printing)
2 *Two frame boxes with one axle for obtaining negatives* (Two walnut film-boxes for holding unexposed film; fitted to top of apparatus when used as camera)
3 *Two receiving boxes* (Clip-on metal containers for receiving the exposed film (4 components); fitted to rear of gate)
4 *An objective lens for negatives* (Camera lens)
5 *An objective lens for projection*

33 Felicien Trewey, French prestidigitator and shadowgraphist, sole manager of the Cinématographe-Lumière in England during 1896, as he appears in the Lumière film *Chapeaux à Transformation*. Note the characteristic perforations of the Lumière film, with two round holes to each frame. *(Kodak Museum, Harrow)*

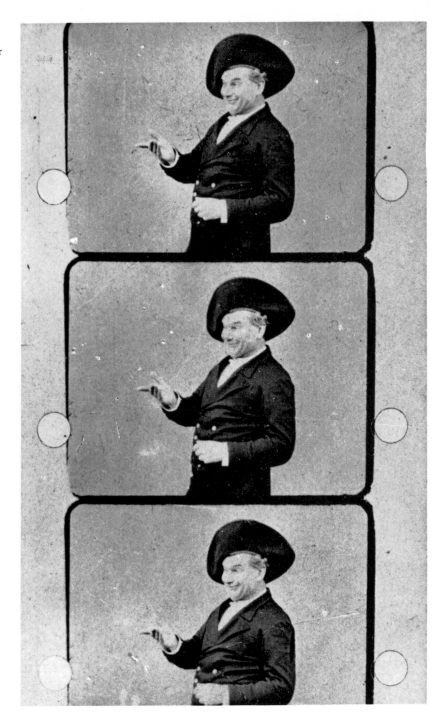

6 *A handle* (Crank-handle for operating the mechanism)
7 *A reel* (Hand-cranked film winder, for forming the correct rolls of film preparatory to insertion in the apparatus)
8 *A film carrier* (Metal frame for holding the roll of positive film for projection)
9 *A projection lamp with spherical condenser* (Optical lantern made by A. Molteni, originally supplied with double condenser, but later replaced with glass globe condenser to absorb heat from lamp)
10 *An electric arc lamp with hand adjustment*
11 *A rheostat*
12 *A stand for projection*
13 *A tripod stand for taking negatives* (Camera tripod)
14 *A moistening box* (Metal humidity box for keeping the film supple)
15 *Extra press glasses* (Glass pressure plates fitted to gate)
16 *Springs for press glasses* (For use with No 15)
17 *Springs for hooks* (Fitted to pins on claw mechanism)
18 *Cleaning accessories*

The introduction of the Cinématographe-Lumière was perhaps the most significant event in the history of the cinema since the invention of the Kinetoscope, and Henry V. Hopwood, in his classic account of the beginnings of cinematography, assesses the contribution of the Lumière brothers in these terms: 'To them must be attributed the credit of stimulating public interest to such a pitch as to lay a firm foundation for the commercial future of cinematographic projecting apparatus.'[4]

The Cinématographe-Lumière was brought to London by Felicien Trewey, a friend of the Lumières who had appeared in several of their early films, including *Assiettes Tournantes, Chapeaux à Transformation* and *La Partie d'Écarté*, where he is shown seated on the right of the card-table enjoying a glass of wine (34).

Trewey was born in France, at Angoulême, and became one of the most popular entertainers in Paris during the latter half of the nineteenth century. He also travelled extensively in Europe and America and gained an international reputation for his ombranie or shadowgraphy.[5] When he arrived in London with the Cinématographe, it was by no means his first visit, for he had appeared there several times before in English music-hall. In 1888 he played the old Alhambra (venue of his future rival R.W. Paul), where his act was billed as numbers 6 and 8 respectively on the programmes for July and September. In the former, he is listed as 'Mons. Trewey, the Fantaisiste, Humoristique, in his Shadowgraph Entertainment'.[6] He later issued a little handbook in English, printed at Middlesbrough, in which he explained some amusing shadow feats performed with the hands. This was so popular that it was reprinted several times, and even appeared in a so-called popular edition,

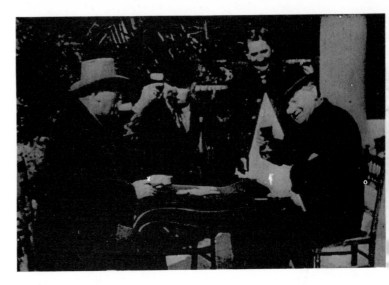

34 Frame enlargement from the Lumière film *la Partie D'Ecarté*, showing Felicien Trewey seated on the right of the table holding a glass of wine. This was one of the films shown at Marlborough Hall, Regent St, on 20 February 1896. *(National Film Archive)*

published by the well-known London toyshop of Hamley's.[7]

Mons. Trewey, as he usually billed himself, was therefore no stranger to English audiences when he arrived with the Cinématographe. He gave his first performance at the Marlborough Hall, Regent Street, on Thursday afternoon, 20 February 1896, which received a lengthy and encouraging review from Anna de Bremont, in the *St Paul's Magazine*:

LIVING PHOTOGRAPHY
Of all the marvels that have recently been brought to light in the way of photography the 'Cinématographe,' which reproduces photographs of actual scenes and persons from life—moving, breathing, in fact, living pictures—is the most startling and sensational, if not the most original, as in the case of invisible photography. It is the most perfect illusion that has heretofore been attempted in photography. Without the aid of any of the usual paraphernalia of the photographer, pictures are thrown on a screen through the medium of the 'Cinématographe' with a realism that baffles description. People move about, enter and disappear, gesticulate, laugh, smoke, eat, drink and perform the most ordinary actions with a fidelity to life that leads one to doubt the evidence of one's senses.

The first exhibition of the Messrs Lumière to introduce their invention to the London public was given at the Marlborough Hall (the Polytechnic) on Thursday afternoon. At their invitation a distinctively representative Press and artistic gathering assembled to pass judgment on the new sensation, a judgment which was not only favourable, but enthusiastic. A short description of the successive pictures will give a clearer idea perhaps of the marvellous character of the display, in which there were much humour and vivacity. The 'Cinématographe' or electric camera,

was placed in the gallery directly opposite the stage, on which was a huge screen of white cloth. When the lights were turned off and the hall in complete darkness, and the first picture, a street scene, was revealed upon the screen, the effect was startling beyond description—fully a hundred figures came and went across the canvas, people jostled one another, stopped to chat, shook hands and away, newsboys appeared in search of customers, dogs scampered by (as though in dread of the muzzling decree), and other details too numerous to mention.

This was succeeded by another marvellous piece of realism in a picture of the landing of passengers from a steamer. The throng passed down the gangway and off in groups of two or more, in high good humour, as though on pleasure bent; and here again scores of figures all different were represented in the most natural manner imaginable.

The third picture, perhaps the most ingenious, represented a train arriving. The locomotive, advancing with lightning rapidity, then slows up, the guard jumps out, opens the doors, out pop the passengers, and go off until the platform is quite empty and the guard slowly inspects each carriage. The illusion was so perfect that one felt like pinching oneself or a neighbour to be sure one was not dreaming, but awake, and actually gazing on a mere photograph.

The next picture was an amusing one, wherein a child, held by its father, attempts to capture the goldfish in a great globe of water, the fish proving decidedly slippery and active. This was followed by a marvellous representation of a photograph from life of the famous Trewey in one of his manipulation tricks with the tops—nothing could exceed the grace of movement and rapidity of action. The next was a scene wherein a blacksmith is at work, the effect of steam in the cooling of the iron being quite wonderful. Then followed a picture of a card-party. You could almost hear the clink of the money, the rustle of the cards, and the popping of the cork as a waiter opened a bottle of champagne and proceeded to fill the glasses.

This piece of realism awoke keen applause, but the best was reserved for the last, which was a reproduction of a party of bathers in the surf of the ocean. Nothing could have been more realistic than the breakers rolling in, and a great deal of merriment was evoked by the antics of the bathers as they dived successively from the bathing-pier.

The most lavish in their praises of Messrs Lumière's marvellous invention were the representative London photographic artists present. Mr Van de Weyde declared it so wonderful that it left him 'breathless' with surprise; whilst Mr Downey pronounced it the most marvellous degree of perfection in the way of photography that the art had theretofore attained. For each of the pictures from 900 to 1,000 negatives from life had been taken on a continuous band, and are, by means of the electric light, projected life size

upon the screen. It would be difficult in this limited space to explain fully this remarkable process. 'Seeing is believing,' as the adage says, and the Messrs Lumière have in their exhibition the most fascinating thing of its kind to be seen in London. Discoveries are thick upon us, from the Invisible to the North Pole, but in this we have one by far more immediately interesting.[8]

The arrival of the Cinématographe in London was also noted in the photographic press, on the whole favourably, though some journals pointed out imperfections. The *Optical Magic Lantern Journal*, of course, had to plug the name of Friese-Greene in its report:

The present boom, as regards the lantern, appears to be in the direction of 'animated projection.' Some time ago we had Friese Greene's apparatus, but latterly quite a host have arisen.[9]
 In the race for first place as regards public exhibition priority the foreigner wins, Messrs Lumière's projection kinetoscope [*sic*] being on view in the Marlborough Hall, Regent Street.[10]

From the *Amateur Photographer*'s account, published on 28 February, we learn that the price of admission was one shilling. The films singled out for mention were *The baby and the goldfish, The prize fighters, The cowboy* and *Dinner-hour exodus from the factory*. Some defects were also noted, these being 'a certain amount of vibration in the moving picture', and a 'distressing glittering flicker'.[11] Yet in the issue of 13 March a different opinion prevailed and the exhibition was described as 'excellent' and 'probably the best thing of its kind which has yet been done'.[12] However, certain defects were noticed by the *British Journal of Photography*, which wrote:

Setting aside some minor imperfections of vibratoriness and 'light streaks' rapidly flashing across the pictures, the representation of lifelike movement on the screen was very successful on the occasion of our visit last week.[13]

The Optician, too, noticed some imperfections:

The Cinematographe now being shown from two o'clock to six at the Marlborough Hall, in Regent Street, is a variant of the kineti lantern of Mr Acres. The disc shown is about ten feet in diameter and the source of light an electric arc. There is a considerable amount of 'jump' about the pictures, which are otherwise good although the light upon the screen is not very brilliant.[14]

Perhaps the most informative and least biased of the reviews was that written by G.R. Baker for his monthly column in the Supplement to the *British Journal of Photography*. We will quote only that part

86

which refers directly to the performance:

The audience at Marlborough Hall or Room only see the results of the projection, for the apparatus is placed in a gallery and carefully concealed by curtains. I am, however, indebted to Mons. Trewey, who is the *concessionaire* for England, for certain particulars respecting the apparatus. Optically, it is an ordinary magic lantern supplied with an electric light, the regulator for same having 12mm carbons, and using 15 amperes of current. Each subject or picture, of which at present there are ten shown at each *séance*, consisting of 900 to 1000 exposures, and the film on which they are produced is fifteen yards long. The latter is propelled through the lantern front by hand motion, it having been found that more care could be taken of the films in that way than if electricity were employed.

And now for the subjects. Imagine yourself sitting in a nice-sized hall, and a small screen five or six feet square, or rather oblong, with a dark border, hanging in front of you, well above your head and level with the gallery, when presently, after a little introduction, a picture appears on the screen, at the same time as the electric lights are turned out in the hall. What is it? Well, we will take a typical one; and, as it is photographic in more senses than one, it shall have precedence. It is a steamboat pier, and there is a gangway in the mid distance. A little whirr is heard in the gallery above our heads, and the picture on the screen is all animation. Some one is walking up the gangway carrying a camera, and he is followed in quick succession by a hundred or so of others. Some turn to the left at the end of the gangway, and others to the right; every third or fourth person raises his hat, as if he recognised some one the audience cannot see; but, when two or three run across the intervening space, one concludes they wish to be quickly out of the field of view of the camera, and that the salutations are for M. Lumière, who is photographing this wonderful scene. It was stated that the gentlemen coming from the boat were those attending the Photographic Convention at Lyons (I think). Certainly the marvellous detail, even to the puffs of smoke from the cigarette, spoke volumes for the perfection of the apparatus employed.

The subjects are considerably varied, the first being a domestic scene, *The Family Tea Table*, in fact with father and mother and the little baby seated at the table; the child is in turn fed, and the lady sips her tea or coffee, and every movement is gone through with all the exactness of life. *The Railway Station* again forms another scene. The station is at first apparently empty when the train is seen approaching, and gradually gets nearer and larger until the engine passes where we are apparently standing, and the train stops, the guard comes along the platform, passengers get out and in, and all is *real. The Forge* again gives an opportunity of showing that the apparatus can faithfully reproduce delicate objects, for, when the hot iron is plunged into the barrel of water, the

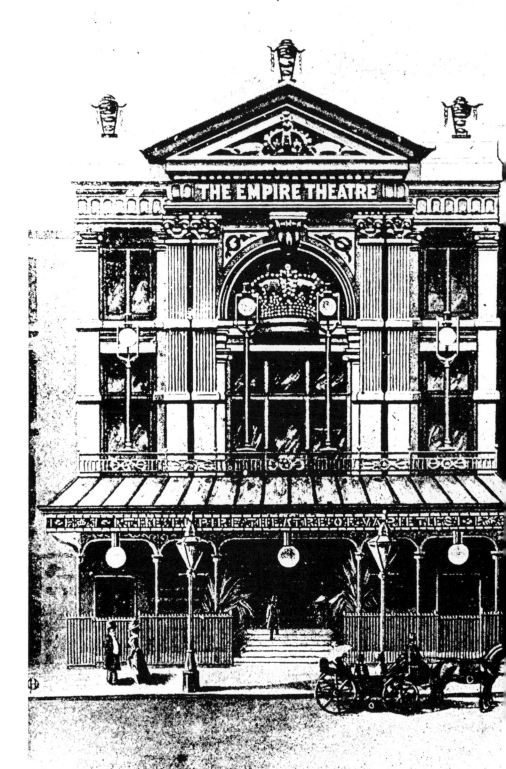

steam rises in a most natural manner.

The scene outside a café of three gentlemen playing cards, and the waiter bringing in refreshments, drawing the corks, pouring out the contents of the bottle, and each of the three toasting the other during an interval in the game, was rather 'mouth-watering,' and the hilarity of the garçon at the results of the game seemed almost bound to produce laughter among the audience. The photographic reproduction of Monsieur Trewey's wonderful girations of a strip of long calico whipped round and round must be seen to be realised, for it baffles description.

The same may be said of the *Street in Paris*, and finally, the *piece de resistance*, viz., *Sea Bathing in the Mediterranean*, for here we have the breaking waves on a shingly shore, a diving or jumping board, and the bathers in succession going down this board, jumping into the sea, battling with the breakers, climbing the rocks, and getting once more on the diving board, all so faithfully to life that one 'longed to be there.'[15]

It would seem that it was Trewey's original intention to exhibit the Cinématographe at Marlborough Hall for about three months,[16] but as a result of the huge success of the initial performances an attractive offer was apparently received to exhibit the apparatus at the Empire Theatre of Varieties in Leicester Square, and the performances at Marlborough Hall were consequently curtailed. For a short period, performances were given at Marlborough Hall concurrently with those at the Empire,[17] the same machine serving both places.[18] But sometime on or before 14 March the performances at Marlborough Hall were discontinued and afternoon and early evening performances were thereafter held in the foyer of the Empire.[19]

A copy of the official programme for the Marlborough Hall performances is in the Will Day Collection and is reproduced as Plate 36a in the catalogue. It was published by an advertising agent named W. Constable, of Bradford, and printed in that town by F.S. Toothill, of 71 Godwin Street. It lists the titles of twenty-five films, of which only about ten were shown at each performance. Some of the films known to have been shown are not included, but a statement is made to the effect that the programme 'will be liable to frequent changes, as well as additional pourtrayals [*sic*]'. The films were to be accompanied by Francis Pochet as lecturer. The engagement at Marlborough Hall appears to have lasted for about three weeks.

So after this brief introduction to the London public at Marlborough Hall, Mons. Trewey began his season at the Empire (35). The success which the Cinématographe had at this theatre was so phenomenal that it was retained until July of the following year, being eventually replaced by Professor Jolly's apparatus.[20]

Thus from the start the Cinématographe-Lumière was an unqualifed success, and it was these performances at the Empire which were largely responsible for establishing the early cinema as part of

35 The Empire Theatre, Leicester Square, where the Cinématographe-Lumière was exhibited from 9 March 1896 under the management of Felicien Trewey. The Empire was the first music-hall in England to show Films. (*Barnes Museum of Cinematography*)

the regular repertoire of almost every major music-hall in the country. Contrary to popular belief, it was not until the following year that the 'animated pictures' began to infiltrate into the fairground and the village hall, and later still before they were being shown in converted shop premises which can be considered as the direct precursors of the cinema theatre. The latter began to appear only from 1907 onwards.[21] The home of the cinema during 1896 was the music-hall.

And so London's most famous theatre of varieties became the first music-hall in the country to embrace the new medium of entertainment which would one day be the cause of its own extinction. But such events were still in the unforeseen future, and the Cinématographe's debut was meanwhile rapturously received by the music-hall public:

> The Cinématographe, the invention of M. Lumière, was shown at a private view at the Empire on Saturday, and on Monday a house packed in every part viewed with wonder and delight the novel invention.[22]

Owing to the extraordinary demand for seats to witness the Cinématographe, the directors of the Empire decided to give a series of afternoon performances.[23] These were held in the Grand Foyer at 3, 4, and 5 o'clock each day.[24]

The opening night, which took place on Monday, 9 March, was written up in *The Era* the following Saturday. The opening paragraph has been quoted above and a further extract follows.

> The cinématographe is sure to be the talk of the town. Monday's audience applauded it lustily, and so enthusiastic did they become that two of the living and moving pictures were reproduced—viz., the arrival of a train and debarkation of passengers at a railway station, a wonderful illusion, and really funny, and 'The Bathers'— a number of men luxuriating in a bath on the shores of the Mediterranean. The pictures presented also include:—'Dinner Hour at the Factory Gate of M. Lumiere at Lyons,' 'Tea Time' (a very droll representation of a youngster being fed), 'The Blacksmith at Work,' 'A Game at Ecarté,' 'Children at Play,' 'A Practical Joke on the Gardener' (a distinctly humorous subject), 'Trewey's Serpentine Ribbon,' and 'La Place des Cordeliers, Lyons.' The representation is under the management of M. Trewey. Of course, the possibilities of such an invention as the cinématographe are practically endless, and the British public have now a new toy of which they are not likely soon to tire.[25]

The continued success of the Cinématographe at the Empire is confirmed by the *Amateur Photographer* which, surprisingly, devoted a couple of paragraphs to it in the issue of 10 April:

> Society is taking to photography with as much enthusiasm

almost as it has bestowed upon cycling. Not so much to the camera itself—which has been long and safely established in favour—but to its latest development, which has been christened 'Cinématographe.' This is of necessity, a trying word to talk glibly about, but it has for the present conquered the town almost as completely as 'the living pictures.' To see the carriages rolling up to the Empire matinées one would suppose that Society had only just discovered Leicester Square. The 'boom' is tremendous, and apparently as catching as measles, for, besides the afternoon shows, Society is flocking so unconcernedly to see the new thing that there is never a stall to be secured in the evening.

And very clever is M. Trewey, who presides over the 'Cinématographe.' He is a conjuror and juggler who has earned a handsome competence with his fingers; but as a shadowgraphist he is unsurpassed. It is truly remarkable what he can do with his eight fingers and his two thumbs, for there is never an animal nor hardly a face but he can recall it to you in this way, and when he adds a little scenic effect and some cunningly-devised 'make-up,' his success is really startling. It may be that the handsome competence which he has secured in this way enabled him to advocate the retention of the sole rights in the 'Cinématographe,' when, as we are credibly informed, the owners were offered the tempting *dot* of one million francs for them. The great boom in the thing—it is of so complex a nature as to render an exact definition of its *genus* almost impossible—has justified his prescience.[26]

Even after four months there were no signs that the Cinématographe was losing its popularity; indeed, it was becoming clear that this new medium of entertainment was no mere flash in the pan. *The Era*'s review of 1 August was just as enthusiastic about the pictures as it had been at the beginning:

The attractions of M. Lumière's Cinématographe are endless, and from time to time M. Trewey, who is in charge of this novel exhibition, adds subjects that appeal readily to every class of society. For instance, at the Empire nightly cheers are raised by the excellent representation of a steeplechase. The gallant steeds come along at racing speed towards the footlights, and then pass from the field of view, and the next picture—the finish on the flat—is most exciting. Another most popular subject is the 'Outside of the Empire,' with cabs arriving and departing. Here we recognise the well-known form of Mr Dundas Slater, the popular acting-manager, and others of the staff. But the latest novelty introduced is a series of living representations of episodes connected with the coronation of his Imperial Majesty the Czar of Russia at Moscow. Number one displays on the white screen a number of Cossacks, in picturesque attire, entering the Moscow gate. Soldiers are marshalling the cavalcade which is walking slowly into the historic city. 'State

Carriages going to the Ceremony,' 'Procession of Ladies-in-Waiting,' 'Procession of Asiatic Ambassadors' are full of life and movement. Much interest is felt, too, in the progress of the Grand Duchess Eugenie in a state carriage, followed by her Imperial Majesty the Czarina; and other excellent studies of what was one of the most brilliant pageants of modern history are found in the procession of the Czar and suite entering the Kremlin and in the picture of their Imperial Majesties leaving the palace and entering the church. At the conclusion of the series the audience find a more familiar subject in the 'Change of Guard at St James's Palace,' which on the night of which we are now writing had to be repeated. The arrival of a train at a French station is still as popular as ever, and the bathers plunging into the wild waves of the Mediterranean always excite amusement.[27]

As the year progressed, more and more music-halls throughout the country were including 'animated pictures' in their programmes, and although they were often advertised as the Cinématographe, in no instance was the Lumière machine ever exhibited except at the Empire Theatre in Leicester Square. Under the sole management of Mons. Trewey it remained exclusive to that theatre, and it was not until the following year that the Cinématographe-Lumière became available on the open market. In the meantime, its English agents, Fuerst Bros, addressed a letter to prospective purchasers stating that they were now willing to accept orders for the machine, for which a delivery date effective from May next was promised. This letter was published in the *Amateur Photographer* on 20 November, and reads as follows:[28]

LUMIERE'S 'CINEMATOGRAPH.'
Sir,—It may interest you to know that we, being sole agents for Lumiere's 'Cinematograph' [*sic*] for Great Britain, the colonies, and the U.S. of America, are in a position to take orders for the complete apparatus for producing animated pictures.

All applications will be considered in rotation as they are received, and deliveries of said apparatus will be effected accordingly in May next.

All those who are interested should communicate with us promptly.

—Yours truly, Fuerst Bros.
17, Philpot Lane, London, E.C.

The original apparatus, used by Trewey at the Empire, was subsequently acquired by Will Day and is listed in his catalogue as item number 119. With it was a letter from Trewey vouching for its authenticity. Also listed are a number of the accessories.

92

7 Exploitation of the Theatrograph

Whereas the Cinématographe-Lumière was confined to the performances at the Empire Theatre, Leicester Square, R.W. Paul's Theatrograph was soon being exhibited in many of the major music-halls in London, and before the year was out was penetrating the provinces and making inroads into the foreign market.[1]

Originally it was Paul's intention merely to manufacture the apparatus, which was intended to sell at five pounds.[2] Its commercial exploitation as regards public exhibition he was content to leave to others. Naturally, having once achieved a successful method of screen projection he was anxious to prove its merits, and arrangements were made accordingly to hold a demonstration as soon as possible. With commercial considerations absent, his choice of venue was the Finsbury Technical College, the place where he had received his early technical training.

The performance was held on 20 February 1896, the same day on which the Cinématographe-Lumière had its English debut at Marlborough Hall. It must have been with some pride that Paul exhibited his new invention at his old college, and before an audience which surely included some who remembered him from his student days, for he was still a young man of twenty-seven. The performance seems to have been a success, and *Reynolds's Newspaper* reported on the 23rd that the 'Theatrograph was shown on Thursday last in the presence of a large and enthusiastic audience'.[3] In the same column, there appeared a notice of the first performance of the Cinématographe-Lumière at Marlborough Hall which took place in the afternoon of the same day. Paul's performance probably took place in the evening, in which case the Lumière show pre-dates Paul's by a few hours.

The Finsbury Technical College, founded in 1881, was the first of its kind in England. It had originally been established to provide a technical training for the working man, but had developed in such a way that it tended more and more to appeal to a richer class of student.[4] Instruction was largely devoted to chemistry, electrical engineering and mechanical engineering,[5] the three subjects which were to prove of inestimable value to Paul's future career.

In 1891, Paul set himself up as an electrical engineer and scientific instrument maker at 44 Hatton Garden, then a centre of precision engineering and craftsmanship. It was whilst engaged in this line of business that he first came into contact with moving pictures, when he was contracted to make replicas of the Kinetoscope. We have already described the consequences attendant upon this chance encounter with the Edison machine.

After the performance at Finsbury, Paul's next demonstration was given on the 28th, at the Royal Institution in Albemarle Street with which he probably already had associations as a member of the

Institution of Electrical Engineers, the Royal Institution having been the birthplace of electrical science under Michael Faraday.[6] It was only fitting that the new invention should be presented before a scientific circle, since its potentialities as a medium of popular entertainment had not then been fully realised, and its capabilities at first suggested a more scientific use, perhaps more in line with the work of Professor E.J. Marey whose chrono-photographic apparatus was being employed in the field of physiological research.

The films which Paul presented at the Royal Institution could hardly have been less suited to the occasion, but it must be remembered that at that time subject-matter was secondary to the principles being demonstrated. An account of the performance appeared the next day in the daily newspaper, *The Morning:*

THE THEATROGRAPH
A Chat with its inventor
A representative of *The Morning* attended the conversazione held in the library of the Royal Institution last evening in order to witness an exhibition of the theatrograph, a new appliance for exhibiting kinetoscope pictures on a full-sized screen, which has been invented by Mr Robert W. Paul, the well-known scientific instrument maker of Hatton Garden. In response to a question put to him by the representative, Mr Paul said that he had had the idea of the theatrograph in his head for some time past, but he had been moved to put the idea into working form, because one or two other appliances of a somewhat similar description had appeared. Mr Bert [*sic*] Acres in this country, and MM. A. and L. Lumière in Paris, have both invented instruments which show kinetoscopic pictures on the screen, though these appliances differ in detail from the theatrograph.

The Theatrograph at Work
At one end of the library a long screen was suspended and at the other end of the room was an optical lantern fitted with an electric arc lamp. The theatrograph was fitted in between the condenser and the objective, and the whole apparatus surrounded by curtains in order to cut off any light which might escape from the sides of the lantern and so dim the image on the screen. Among other subjects which were projected were the following—A ship is seen on the point of leaving for foreign parts. When the theatrograph is started the scene changes from one of quiet to one of bustle and excitement. The ship moves slowly on, the spectators walk about and wave their hands to their friends on the departing boat, and amid the cheers of the bystanders the majestic vessel slowly steams out of the picture.

The Boxing Kangaroo
Another scene was the well-known boxing kangaroo. As soon as the machine was set in motion the kangaroo and his opponent

began to box in a vigorous manner. The whole scene was remarkably life-like, and elicited much applause from the audience. Another scene showed a stormy day at the seaside. The waves dashed against the breakwater, the spray seemed to start out of the picture and those who stood near the screen appeared to be in imminent danger of being wetted. A few people were observed dodging the flying foam, while all the time the sea was in a perpetual state of motion. Another scene showed some performers rehearsing a play. The various attitudes were gone through and the figures moved about on the screen in a most remarkable manner. Another showed an acrobat performing with a pole and the manner in which he twisted about and balanced the stick elicited loud applause. Various other scenes were shown.[7]

The films of the boxing kangaroo and rough sea were photographed for Paul by Birt Acres, with the Paul–Acres camera, whereas the acrobat performing with a pole was probably the Edison Kinetoscope film of Juan Caicedo.[8] The question of copyright evidently did not apply here, as the performance was restricted to a private audience. It was this performance, however, which was to lead to Paul's future involvement in the entertainment business, for among the audience was the wife of Sir Augustus Harris, general manager of Olympia. The occasion, according to Talbot, had the following consequences:

Next morning Paul received an urgent invitation from Sir Augustus Harris to join him at breakfast. The latter had heard from Lady Harris all about the remarkable exhibition at the Royal Institution, and, with a showman's keen instinct, desired to glean further details without delay. He said that he had heard in Paris of a French invention similar to Paul's. This took the English experimenter by surprise, for he had been labouring in absolute ignorance that other men were at work in the same field. However, the impresario was on business bent. He saw the possibilities of the Theatrograph as a form of amusement, and Paul was asked if he were willing to permit its being exploited at Olympia, which Harris had acquired.

'Well, I don't know,' rejoined the experimenter. 'I have no idea of its value from the public point of view.' He thought that the indifference of the British public to the Kinetoscope did not augur well for the new development.

'Now look here,' continued Sir Augustus Harris. 'It won't draw the public for more than a month. They soon get tired of these novelties. Are you prepared to come in on sharing terms, say, 50 per cent of the receipts? Do you agree?'

Paul was somewhat doubtful of the results, but he acquiesced, and the agreement was drawn up there and then. The sequel showed how ill-founded his apprehensions had been. The Theatrograph caught the popular fancy, and proved the most

powerful amusement-magnet at Olympia. It was the first picture palace in the world, that is to say, the first establishment devoted exclusively to the projection of moving pictures as a complete entertainment. From it the whole modern development of cinematography may be said to have sprung.[9]

It was rather an exaggeration on Talbot's part to describe Olympia as the first establishment devoted exclusively to the projection of moving pictures as a complete entertainment, since the Theatrograph was only one attraction among many which drew the crowds to Olympia. It was described in the official programme as 'the greatest combination of entertainment ever presented to the public, under one roof'. True, the apparatus was exhibited in a separate hall of its own known as the 'Palmarium' and an admission fee of sixpence was charged; even so, the Palmarium also served other amusement purposes when the Theatrograph was not being shown.[10]

In his BKS lecture Paul recalled the events a little differently from Talbot. Having referred to the Royal Institution demonstration, Paul continued:

There the pictures were seen by Lady Harris, whose husband was a leading impresario, responsible for managing the Theatre Royal, Drury Lane, and a big spectacle at Olympia. Next morning he telegraphed me to meet him at breakfast, and proposed to me the installing of a projector at Olympia on sharing terms. He added that he had recently seen animated photographs in Paris, and prompt action was necessary, as he was sure that the popular interest would die out in a few weeks. Though I knew nothing of the entertainment business, I agreed, installed the machine in a small hall at Olympia in March, 1896, and was surprised to find my small selection of films received with great enthusiasm by the public who paid sixpence to view them.[11]

The first performance took place on 21 March, and the following morning the *Daily Chronicle* reported that 'the large audience have been greatly pleased with Mr Paul's Theatrograph'.[12] Two days later, an advertisement in the same paper announced: 'The Theatrograph [Paul's] Animated Pictures. Most startling scientific marvel. Life-like series of Trilby, Boxing Contest, Skirt Dancer, Comic Singer, Egyptian War Dance, &c., &c., At frequent intervals during the day.'[13] Olympia was advertised as 'London's greatest pleasure resort', and at that time occupied a site of six acres, facing Addison Road Station. It had been opened in 1887, but has since been rebuilt.

With the Theatrograph thus embarked on a successful engagement at Olympia, and the Cinématographe-Lumière already drawing in record crowds at the Empire, Alfred Moul, general manager of the Alhambra Theatre (36) was determined not to be outdone and approached Paul. The story is best told in Paul's own words:

96

ALHAMBRA

Theatre of Varieties.

General Manager—Mr. ALFRED MOUL.
Business Manager—Mr. DOUGLAS COX.

36 The Alhambra Theatre, Leicester Square, London: front cover of a programme for the week beginning 6 April 1896. Paul's Theatrograph was exhibited here from 25 March 1896 under the name 'Animatographe'. *(Barnes Museum of Cinematography)*

Marvellous ANIMATED PHOTOS.

The Great ALHAMBRA SUCCESS

PAUL'S

Original

THEATROGRAPH

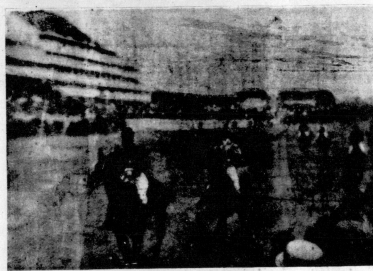

COMIC,
Military,
Naval,
Domestic
and
Topical
Scenes.

Constant
Change.

SCENES
of
London
Life.

Selections
from
50
Stirring
Subjects.

The Prince's Derby will be run Daily

(See "Strand Magazine" for August.)

ss Maud's Wedding &c. &c.

rs to a pitch of excitement.
up and wonder.
aw a thundering demand for an encore.

Times.—Rapturously received and repeated.
Lloyd's.—Nothing more realistic was ever devised.
Daily Mail.—Received with yells of enthusiasm.

37 Handbill advertising Paul's
Theatrograph, 1896, illustrated
with a scene from *The Derby* of
1896 and a portrait of Paul.
(National Film Archive)

To compete with that machine, as shown at the Empire Theatre in Leicester Square, the Manager of the Alhambra asked me to give a show, as an item in the programme lasting ten minutes, with my Theatrograph, which he renamed the Animatographe. This engagement was for two weeks from March 25th, and actually continued for about two years. The salary, or fee, was at the rate of eleven pounds per performance, far more than I had expected.[14]

Actually Paul's performances at the Alhambra were terminated on 28th June 1897, through a dispute with the management over the terms for showing the films of Queen Victoria's Diamond Jubilee. A court case ensued[15] and Paul's 'Animatographe' was consequently withdrawn and replaced by a programme of films by J. Wrench & Son.[16]

But to return to the opening performance at the Alhambra. This took place on Wednesday, 25 March 1896, with Paul's machine billed as the 'Animatographe'. This was a term coined by the management and was exclusive to that theatre. Elsewhere, the machine was exhibited under its original name of Theatrograph (37).[17] Despite a certain imperfection in the quality of the projection, which has already been noted, *The Era* considered the exhibition a 'considerable success', and went on to describe some of the films:

An early picture displayed the sinuous movements of some Nautch dancers to perfection. Scarcely so successful was the reproduction of the action of a contortionist who is preparing to spin round while holding an apparatus in her teeth. A touch of humour is introduced in the life-like reproduction of a carpenter's shop with one of the thirsty souls taking a long pull at a pewter, and a picture full of life and movement is the boxing bout between a kangaroo and a man. The next picture, 'waves breaking upon the shore,' drew forth loud approval, and positive excitement attended the reproduction of a couple of rounds between scienific boxers, whose sparring seemed to us a little slow. The performance of a lightning cartoonist, who draws Bismarck, is another successful picture. Of course, the series of subjects may be indefinitely extended, and there can be no doubt that the Animatographe will remain an attraction at the Alhambra for a long time to come.[18]

The contortionist holding an apparatus in her teeth sounds suspiciously like the Edison Kinetoscope film of Bertholdi.[19] The others were turned by Birt Acres with the Paul–Acres camera and were originally intended for use in the Kinetoscope. This accounts for the remark that the sparring of the boxers seemed a little slow, for the rate at which these pictures were taken was about forty per second, thus producing almost a slow-motion effect when projected at fifteen per second, which is the estimated speed of Paul's projector (see page

44). One of the reasons for the Cinématographe's initial superiority was that the Lumière films were projected at the same rate at which they had been taken.

With successful performances now being held at the Alhambra and Olympia, Paul looked for new grounds to conquer. By the end of the following month he was able to extend his territory to East and South London. George Adney Payne, the comptroller of the renowned Canterbury and Paragon music-halls, secured the Theatrograph for both theatres, the contract being made through Fred Highams, a well-known theatrical agent.[20]

The Canterbury Theatre of Varieties was situated in Westminster Bridge Road, south of the river, and the Paragon in the working-class district of Mile End, in the East End. The performances at both theatres opened on the Monday of 27 April. As previously stated, we have reason to believe that the projectors being used at this time were Paul's first model and this probably accounts for the initial performances at the Canterbury being described in *The Era* as only a 'partial success'. Whether or not the same applied at the Paragon has not been recorded. In any case, the sheer novelty of witnessing animated pictures at this time, however imperfect, was enough to ensure even a modicum of success. After briefly noting the defects, *The Era* continued its review with a certain amount of optimism:

> There were several subjects, however, which in their development on the screen elicited applause. One of these was a spirited boxing bout, in which each competitor was floored; and another showed the performance of a graceful lady gymnast. There is little doubt that the exhibition after a night or two will be quite worthy of the confidence that Mr George Adney Payne feels and expresses in its drawing powers; but even without it the Canterbury programme is brimful of diversion and amusement.[21]

Mr Payne's faith in the new invention proved correct, and the Theatrograph continued an uninterrupted run at both theatres which lasted for over a year. Of course, the original machine was not retained for the whole of this period, new models naturally replacing the old as soon as available. We can gather how successful the Theatrograph eventually became at the Paragon music-hall from a review published in *The Era* for 3 October:

> The popularity of the Theatrographe [*sic*] has spread from Mayfair to Mile-end, and the Paragonians, who are so excellently catered for by Mr George Adney Payne, are this week enjoying the series of animated pictures, presented in such lifelike and realistic fashion through the medium of the apparatus invented by Mr R.W. Paul. The familiar features of Mr Chirgwin, the white-eyed Kaffir, are hailed with delight by gallery and pit as that original comedian goes through a portion of his performance on the screen; and Mr David

Devant's rapid manufacture of a large number of familiar objects from a large sheet of paper is cleverly realised. The scene on Hampstead Heath on last Whit Monday is remarkable for its movement; and in the street scene near Westminster-bridge we see the busy traffic just outside St Thomas's Hospital, a somewhat similar picture being the scene on Blackfriars-bridge. The comic costume scramble at the Music Hall Sports on July 14th last forms an amusing series of incidents that appeal with special force to a variety audience; and quite a little comic drama is enacted by M. Paul Clerget and Miss Ross-Selwicke, who play respectively a meek husband and an irate wife. The most popular presentment of the series is the finish of this year's Derby, won by the Prince of Wales's Persimmon, and the scurry of the crowd on to the course after the gallant steeds have swept by is a very truthful realisation. Mr Paul has an extensive list of subjects, and the pictures are changed every week, so that we may expect a long spell of popularity for the Theatrograph at the Paragon.[22]

In the meantime, the Theatrograph was maintaining its popularity at the Alhambra under the name Animatographe, and *The Era* in its column of 5 September still chose to single it out as the principal attraction of the variety programme:

The management of the Alhambra is 'booming' the animatographe, and no less than eighteen animated photographs are now exhibited each evening. These do immense credit to Mr Robert W. Paul, M.I.E.E., who distinguished himself by his exploit in reproducing the Derby of 1896, still one of the most popular of the photographs presented. The first scene exhibited on the occasion of our visit to the Alhambra showed engineers and blacksmiths at work at Nelson Dock; and another depicted the passengers coming on shore from a steamboat at Rothesay Pier. A dramatic episode was the arrest of a bookmaker. First the betting-man and his clients were shown transacting business on the curb-stone. Then the 'bookie' was seized by a policeman in plain clothes, who, being resisted, applied his whistle to his lips, and summoned a 'man in blue'. A struggle took place, and one of the bettors escaped by leaving his coat in the hands of his captor. The pretty picture of children at play is much enjoyed; and the traffic near Guy's Hospital is reproduced with surprising animation and fidelity. The broad humour of the landing of some excursionists from a boat on Brighton beach creates laughter, and the arrival of a train at a station is as popular a subject as ever. Great amusement is created by the view representing the comic costume race at the Music Hall Sports this year; and the imposing procession of horse soldiery which escorts the Princess Maud from Marlborough House after her wedding is very effective. The 'wake' made by a steamer in leaving a Scotch pier is pretty, and the droll gestures of two

children at a nursery tea-party evoke much merriment. There is an attempt to introduce the dramatic and farcical elements in the animated photograph '2.0 a.m.; or, the Husband's Return.' An inebriated spouse enters his wife's room in the small hours, and behaves in a riotous manner, much to the indignation of his help-mate. Mr Morris Cronin's adroit manipulation of the Indian clubs is shown in another photograph; and the fun of the 'Soldier's Courtship' and the excitement of 'The Prince's Derby' are equally applauded. The military pomp and pride of the departure of the Gordon Highlanders from barracks also evokes admiration and approval. Since the first exhibition of the Animatographe at the Alhambra on March 25th last, over seventy different scenes have been successfully photographed and introduced in the series nightly exhibited.[23]

Sometime in November (16th?) the Theatrograph was booked at the famous Middlesex music-hall in Drury Lane. Here, however, the apparatus was exhibited under yet another name:

Mr J.L. Graydon determined to be right in line with the rest of the music halls when he engaged the Vitamotograph, which is still another name for Mr R.W. Paul's marvellous invention. Some of these animated pictures are wonderfully effective. 'The Engineer's Shop at Nelson Dock' shows very realistically a crowd of men busy at their daily toil, while huge wheels fly round until one almost imagines the whirr of the machinery. A scene in Paris during the visit of the Czar, with a body of black troops passing by; the 'Departure of the steamship Columba from Rothesay Pier,' 'Brighton Beach,' the nocturnal adventures of a gentleman with a gigantic insect,[24] the return of a husband to his home 'with the milk,' and the race for this year's Blue Riband of the turf, with H.R.H. the Prince of Wales's Persimmon coming in a gallant winner, are all extremely popular pictures, enthusiastic applause bringing the inventor forward to receive well-merited honours.[25]

On 5 December, *The Era* again mentioned the Middlesex programme, noting that the 'special attractions were the phonograph exhibited by Mr Fred Karno[26] and the interesting series of pictures of everyday life shown by the Vitamotograph'.[27]

The one other London theatre of note where the Theatrograph was exhibited before the year ended was Sadler's Wells. This theatre which had been failing for a considerable period, was given a new lease of life under the direction of the impresario George Belmont. This colourful showman, nicknamed 'Barnham's Beauty', stamped the Theatrograph with a true Hollywood flavour, announcing it as 'a mighty mirror of Promethean Photographs and a superb, brilliant and electrifying entertainment specially adapted to cheer the toiling millions'.[28]

102

The Theatrograph made its debut at Sadler's Wells on 14 December, and the nature of the performance was duly recorded in *The Era*:

Under the management of Mr George Belmont, the ancient house flourishes again, and this week a special attraction has been introduced into the programme in the shape of Mr R.W. Paul's exhibition of animated photographs known as 'The Theatrograph'. Crowded and delighted audiences have witnessed the well-chosen series of pictures. Amongst the most interesting of these is that representing the scene of the music hall sports at Herne-Hill. The particular event depicted is the costume race, and the manner in which the competitors scramble into their fancy dresses and tear down the course causes the heartiest merriment. Another effective picture is the feeding of the pelicans at the Zoo; and humour has full effect in the domestic scene which follows the arrival home at 2.0 in the morning of a husband who has evidently been dining not wisely but too well. In other views Mr George Chirgwin, the white-eyed Kaffir, is seen playing upon a tray with two long clay pipes, and Mr David Devant gives a display of the art of conjuring. The last picture shown represents the Derby rendered famous by the fact that the race was won by a horse belonging to the heir to the crown.[29]

By this time, Paul had at least five shows running in London simultaneously, all of which were under his personal supervision. Recalling these hectic days, Paul said:

At this period the purchasers of many of my projectors worked them personally. Though we did our best to train lanternists and limelight operators to use the machine properly, their results were sometimes indifferent. Therefore, I attended in the evenings at many of the London music halls, the times of showing being carefully arranged in advance. This helped to maintain the reputation of the projector. I drove, with an assistant, from one hall to another in a one-horse brougham, rewinding the films during the drive.[30]

There is little doubt that the care and attention which Paul bestowed upon the performances under his control were responsible for the high esteem in which the Theatrograph was held during these formative months of the cinema in England, and also brought about a demand for more and more machines, so that before the year was out, animated pictures were being shown in many of the larger towns throughout the country.

The kind of mishap that could happen when Paul's supervision was lacking is instanced by an exhibition during April, in the East End of London, where the Theatrograph was being shown at 'Wonderland'

in Whitechapel Road. The failure of the performances was due to poor illumination provided by the electric accumulators, and resulted in a court action in which Paul sued for non-payment of dues. The matter was settled in Paul's favour at the Clerkenwell County Court on 14 July:

The plaintiff's case was that in April last he was engaged by the defendants, through their managing director, Mr Jonas Woolf, to give performances with his theatrograph at 'Wonderland'. For these the plaintiff was to receive £20 a-week, in addition to £7 10s. a-week for supplying accumulators on hire, the defendants to provide the electric current. The plaintiff exhibited for three weeks, and was paid his salary, but had received nothing for the hire of the accumulators.

The defendants admitted their indebtedness for two weeks only. In support of their counterclaim they alleged they had lost heavily through the neglect of the plaintiff, whose performances were a complete failure. It was his duty to provide the electric current, but he had not done so, contenting himself with the use of weak batteries obtained from the defendants, and afterwards of limelight apparatus. The result was that the illusions presented by the 'Theatrograph' were blurred and indistinct. The audience, it was said, used to hiss the performance, and many people had demanded and received back their money. The 'Theatrograph' was the 'star attraction,' and, owing to its failure, the takings of 'Wonderland (Limited)' fell in one week from £128 to £73, and in the next to £58.

Mr Gill [barrister for the plaintiff] (to Mr Woolf)—You say the 'theatrograph' was your star attraction, and that the losses of your music hall were due to its failure? Witness—The rest of the programme was mere padding.

Mr Gill (reading from a poster)—Do you call the Bear Lady padding—'A native of Africa, full grown, whose arms and legs are formed in exactly the same manner as the animal after which she is named?' Witness—Yes, the Bear Lady was padding.

Mr Gill—And the Fire Queens, 'who have appeared before the Prince of Wales, the King and Queen of Italy, and King and Queen of Portugal, who pour molten lead into their mouths, lick red-hot pokers, and remain several minutes enveloped in flames and fire?' Witness—Yes, the Fire Queens were also padding.

Mr Gill—I am not surprised that these monstrous exaggerations damaged your business. It was not the theatrograph.

Judge Meadows White held that it was the duty of the defendants to have supplied a proper light, the absence of which had caused the failures of which they complained. He gave judgment for the plaintiff, with costs, and disallowed the counter-claim.[31]

Proper illumination was an essential factor in the running of a

satisfactory performance, and even when the illuminant was reasonably good, the excessive density of most cinematograph film in those days was often the cause of the images on the screen appearing rather dim. Many of the films were printed on film stock originally intended for the Kinetoscope, which had a semi-matt surface in order to diffuse the light when the pictures were being viewed in the Kinetoscope by transmitted light. It was therefore essential that the illuminant be well tended, and the theatre kept as dark as possible. The audience was requested not to strike matches during the performance and the request was often repeated on the printed programme. One such for the Canterbury Theatre reads: 'Notice.—The Audience are particularly requested not to strike any matches whilst the Theatrograph pictures are on view' (38). The matter was also referred to in *The Era* for 25 April:

> Darkness is essential to the effective exhibition of the pictures, and a difficulty arises in this respect at a variety theatre where smoking is in progress, and where there is a frequent ignition of matches. One learns for the first time the illuminating power of a single wax vesta, when it is suddenly ignited in the darkened Alhambra during the progress of Mr Paul's exhibition.[32]

The fire hazard of cinematograph film was for the most part ignored, and it was not until the frightful tragedy of the charity bazaar fire in the Rue Jean-Goujon, Paris, in May 1897, that the matter began to receive official attention. The fire had caused the death of several notable citizens and its cause was traced to the cinematograph which was being operated by a M. Bailac. The only fire precaution which seems to have been adopted during 1896 was the use of a safety drop-shutter on the lantern to cut off the light to the projector when the film was stationary. Such legislation that existed applied to magic-lantern exhibitions and in particular to the use of compressed gas cylinders for limelight apparatus and calcium carbide used in acetylene generators.

Three events can be singled out as providing the highlights of Paul's production achievements during 1896. One was the staging of a little picture-play on the roof of the Alhambra, and the other two were the films of the Derby, and the Tour in Spain and Portugal. 'In April,' Paul recalls, 'the Alhambra manager, Mr Moul, who wisely foresaw the need for adding interest to wonder, staged on the roof a comic scene called "The Soldier's Courtship," the 80-feet film of which caused great merriment.'[33] Unfortunately, no complete copy of this film is known to exist, which is a great pity as it was the first comic picture-play produced in England. However, when it was first shown at the Alhambra at the beginning of May, *The Era* singled it out for special mention. From the description given, it is easy to visualise the simple incident, photographed in a single take, before a static camera set-up:

Programme.

This Programme is arranged under the direction of
MR. GEO. ADNEY PAYNE.

1.	OVERTURE "Arion"	*Bayman*
2.	BESSIE HINTON.	
3.	CYRUS AND MAUDE.	
4.	AGNES HAZEL.	
5.	PAT RAFFERTY.	
6.	BELLA AND BIJOU.	
7.	JACK CAMP.	
8.	IDA RENE.	
9.	THE ZANETTOS.	
10.	ADA TWIBELL.	
11.	FRED EARLE.	
12.	CORA CASSELLI.	
13.	BUNTH, RUDD AND BARNARD, First appearance in England. The success of America.	
14.	NELLY RANDALL.	

INTERVAL.

15.	WILLIE AND CHARLIE.
16.	VESTA VICTORIA.
17.	WILL EVANS.
18.	**THEATROGRAPH.** By Mr. R. W. Paul.

Notice.—The Audience are particularly requested not to strike any matches whilst the Theatrograph pictures are on view.

19.	BESSIE WENTWORTH.
20.	HARRY CHAMPION.
21.	THE FOUR BURNELLS.

GOD SAVE THE QUEEN.

Manager	Mr. FRED HOLDEN.	
Musical Director	Mr. PETER CONROY.	

THIS PROGRAMME IS SUBJECT TO ALTERATION.

NOTICE—It is the desire of the Management that the Entertainments offered at this Establishment shall be at all times absolutely free from objectionable features; they invite the co-operation of the public to this end, and will be obliged to anyone who will inform them of anything offensive upon the stage that may have escaped the notice of the Management.

The element of humour is introduced by a picture of a soldier's courtship. Mars and Venus (a befeathered Harriet) are interrupted in their 'billing and cooing' by a lady of maturer years, who insists on making a third on the seat occupied by the lovers. Protestations are in vain. Finally, the linesman, taking the law into his own hands, tips up the seat violently and throws the uninvited one to the ground. The courtship then continues.[34]

We are fortunate in having a fragment of this film reproduced as a series of paper prints in the little toy called the Filoscope (39). In principle it resembles the ordinary flicker-book, but instead of the leaves being flicked over by the thumb, they are contained in a metal case and actuated by pressure on a brass lever. The toy was invented and patented by Henry William Short (pat no 2315, 3 November 1898) and manufactured with a choice of at least twelve different subjects. The subjects were not interchangeable; each was a permanent fixture in its own metal case. The inventor, H.W. Short, or 'Harry' Short as he was more popularly known, holds a peculiar place in the history of the cinema in England, not on account of his own particular achievements in this field, but because he acted as a kind of catalyst, for he set in motion a series of events which were to lead to the beginnings of cinematographic invention in this country. It was he who introduced the two Greeks, Trajedes and Georgiades, to Paul

39 The Filoscope, invented by Henry William Short and Patented in 1898. The pictures used in the Filoscope are half-tone prints made from the original negatives of films produced by R.W. Paul in 1896. The example illustrated is *The Soldier's Courtship.* *(Barnes Museum of Cinematography)*

when they were seeking a suitable person to manufacture replicas of the Kinetoscope for them, an event which resulted in Paul's first interest in cinematography. It was also Harry Short who brought about the meeting between Paul and Birt Acres, leading to the invention of the first cinematograph camera in England—the Paul–Acres camera. It is a pity so little is at present known about him. Birt Acres, in the letter quoted on page 35, refers to Short as a constant visitor to his house, yet in a note scribbled in the margin of Talbot's *Moving Pictures* (quoted on page 21), Acres refers to him as his paid assistant. We do know that he was a friend of Paul's. He became one of Paul's cameramen and photographed the series of films made in Spain and Portugal, of which *Sea Cave Near Lisbon* became one of the most successful of early British films. Short also made use of Paul's films for providing the pictures for his Filoscope. Moreover, Short was a pioneer of cinematography in his own right. As early as 19 February 1896 he had patented a 'new or improved means for giving intermittent motion to a strip of film for taking or exhibiting photographs', whereby a sprocket-wheel was intermittently actuated by a helix or worm-gearing, part of the worm being cut away (pat no 3777). Two other patents applied for received provisional protection only and were not published. The first was a 'method for exhibiting or displaying consecutive photographs or pictures of moving objects or figures' (pat no 4166, 25 February 1896), and the other, 'improvements in or relating to the manufacture of book forms of kinetoscopes' (pat no 10276, 13 May 1896). Short will be best remembered for his invention of the Filoscope, which at one time enjoyed a considerable vogue; several examples of it are extant.[35]

The consecutive series of pictures which make up the leaves of the Filoscope are small half-tone prints made from Paul's original negatives, and faithfully reproduce each frame actual size—minus, of course, the perforated edges. The example in the Barnes Museum of Cinematography is number 11 of the series and the leaves are numbered from 1 to 176. There is no difficulty in identifying the subject as *The Soldier's Courtship*, as the fact is stated in the printed text which appears on one of the preliminary leaves. Although the leading edge is frayed, enough of the text remains to arrive at a reasonably accurate transcription. This is given below, with the missing letters or words enclosed in parentheses:

> (The) scene of which the present incident forms
> (the act)ion was enacted upon the roof of the
> (Alham)bra Theatre, London for the purpose of exhi-
> (biting) in the Cinematographe [*sic*] and remained
> (for so)me time one of the most popular sub-
> (jects.)
> (The) principals are Mr Fred Story and Miss
> (Julie S)eale, both familiar figures in the well-known
> (...)us Alhambra Ballets.

108

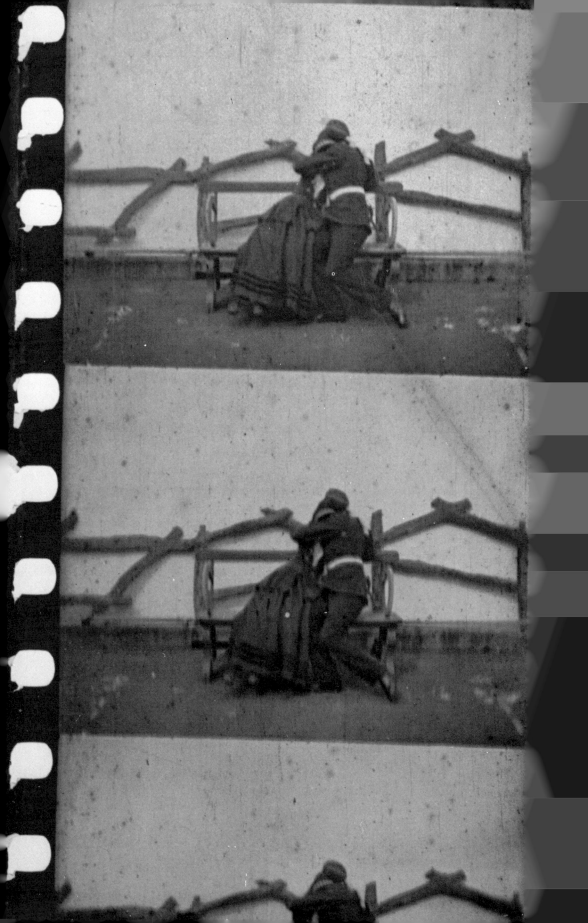

A further fragment of this film, consisting of a few frames taken from a contemporary print, is preserved in the Kodak Museum at Harrow (40).

Paul achieved his greatest success of the year with his film of the Derby (41) made doubly successful, of course, because of the popularity of the result. The film seems to have had a greater impact on English audiences than any other film of the period, and even Paul, recalling the event nearly forty years later, found it difficult to comprehend the mad enthusiasm which the film engendered:

> The climax came in June, with the presentation of the Prince's Derby, won by Persimmon. The incidents connected with its taking were fully recounted in an illustrated article in the Strand Magazine, and his Royal Highness came to see the film. It is a little difficult to-day to visualise the mad enthusiasm of the closely-packed audience, which demanded three repetitions of the film, and sang 'God Bless the Prince of Wales,' while many stood on their seats.[36]

The article in *The Strand Magazine*, to which Paul referred, gives the following account of the film's production:

> Mr Paul went down a few days before the Derby to make his arrangements. Disappointed in the use of one of the stands, he at length rented a few square yards of ground from a man on the course, whose legal rights were by no means well defined. The spot chosen was near Mr D'Arcy's stand, on the opposite side to the Grand Stand, and about 20yds. past the winning-post.
>
> At five o'clock on the morning of Derby Day, Mr Paul set out for the Downs in a wagonette, with two assistants, and the camera shown on the first page of this article [13]. As in the case of other expeditions, great care was taken to provide the necessary appliances. Among the impedimenta were a number of beams of wood, wherewith to shore up the vehicle, so as to take the weight off the springs. This was in order that the camera might have a perfectly steady platform. . . .
>
> Like a mariner whose vessel is in deadly peril, he stood with his hand on the wheel, looking anxiously along the vast expanse of green turf. Strange as it may seem, he commenced to turn the wheel eight seconds before the horses came into the 'field'; of course, I mean the field of the camera. At first the photos, were taken at the rate of about 12 a second, but during the exciting finish the pace increased to 30 and 35 a second, or over 2,000 pictures a minute. The operator slowed down somewhat when the two favourites had passed the winning-post, but the curious photos. of the crowd pouring over the course were taken at about 15 a second. It took Mr Paul exactly a minute and three-quarters to take the whole scene—the complete set of 1,280 photographs.

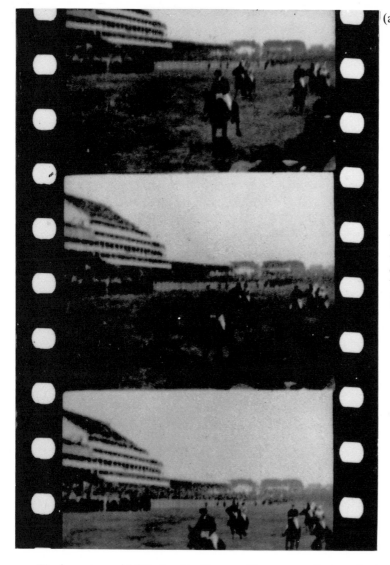

41 *The Derby*, 1896, by R.W. Paul. (a) Towards the end of the race; (b) the finish, with the crowd beginning to surge over the course. *(Science Museum, London; Crown copyright (a): National Film Archive (b)*

(b)

The inventor paid little heed to the appalling uproar that marked the finish of the race; he only turned his wheel for dear life, and for the benefit of the public who weren't there. The moment the race was over, Mr Paul whipped out the film, packed it up securely, and made a dash for Epsom Downs station, only regretting that he couldn't take the uproariously popular sequel to the race—the Prince of Wales leading in his superb horse, Persimmon. However, he had another worry on hand at the moment, for he was by no means sure that his prodigiously long negative was a photographic success.

Mr Paul, I say, left wagonette, camera, assistants, and everything else, and hurried back to London, reaching Hatton Garden at six o'clock. The assistants, by the way, re-commenced

operations on the next race. The great negative was developed and hung up to dry at one o'clock in the morning. Later on the Thursday prints were made and tested in the inventor's workshops at Saffron Hill, where a couple of projecting machines and a full-sized screen are always kept in readiness. Thus the same evening an enormous audience at the Alhambra Theatre witnessed the Prince's Derby all to themselves amidst wild enthusiasm, which all but drowned the strains of 'God Bless the Prince of Wales,' as played by the splendid orchestra. The favourites raced in once more with a tremendous stride, checking their speed only when the winning-post was passed; next were seen the laggard horses, and lastly a seemingly illimitable multitude which swarmed over the course as far as the eye could see. In short, the great race, as depicted by Mr Paul's animatographe, is a veritable marvel of modern photography and mechanism.[37]

This event marked the true beginning of the topical news film in England, for speed is the essence of any news medium. Paul was able to show the film at two major London theatres simultaneously, the Alhambra and the Canterbury, within twenty-four hours after the event, no mean feat in those days. *The Era* noted that the film at the Alhambra 'was enthusiastically encored by the loyal audience, who rejoiced to see Persimmon's victory so faithfully depicted';[38] and at the Canterbury,

Mr Holden announced from the stage that a picture of the finish of the Derby between Persimmon and St Frusquin would be shown. The scene was then displayed on the screen, and to the strains of 'God Bless the Prince of Wales' the gallant horses ran their race again, amid enthusiastic cheers and cries of 'Encore.' The picture, of course, had to be repeated, and the clever series should be successful in drawing all London to the Canterbury.[39]

During the summer of 1896, film production was getting into its stride and Paul added many new subjects to his list of films. Some of the leading entertainers were quite willing to participate, often without payment.[40] Among the notable music-hall artistes who appeared in his films at this time were G.H. Chirgwin, the white-eyed Kaffir, and David Devant and Nevil Maskelyne of the Egyptian Hall. But perhaps the most ambitious undertaking was a tour of Spain and Portugal to secure a series of films which were photographed by Paul's cameraman, Harry Short. Concerning this project, *The Era* commented:

The Interest in animated photographs can never die out so long as money and labour are expended on the obtaining of novel and original scenes. This work is in this country practically in the hands of one or two persons only, the remaining exhibitors depending on

them for their pictures. Mr Paul, owing to his extensive business in the production and exhibition of the animated photographs, is enabled to incur the great expense of photographing local scenes in all parts of the world, and has just completed a series of striking views taken throughout Spain and Portugal during a period of five weeks. These include street scenes in six of the principal towns, bull fights, national games and dances, and the finest sea and bathing scenes ever produced. These will be exhibited exclusively at Mr Paul's own engagements. During the coming winter he proposes to arrange a tour throughout Egypt, Persia, and if possible, Japan, for the purpose of obtaining new scenes. Among the provincial managers who have secured Mr Paul's Theatrograph for an additional attraction to pantomime are Messrs Henry Dundas, Machin, and Winstanley.[41]

According to Paul's catalogues, the Iberian tour resulted in a series of fourteen films, any one of which could be booked separately, but when they were first shown, on 22 October, they composed a complete programme called 'A Tour in Spain and Portugal'. This received its première at the Alhambra and was reviewed in *The Era* on 31 October:

Mr R.W. Paul's Animatographe still continues its triumphant career at the Alhambra, and its clever inventor takes care to introduce from time to time fresh pictures. The latest series, entitled 'A Tour in Spain and Portugal,' is not only entertaining but highly instructive. Street scenes in Madrid, Cadiz, Lisbon, and Seville are happily depicted. We see worshippers leaving the Church of San Salvador, Seville; and other excellent illustrations of Peninsular life include a fish market scene in Lisbon; procession of bull-fighters at Seville; the bull-fight, an exciting picture; and a cave on the coast of Galicia, one of the most beautiful realisations of the sea that we have ever witnessed. The foam-crested waves rush into the recesses of the rocks, clouds of spray are hurled into space, and the grandeur and beauty of the scene are remarkable. The new pictures are received night after night with much favour, but their popularity is not greater than some of the old series—notably the Prince's Derby and the Gordon Highlanders leaving Maryhill Barracks, Glasgow—a stirring incident that never fails to elicit the heartiest applause.[42]

By far the most successful picture of the tour proved to be *A Sea Cave Near Lisbon* (42) which the above review, more correctly, locates in Galicia. This film retained its popularity for a number of years and was still being listed in the Paul catalogues in 1903. The catalogue entry for June of that year reads:

A SEA CAVE NEAR LISBON. This famous film has never been

equalled as a portrayal of fine wave effects. It is taken from the interior of a great cave, looking over the ocean. Big waves break into the mouth of the cave and rush toward the spectator with the finest and most enthralling effect. Code word—Cave. Length 80 feet. Price 60s.[43]

Another innovation which Paul introduced was coloured films. The first was shown on 8 April 1896, and was probably the first of its kind in the world; certainly it was the first in England. Of course, it was not the result of a new photographic process, but merely entailed the meticulous hand-colouring of each frame. *The Era* for 11 April gives the following account of this novel presentation:

> Mr R.W. Paul, the inventor of the Animatographe, has at length been able to overcome the difficulties of presenting his moving pictures in colours, and by that means to add to the realism of their animation. At the Alhambra, where his invention is being nightly exhibited, he is now presenting a perfect display of actual life in motion, his Eastern dance being endowed with a brilliancy of colours that results in a very striking effect. This coloured picture was shown for the first time on Wednesday, and excited much enthusiasm.[44]

Some idea of how these first coloured films were executed is given in the interview with Paul published in *The Era* for 25 April:

> Very nearly a thousand photographs go to form one picture; and so

42 *A Sea Cave Near Lisbon*, one of a series of fourteen films comprising *A Tour in Spain and Portugal*, photographed by Harry Short for R.W. Paul and first shown at the Alhambra Theatre on 22 October 1896. *(Kodak Museum, Harrow)*

the immense difficulty of procuring coloured pictures will be apparent. The colours have to be very carefully chosen, and then every photograph has to be painted, with the aid of a magnifying glass, in identical tints. The photographs are about the size of a postage stamp; and the work of colouring them occupies nearly three weeks—greatly increasing the cost of the exhibition, of course. But on the other hand, the coloured pictures give a remarkable fillip to the entertainment, and have proved to be worth all the trouble and expense of preparation.[45]

Before long, Paul may have devised a less laborious method of colouring the films by the adoption of some sort of stencil process similar to that which was later developed with great success by the famous French firm of Pathé Frères. A report published in *The Era* for 2 May seems to imply that Paul had overcome the difficulties by adopting some form of mechanical aid:

Mr R.W. Paul, the inventor of the Animatographe, has overcome the difficulties with regard to the colouring of the animated photographs, and several of his living pictures are now shown in colour, notably the race for last year's Derby, which has to be repeated every night in response to the enthusiastic call from the audience.[46]

However, *The Optician* reported on 30 July that 'Kinescopic [*sic*] images are being coloured by female labour at an average of forty shillings per hundred pictures'.[47]

8 Independent Exhibitors of the Theatrograph

In the beginning, there were very few independent exhibitors of the Theatrograph. At most of the London theatres where the Theatrograph was operated, the performances were under the personal supervision of R.W. Paul, who supplied the projector and films at a certain fee. The fee for the first two weeks at the Alhambra, we are told, was £11 for each performance,[1] whereas that at 'Wonderland' in Whitechapel Road was £20 a week, in addition to £7 10s a week for the hire of accumulators.[2] The rates for other theatres are not known, but probably varied according to the district and the nature of the films presented. It was not until the production of more machines got under way that Paul was able to turn his attention to the

43 David Devant (1868–1941), conjurer and shadowgraphist of the Egyptian Hall, Piccadilly, the first independent exhibitor of Paul's Theatrograph. *(Barnes Museum of Cinematography)*

provinces. He appointed as his agents Tom Shaw & Co, the well-known variety agents of the Strand, who handled the provincial bookings and arranged terms.[3] However, a few independent exhibitors managed to acquire machines and films which they bought outright from Paul. The provinces thus began to share the new entertainment which in the beginning had remained the monopoly of London. At that time, Paul was almost the sole supplier of cinematographic equipment in England and it was only during the latter half of the year that other manufacturers began to enter the field.

The first independent exhibitor of Paul's Theatrograph was David Devant (43) of the Egyptian Hall. Devant was a distinguished magician who had joined the famous company of Maskelyne & Cooke[4] in 1893. Starting with a three-month contract at a small salary, he soon became so much a part of the company that he was taken into partnership and it was he who took the initiative in acquiring one of the first projectors Paul made, paying £100 for it out of his own pocket.[5] It was immediately put into the programme at 'England's Home of Mystery', where it was exhibited for the first time on 19 March 1896. The Theatrograph's debut at the Egyptian Hall thus took place two days before Paul himself gave his first public performance at Olympia. An advertisement for 21 March announced:[6]

<div align="center">

EGYPTIAN HALL
Just added to the already Attractive Programme,
a Series of
Animated Photographs,
Projected by the most Perfect Apparatus yet
constructed, and the first ever
Exhibited in this Country, Illustrating
Amusing Scenes in Real Life and
Performances of Celebrated Artistes.
Introduced by Mr Nevil Maskelyne,
who will give an interesting
explanation of the development of
this extraordinary effect from its
inception.

</div>

The programme was reviewed in *The Era* on 18 April, with the Theatrograph receiving more space than any other item on the bill. After a resumé of Nevil Maskelyne's historical introduction, the reviewer went on to describe some of the films:

Mr R.W. Paul's apparatus shows us a series of pictures of photography come to life—photography taken 'in the action.' The first moving scene announced by Mr Nevil Maskelyne is a band practice. The music of the march that one may imagine is being played is given on the pianoforte by Mr F. Cramer. A number of

Highland dancers are scarcely quick enough in their movements; but the remark does not apply to the graceful evolutions of a serpentine dancer or to the good natured boxing of a couple of trained cats. The animated pictures are likely to be very popular. The interest of Mr R.W. Paul's invention is inexhaustible, for the attraction may be revived again and again by new pictures.[7]

In the *Serpentine Dancer* and the *Boxing Cats* we recognise two Edison Kinetoscope films. Neither the *Band Practice* nor the *Highland Dancers* was included in Paul's printed lists, and the titles suggest that these also were Edison films.

The Theatrograph continued at the Egyptian Hall for several months, but in July, or thereabouts, David Devant extended his film activities by giving evening performances at private houses at a fee of 25 guineas,[8] though he still maintained his association with the former place of entertainment. He also toured Scotland with a conjuring and musical troupe, of which the Theatrograph was one of the main attractions. The films were projected by an experienced lanternist, C.W. Locke, who was well-known in the lantern world for his numerous innovations in optical projection.[9] A performance was given in Brechin on 2 October, and C.W. Locke was also booked to operate the Theatrograph at Aberdeen, Peterhead, Montrose, Inverness, Macduff, Elgin, and other places.[10]

Paul did not long remain the sole source of Devant's film supply, for an advertisement of 1 August announces a series of films 'especially made in France for Mr Devant'. The titles listed include *Wedding Party Leaving Church*, *A Bicycle Lesson*, *Gardener Burning Bad Plants*, *Railway Train*, *Roundabouts at a Fair*, and *Child Skipping and Playing with Wooden Horses in Garden*. They were described as '75ft long. Beautifully transparent, and at the same time very strong; the perforations and printing are accurate and they are guaranteed to run steadily. None of them have been shown in England, America or Germany, and they can only be obtained from Mr David Devant, 55, Ridgmount gardens, W.C.'[11] These films were probably made by Georges Méliès, since the subjects correspond with titles in the Star Film Catalogue. As the year progressed quite a number of foreign films were being imported, as is evident from contemporary advertisements.

That Devant's film activities were a success may be assumed from an advertisement in *The Era* for 28 November in which he claims to have given 793 'enormously successful' performances since 19 March, having three machines by R.W. Paul.[12] Devant's film career owed much to Paul. Besides using his apparatus, he also appeared in three of his films. These were probably made during July, and showed Devant performing three of his most celebrated acts, *The Mysterious Rabbit*, *The Egg Laying Man*, and *Objects Produced From Paper*. He also featured in another of Paul's films made a few years later called *Devant's Hand-Shadows*.

David Devant, like Felicien Trewey, was an accomplished shadowgraphist, and both seem to symbolise the close link between shadowgraphy and the cinema. According to W.J. Hilliar, another exponent of the art, 'some performers who happen to be touring with cinematograph entertainments use the light for their exhibition and go down amongst the audience, standing somewhere about a yard in front of the lens, thereby making their silhouettes appear on the sheet on the stage even larger than life'. Hilliar informs us that Devant adopted this method in his entertainments at the Egyptian Hall.[13]

David Devant later wrote his autobiography, which was published in 1931 under the title *My Magic Life.* In it the author recalled some of his early film experiences.

When Lumière brought the first exhibition of animated pictures to London in 1896, I witnessed one of the original representations at the Polytechnic. At once I saw the great possibilities of such a wonderful novelty for the Egyptian Hall.

I persuaded Mr Maskelyne and his son to accompany me to the next performance, and felt confident that after seeing the exhibition they would wish to secure it, if possible, for the Hall. To my surprise, Mr Maskelyne gave it as his opinion that it would be only a nine days' wonder, and was not worth troubling about. Although I had no interest in the matter, except the good of the firm, nothing I could say would persuade them even to ask terms or trouble further with the matter.

Personally I was convinced that here was a rare novelty, and I asked terms, intending, if a machine could be secured, to speculate on one for myself. I found that M. Trewey, who was managing the show for himself, would not sell a machine at all, and that the hire price was £100 a week. At this price the Empire had secured the London rights, and the exhibition was to open there in a few days. The performances at the Polytechnic were, it appeared, dress rehearsals, to show the pictures to managers.

One hundred pounds a week was more than I cared to risk, and I had given up the idea of being able to exploit the machine myself or of inducing Mr Maskelyne to do so, when I made a discovery that set me on the track of another cinematograph. In reading a copy of the *English Mechanic* I came across a paragraph which stated that a Mr R.W. Paul had invented a machine for projecting kinetoscopic pictures on the screen, and that this was the first machine to achieve good results.

My wife and I were about to commence dinner, but on her advice I left the meal and made my way in a hansom cab as quickly as possible to the office of the paper, and there obtained the information that Mr Paul was a scientific instrument maker with a place of business in Hatton Garden. Going to Hatton Garden, I found a gentleman just getting into a cab loaded with boxes. Here was the inventor I was in search of.

119

I quickly made my business known and asked for particulars of the machine. Mr Paul told me that he was just going to show the instrument at the Olympia at a side-show, and invited me to accompany him there and see it. My time was limited, as I had to be back at the Egyptian Hall for the evening show, but afterwards would have been too late. I decided to go.

During the journey I gathered from Mr Paul that he had made the machine and had shown it to some friends some time previously, but looked upon it as a kind of plaything, and had put it away again until recently. He quoted me a price for the machine, and promised me the first one if I wished, also a commission on any further machines I might be the means of selling. The price for each was to be £100, less commission.

After seeing the performance I asked for an option on buying the machine until the following day, intending to offer it to Mr Maskelyne. Surely, I thought, he would be glad to take such a chance, but I found that he would not risk even £100, so convinced was he that there was nothing in it.

I then proposed that if he would give me a salary for the novelty and try it, I would buy the machine myself and risk the result. He agreed to give me £5 a week for a month, but impressed upon me that I must not be disappointed if, after that time, the contract ended. I do not remember how long the original machine was shown, but it was for years, not months, and we had the satisfaction of showing animated pictures, as Mr Maskelyne called them, two days after the Lumière Cinematograph [sic] was first presented at the Empire, so that we were the second house in London to show the novelty, and the hall was packed to capacity in consequence.

I soon bought a second machine and fitted it up for private performances with limelight. I was, I believe, the first to do this. I received £25 for each performance for some time. It would be a long, long story to recount all that was done with these pictures, as difficulties in obtaining good results were at the time very great. For instance, for one winter I journeyed every week-end to Paris in search of films. I left by the night-boat after the show and returned by the Sunday night-boat.

M. Méliès, of the Theatre Robert Houdin, bought several machines from me and eventually started a business of manufacturing films and machines, which he carried on for some years. For a time I was his sole agent in Great Britain for the sale of films and cameras, and soon I had to decide between giving up conjuring or selling these goods. I gave up the commission agent's business after a most successful and remunerative run and stuck to showmanship only. During this period I sold machines to Carl Hertz, who was the first to show pictures in Africa. Victor Andre was also one of my customers, as well as many other showmen all over the country.[14]

120

As with all showmen with a story to tell, the facts are likely to get a little lost in the telling. So if Devant's account is not strictly accurate, he is doing no more than manipulating the facts as if they provided further subjects for his legerdemain. A top hat is still a top hat even if it has got a rabbit inside, and David Devant's account is not all that far from the truth. His connections with Georges Méliès probably began in July 1896, since an advertisement of Devant's in *The Era* for 1 August lists several titles which appear to be Méliès films.[15] His dealing in French films during the period under review is firmly established and there is no reason to doubt his hasty cross-Channel quest for new subjects. We have no evidence that Devant sold machines to Carl Hertz during 1896, and this may refer to a later date.

As already noted, David Devant appeared in several films for Paul, in which he is shown performing some of his well-known acts. The autobiography relates some interesting particulars concerning his first appearance:

The first animated picture ever taken of a performer was shot by R.W. Paul on the roof of the Alhambra Theatre. It was one of myself doing a short trick with rabbits. I produced one from an opera hat, then made it into twins, all alive and kicking. This picture was reproduced in a little device called a Filiscope [*sic*]. The hundreds of pictures which go to make up a film of a cinematograph were printed on paper in the form of a little book, the leaves of which were turned one at a time by a simple mechanical device, the rapidly moving leaves giving the effect of movement. This pocket cinematograph sold by the million.[16]

Devant's activities as a film-maker are only briefly mentioned in his book, and it would appear that his film production was far from prolific. Unfortunately, he does not state a date when he first commenced turning his own films, but an account of his abortive attempt to film Queen Victoria's Diamond Jubilee Procession in 1897 points to the fact that he was still little more than a novice at this time. However, the following description of the successful filming of a garden fête at Chelsea Hospital may refer to 1896 and is worth quoting:

I had never studied photography, so it is not surprising that I had some rather curious adventures with the pictures. The first time I uncapped a lens to take a photograph was at a garden fête at Chelsea Hospital, at which were present nearly the whole Royal Family, with the exception of Queen Victoria. It was more by luck than judgment that the negatives turned out to be excellent and were shown all over the world. Miss Knollys wrote to me on behalf of the Princess of Wales, afterwards Queen Alexandra, asking for a copy of the picture. I sent Her Royal Highness the roll of film, and often wonder what she did with it. What made this incident more

44 Carl Hertz, the American magician, an early exhibitor of Paul's Theatrograph. He was the first to give a film performance at sea, on board SS *Norman* in April 1896, and the first to show films in South Africa and Australia. The apparatus used was Paul's Theatrograph No 2, Mark 1. *(British Museum)*

extraordinary was that the camera had only arrived from France on the very morning of the day on which I took this lucky picture.[17]

The second independent exhibitor to acquire one of Paul's projectors was another famous magician of the day named Carl Hertz— pseudonym of Louis Morgenstein (44). The story of how he practically snatched the machine from under Paul's nose is amusingly told in his autobiography, *A Modern Mystery Merchant*:

The cinematograph had lately been shown, for the first time in London, at the Polytechnic, by Trewey, formerly a well-known juggler and a relative of the Lumières, who were one of the first makers of cinematograph machines. It was subsequently transferred to the Empire Theatre, where it was shown at matinees only. Shortly afterwards an English machine, made by a man named Paul, was exhibited at the Alhambra. At this time these

122

were the only two types of machine on the market.

It occurred to me that it would be good speculation if I could get one of these machines to take to South Africa with me and introduce into my entertainment. I accordingly went to see Trewey, whom I knew very well, to try either to purchase or hire a machine, but he would not let me have one. So I went to see Paul, in the hope that he would prove more accomdating [sic].

Paul agreed to sell me a machine for £50, but said that he could not deliver it for two or three months. I told him that I was leaving for South Africa on the following Saturday—it was then Wednesday—and that I would like to take the machine with me. But he said that he only had two machines, and that these were on the stage at the Alhambra, where he was fulfilling a six months' engagement at £100 a week. I asked him whether he would not let me have one of these machines, to which he replied that that was impossible, as he had to have a spare machine in readiness, in case the other got out of order. I offered him £80, but he would not listen to me, and I went away much disappointed.

The next night I called to see him again, took him out to my club to supper and did all I could to induce him to sell me one of his machines. But it was no use; he would not do so. However, on the Friday night, the night before I was to sail for South Africa, I determined to make a last attempt, and accordingly took him out to supper again and offered him £100 for one of his machines. He repeated, however, that he could not risk parting with one; he must have a machine in reserve in case of accidents.

'Well,' said I, 'you had better take me over to the Alhambra and explain to me the working of the machine and all about it, so that I shall understand how to use it when one is sent out to me.'

So we went back to the Alhambra, where he took me on to the stage and showed me the whole working of the machine—how to fix the films in and everything concerning it. We were there for over an hour, during which I kept on pressing him to let me have one of the machines. Finally, I said:—

'Look here! I am going to take one of these machines with me now.'

With that, I took out £100 in notes, put them into his hand, got a screw-driver, and almost before he knew it, I had one of the machines unscrewed from the floor of the stage and on to a four-wheeler.

The next day I sailed for South Africa on the *Norman* with the first cinematograph which had ever left England. . . .[18]

Much of this smacks of a typical showmanship anecdote, of course, but that the story is substantially true is borne out by the following, which appeared in the music-hall gossip column of *The Era* for Saturday, 28 March:

Mr Carl Hertz, who has just arrived from America, sails to-day on board the Norman with his contingent of artistes engaged by Messrs Hyman and Alexander for Johannesburg. Mr Hertz takes out with him an Animatographe [ie the Theatrograph], the invention of Mr R.W. Paul, of Hatton Garden, an apparatus for exhibiting 'Living Photographs' similar to that now to be seen at the Alhambra.[19]

It has already been established that the projector Hertz took with him was Paul's second Theatrograph (Mark 1) and the notice in The Era just quoted thus confirms that the first of these models was ready for operation by 28 March.

On the voyage out, Hertz gave a performance on board the SS Norman with his newly acquired Theatrograph, which was the first time that a film had been shown at sea.[20] In Johannesburg he held a preview at the Empire Theatre of Varieties on 9 May, and two days later gave the first public screen performance of moving pictures ever to be held in South Africa. The films shown included the familiar Highland Dancers, Street Scenes in London, A Trilby Dance, A Military Parade, and the famous Soldier's Courtship.[21]

Hertz visited various places in South Africa and then went on to Australia. His Australian visit is mentioned in The Era for 31 October:

When Chirgwin[22] gets to Melbourne he will be surprised to find that Carl Hertz has been showing him as an animated photograph—an excellent form of advertisement—to the Antipodeans. Mr Paul, the well-known inventor and practical worker of animated photography has supplied Carl Hertz with the Chirgwin film.[23]

There can be little doubt that the Theatrograph (Model 2, Mark 1) which Carl Hertz took with him on his foreign tour was the first English machine to be exhibited abroad, for it is unlikely that Paul's first model, of which so few were made, was ever exported. In fact, the only independent exhibitor known to have used that model was David Devant, the others being exhibited under Paul's personal supervision.

It is not at present known how many of Paul's second model were exported, but the Dutch historian of the cinema, Adriaan Briels, in his admirable work De Intocht van de Levende Photographie in Amsterdam (The Introduction of 'Living Photography' in the City of Amsterdam), records a showing of Paul's 'Theatrographe' sometime in 1896, at 17 Vijzelstraat, for which two original printed programmes or handbills have survived. These list the titles of fourteen films, for which Mr Briels has supplied the following English translations. I have added the original titles, so far as they can be ascertained, in parentheses:

124

First Programme
1 The Sea at Scheveningen (Rough Sea at Ramsgate)
2 The Bookmakers on the Square of the Courses (The Arrest of a Bookmaker)
3 The Blacksmiths in their Workshop (The Engineers' Shop at Nelson Dock)
4 On Board the Mail-Steamer 'Queen Wilhelmina' (On the Calais Steamboat)
5 The Westminster Bridge in London (Westminster Bridge)
6 The Conjurer; conjures: Rabbits, handkerchiefs etc., out of a hat (David Devant)
7 Street-artists on a Fair (Hampstead Heath)
8 Arrival of a Train (Arrival of the Paris Express at Calais)
Second Programme
1 The Sea at Scheveningen (Rough Sea at Ramsgate)
2 After a Boating-Excursion on the Beach (On Brighton Beach)
3 Arrestation of a Bookmaker (The Arrest of a Bookmaker)
4 The Westminster Bridge in London (Westminster Bridge)
5 A Negro-Clown (Chirgwin, the White-eyed Kaffir)
6 Arrival of a Train (Arrival of the Paris Express at Calais)

The first English films to be seen outside England were probably the Paul–Acres films made in 1895 and exhibited in Kinetoscopes. The first time such films were seen on the screen abroad was in America. The film of the 1895 Derby, for example, was shown on 4 April 1896 at a special press show given at the Edison plant in West Orange, to launch the new Armat–Edison Vitascope projector,[24] and the popular film *Rough Sea at Dover,* was included in the programme at Coster and Bial's Music Hall, New York, when the Vitascope received its Broadway debut on 23 April.[25] Here the scene was referred to as the Jersey coast, and the enthusiasm with which it was received by the audience is described by Thomas Armat, the designer of the Edison-made machine:

All the scenes shown, with one exception, were what might be called vaudeville turns, or stage subjects. A crowded audience applauded each of the scenes with great enthusiasm. The one exception to the stage scenes was an outdoor scene that Raff and Gammon[26] had succeeded in getting from Robert Paul, who by that date was experimenting with motion pictures in England. This scene was of storm-tossed waves breaking over a pier on the beach at Dover, England—a scene that was totally unlike anything an audience had ever before seen in a theater. When it was thrown upon the screen the house went wild; there were calls from all over the house for 'Edison', 'Edison', 'speech', 'speech'.[27]

David Devant and Carl Hertz were already familiar names to the general public before either became associated with Paul's

125

Theatrograph, and the new 'animated photographs' played only an incidental role in their success as prestidigitators. Not so the vast majority of exhibitors of Paul's machine. Most were mere operators, who have left little or no trace of their careers save for the advertisements they inserted in the local papers or the theatrical press. It would be an impossible task to trace every exhibitor of the Theatrograph, even for the year 1896, or to list every theatre where the Theatrograph was exhibited during that period. It will suffice to select a few typical examples culled from the pages of *The Era*, and to append a list of those theatres where we know, from sources readily available to us, that the Theatrograph was exhibited.

WILLIAM DOWER. Appears to have been a typical itinerant exhibitor who travelled as far afield as Liverpool and Wales, although his permanent address in October is given as 90 Vauxhall Bridge Road, London.[28] On 24 August he began a week's engagement at the Palace Theatre, New Brighton.[29] In October he was booked at the Public Hall, Morristown, Wales.[30] An advertisement for June offers for sale, cheap, Theatrograph, with films etc, with an address at 3 Fraser Street, Liverpool.[31] Since his later advertisements do not offer apparatus for sale, we may presume that he was selling off an old machine which he had replaced with a newer model, and was not a regular dealer in cinematographic equipment.

J. & F. DOWNEY. Advertised as 'Downey's Living Pictures'. Permanent address: 17 and 19 Elden Street, South Shields.[32] One of the Downeys was the son of the famous photographer, whose studio 'W. & D. Downey' of 61 Ebury Street, London, had an international reputation for portrait photography and were official photographers to Queen Victoria and other members of the royal family. The South Shields concern seems to have been little known outside its own area, until Downey junior, in association with his more illustrious father, gave an exhibition of films before Queen Victoria at Windsor Castle on 23 November 1896.[33] The programme was shared between two machines, Downey junior operating Paul's Theatrograph and his father a special machine devised by an assistant of the firm named Harrison.[34] Downey senior presented a series of films of Queen Victoria and other royal personages, whereas his son showed ten films supplied by R.W. Paul.[35] The royal films and the performance itself are more fully described in Chapter 11. The films supplied by Paul comprised numbers 5 to 14 on the printed programme (45) and included the following subjects: 5. The Bathers; 6. The Costermonger; 7. Brighton Beach; 8. Coronation Scene—Russia; 9. Czar's Procession—Paris; 10. Place de la Republique—Paris; 11. Hyde Park Bicycle Scene; 12. Skirt Dancer; 13. Costume Race; 14. The Derby. Paul naturally made capital out of this performance, and his advertisements proudly announced: 'Exhibited before H.M. the Queen at Windsor Castle.'[36]

JAMES FIONI. Active in the north of England. His address is given as 56 Gilkes Street, Middlesbrough. Performances are recorded at

the Empire Theatre, Middlesbrough, from 19 July for three weeks; the Grand Theatre, Stockton, from 10 August for three weeks; the Empire Theatre, Paisley, from 31 August;[37] and the Empire Theatre, Barrow in Furness, from 21 September.[38] The duration of the last two engagements has not been determined, but was probably for three weeks in each case. Fioni employed as operator a Mr P. Shrapnel, who was in charge of the projection at the various performances. An advertisement for August announces:

Wanted known, Paul's Theatrograph, under the management of

WINDSOR CASTLE,

NOVEMBER 23rd, 1896.

MESSRS. W. & D. DOWNEY'S ANIMATED PHOTOGRAPHS, ASSISTED BY MESSRS. J. & F. DOWNEY, OF SOUTH SHIELDS.

1 ARRIVAL OF HER MAJESTY THE QUEEN AND T.I.M.'S THE EMPEROR AND EMPRESS OF RUSSIA AT MAR LODGE, OCTOBER, 1896

2 HER MAJESTY THE QUEEN AND T.I.M.'S THE EMPEROR AND EMPRESS OF RUSSIA, T.R.H.'S THE DUKE AND DUCHESS OF CONNAUGHT, H.R.H. PRINCESS HENRY OF BATTENBERG AND ROYAL CHILDREN AT BALMORAL.

3 DITTO DITTO

4 A FEW LANTERN SLIDES FROM SOME OF THE OLD ROYAL PHOTOGRAPHS AND THE MODERN ART STUDIES

5 THE BATHERS.

6 THE COSTERMONGER.

7 BRIGHTON BEACH.

8 CORONATION SCENE — RUSSIA

9 CZAR'S PROCESSION — PARIS.

10 PLACE DE LA RÉPUBLIQUE — PARIS

11 HYDE PARK BICYCLE SCENE.

12 SKIRT DANCER.

13 COSTUME RACE.

14 THE DERBY.

45 Programme of the Royal Command Film Performance at Windsor Castle, 23 November 1896. *(British Museum)*

127

Mr P. Shrapnel, is a gigantic success with all the Alhambra successes, including the 'Prince's Derby,' 'Royal Wedding,' 'Chirgwin,' 'Blackfriars Bridge,' 'Henley Regatta,' &c. No blurred pictures. No fiascos. Managers requiring a draw ought to book this marvellous invention . . .[39]

HERCAT. Popular entertainer, ventriloquist, conjurer, etc. Advertised as 'Hercat's Life-endowed Photographs', or 'Hercat's Cinematographe'. Does not appear to have included moving pictures in his entertainments until September, but thereafter his engagements were numerous, mostly at seaside concert parties and the like. An advertisement for October reads:

Open for Pantomime. The Cinematographe.—Hercat's Life-endowed Photographs. The latest and best instrument, combining all recent improvements. New films; also Hercat's Illusory and Ventriloquial Entertainment. Great success at Gloucester, Yeovil, Bournemouth, Eastbourne, and Brighton. First vacant date Dec. 14th. Address, Hercat, care 'The Era;' or, Valentine's Agency.[40]

On 15 October he appeared before the Scientific Society of Gloucester and 'presented his cinematographe, delivering an interesting lecture on the subject of new photography, which was loudly applauded'.[41]

The Theatrograph did not reach the provinces until May,[42] by which time production of the machine had increased sufficiently to permit a limited number of performances to take place outside London. The first provincial town to receive the Theatrograph was probably Brighton, where it was exhibited at the Victoria Hall. But the indications are that these performances were directly under Paul's control and that no independent exhibitor was involved. In his advertisements at this time Paul lists the Victoria Hall with the London theatres where his Theatrograph was being shown,[43] and it therefore seems probable that his supervision extended to Brighton. From July onwards, more and more operators of Paul's Theatrograph entered the field, and some of the theatres and halls where they gave performances are listed below. The dates alongside indicate the commencement of the engagement.

May		Paddington, Liverpool[44]
July	19	Empire, Middlesbrough[45]
August	10	Grand, Stockton[46]
	24	Palace, New Brighton[47]
	31	Empire, Paisley[48]
September	21	Empire, Barrow in Furness[49]
		Rowley's Empire, Huddersfield[50]
October		Public Hall, Morristown, Wales[51]
	12	National Palace, Croydon[52]

	26	Empire, Cardiff (re-engagement)[53]
		Empire, Northampton (re-engagement)[54]
		Empire, Middlesbrough (re-engagement)[55]
November	23	Empire, Swansea[56]
December	1	Assembly Rooms, Cheltenham[57]
	4	Assembly Rooms, Cheltenham[58]
	7	Royal, Halifax[59]
		Royal, Bournemouth[60]
		Grand, Bolton[61]
		Oxford, Middlesbrough[62]
		Palace, Plymouth[63]
	14	Palace, Plymouth[64]
		Empire, Burnley (fifth visit)[65]
		Assembly Rooms, Cheltenham (re-engagement)[66]

9 Other Inventors and Exhibitors

On 6 April 1896 the Royal Aquarium, Westminster, introduced into its programme for the first time a series of films projected by a new machine called the Kinematograph. Prior to that date, the only films which had been publicly exhibited in England were those shown at the Marlborough Hall and Empire Theatre by the Cinématographe-Lumière, and those at the Egyptian Hall, Olympia and the Alhambra by Paul's Theatrograph. The Kinematograph was thus the third film projector to be publicly exhibited in this country. It was patented by John Henry Rigg and Ernest Othon Kumberg on 27 April 1896 (pat no 6731).

Rigg was an electrical engineer of 43 Skinner Lane, Leeds, and Kumberg, according to the patent specification, a French civil engineer of 23 Brook Street, Holborn, London. The famous film pioneer Charles Pathé mentions E.O. Kumberg in his autobiography in connection with four phonographs which he bought from him in 1894 for 3,000 francs,[1] a transaction, incidentally, which paved the way for Pathé's future success. Kumberg's address as stated in the patent turns out to be the same as that for the Anglo-Continental Phonograph Company and so connects him with that firm. Thus, besides supplying more precise information concerning the source of Pathé's supply of phonographs, it also establishes that it was this firm which was responsible for the commercial exploitation of the **Kinematograph projector**, a fact which is later confirmed by the *Optical Magic Lantern Journal* for February 1897, where it is stated that 'the firm that controls the Kinematograph which is in daily use at the Westminster Aquarium, is the Anglo-Continental Phonograph Company of Brook Street, E.C.'[2]

The Kinematograph's debut at the Royal Aquarium, as we have said, took place on 6 April, and the films were introduced by the manager, Charles Le May.[3] The occasion does not seem to have made much impression on the trade press, although the pictures were advertised as the 'most exquisite and charmingly beautiful Living Pictures ever witnessed'.[4] Perhaps the exhibition was not up to the standard already set by Lumière and Paul. However, by August there seems to have been an improvement, as the following review in *The Era* clearly indicates:

> The living pictures at the Aquarium have improved both in number and quality, no less than seventeen new tableaux having been added to the list since whitsuntide. The variety of the subjects is striking, the classic, the domestic, the humorous, and the patriotic being all represented in the beautiful series of thirty living pictures now offered to the patrons of the Aquarium.[5]

The 'living pictures' were exhibited twice daily in the theatre, and

continued as a feature of the Aquarium's entertainment for the remainder of the year, with an occasional change of programme.

The general design of the Kinematograph is not indicated in the patent specification, but an illustration of its appearance is provided by the *Optical Magic Lantern Journal*, which shows the projector in its commercial form (46).[6] A somewhat imperfect example of the machine may be seen at the Science Museum, South Kensington (49),[7] where until now it has remained unidentified. The museum card informs us that it was used by C. Conrad,[8] who presumably was responsible for the altered appearance of its present state, which at first glance makes it almost unrecognisable. A front wooden lens panel and an objective lens have been added and the original electric motor has been replaced by a crank-wheel.

In spite of the fact that Rigg's Kinematograph was the third machine to have been exhibited in this country, it does not appear to have been available on the open market until later in the year. The earliest description of the actual apparatus which I have been able to find, apart from the patent specification, is the following paragraph in *The Optician* for September 1896:

A Kinetograph

Certain details in the construction of kinetographic apparatus form the subject of an invention due to Messrs J.H. Rigg, of 43 Skinner Lane, Leeds, and E.O. Kamberg [*sic*], of 23, Brooke Street, Holborn, E.C. To prevent undue slackness of the film a self-acting

46 Rigg's Kinematograph, patented by John Henry Rigg and Ernest Othon Kumberg in 1896. (*Barnes Museum of Cinematography*)

(spring) brake is applied to the winding-off roller. This brake is
released by, and proportionately to, the pull upon kinetograph
ribbon. In order that the pull upon the film may be an intermittent
one the sprocket wheel engaging with the said film is itself geared
with a worm-wheel of peculiar construction. The teeth or leaves of
this worm-wheel are skewed throughout a small portion only of its
circumference. Throughout a major portion of the circumference
the teeth of the 'worm-wheel' lie in planes normal to its axis.[9]

The patent specification is headed 'Improvements in
Kinematographs, Kinetographs, and like Apparatus', and describes
and illustrates only the salient components to which the patent
applies. These include two alternative braking systems which may be
applied to the top film spool to prevent it from unwinding more than
the necessary amount; also a method of securing the spool on the
spindle by the use of a pivoted catch which slots into a circular recess
on the end of the spindle; and most important of all, the method by
which the intermittent movement is applied to the sprocket-wheel by
the 'drunken screw', or worm-gear shown in the figure (47). The wheel
K is caused to move intermittently by means of the drunken screw L
in which the angular portions of the teeth or grooves occupy only a
very small portion of the circumference, the rest of the circumference
having the grooves continued as rings at right angles to the shaft; or
as Hopwood succinctly puts it, 'if the wheel L be rotated so as to act
on K, the latter will not be moved while all the grooves in L are
straight. But so soon as the inclined part of the screw comes into
action, K will be forced round some distance from one side to the
other, and will then be held steady while the straight part again
passes.'[10] An alternative arrangement is also described, whereby the
teeth in K are irregular and the worm-gear L takes the form shown in
the figure (48), where the plain ring is of larger diameter than the
portion of the worm or drunken screw shown at M.

The projector, as manufactured, was quite simple in design. The
short roll of film was enclosed in the circular box at the top of the
apparatus (46), and not mounted in the way originally described in
the patent. A single sprocket-wheel, intermittently driven by the
drunken screw just described, fed the film through the machine and
into some convenient receptacle, since no take-up spool was
provided. The motive power was a 4-volt electric motor situated on

the baseboard. The illuminant was housed in a standard optical lantern provided with a light cut-off for safety purposes. At the Westminster Aquarium the illuminant comprised a 20-amp arc lamp, although the projector could equally well be used with limelight.[11]

The Kinematograph was manufactured in Leeds by J.H. Rigg, the co-patentee, who was also a manufacturer of telephones, phonographs and other scientific instruments.[12] He also converted the projector for use as a camera, with which he was able to make his own films. Unfortunately, at present little is known about his film production, but one of his films, of which there is a written record, was taken during a severe frost in the winter of 1896–7 and depicted a group of skaters; he made other films especially for use in his 'Kinetophone', an early audio-visual device whereby the Kinematograph was synchronised with a loud-speaking phonograph which provided suitable words or music to the accompanying films.[13] A short account of his method of synchronisation was published in *The Photogram*:

> The Kinetophone.—J.H. Rigg whose business in phonographs and their records is enormous, has completed an arrangement by which he runs a kinetoscope [*sic*] synchronously with a phonograph, and has prepared a large number of Kinetograms [*films*] of popular subjects taken at the same time as the phonographic records.[14]

Hitherto, Rigg has remained an entirely forgotten pioneer of the British film, both as an inventor and as a film-maker. At one time his business interests must have been quite considerable, for towards the end of 1896 he opened an agency at 186 Chestnut Street, Philadelphia.[15]

The Kinematograph seems to have been reasonably successful, and according to a report in *The Photogram* was used in many of the largest halls in the provinces.[16] It also became the subject of a dispute concerning patent rights which was one of the first of its kind involving a cinematographic invention to arise in Great Britain. George Richards of London patented[17] a projector in which the film was driven by two sprocket-wheels, situated above and below the gate aperture, both of which were rotated by a gear intermittently actuated by a drunken screw device similar to that already employed in the Kinematograph, and covered by the patent issued to J.H. Rigg. The dispute was taken before the Comptroller-General of patents, who settled the matter in Rigg's favour.[18]

49 Rigg's Kinematograph, 1896, the projector used by Professor C. Conrad. The front lens panel and objective have been added, and the electric motor has been replaced by a crank-wheel. Below: Detail of the intermittent mechanism. *(Science Museum, London; Crown copyright)*

In July another machine was patented which also employed a variable screw movement somewhat similar to that used in Rigg's Kinematograph, but in this case the screw was reduced to a single thread which interacted with a star-wheel as shown in the figure (50).

The worm-gear was provided with a single thread which was helical for one-third of its circumference and straight, or in the same plane, for the remaining two-thirds. Consequently, when the worm-gear revolved, the star-wheel was given motion only when the helical portion of the thread engaged it. However, as soon as the straight portion of the thread came round, the star-wheel ceased to revolve and remained in a locked position for a short period until the helical part of the thread again returned.

The apparatus was invented by an engineer named William Routledge of 46 Low Friar Street, Newcastle-upon-Tyne, and patented on 21 July 1896 (pat no 16080). The patent states that it could also be adapted for use as a camera. Also associated with the patent were two merchants, Augustus Rosenberg and William Mc-Donald, who were responsible for its commercial exploitation and traded as A. Rosenberg & Co, with an address at Featherstone Chambers,

50 The intermittent mechanism of Rosenberg's Cinematograph, or Kineoptograph, patented in 1896 by William Routledge, A. Rosenberg and William McDonald.

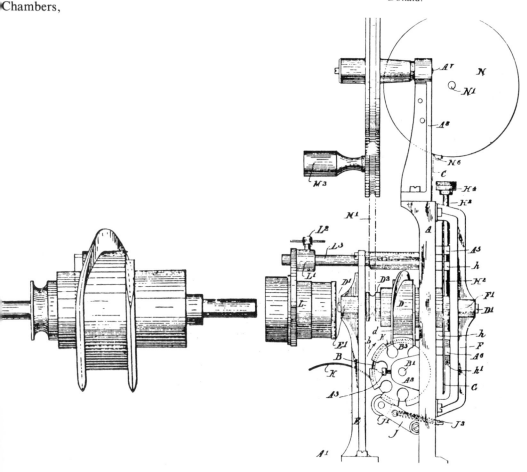

Collingwood Street, Newcastle. The apparatus was given the name of 'Kineoptograph' (51),[19] but was more often referred to as Rosenberg's Cinematograph. The price of the projector was £35 for the complete outfit.[20] It proved to be a popular machine and remained on the market for several years during which period it seems to have undergone only slight modification. The earlier models seem to have been manufactured in Newcastle, but by 1898 the maker is given as F. Brown of 13 Gate Street, Holborn, London,[21] a noted manufacturer

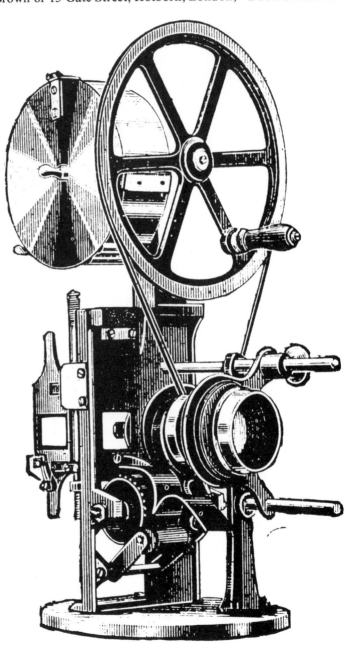

51 Rosenberg's Cinematograph, or Kineoptograph, 1896. *(Barnes Museum of Cinematography)*

of limelight apparatus who specialised in illuminants for optical lanterns and cinematographs.[22] In *The Era* for 25 July 1896 A. Rosenberg & Co advertised the projector under the name of Kineoptograph: 'For sale. Kineoptograph. Fully protected. A perfect machine at last. . . . &c.'[23] An advertisement in the same paper for 5 December, however, refers to the apparatus as 'Rosenberg's Improved Cinematograph'.[24] It is also advertised as such by a Mr Alf Fildes of Greenodd, Ulverstone, in the previous month's issue.[25]

52 Advertisement for Wrench's Cinematograph, August 1896. *(Barnes Museum of Cinematography)*

NOW READY. TRADE **MARK.** **NOW READY.**

CINEMATOGRAPH

FOR SHOWING

Animated Photographs on the Screen.

(PATENT APPLIED FOR.)

Tne following are some of the *SPECIAL FEATURES* of this Instrument :—

NO VIBRATION of the Picture on the Screen, even when running at the highest speed.

Noise reduced to a minimum. Ordinary Kinetoscope Films used.

The Working is SO PERFECT that the Film is NEVER TORN, NO MATTER HOW MANY TIMES USED.

The Instrument is also a Complete Optical Lantern of best make and finish, in which ordinary Photographic Slides can be projected on the screen (the same size as the picture given by the Film) during the intervals while a new Film is being put in position.

It is also fitted with an extra Double Combination Achromatic Objective of 6 inch equivalent focus for use when it is required as an Optical Lantern only.

PRICE OF INSTRUMENT **COMPLETE,** as above, with Patent Double Sliding Carrier Frame, Glass Alum Trough, etc., **£36.** fitted with a very Powerful Mixed Gas Jet. All packed in Case and ready for use. *PRICES OF FILMS ON APPLICATION.*

The above can be purchased through any Dealer in Optical Lanterns, and are supplied Wholesale to the Trade only by:

TRADE MARK.

Telegraphic Address: "OPTIGRAPH. LONDON."

The intermittent movement of the Rosenberg Cinematograph was not so very different from a movement previously patented by Henry William Short, the inventor of the Filoscope and one-time cameraman to R.W. Paul. Short's suggested camera/projector combination does not appear to have reached the production stage, but his patent of 19 February 1896 (pat no 3777) describes an apparatus whereby the sprocket-wheel is intermittently driven by a helix engaging with a toothed wheel, this latter being carried on the same spindle as the sprocket and the whole so arranged that there is an interval between the time of contact of the two ends of the helix with the projections of the toothed wheel. Perhaps the fault of the mechanism was that it failed to hold the toothed wheel firmly enough in its stationary position and so allowed a certain amount of play in the sprocket-wheel. Another fault appears to have been in the design of the shutter, which consisted of a disc with six equidistant apertures; an arrangement, I would have thought, likely to cause excessive loss of light. Although the patent did not apparently receive any practical application, it is none the less interesting since it was the second English patent to cover an apparatus using a perforated film intermittently driven, the first being the one filed by Birt Acres on 27 May 1895 for his Kinetic camera.

At the end of July, Messrs J. Wrench & Son, wholesale opticians of 50 Gray's Inn Road, London, announced their Cinematograph projector to the trade with a full-page advertisement in *The Optician*.[26] A similar advertisement also appeared in the Almanac of the *Optical Magic Lantern Journal*, published in August (52).[27] This firm, established as long ago as 1816, was already well known as a manufacturer of optical lanterns and accessories, and it was to be expected that cinematographic equipment would eventually be included. Rumours to the effect had circulated the previous month, when it was reported that William Friese-Greene's patent had been acquired. Both the *Photographic News* and *The Optician*[28] printed statements to that effect, as did the *Optical Magic Lantern Journal*:

> Messrs Wrench & Son have acquired the patents rights of Mr Friese Green, in connection with all the apparatus invented by him for making and producing so-called animated photographs on the screen. The apparatus is exceedingly simple in make, and will probably soon be put upon the market to sell for a few pounds.[29]

It transpired that the matter concerning the acquisition of the Friese-Greene patents was completely unfounded and Friese-Greene himself promptly denied the reports in a communication to the photographic press. The following letter is one he sent to the *Optical Magic Lantern Journal*:[30]

> Dear Sir,—My attention having been drawn to a paragraph in your issue June, 1896, in which you say I have disposed of my

patent rights for producing so-called animated photographs upon a screen, I should like you to mention that I have not disposed of my 1893 patent, which is the only completed one I hold, to anyone.—Thanking you in anticipation.

> Yours truly,
> W. Friese-Greene.

39 King's-road, Chelsea.
June 9th, 1896.

The *Optical Magic Lantern Journal* was partly to blame for these false reports, for it was this journal's consistent campaign on Friese-Greene's behalf which no doubt contributed to the notion that all cinematographic invention rested with the Friese-Greene patent. The Birt Acres letter printed the previous March in the *British Journal of Photography* and quoted on page 33, also helped to propagate the myth. Acres was nursing a personal animosity towards Paul and was determined to deprive him of any credit for the invention of the Paul–Acres camera. He thus preferred to give the credit for the whole invention to someone else rather than acknowledge Paul's part in the invention. In this feeble attempt to discredit Paul he dragged in the name of Friese-Greene as being the most acceptable.

The Wrench Cinematograph was patented on 12 August 1896 by Alfred Wrench (pat no 17881), under the heading 'Improvements in Cinematographs'. The design of the projector was quite novel and employed a complicated but efficient intermittent mechanism consisting of a double ratchet and pawl device. The shutter was of the segmented barrel variety somewhat similar to that already used in Paul's Theatrograph, and was situated behind the gate directly in the path of the lantern condenser. The apparatus appeared on the market almost immediately the patent had been applied for, and was offered for sale at £36,[31] a price which was considered at the time to be remarkably low; so much so that it was commented upon in the *Optical Magic Lantern Journal*:

CINEMATOGRAPHS AT MODERATE PRICE.—Those who have hitherto purchased instruments of the Cinematograph class for exhibiting so-called living photographs, have been called on to pay something like one hundred pounds for the outfit.—Prices of this kind have received their death blow, for Messrs. Wrench & Son are now supplying the trade with an outfit to sell at £36.—It can be used in conjunction with any modern make of lantern.[32]

According to a later issue of the *Journal*, the apparatus met with an immediate success and a number were already being exhibited in the provinces with good financial returns.[33] The *Journal*'s Almanac described it as being 'simple, effective and enjoys great popularity'.[34] The *Journal*'s October issue carried a full description of the apparatus, with two illustrations which are reproduced in the present

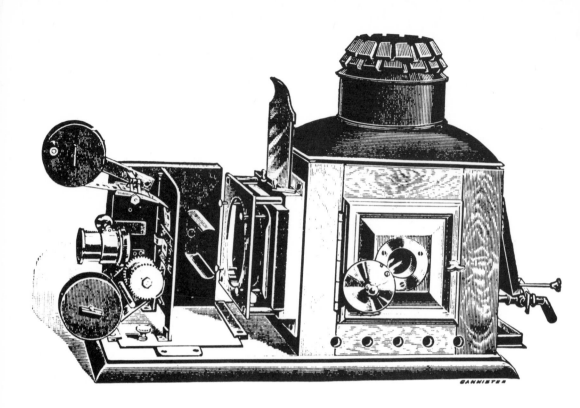

work (53). The description, in part, is as follows:

We have had an opportunity of trying Mr Wrench's apparatus, and were surprised at the quietness with which it worked, the sound being similar to that made by a sewing machine. It works with great smoothness, is quickly charged with a new film, the projected picture is particularly steady, and leaves nothing to be desired. On the side of the body of the lantern is a driving wheel, connected by means of a band with a smaller wheel in the changing apparatus, on which is attached the revolving shutter, which rotates at a high rate of speed.

The film to be used is wound on the upper reel shown in illustrations; it then passes over a velvet-lined tilting guide, and in front of the condenser on to the teeth of the ... [sprocket] ... from which it is wound on the bottom reel. Immediately in front of the condenser is placed an alum or water-trough (not shown in illustration) to prevent the heat from injuring the film. This when necessary can be hooked off, the cinematograph portion lifted away, a front and lens attached, and we at once have an ordinary projection lantern. The complete apparatus is supplied with all these adjuncts, and also includes a powerful mixed jet—in fact, everything except the film itself, and of these there are about one hundred subjects from which a selection can be made.[35]

53 The Wrench Cinematograph, manufactured by J. Wrench & Son, London. It was first marketed in July 1896 and was soon to become one of the most popular projectors of the period. *(Barnes Museum of Cinematography)*

The Wrench Cinematograph was perhaps the only serious rival to Paul's Theatrograph at this time, and the excellence of its performance was vouched for by many of the leading trade journals. Furthermore, it was one of the very few machines that were readily available on the open market in sufficient quantities to supply the ever-increasing demands of the swelling ranks of independent exhibitors.

Some three months after its first appearance, *The Optician* commented that 'it still holds its own as the simplest and (we believe) in every way the best such mechanism',[36] and a week later proffered this warning for consideration: 'The Wrench cinematograph as now made, is unequalled in its kind, and those lanternists who wait for a better apparatus, on similar lines, to be invented and worked out, may wait unprofitably, since they may wait long.'[37]

Either in November or December, Messrs Watson & Sons introduced a small machine principally intended for amateur use, which served as both camera and projector. It was called the 'Motorgraph' (54) and sold for twelve guineas.[38]

Watson was an old-established firm of manufacturing opticians, founded in 1837. Until 1861 its premises had been at 71 City Road, London, but thereafter the business was carried on at 313 High Holborn where it remained until well into the present century. This firm was already dealing in photographic and optical lantern equipment when it turned its attention to cinematography.

54 Watson's Motorgraph, manufactured by W. Watson & Sons, London. A combined camera/projector intended mainly for amateur use, it first appeared on the market towards the end of 1896. *(Barnes Museum of Cinematography)*

The most striking feature of the Motorgraph was its compactness and simplicity of operation, as the following description in the *Amateur Photographer* points out:

It is contained in a compact box measuring 6 by 4 by 5½ in. It is designed for photographing as well as projecting, it is strongly made, not liable to get out of order, and is free from vibration. The shutter is arranged to admit the passage of a large amount of light. The instrument, it may be mentioned, can easily be worked and presents no technical difficulties.[39]

Since no patent specification is traceable to this apparatus, the following details of its mechanism are taken from Hopwood's *Living Pictures*. The film was driven by a sprocket-wheel containing a continuously wound spring. The sprocket-wheel bears a ratchet, which is locked by a spring pawl lifted at regular intervals by the action of a cam on the same axis which supplies power to the contained spring. When it is employed as a camera, two film boxes take the place of the open spool and loose film shown in fig 54.[40]

An advertisement issued during November states that 'W. Watson & Sons manufacture and supply three different patterns of machines for projecting animated pictures'.[41] The Motorgraph just described was probably one of them, but I have been unable to find specific details concerning the other two. The earliest reference to a Watson machine is contained in a letter written by T.W. Watson,[42] in which he states that he has in his possession 'a letter of Agreement signed by the late Charles Morton of the Palace Theatre dated 18th April 1896 booking the Motograph [*sic*] for a period of 4 weeks at £100 per week'.[43] Watson's letter is dated 12 June 1956, and a recent attempt to contact Mr Watson resulted in my letter being returned unopened, with a note on the envelope informing me that he had died ten years previously. We know, however, that 'living pictures' were included in the programmes at the Palace Theatre (Cambridge Circus) at the period mentioned in the document, from an account published in *The Era* for 9 May: 'The orchestra is as strong as ever, and the selections

142

which it performs in the interval between the variety bill and the "living pictures" are keenly appreciated by music lovers in the audience.'[44]

A machine called the Motograph (again without the 'r') is listed in an article published in the *Optical Magic Lantern Journal* for August,[45] but no details are given. This and Mr Watson's letter are the only references to a machine of this name that I have found. Obviously it is a different apparatus from the motorgraph, previously described.

A second machine, which may have been a modified version of the Motograph, is advertised in *The Era* for 3 October: 'W. Watson & Sons' New Cinematograph. Free from vibrations. Almost noiseless. One of the best machines on the market. Price complete £40.'[46] This is obviously a more substantial machine than the Motorgraph which was offered for sale a few weeks later at £12. 12s. 0d.

Watson & Sons were also suppliers of films and in October announced that they had a stock of about 100 different subjects from which to choose. They also provided, at their premises in Holborn, a special room for projecting the films so that prospective customers could view them before purchasing.[47] This was a decided advantage since at that time films were not rented but had to be bought outright, more often than not unseen.

The Watson films and apparatus await further investigation, but their frequently advertised Motorgraph retained its popularity for well over a year, and the only modification it seems to have undergone during the whole of this period is the addition of a condensing lens.[48]

Another very compact apparatus which appeared shortly after Watson's Motorgraph was the 'Kineoptoscope' projector, designed to fit into the slide-stage of a standard optical lantern in the same manner as a mechanical lantern slide. It was invented by Cecil Wray, an electrical engineer of 2 Southbrook Terrace, Bradford, and patented on 31 August 1896 (pat no 19181).

Cecil Wray was later to design other cinematographic apparatus, and in association with C.W. Baxter designed and manufactured a cine-camera which had the distinction of being the first to be used in Japan.[49] Wray had shown an early interest in cinematography and on 3 January 1895 patented a device whereby the pictures in the Kinetoscope could be deflected and enlarged so as to appear on a screen. The patent specification is headed 'Improvements in or relating to the Kinetoscope' (pat no 182). The method employed was to strongly illuminate the film in the Kinetoscope and place above it a lantern attachment consisting of a horizontal condenser and a horizontal objective lens, with a prism mounted in position to project the picture upon a vertical screen in focus. Since the Kinetoscope film was not moved intermittently, Wray's apparatus could hardly have been very satisfactory. In fact *The Optician* remarked that 'the arrangements, which involve the use of a pair of mirrors, do not seem

143

to be the best that could be chosen, nor does the general idea strike one as particularly novel or ingenious'.[50]

On 9 March 1896 Wray lectured to the Bradford Photographic Society on 'Phonographs, Kinetoscopes, and the Kinetograph'. The lecture was divided into two parts, the first being devoted to the advances made in cinematography with an explanation of different apparatus. The second part concerned the Edison–Bell Phonograph and its use in lieu of a shorthand secretary.[51] Wray was also the first to show films in Bradford when he gave a performance in the rooms of the Photographic Society on Monday, 7 December. The *Amateur Photographer* commented that 'some of the subjects were as good as anything yet shown in London or the provinces. "Eating Water Melons for a Wager" was highly effective and amusing; also "The Kiss!" '[52] Although not stated, the performance was probably given with his recently invented Kineoptoscope projector. The films shown, at least the two mentioned, were Edison Kinetoscope films.

The patent rights of Wray's projector were acquired by the well-known Bradford firm of Riley Bros, whose address at that time was 55 and 57 Godwin Street. They were, or claimed to be, the largest lantern outfitters in the world, and also had a branch in the USA at 16 Beekman Street, New York, which was opened in 1895. Their interest in cinematography was thus a logical development of their already existing resources and interests. The manufacture and exploitation of Wray's Kineoptoscope was the start of a considerable business in cinematographic equipment, which was to include cine-cameras and projectors as well as the production of films. Riley Bros also played an important role in establishing the film production of James Bamforth, by providing technical assistance and equipment. The firm of Bamforth, in the Yorkshire town of Holmfirth, is better known today as a producer of picture postcards and calendars, but was then engaged in the production of magic lantern slides. Its speciality was life-model slides, a form of static picture-play in which life models acted out situations in static poses against painted backcloths or natural scenery. The slides illustrated scenes from popular romances, poems and ballads, such as those by George R. Sims, the author of 'It was Christmas Day in the Workhouse'. The method of producing these slides was not very different from the way in which early film plays were made, and it was relatively simple for Bamforth to make the transition from slides to films. James Bamforth made his first film in 1899 with a camera supplied by Riley Bros, and subsequently established a thriving film business which lasted until the outbreak of the First World War.

Returning to our discussion of the Kineoptoscope, the apparatus was described and illustrated in the November issue of the *Optical Magic Lantern Journal* (55) under its regular feature devoted to new apparatus:

This apparatus is separate and distinct from the lantern itself, and

144

can be applied to any lantern provided with a tolerably wide stage. The appliance is merely pushed in after the style of a slide. We have not yet seen this apparatus at work, but as everything that is introduced by this firm Riley Bros. is of the highest class, we can readily form the opinion that it will be found of a high standard, and that the claims that it is inexpensive, neat, strong, and satisfactory will be maintained.[53]

The internal mechanism of the projector is not explained, but the patent specification informs us that the intermittent movement of the film was effected by a reciprocating four-toothed claw which engaged

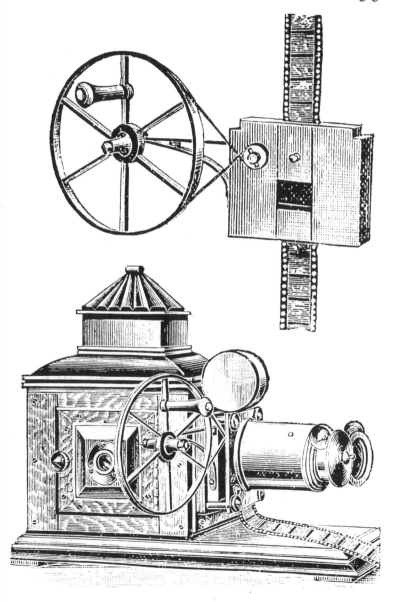

55 Riley's Kineoptoscope, invented and patented by Cecil Wray and manufactured by Riley Bros of Bradford. It first appeared on the market towards the end of 1896. *(Barnes Museum of Cinematography)*

the perforations of the film, drawing it down one frame and then withdrawing before continuing its next stroke. There was no sprocket-wheel to drive the film, the action of the claw being sufficient to feed the short length of film through the machine. Within a few months, a slight modification was made to the design and eventually several different models were produced, but the general principle of the intermittent movement supplied by a claw mechanism remained the same in each. Although the claw method was later used in many makes of camera, it was not generally considered satisfactory in projection apparatus owing to the wear and tear it inflicted on the perforations, a factor which could be ignored in the camera since the negative film passed only once through the machine.

Many of the larger manufacturing opticians who had previously specialised in optical lanterns and accessories sooner or later turned to making cinematographic equipment. Among their number we have already had occasion to mention J. Wrench & Son, W. Watson & Sons, and Riley Bros. Another such was J. Ottway & Son. Its founder was John Ottway, who is listed in 1859 as an optician and brass turner of 83 St John's Street Road, Clerkenwell, London, EC, but after 1867 his address is given as no 178, where in 1871 the business was continued as J. Ottway & Son. The cinematograph associated with this firm was called the 'Animatoscope' (56) and seems to have been ready for the market by November 1896, when it was described and illustrated in *The Optician*:

> It is made of steel, gun metal, brass, and aluminium. It is fitted with an alum bath, mounted on a metal standard in such a way that it can be brought into use or thrown out with a touch of the finger. It is provided with a double combination achromatic lens, of 2½in. focus, giving an 8ft. picture at 20ft. from the screen. The lantern and apparatus are fixed upon an adjustable platform attached to a light iron column, giving steadiness and solidity to the picture. The lantern is fitted with a powerful limelight jet, and is also adapted to receive an electric arc lamp. It is also provided with an arrangement by which ordinary lantern slides can be shown upon the screen the same size as the animated pictures, also the name or title of each film can be projected before it is shown. The price is £60.[54]

The *Photographic News* listed its special features as 'the absence of vibration or flicker of the picture, the smooth working, and the fact that the film is not torn or injured', and judged it to be, from the opinions expressed of it, 'a distinct advance in this branch of photography'.[55]

In certain respects the Animatoscope resembled Paul's Theatrograph no 2 and employed a similar intermittent mechanism consisting of two star wheels based on the Maltese cross, actuated by a central cam.[56] Its lack of originality in general principles probably accounts for the fact that it is not covered by a patent.

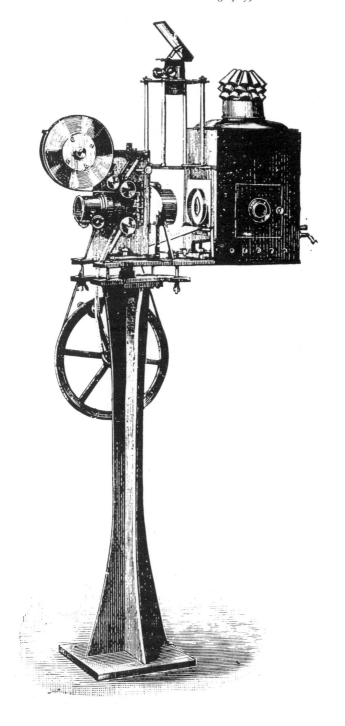

56　The Animatoscope,
manufactured by J. Ottway &
Son, London. It appeared on
the market in November 1896.
*(Barnes Museum of
Cinematography)*

J.H. Steward, of 406 Strand, London, was another well-known manufacturer of optical lanterns and accessories who later turned to making cinematographic equipment. The firm was established in 1856, and remained in business at the original address until quite recently. In November 1896 it advertised a portable cinematograph priced at £36 and said to be 'simple, certain, and noiseless'.[57] These are the only particulars concerning it that I have been able to find.

Mention must also be made of Philipp Wolff, of 9 Southampton Street, Holborn, London WC. He seems to have been a dealer rather than a manufacturer and was soon to build up an extensive business in films and equipment. He seems to have entered the film business late in 1896, for the earliest reference I have found is for December.[58] His career more properly belongs to 1897 and after, by which time he had become one of the largest suppliers of films in Great Britain, if not the world. He had branches in London, Paris and Berlin and his film catalogues were issued in three languages. Among the films he handled were those of Lumière and Méliès.[59] He also dealt in cinematographic equipment and in 1897 marketed a projector called Wolff's Vitaphotoscope. Philipp Wolff died in April 1898 at Barcelona of tuberculosis, but the business was continued under the management of a Mr Hessberg.[60]

Following the precedent set by the Kinetoscope, the majority of machines were designed to take film of the standard Edison gauge. Even the Lumière film, with its round perforation holes, was ultimately made available with a choice of either Edison or Lumière perforations, as the width of the film was the same. But a few attempts were made to introduce machines taking a larger size film such as The American Biograph and the Demeny Chronophotographe. In England, too, a machine called the Grand Kinematograph was designed for a larger film. This particular machine had rather an interesting history.

At a meeting of the Croydon Camera Club held on 28 October 1896 its president, Hector Maclean, referred to

> a newly invented camera and projection apparatus, called the Grand Kinematograph, which had just been perfected by the firm of which their member, Mr Victor Bender, was one of the leading partners, viz., Messrs. Bender & Co., of Croydon. The apparatus in question was in many ways a great advance upon those machines hitherto shown; the negatives were double the size of any other camera of the class, the vibration was much reduced, as also were the noise and clatter which usually accompany the projecting apparatus when in action. The President was able to announce that by the kindness of Messrs Bender & Co., Mr Adolph Langfier had promised to show the Grand Kinematograph in action at the lantern show of the Club, to be held on January 13, 1897.[61]

When this account of the Grand Kinematograph appeared in the

British Journal of Photography on 6 November it brought an in-
teresting response in the form of a letter addressed to the editors of
the *Journal*:[62]

Gentlemen,—Will you allow us to correct a slight error in your
report of the meeting of the Croydon Camera Club of the 28th ult.?
We wish to state that the apparatus referred to by the President
under the name Grand Kinematograph was invented by my son,
Mr Gilbert Harrison, and myself; but the sole right to use and sell
the same has been acquired by Messrs Bender & Co., of Croydon.
Relying on your sense of justice for insertion of this, and thanking
you in anticipation,—We are, etc., yours,
　　　　　　　　T.J. & G.H. Harrison.
Bowes Park, N.　　　　　　November 24, 1896.

The Harrisons had in fact filed a patent for the apparatus on 1 August
1896, which was issued as British patent no 17049. Their names and
occupations are stated as 'Gilbert Howard Harrison, Draughtsman,
and Thos. James Harrison, Photographer, both of 10 Cherson
Terrace, Wood Green, in the County of Middlesex'. We know from
the letter just quoted that the men were father and son. The father,
Thomas James Harrison, according to the patent, was a
photographer, and we have good reason to believe that he was
employed by Messrs W. & D. Downey, the well-known
photographers of 61 Ebury Street, London. Messrs Downey were
responsible for the first films ever taken of Queen Victoria, when she
was photographed at Balmoral sometime in October (see Chapter
11). These films were later shown to the queen and other members of
the royal family and household at Windsor Castle, on 23 November,
the Downeys again being responsible for the arrangements. A special
Supplement to mark the occasion was published by the *Lady's Pic-
torial* on 5 December, and in it we are informed that the man respon-
sible for designing the camera and projector was Mr A. Harrison, a
highly valued assistant of Messrs Downey, who had been with the
firm for the past fifteen years.
Further investigation reveals that the apparatus used by the
Downeys was in fact the Grand Kinematograph and the Mr A.
Harrison mentioned in the Supplement is no other than Thomas
James Harrison, the co-patentee. The Supplement informs us that
the films were 'considerably larger than those employed elsewhere'.
We know, too, that they had round perforation holes, for they
are shown as such on the strips of film reproduced in facsimile on
three whole pages of the Supplement 70. The description of the
Grand Kinematograph given by the president of the Croydon
Camera Club also mentions the large size of the film when he refers to
the negatives as being 'double the size of any other camera of the
class'. Furthermore, we know from the letter just quoted that the
Grand Kinematograph was invented by G.H. and T.J. Harrison. The

Harrison patent does not mention the machine by name or the size of the film used, but it does describe the sprocket-wheels for driving the film, which are specifically referred to as 'pin rollers'. It also states that they are provided 'at each side with a peripheral series of radial pins that engage in corresponding holes in the film'. Surely the reference here is to round perforation holes accommodating the pin-like projections. The two descriptions are too similar to be mere coincidence, and the fact that the surname of the men is also the same finally clinches the matter.

Mystery seems to have enveloped the Grand Kinematograph throughout its existence, for no sooner had it been christened than it lost its identity under a different name. About June of the following year, a company was formed calling itself the Velograph Syndicate Ltd, with an address at 242 London Road, Croydon. As was to be expected, the apparatus put out by this firm was called the 'Velograph'; bv chance I came across an advertisement for the apparatus which qv oted a patent number (without any date) that led me to connect the Velograph with the Grand Kinematograph.

The Grand Kinematograph was grand in more senses than one, for besides its use of extra large film, it also had the distinction of having Queen Victoria as its first subject. It later distinguished itself at her Diamond Jubilee procession on 22 June 1897, when a series of pictures were obtained which merited frame reproductions in the *Optical Magic Lantern Journal*'s Almanac for 1898.[63] By this time, however, the apparatus had been modified to take film of the standard Edison gauge and had been renamed the Velograph. This is confirmed from the frames reproduced in the work just mentioned and also from the following account which appeared in *The Photogram*:

> Although it was one of the earliest [*sic*] machines completed, it has not been generally on the market because it took films of double the standard size, and the makers have preferred to use it for their own exhibitions rather than attempt to induce the public to buy a machine with this size film. It is now, however, ready for films of the standard size, and is a very complete apparatus, including Dallmeyer projection lens, Gywre [*sic; ie* Gwyer] jet, a neat, light, but firm iron stand and packing case, which includes a liberal supply of tools and accessories. The price complete is £55. [57][64]

In the July issue of the same journal, its readers were informed that 'The Velograph Syndicate, Limited, had been formed to take over the Kinetographic section of the business of Bender & Langfier, 242 London-road, Croydon'.[65] The success of the Velograph Syndicate was of short duration, however, for on 7 January 1899 an advertisement appeared which stated that 'they are relinquishing that portion of their business pertaining to animated photographs and are prepared to dispose of the existing stock, &c., &c.'[66]

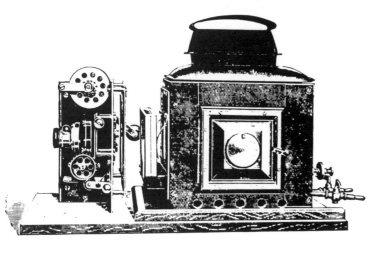

57 The Velograph, 1897, manufactured by the Velograph Syndicate of Croydon. This was a modified version of the Grand Kinematograph, originally invented and patented by G.H. & T.J. Harrison, 1896. *(Barnes Museum of Cinematography)*

The apparatus as described in the patent specification employed a novel form of intermittent mechanism, as shown in the figure (58).

The two 'pin rollers' or sprocket-wheels B, B¹, are geared to a central wheel F containing a number of radial pegs. Mounted at right angles to the latter is a revolving disc G carrying a channel which, for one half of its circumference, is radial with the axis and for the remainder is inclined to the centre. As it revolves, one of the pegs on the wheel F enters the channel at one end and remains in a stationary position until the channel inclines to the centre when the peg is forced round until it re-emerges at the other end, its place being taken by the adjacent peg, and so on. An intermittent movement is thus imparted to the wheel F which, being geared to the two sprocket-wheels B, B¹, naturally imparts the same movement to these also. According to the account published in the Supplement to the *Lady's Pictorial*, the usual speed at which the apparatus operated was fourteen frames per second, but this could be increased to twenty or more. The film capacity was about 120ft.

During 1896 at least eighteen patents relating to cinematograph cameras and projectors were filed by British inventors, and this does not include the numerous provisional applications which, for various reasons, were either not completed or not accepted. Some of those that were accepted covered inventions which failed to reach the practical stage, or, if they did, have not been traced, whilst others, although patented in 1896, did not materialise until the following year. Among the latter were those of H.J. Heinze, A.S. Newman, and J.W.L. Naish.

Horatio John Heinze, a mechanical engineer of 16 East Road, City Road, London, filed two patents for which complete specifications were not deposited until the following year. The application for the first patent is dated 14 July 1896 (pat no 15603). The complete specification shows rather an awkward mechanism which could not possibly augur well for commercial success. A crank-arm imparts an upward and downward motion to two rollers which, on the upward

58 The intermittent mechanism of the Grand Kinematograph.

stroke, roll along the film and are prevented from rotating in the opposite direction by ratchets. On the downward stroke, the rollers become fixed and act like claws, drawing the film down with them. A cam-actuated grip steadies the film during the upward movement of the rollers. This arrangement obviously did not satisfy Heinze, for he filed a second patent on 12 October (pat no 22627). In this one, no sprockets were used; instead, two blocks were driven forward to grip the edges of the film against a plate on the other side. The gripping-blocks and plate then sunk together, carrying the film with them. Heinze advertised the apparatus as the 'Pholimeograph'.[67] I have found only this one reference to the machine under this name, but a notice of a proposed meeting of the Streatham Photographic Society for 18 May 1897 in the Beehive Assembly Rooms may refer to it. The notice simply states that 'a demonstration of "Animated Photographs" will be given by Mr Heinzes [sic]'.[68] The scarcity of publicity regarding this apparatus seems to indicate that it was not very successful.

Arthur Samuel Newman probably began his experiments early in the year; they resulted in a curious little machine now in the Science Museum (59).[69] It was not patented, and employed a peculiar type of worm gearing for imparting the intermittent movement to the film, which necessitated an additional action performed by a 'stop' mounted on a horizontal shaft, above and at right angles to the worm, to hold the gear rigid during its period of rest. The movement was rather ingenious but the apparatus itself is a little crude and primitive, suggesting its early origin. An exact date for its completion has not been established, but it would seem to be not later than the middle of 1896.

Newman was a partner in the firm of Newman & Guardia, a noted photographic establishment, and obviously his first attempt was considered unsatisfactory for commercial purposes. He thus set about designing a second machine which became the subject of his first

152

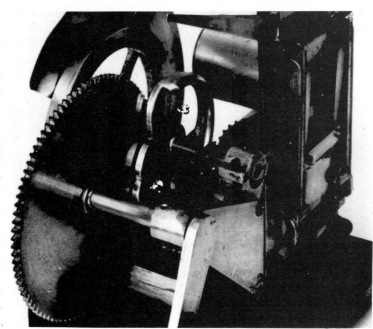

59 The Newman Cinematograph, an experimental projector designed by A.S. Newman in 1896. *Below:* Details of the intermittent mechanism. *(Science Museum, London; Crown copyright)*

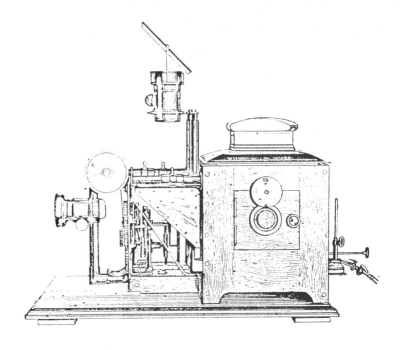

60 Naish's Cinematograph, invented and patented by J.W.L. Naish of Edinburgh, 1896. *(Barnes Museum of Cinematography)*

cinematographic patent. This was filed under his own name and that of the firm's, on 13 October (pat no 22707). The complete specification was not deposited, however, until 13 July 1897, and the apparatus itself seems to have been completed only the previous month, when it was due to be shown at the Printing & Kindred Trades Exhibition held at the Royal Agricultural Hall, Islington: 'Messrs. Newman & Guardia, of 92 Shaftesbury Avenue, W., will give six exhibitions of animated photography daily, their recently completed apparatus being used for the production of the pictures'.[70] However, the launching of the new machine at the Agricultural Hall was somewhat premature, for as late as the following September the long-awaited apparatus had still not arrived on the market.[71] The machine was obviously undergoing modifications, and here we must leave it, for its belated appearance precludes it from being considered among the 1896 machines. We need only add that the intermittent movement was of the claw variety.

The other machine patented in 1896 but not ready for the market until the following year was Naish's Cinematograph (60). A few of its salient features were noted in the *British Journal of Photography* for 5 February 1897:

The makers claim that this cinematograph is different in construction to all others. There are no rollers, no drums, no sprocket wheels, no springs. The pictures are steady from start to finish, the flicker is scarcely seen and it is impossible to tear the film. Whilst a new film is being put in, other pictures can be shown on the screen. Titles or descriptions of the next films can also be shown. The

154

mechanism is very simple, and not liable to get out of order. It is driven by a small handle, but a motor can be used if preferred.[72]

The apparatus was invented and patented on 16 December 1896 (pat no 28799) by John William Leslie Naish, of 12 Carnegie Street, Edinburgh, who is described as a photographic mechanician. This is the first instance of a Scottish involvement in cinematographic invention, which hitherto had been confined to three main centres, London, Bradford, and Leeds. The Naish Cinematograph had a claw raised and lowered by a triangular eccentric. The claw was forced forward by a cam disc and returned from contact with the film by the same means. The shutter, which was situated immediately in front of the gate aperture, was of a segmental shape eccentrically mounted so that the edges travelled across the aperture parallel to the margins of the view, and although revolving, its action was more like that of a drop shutter.

An apparatus called the 'Mutagraph' was introduced at the Egyptian Hall, Piccadilly, and although the patent application is dated 28 May 1896, it has not been established when the machine was first exhibited there. The Egyptian Hall had been the second place of entertainment in London to include 'animated photographs' in its programmes, and it will be remembered that when David Devant first acquired Paul's Theatrograph for 'England's Home of Mystery' his senior partner J.N. Maskelyne (61) had not been over-enthusiastic about its chances of success. He soon changed his mind, however, and himself became involved in cinematographic invention.

Maskelyne was, of course, a clever mechanic, and many of the illusions used in the performances were created by him and constructed in his own workshops. Ideas for a film projector designed on entirely new lines began to occupy him and he wondered if the irritating flicker produced by conventional machines could be overcome by employing a continuously running film rendered optically stationary. An account of his efforts in this direction is given by his grandson, Jasper Maskelyne, in a book about the family published under the title of *White Magic*:

Meanwhile, the workshops behind the stage [ie of the Egyptian Hall] were busier than ever, for J.N. and his son Nevil were now taken up with the problem of devising an apparatus that would run movie films continuously and smoothly. The two of them spent months trying to overcome the difficulties that faced them in their task, but never succeeded to their satisfaction.[73]

Some measure of success was achieved, however, and if it did not fulfil the Maskelynes' expectations, it was nevertheless considered important enough to warrant application for a patent. This was issued as patent no 11639. The complete specification was left on 1 March 1897, but whether or no the apparatus had reached a practical

stage by then has not been determined. A poster advertising the machine at the Egyptian Hall, under the name 'Mutagraph', is not dated, (62) and attempts to date it from internal evidence have proved inconclusive. Two Paul films are instantly recognisable from the subjects depicted in the drawings: *David Devant: The Mysterious Rabbit*, and *Maskelyne: Plate Spinning*. Both date from the summer of 1896. The other subjects depicted in the poster cannot be identified with certainty. A fire-engine and railway train are shown, which could be associated with Paul films made during 1896, namely *Turn Out of a Fire Brigade*, and *Arrival of the Paris Express*. The diving scene probably represents the Paul film called *Diving*, or *The Divers*, made at Douglas in the Isle of Man during the summer of 1897. The two Arabs with a mule or donkey, and the picture of the elephant, probably represent scenes taken in Egypt by Paul's cameraman

61 John Nevil Maskelyne (1839–1917), founder of the magical entertainment known as Maskelyne & Cooke, presented at the Egyptian Hall, Piccadilly, from 1873 to 1904, and inventor and patentee of the Mutagraph (1896). *(Barnes Museum of Cinematography)*

156

Harry Short, also made in 1897. The earliest possible date for the poster would therefore appear to be the latter part of 1897.

The Mutagraph was probably exclusive to the Egyptian Hall, for it seems unlikely that it was ever manufactured for the commercial market. Apart from the patent drawings, the only illustration of the apparatus I have found is the artist's impression shown on the poster just mentioned. The film ran continuously and was rendered optically stationary by a series of revolving and static lenses, which allowed each frame to be projected at the precise moment it coincided with the optical axis of the lenses involved.

Applications for four other patents were made in 1896 which may be briefly mentioned although no apparatus which may have resulted from them has been traced. The earliest concerns apparatus patented by three Bradford clockmakers, Joseph Oulton, William Shaw and Reginald Henry Adams. Oulton was later connected with another cinematographic patent but the other two men seem to have stuck to their clockmaking trade. Their specification is dated 4 April and covers so-called improvements in 'Apparatus for Taking and Exhibiting Series of Photographs', in which several different methods are described for intermittently driving the film or pictures, using rollers actuated by wheel and teeth, or pegs (pat no 7817).

Later in April, Jacob Bonn, an engineer of 1 Holborn Place, London, patented a projection apparatus which employed a similar movement to that patented by the German inventor Max Skladnowsky in 1895.[74] A gear-wheel fixed to the driving sprocket is intermittently revolved by a worm situated below, which is mounted on a sliding axle driven backwards and forwards by a stud bearing in a cam-groove (pat no 8418, 21 April 1896).

A patent of Theodore Reich, a photographer of 63 Maitland Park Road, Haverstock Hill, London, describes two movements, one employing a ratchet and pawl device and the other a claw mechanism (pat no 12128, 3 June 1896). The complete specification was not filed until March of the following year.

A rather complicated apparatus is described under patent no 17848, 12 August 1896, in the names of Julius Peschek and George Henry Chard, electricians, and Hermann Ackermann, instrument maker, all three with addresses in London. I quote Hopwood:

The intermittent motion of the film is effected by a lever connected to a plate carrying pins, or a rubber pad which presses on the film. The lever has a side-motion which drives a wedge into another wedge-piece on the plate, thus forcing it against the film, the vertical movement of the lever drawing the film down by means of the pins or pad. A return sideway movement releases the wedge-action, and the plate is forced back free of the film by a spring, and is carried up by the lever ready for another stroke. Either a rotary or hinged shutter is employed, the latter being a frame covered with tissue paper, etc.[75]

157

62 Undated poster advertising
the Mutagraph at the Egyptian
Hall. Among the subjects il-
lustrated are *David Devant:
The Mysterious Rabbit* and *Mr
Maskelyne: Spinning Plates
and Basins,* two films made by
R.W. Paul in 1896. *(London
Museum)*

This survey would not be complete without mentioning two
patents bearing the name of William Friese-Greene. Friese-Greene
had been experimenting with the idea of moving pictures ever since
his association with another inventor named J.A. Rudge back in the
early 1880s, but had never succeeded in achieving a practical method
of cinematography, despite claims to the contrary. I think his actual
place in the evolution of cinematography has been admirably
summed up by Brian Coe:

> Friese Greene's work must, then, be considered, with that of
> Rudge, LePrince, Donisthorpe, Varley and others, as an in-
> teresting but unfruitful attempt to solve the basic mechanical and
> photographic problems involved in kinematography; work off the
> mainstream of development of moving pictures. Friese Greene's
> own tragedy is that, while possessing a fertile imagination, he
> lacked the technical skill and scientific knowledge that might have
> led him to success.[76]

The first of Friese-Greene's two 1896 patents bears the name of John
Alfred Prestwich as co-patentee. Prestwich was an engineer of out-
standing ability who during the next decade of the cinema's history
constructed some of the best cinematographic apparatus of the

63 The Greene–Prestwich
projector, invented and
patented by William Friese-
Greene and J.A. Prestwich,
1896; the apparatus used a
special film 60mm wide.
*(Science Museum, London;
Crown copyright)*

period. He is best remembered today, outside of cinematographic circles, for the 'JAP' motorcycle, so named from his initials. How he was persuaded to join Friese-Greene in designing and constructing the bizarre apparatus which was the subject of their joint patent is beyond comprehension. The apparatus was patented on 4 August 1896 (pat no 17224) and is now in the Science Museum (63).[77] It is an expert piece of machinery which is clearly stamped with the characteristics of its creators. The woolly thinking behind the apparatus is obviously Friese-Greene's, whilst the accomplished technical application is due to Prestwich. The Science Museum's official description of the apparatus is as follows:

> This is an ingenious double projector for film 2⅜ inches wide. The inventors claimed that it removed flicker and that projection speeds could be reduced below 16 pictures per second without losing the moving picture effect.
>
> The shutters are so arranged that the screen is always illuminated from one or other of the two apertures. When one shutter is closing the top aperture the other shutter is opening the lower one and so one picture 'dissolves' into the next.
>
> The film is moved forward two frames at a time. One frame is drawn past the upper lens each time without being projected but this frame is projected at the lower lens. As consecutive frames projected are not adjacent to each other, the film used has to be specially printed so that the frames are shown in the order in which they were taken in the camera. The idea for the projector was probably due to Friese Greene who had shown moving pictures based on dissolving views some years earlier. The mechanical details such as the epicycle intermittent motion are undoubtedly due to Prestwich.

Friese-Greene's second patent is no 22928 of 15 October, and describes and illustrates two forms of apparatus for use as camera or projector. In the first, the method of imparting an intermittent motion to the film is by a roller mounted on a revolving crank arm, and in the second it is by a plunger device comprising a reciprocating roller actuated by means of a connecting rod and crank. In both methods, the film is pushed out of its vertical alignment the distance equal to one frame, thus drawing the film through the gate one frame at a time as the roller or plunger makes contact with the film. An interesting feature of the second machine is the hinged rear frame, carrying the guide rollers and pressure plate for the gate, which reminds one of the Pathescope 9.5mm projector of later years.

Friese-Greene displayed some of his apparatus at a meeting of the Croydon Camera Club on 2 December. 'He described and showed various models of cameras which he had successively invented, and similarly treated of the lantern apparatus used for projecting the moving image upon the screen.'[78] Several films were also projected,

The Broken Melody, and *The Lord Mayor's Show,*[79] both made by Esme Collings; an Edison film, *Buffalo Bill*; the Paul–Acres film *Rough Sea at Dover,* and *The Tub Race (in the sea).* The most extraordinary thing about this demonstration is that none of the films shown seems to have been the work of Friese-Greene. Could it be that his own apparatus was not really capable of producing practical results, or any results at all? He was, after all, a professional still photographer with studios in London and Brighton. Surely, if a practical cine-camera had been invented by him, he would have chosen examples of his own work rather than that of others, especially since the purpose of the meeting at the Camera Club was to show off his own contribution in the field. By far the most important aspect of the occasion was the inclusion of two films by Esme Collings.

Esme Collings was a well-known portrait photographer of Brighton[80] who, according to the biographer of Friese-Greene,[81] formed a partnership with the latter in 1885. His interest in cinematography may stem from this association, although his achievements in this field owe nothing to Friese-Greene. His importance in the history of cinematography lies not in technological invention but in film production, for he was the first of that small group of film-makers which has since become known as the 'Brighton School' and regarded by some as the *avant-garde* of film technique.

It would seem that Esme Collings took up film production during the latter half of the year, for a notice to the effect was published in *The Optician* on 26 November where it is stated that 'the Kinetoscope [*sic*] is now commencing to shape itself into a very practical form. Mr Isme Collins [*sic*], a photographer of Brighton and Bond Street is supplying rolls of transparencies'.[82] This means, of course, that Collings was supplying film subjects, not raw stock. The first film of his of which we have a record is *The Lord Mayor's Show.*[83] In 1896 this event took place on 9 November and was covered by at least two other early film-makers, Birt Acres and R.W. Paul. A description of the Esme Collings film was published in the *British Journal of Photography*:

> The waiting flunkeys, the soldiery and police, the seething and expectant crowd, all were there. Then was seen the Lord Mayor's coach approaching. It drew up, the flunkeys formed up in two lines, the mace-bearer and sword-bearer alight, and pass by; finally the Lord Mayor himself is beheld striding along in his weighty robes.[84]

The film was at first reported, by the *British Journal of Photography*, to have been taken by Messrs Wrench & Son, but a communication from Esme Collings, published the following week, stated that it was he who had taken it.[85] The fact that the name of Wrench had been linked with the film may suggest that Esme Collings was equipped with a camera made by that firm.

161

Another of Esme Collings's films dating from this period was *The Broken Melody*.[86] This simple drama was based on the play by James Tanner and Herbert Keene, and probably compressed the action into a single scene in which a servant persuades the cellist to play and the errant wife returns. The leading parts were played by Auguste Van Biene and his wife.[87] One would have to see the film to know if Collings had introduced any startling innovations in film technique, but, unfortunately, no copy is known to have survived.

I have not been able to identify a machine called the 'Anarithmoscope' exhibited by Webster and Girling. Most probably the name was adopted by the two entertainers for theatrical purposes, just as Paul's Theatrograph had been renamed the Animatographe by the management of the Alhambra. The name first appears shortly after the Cinematograph of J. Wrench & Son was placed on the market and it could have been one of their machines. An advertisement of 15 August announced:

Living Photographs. The Anarithmoscope is the most perfect instrument yet devised for illustrating this marvellous novelty. Electric current not essential. Dates now being booked for halls, institutes, &c. Apply, Webster & Girling, 44 Upper Baker Street, London, N.W.[88]

A similar advertisement appeared in the same paper on 31 October.[89] It is also mentioned by the *Optical Magic Lantern Journal* in December:

The Anarithmoscope.—Many are the names by which the apparatus for producing animated photographs on the screen is known, the latest being that in use by Messrs. Webster & Girling, the entertainers, of Upper Baker Street. Their apparatus they call the Anarithmoscope, and a public demonstration of its capabilities was given last month at Portman Rooms, W. A large audience was present on the evenings of the three days on which the apparatus was exhibited. The apparatus worked well, and the definition of the majority of the pictures was good.[90]

Webster & Girling are among the names included in a list of suppliers of apparatus and films published in the *Photographic News* for 2 October.[91]

Shortly after the debut of Rigg's Kinematograph at the Royal Aquarium, the name Fred Harvard appears, both as a dealer in cinematographic equipment and as exhibitor,[92] but whether he invented or manufactured his own apparatus at this time is open to question. He is said to have invented a new 'cinematoscope' the following year, which, we are told, looked uncommonly like a machine made by J. Wrench & Son,[93] but nothing is known about the apparatus he was exhibiting prior to this, except that it was variously

162

billed as the Animatoscope, Cinematoscope, and Cenematoscope.

On Monday, 4 May 1896, he was engaged at the Theatre Royal, Leeds, where his apparatus was announced as 'Harvard's Animatoscope'. The performance was written up in *The Era* on the following Saturday:

At the end of the second act occasion in the interval was taken by Mr Reynolds to exhibit the wonderful properties of the Animatoscope, a series of photographs thrown on a white sheet and showing animated nature to a detail. Every figure in the pictures seems invested with life. Mr Reynolds—assisted by F. Harwood [*sic*]—intends showing this wonder for a fortnight at least.[94]

In the same issue of *The Era*, this advertisement also appeared:

For sale, a cinematographe machine, with ten films, complete. No experiments, a proved success. Can be seen nightly at the Theatre Royal, Leeds, during the last week of its enormous success (commencing May 11th) Apply, Walter Reynolds.[95]

Walter Reynolds, who was the sole lessee and manager of the Royal, had apparently bought the machine and, finding it did not fulfil his expectations, decided to get rid of it as soon as it had completed its fortnight's run. Fred Harvard had advertised a similar machine the previous week:

The latest London craze, Harvard's Animatoscope (Living Photographs). Animatoscope. Theatre Royal Leeds. Every evening and daily matinées. Open for engagements for any part of the world. Address, Harvard, 31 Reedworth-street, Kennington-road, London. Agent Geo. Ware. Machines and films for sale.[96]

As already noted, a machine of this name was manufactured by the well-known firm of J. Ottway & Son, but whether it was their machine which was now being advertised as Harvard's Animatoscope has not been determined. I have found no evidence of Ottway's Animatoscope being in existence before November.

On 9 May, Harvard again advertised the Animatoscope,[97] but two weeks later he was advertising Harvard's Cinematoscope at the Star Theatre, Liverpool.[98] Either he had changed the name of the machine or he had acquired a different one. Cinematoscope was the name used by Lewis Sealy for the Kineopticon of Birt Acres. The matter is further complicated by the following which appeared in *The Era* for 6 June:

Amusements in Liverpool. Star Theatre of Varieties.—A particularly attractive list of special items of amusement was an-

nounced for the 'Star' on Monday [June 1], the chief of these being the Cinematoscope, but owing to the late arrival of the novelty from Paris it could not be shown till Tuesday, when it aroused the usual amount of enthusiasm.[99]

The late arrival from Paris sounds like a typical showman's cover-up for mismanagement, and Harvard had evidently failed to get the machine up to Liverpool on time.

After a two-week engagement at the Star, Liverpool, Harvard was booked at the Tivoli Theatre of Varieties, Leicester, from 15 June to 27 June. An advertisement in *The Era* announces the apparatus as Harvard's Cenematoscope,[100] although an editorial refers to it as the Cinematoscope: 'Tivoli Theatre of Varieties. An attractive programme is provided here this week, which includes the Cinematoscope, "the photo-electric sensation of the age".'[101] A review in the *Leicester Mercury* for 23 June refers to the machine as the Cenematoscope: 'The Cenematoscope, under the management of Mr Fred Harvard, continues to be the centre of attraction. The scenes were given with usual distinctness and the whole of the pictures received a well-deserved round of applause.'[102] It played two weeks at this theatre and then moved on to the Grand, Manchester, where it opened on 29 June.[103]

Harvard's advertisements appeared at intervals throughout the remainder of the year and at the beginning of October had announced an 'Improved Cenematoscope'.[104] Whether or not Harvard's Animatoscope, Cinematoscope, or Cenematoscope were one and the same machine it has not been possible to determine; neither have I discovered the source from which his films were obtained. Lack of information prevents one from making a just estimate of his talents. He was probably typical of the kind of exhibitor who became more common during the following years. Nevertheless, he has earned his place as one of the earliest exhibitors of 'living photographs' in this country.

Such also is the case of another early exhibitor named Vincent Paul, of whom even less is known. He seems to have been the first to introduce moving pictures to Liverpool, where they were exhibited at the Tivoli Vaudeville Palace on 18 May:

Proprietor and Manager, Mr James Kiernan—ever in search of novelties for the purpose of maintaining the Tivoli reputation, the master of the entertainments brought the latest wonder (the cinématographe) for the first time to Liverpool on Monday evening, when crowds of the curious viewed with wonder and received with enthusiasm the marvellous living pictures, which were superintended by Mr Vincent Paul.[105]

The Cinematographe referred to was not of course the Lumière machine; most probably it was Paul's Theatrograph.[106] Vincent Paul

164

seems to have made Liverpool his special preserve, since an advertisement for 16 January 1897 states that he had six shows running there in one week.[107] His address is given as Roscommon, Liverpool.

Several other exhibitors were active during the latter half of the year, Chard, for instance, of Great Portland Street, London. He was little known at this time, a single advertisement in *The Era* for September[108] being the only reference to him that I have found. The following year, however, he is much to the fore and his shows are widely recorded as Chard's Vitagraph. He was presumably an exhibitor of the Clement & Gilmer machine known in France as the Vitagraphe.

One William Turle was active in the Isle of Man during August,[109] but details of his performances are wanting. During the same month, M. Alberto Duran was exhibiting his Vivagraph at two London music-halls, the Pavilion and South London,[110] but again no further details are to hand. Phil & Bernard were beginning their careers in 'animated photography' at the end of the year,[111] and were later to achieve success with an engagement at the Alhambra Theatre, Leicester Square, where they exhibited a Wrench Cinematograph.[112] There is a record of a performance of 'living pictures' at the Armoury, Stockport, for the week commencing 21 September, given by the Louis Tussaud's Exhibition & Entertainment Company.[113] There can be little doubt that the man in charge of the 'living pictures' was C. Conrad and that the machine used was Rigg's Kinematograph. The evidence for this is supplied by a publicity sheet issued by Conrad in 1898 and now in the Science Museum. Here he is billed as Prof. C. Conrad, Cinematographist & Illusionist. The printed text informs us that he was for four and a half years stage manager of the Louis Tussaud's Company and that he had given exhibitions of 'animated photos' in all the principal towns in England and Wales. This publicity handout was acquired by the museum at the same time as the apparatus used by him. We have already identified this apparatus as Rigg's Kinematograph (49).

On 26 October an exhibitor by the name of Emil Theodore fulfilled an engagement at the Royal music-hall in London which was severely criticised in *The Era*:

The taste for animated photographs still continues, and the introduction of M. Emil Theodore's series of scenes into the Royal programme on Monday evening attracted a crowded house. Truth to tell, the pictures were somewhat disappointing, some of them being so blurred and indistinct that it was hard to discover what they were all about. Whether the defects were due to the lighting, to the operator, to the projecting machines, or to the films, or to a combination of unfortuitous circumstances we need not pause to enquire. It will be sufficient if we point out that the more successful scenes included a train coming into a station, a stormy sea, and an interview between a pierrot and pierette. The movements of the

64 Handbill issued by Randall Williams in 1897. Williams was the first showman to introduce the cinema to the English fairground. *(Peter Williams)*

RANDALL WILLIAMS

THE
KING OF SHOWMEN,

IS NOW EXHIBITING HIS GRAND

ELECTROSCOPE
AND
MAMMOTH
Phantoscopical
Exhibition,

The Sensation of the 19th Century,

FROM THE

Royal Agricultural Hall, London.

The whole of this Magnificent Exhibition
is worked by

ELECTRICITY,

Generated on the premises by our own
MAMMOTH ENGINE.

The Greatest Scientific Invention of the age, THE

CINEMATOGRAPHE,

OR

ANIMATED PHOTOGRAPHS,

In which is represented THE

QUEENS' DIAMOND JUBILEE.

So that those people who did not go to London have an opportunity of seeing the Diamond
Jubilee Procession as well as those who did, and paid £5 for a seat.

This Exhibition is one of the most Wonderful Sights and
should certainly not be missed.

dancers in one picture were much too slow, and the interior of a barber's shop was quite ineffective. The pictures of flowers thrown up on the field of view during some of the intervals between the exhibition of the photographs were pretty, but the adjective used did not apply to some of the portraits of the Royal Family. Fortunately there are many excellent variety turns.[114]

The slow-moving film of the dancers indicates that this was a Kinetoscope film, which seems to be confirmed by the film of the barber's shop which was almost certainly a 'Black Maria' production. The other films mentioned could have been turned by Birt Acres; and the projector used, the Kineopticon perhaps?

Contrary to popular belief, the cinema did not appear in the fairgrounds until the summer of 1897, and even then the number of fairground shows was very few, perhaps numbering less than half a dozen throughout the British Isles.[115] The great days of the travelling Bioscope date from 1898 onwards, when it was accompanied by its fascinating Gavioli organ and electric generator. However, at the end of December 1896 one of the great names of the English fairground, Randall Williams, became associated with the cinema for the first time (64).

Each year, at Christmas time, the Royal Agricultural Hall in Islington was given over to a mammoth fair with 'a multitude of amusements for all classes under one vast roof. Circular railway, switchback, roundabouts, various side shows and funny parades, shooting gallery, monster Christmas tree laden with toys, grand ball room, and numerous other attractions. A monster programme of incessant fun and entertainment for the people at the popular price of six pence'.[116] This yearly event was known as 'The World's Fair', and opened on Christmas Eve for six weeks. 1896 was its eighteenth year and fairground people from all over Great Britain were represented. Previously, Randall Williams had regularly exhibited his famous ghost show here, but, as *The Era* points out, 'they have this year abandoned the spectral business, and are giving an exhibition of animated pictures, an alteration that appears to meet with approval'.[117]

Thereafter, Randall Williams exhibited moving pictures at the principal fairgrounds in the north of England and Scotland. In 1897 his show was the star attraction at Lynn Mart. He was immediately followed in the field by other showmen with the result that the travelling cinema, or Bioscope as it came to be known, henceforth appeared as a regular feature of the fairground scene. Williams died in November 1898, but the show was carried on by his two sons, and the family eventually ended up owning a chain of permanent cinemas.[118]

The Royal Agricultural Hall, although originally built in 1861 for the purpose implied in the name, had seen varied activities such as mule and donkey shows, bull fights, revivalist meetings, dog shows, military tournaments and circuses, etc. A ball attended by the Prince

of Wales was held there in 1867, as was the Workmen's International Exhibition which Queen Victoria visited in 1870. Charles Blondin, famed for crossing Niagara Falls on a tightrope, performed there at the age of seventy at the World's Fair of 1894.[119]

Unfortunately, we do not know the make of the machine used by Randall Williams at the Royal Agricultural Hall, but it may well have been acquired locally, for there were in Islington at this time two or three firms engaged in the sale and manufacture of cinematographic apparatus. This is not surprising since the district was noted for its many small workshops where artisans were busily engaged in making an assortment of goods appropriate to small-scale engineering and allied trades. In a letter written by Randall Williams in 1946[120] (this must have been one of the sons of the Randall Williams previously mentioned) he states that he and his two brothers were connected with the firm of Haydon & Urry. This firm was situated at 353 Upper Street and achieved considerable success with its Eragraph projector. It also produced its own films. But, as far as I have been able to ascertain, these activities did not commence until the beginning of 1897. For some part of 1896 the firm's place of business was at 34 and 58c Gray's Inn Road, and its move to Islington does not seem to have taken place until towards the end of the year. As of 20 June, it was still at its old address, for it was advertising from there a consignment of 'Cackling hens. Splendid layers and money-makers'. The same advertisement also mentions 'Autocosmoscopes'. These were evidently some kind of Kinetoscope or perhaps a precursor of the Mutoscope or 'what the butler saw' machine. The advertisement describes it as 'the most perfect penny-in-slot seeing machine ever produced. Lifelike reproductions of living pictures. Neat, compact, well-made. Works and is illuminated without electricity. Results equal to any thirty guinea machine. Very portable. Just the thing for showmen. Price only £7.10s.'[121] So by June the firm's interests were already turning towards cinematography. In pursuit of these aims it probably soon contemplated the move to Islington where likely premises were to be had for manufacturing this kind of equipment. It is just possible that it supplied the machine used by old Randall Williams at the Royal Agricultural Hall, in which case this would have been the first of its Eragraph projectors,[122] which did not appear on the open market, however, until the following year.

Also manufacturing cinematographs in Islington was James Henry Lee, of 553 Holloway Road, who is described as a photographer and limelight constructor. He was the maker of a projector called the 'Projectomotoscope'.[123] His son, Walter George Lee, in an article in the *Islington Gazette* recalled that his father combined with R.W. Paul 'to apply limelight to throw an illuminated picture on to a screen, which they achieved at Mr Paul's workshop near Hatton Garden'.[124] No details of the Projectomotoscope have been found, but it is quite likely that Lee's interest in animated pictures stems from this association with Paul, who may have consulted him for an illumi-

nant for his Theatrograph. Lee is another of those early pioneers of whom too little is known at present. He was certainly quite early in the field, for by August he was already advertising his machine which he undertook to manufacture to order.[125] Lee's work as a still photographer is represented in the Barnes Museum of Cinematography by a miniature photograph of a young lady, mounted on a card printed with his name and address.

Another firm located in the district was the Interchangeable Syndicate Ltd, of 57 St John's Road, Holloway. Most probably they were dealers rather than manufacturers of cinematographic equipment. In an advertisement of November, they claim to be the sole agency for 'Edison cinematographs'.[126] The only machine of Edison's on the market at this time was the Projectoscope, the English agent for which was the London Phonograph Company (see Chapter 10). The firm of J. Ottway & Son, already noted as the manufacturer of the Animatoscope, was also situated near by, although at that time its address would properly be considered part of Clerkenwell.

Considering the short time that the cinema had been in existence, it is amazing how many inventors, manufacturers, dealers and exhibitors had entered the field in England by the end of 1896. We have already noted the most important of these, but there were still others who have left little or no trace of their activities, and await further research. We can, however, name some of them.

Fred W. Duval, of 272 Gloucester Terrace, Bayswater, London, advertised regularly in *The Era*. His first advertisement appeared on 18 April and offered 'Cineomatographes' and films for sale. A portable apparatus at £60 is advertised in May, also 'films made to order at a few hours' notice and at wholesale prices, but only sold with our machines'. An advertisement for 6 June offers Eastman's sensitised film and one for 1 August lists the price of his apparatus as £50. A developing and printing service was also available and prospective customers were informed that 'new and original films are being taken daily'.[127]

B. Doyle, of 71 Bessborough Street, South Belgravia, London, was also a dealer and film producer. An advertisement in *The Era* for 23 May offers for sale 'a combined machine, with which the operator takes his own films, develops [?] and projects same'. The advertisement also boasts 'no shortage of films'. Later advertisements also offer French films which are stated to be longer than any other make. English subjects were also available, one of the titles listed being *Traffic on the Thames*. An advertisement of 25 July states that 'special arrangements can be made by which local subjects desired by purchasers will be taken'.[128]

Simpson Bros, electrical engineers of Hapton, near Burnley in Lancashire, advertised a machine called the 'Edisim', which was 'guaranteed to give 50 per cent more light on the screen than any other machine on the market', and was described as the 'steadiest, most compact, and most silent, and most modern'. Films were also

available including French, English, Russian and American subjects.[129]

The British Athletic Co Ltd, 118 Southampton Row, London, advertised in *The Era* on 11 October, stating that the company was introducing a new Kinematograph. An advertisement of 12 December refers to this machine as Gyngell's Kinematograph.[130]

There must obviously be other names at present forgotten which will be rescued from oblivion only by a thorough search of local documents. Still others may be known to a few private persons, from printed ephemera in their possession. We can only hope that one day such private collections will be recorded and made public.

10 Apparatus from Abroad

The rapid growth of the cinema in England in 1896 put her temporarily ahead of any other country, with the possible exception of France. America, which had been the birthplace of cinematography, was momentarily left behind. The hullabaloo over the debut of the Armat–Edison Vitascope at Coster & Bial's Music Hall on 23 April was confined to America, for in Europe successful film performances were already well established by that time. In England, for example, regular performances were being given by Trewey and Paul to enthusiastic audiences, the former since 20 February and the latter since 19 March.

Evidently the advanced state of the English cinema had escaped notice in America and high hopes were being raised for the successful introduction of the Vitascope on the European market. The renowned juggler and equilibrist Paul Cinquevalli was prompted to come to London to explore the possibilities of exploiting the machine on this side of the Atlantic, a tentative price of $25,000 each being set for England and France. According to Terry Ramsaye, the great Cinquevalli sailed for England to get orders for the Vitascope before even a demonstration model was available.[1] The complete failure of the mission is attested to by the complete silence that ensued concerning its results.

A second attempt to breach the English market met with a trifle more response, but was equally doomed to failure. This time, Raff and Gammon, the controllers of the Vitascope, despatched Charles H. Webster with a machine in an attempt to obtain concessionaires for the apparatus in England.[2] The Vitascope was not to be sold, only leased.[3] When Webster arrived in London on 30 April it must have been with some disappointment that he found Lumière and Paul already firmly entrenched. Furthermore, the Vitascope was judged to be inferior to the home product. A correspondent for the *British Journal of Photography*, in an obvious reference to the apparatus, had this to say:

I went to see an apparatus that I understand was the outcome of Edison's inventive genius, and which was announced to be the steadiest extant, and, hoping to witness a decided improvement on what had been produced before, I must confess I was disappointed to find the results not equal to those obtained at the Empire and the Alhambra.[4]

If the Edison Vitascope was ever taken up in this country, I have yet to find a reference to it. The apparatus was not, of course, an Edison invention at all, but was patented by Thomas Armat.[5] It carried Edison's name only for commercial purposes. It was, however, manufactured at the Edison plant. When the relationship between

Edison and Raff & Gammon was abruptly terminated in November, it was also the virtual end of the Vitascope. Just eighty machines had been made and delivered,[6] but by this time, Edison already had a machine of his own ready for the market. It was called the Edison Projecting Kinetoscope, sometimes referred to as the Projectoscope. The Projecting Kinetoscope arrived in England sometime during November, and its arrival naturally sparked off a certain amount of curiosity. The *Photographic News* reported: 'We hear that a perfected instrument designed by Edison, for projecting "animated photographs" has reached this country and will shortly be placed on the market. It is said to work with absolute smoothness. We await its advent with much interest.'[7] The agents for the new machine were the London Phonograph Company, of 3 Broadstreet Buildings, Liverpool Street, London, who advertised it under the name Edison Projectoscope. Edison films were also advertised and stated to be 50ft and 150ft long.[8]

It was thus only towards the end of the year that the Americans began to infiltrate the English market and then only to a small degree. In fact, the Edison Projecting Kinetoscope appears to have been the only apparatus of American design and manufacture to have been used in England during 1896. Not so the following year, when the American impact on the English market began to be felt for the first time. This was the year when the great American Biograph first arrived,[9] to be followed by the Charles Urban Bioscope.[10]

The few foreign machines which were employed in England during 1896 were mostly of French origin. The first of these was, of course, the Cinématographe-Lumière which had its debut at the Marlborough Hall on 20 February. However, the Lumière machine was not for sale in this country until the following year, and until then was only leased. Exhibitors had to obtain a special concession for the area or country in which they chose to operate. Felicien Trewey, for example, held the sole rights in England. Two of the first French machines to become freely available on the open market were the Kinetographe De Bedts, and Clément & Gilmer's Vitagraphe.

Clément & Gilmer, of 8 and 10 Rue de Malte, Paris, were an old-established firm of manufacturing opticians whose optical lantern equipment was already well-known on the English market. Their Vitagraphe, or Vitagraph as it was advertised in England, was a duel-purpose apparatus which served as both camera and projector (65). It employed film of the Edison standard 35mm gauge. The illustration shows the complete apparatus mounted on its baseboard. The special large lantern and alum trough were supplied at extra cost. The high reputation enjoyed by the products of this firm was a sure guarantee of the Vitagraphe's worth and it was soon being employed in England.

Among the first to adopt the French machine was the popular minstrel show of Moore & Burgess, whose permanent home was St James's Hall, Westminster. The Vitagraphe was added to the

programme on 18 May, and special showings were also arranged at 3 and 8 o'clock.[11] During the temporary closure of the hall for redecorating, the Vitagraphe travelled with the show on tour. It opened for one night at Victoria Hall, Hoe Street, Walthamstow on 10 June. This was the first time films had been shown in this district.[12] An advertisement in the local *Guardian* announced 'the latest sensation Animated Photographs by the marvellous Vitagraphe'.[13]

It has not been established how widely the Vitagraphe was shown in England during 1896, but advertisements for the apparatus appeared in several of the English photographic journals.[14] A recorded performance at the Argyle Theatre of Varieties, Birkenhead, during September[15] seems to point to the fact that performances with the machine were fairly widely dispersed throughout the country.

The Kinetographe De Bedts (66) was one of the very first machines available for sale in France, and may have found its way to England even before the Vitagraphe, although it was not widely advertised in England until the latter part of the year. According to an advertisement in *The Optician* for 1 October, the apparatus had been on sale for the last six months,[16] which means that it was ready for the market sometime during April. Like the Vitagraphe, it served as a camera and projector. It was invented by G.W. de Bedts and patented in France on 14 January 1896 (French pat no 253195). A British patent was taken out in March.[17] The firm responsible for its commercial exploitation was the Anglo-American Photo Import Office, of 368 St Honoré, Paris, which was advertised as having 'the largest stock of films and largest printing and developing works on the Continent'.[18] However, by November an English agency had been opened called the Kinetographe Company, of 62 Romola Road, Herne Hill, London,[19] under the management of Archibald W. Rider, who had been for many years the secretary of the Eastman Photographic Materials Company.[20]

65 The Vitagraphe, made by Clement & Gilmer, Paris; a combined camera and projector introduced into England during 1896. The illustration shows the complete apparatus assembled for projection. *(Kodak Museum, Harrow)*

66 The Kinetographe de
Bedts, 1896, a combined
camera and projector invented
and patented by G.W. de Bedts.
This was one of the first
machines to be sold on the open
market. *Top:* the apparatus
converted for projection; *Bottom:* for use as a camera.
*(Barnes Museum of
Cinematography)*

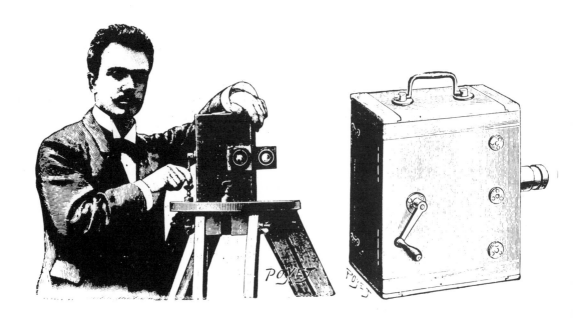

Some details of the de Bedts machine were published in the *British Journal of Photography* for 17 July. The taking rate was said to be five to eighty pictures per second, with a loading capacity of 100ft of standard 35mm film. It weighed 10lb and measured 8in x 8in x 6in. The price was £40, with a discount for the trade.[21] However, by November the price had been reduced to £20. An example of the apparatus is in the Science Museum, South Kensington (67).[22]

The one other French machine that we know reached the English market during 1896 was the Chronophotographe of Georges Demeny, made by L. Gaumont et Cie, of 57 Rue St Roch, Paris. But it arrived in this country probably too late in the year to have been in commercial use before the following year. It was, however, demonstrated before then and just qualifies for inclusion in this history. It used a special film 60mm wide, and employed the beater or 'dog' movement patented by Demeny in 1893. It was demonstrated on 9 December, at a meeting of the Photographic Club held at Anderton's Hotel Tavern in Fleet Street, which was the first time it had been shown in this country.[23] It was demonstrated again the following afternoon at the Empire Theatre.[24] The reports of its performance were most favourable and the *British Journal of Photography* judged

175

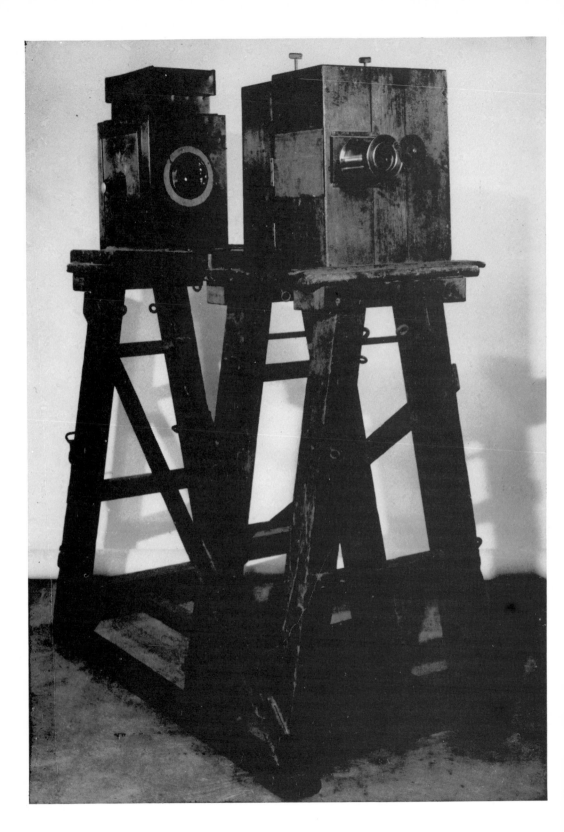

it to be 'the best, photographically and mechanically, that we have seen'.[25] An example of the apparatus is in the Kodak Museum at Harrow (68).

It is not possible to say whether the foreign machines which have been discussed in this chapter were the only ones to have been exhibited in England. It is probable that others were used here but have escaped notice. Not every machine was exhibited under its original name, and this makes identification difficult. The German Matchless Kinematograph Messter was advertised here during September and November,[26] but no reference to its having been exhibited in this country has been found, although it was shown in two or three countries on the Continent. It was invented by Osk. Messter, whose advertised address was the Institution for Optics and Mechanics, Friedrichstrasse 95, Berlin. In his autobiography, *Mein Weg mit dem Film*,[27] Messter admitted that he was influenced in the design of his machine by examining an imperfect imitation of a Paul projector. From sketches of this apparatus which Messter made at the time (reproduced in his book as illustrations 10 and 11) it appears that the projector which served as his model was a reconstruction of Paul's second Theatrograph (Mark 1).[28]

11 Royal Film Performances

Royalty showed an early interest in the cinema in England, and since the Royal Command Film Performance is still a yearly occasion in the British cinema, it may be as well to examine the roots of this typically British institution.

Until recent years, royal events provided a constant source of material for newsreels in this country, and this particular aspect of the national life has almost been too well covered to the exclusion of more significant events. It is probably true to say that royal interest in the new animated photographs was stimulated by R.W. Paul's film of the Prince's Derby of 3 June 1896, and which the Prince (later King Edward VII) himself came to see.[1] Henceforth, the Prince of Wales seems to have shown a keen interest in cinematography and it was by his command that the first royal film performance was given. This took place on 21 July, at Marlborough House. The Prince was also among the first of the royal family to appear on the screen when he and other members of the royal household were filmed by Birt Acres during a visit to the Cardiff Exhibition of Industry and Arts on 27 June. This event was filmed without the prior knowledge of the royal visitors and was secured by what would now be termed a candid camera. According to the *Amateur Photographer*, Birt Acres 'obtained permission to cut a hole in the exhibition walls, and through this pointed his peculiar camera full at the Royal party'.[2] A correspondent for the *Cardiff Western Mail* has left us a precise description of the contents of the finished film, which is well worth repeating here as it might be of help to film archivists in identifying the film should a copy still exist:

> The roadway, lined with troops, is first seen, and then Mr Robert Forrest is to be noticed walking across the foregound. Lord Windsor, in his mayoral robes, and Lady Windsor are also to be seen, and then, coming up the road, are shown the escort of Yeomanry and the carriages containing the Royal party. They are seen to alight, and are received by the mayor, when they move towards the Exhibition, and at this interesting point a 'Western Mail' representative, note-book in hand, is seen to rush across the road, but just as the audience is beginning to like him the series of photographs ends.[3]

What the reporter failed to notice, however, was that Birt Acres's candid camera had caught the Prince in the act of scratching his head. When the film was publicly shown, this incident caused quite a furore in the daily press and Birt Acres was referred to as a 'photographic fiend'.[4] He was thus goaded into writing a letter in reply, in order to try and allay the fuss caused by this frightful indiscretion. His own interpretation of that unprincely act undoubtedly helped to calm the

178

69 The Ross–Hepworth arc-lamp, invented and patented by Cecil M. Hepworth and manufactured by A. Ross & Co of London. It was used in Birt Acres's Kineopticon during the Royal Command Film Performance at Marlborough House on 21 July 1896. *(Barnes Museum of Cinematography)*

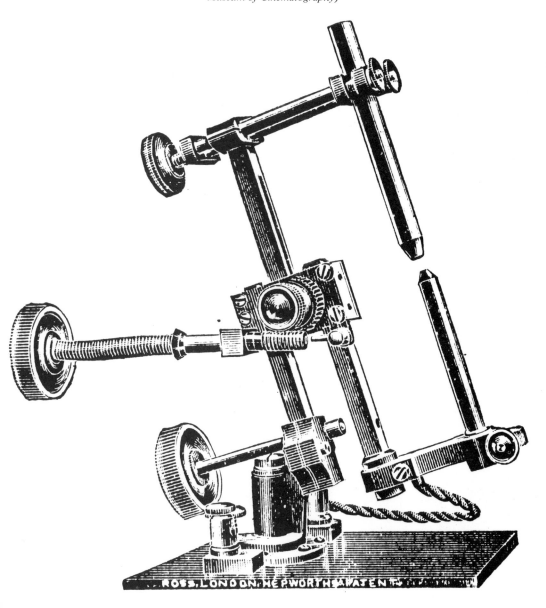

outraged royalists of Victorian England. He wrote: 'The allusion to His Royal Highness scratching his head is wrong, in fact the movement referred to is simply an elementary placing of the hand to the ear, probably to brush away an intrusive fly.'[5] Fly or otherwise, the incident provoked a great deal of merriment on the part of the royal audience when they witnessed the film at Marlborough House, as we shall note later.

Although Birt Acres had not obtained permission to film the royal visit to Cardiff, he nevertheless felt it prudent to send a request to the Prince, through his equerry Sir Dighton Probyn, for permission to show the film to the general public, with the result that he was invited to show the film, and others, at Marlborough House. The date chosen for the royal performance was the eve of Princess Maud's wedding. Birt Acres was assisted at the performance by Cecil M. Hepworth, whom he had brought along to operate the arc-lamp used in the Kineopticon projector, and which Hepworth had invented and patented the previous year (69).[6] The performance was a huge success and the resultant publicity more than compensated for the lack of success which the Kineopticon was experiencing in the commercial field. *The Era* reported the event enthusiastically in its issue of 25 July:

> By command of H.R.H. the Prince of Wales Mr Birt Aires [*sic*] attended at Marlborough House to give an exhibition of his 'Kineopticon' before H.R.H. and the Royal wedding guests on Tuesday, July 21st. A series of twenty-one beautifully executed photographs was exhibited by means of this wonderful machine. One which interested the Royal party more particularly was a view of the Prince and Princess of Wales, the Princesses Victoria and Maud, and their suite on the occasion of their recent visit to the Cardiff Exhibition, in which picture portraits of the Royal group were faithfully represented. This was loudly applauded and repeated. At the close of the entertainment H.R.H. complimented Mr Aires on the successful exhibit, and honoured him by a special permission to photograph the Royal wedding on the following day.[7]

The *Optical Magic Lantern Journal* also devoted a short paragraph to the performance,[8] but by far the most flattering account was given by the *Amateur Photographer*, which always made a point of favouring this inventor whenever the opportunity arose:

> Why Mr Birt Acres should be so extraordinarily modest in this brazen age of self-advertisement we know not. One hears of the 'Animatograph,' and similar names meaning the same thing, on all hands, and the phenomenon of moving photographs has become already familiar to many, and yet the public only knows indirectly of the existence of Mr Birt Acres and his really remarkable show—

we beg his pardon—it's the word 'show'. It is just because he dreads his 'kineopticon' becoming accepted by the unappreciative public as a 'show' instead of as a really remarkable scientific spectacle and entertainment that has kept Mr Birt Acres from blowing the trumpet a little more loudly. Well, who can blame him if one sympathises with the fond mother who flinches at making a public exhibition of a singularly handsome and talented child?

However, notoriety of a pleasing kind has now been thrust upon him, for last week Mr Acres met with Royal recognition, having had the honour to give an exhibition of his very wonderful invention at Marlborough House before their Royal Highnesses the Prince and Princess of Wales and their guests, the occasion being the dinner party on the eve of the Princess Maud's marriage to Prince Charles of Denmark.

The whole series of pictures were received quite enthusiastically, but the last view of the series—one might almost put it in the plural, for it consisted of *fifteen hundred photographs* ranged side by side on a strip of celluloid film eighty feet in length—merits special attention. It was taken at the opening of the Cardiff Exhibition by the Prince and Princess of Wales and the Princesses Victoria and Maud, by Mr Birt Acres. He obtained permission to cut a hole in the exhibition walls, and through this he pointed his peculiar camera full at the Royal party. The result was greeted with much enthusiasm by the Royal guests at Marlborough House. The easy gesture of the Prince and Princess as they alighted from their carriage raised much laughter; indeed, there was evidently something characteristic about it which escaped our untutored perceptions.[9] Royalty recognised themselves as they had never been portrayed before, the result being that this picture was most enthusiastically received, and as their Royal Highnesses were shown life-size on their screen, and the portraits were excellent, this last picture had to be repeated, although the programme was such a long one. The whole entertainment was a brilliant success, nor must one omit to award due praise to Mr Cecil Hepworth, whose electric arc lamp (known as the Ross-Hepworth lamp) supplied the necessary illumination, and did its work well and to the entire satisfaction of Mr Acres. At the conclusion H.R.H. the Prince of Wales personally thanked Mr Birt Acres for the exhibition.

The disc[10] thrown on the screen was, perhaps, the largest ever attempted in this class of work, measuring 11 ft by 8 ft. 6 in. Mr Acres obtained permission from H.R.H. the Prince of Wales to take kinetic photographs at Marlborough House on the following day (the wedding of the Princess Maud with Prince Charles), and succeeded in obtaining excellent pictures of the departure of the wedding party from Marlborough House, the return after the ceremony, and finally, taking up his position on the lawn at Marlborough House, obtained an excellent picture of the departure of the Royal couple for Sandringham. Mr Acres says that he

cannot speak too highly of the uniform kindness exhibited towards him by their Royal Highnesses, every facility having been granted to him to ensure satisfactory results.[11]

Both the *British Journal of Photography* and the *Photographic News* devoted considerable space to the occasion and each printed a list of some 75 royal guests present as well as the titles of the films shown.[12] The programme consisted of the following twenty-one subjects:

(1) Capstone Parade, Ilfracombe. (2) Children Playing. (3) Great Northern Railway—Departure of an East Coast Express. (4) The Derby, 1895. (5) Niagara Falls (in three tableaux): No. 1, The Upper River just above the Falls; 2, The Falls in Winter; 3, The Whirlpool Rapids. (6) The German Emperor Reviewing his Guard previous to the Opening of the Kiel Canal, June, 1895. (7) Carpenters' Shop Scene 'Refreshments'. (8) The Boxing Kangaroo. (9) The Arrest of a Pickpocket. (10) A Visit to the Zoo. (11) Yarmouth Fishing Boats Leaving Harbour. (12) Golf Extraordinary. (13) Tom Merry (lightning artist) drawing Mr Gladstone. (14) Tom Merry (lightning artist) drawing Lord Salisbury. (15) Boxing Match in Two Rounds by Sergeant Instructor F. Barratt and Sergeant Pope. (16) Highgate Tunnel. (17) Henley Regatta. (18) The Derby, 1896. Clearing the Course; the Preliminary Parade; the Race; Persimmon wins; the rush, intense enthusiasm, waving of hats, &c. (19) Broadway, New York. (20) A South Wester. (21) H.R.H. The Prince of Wales accompanied by T.R.H. The Princess of Wales, Princess Victoria, and Princess Maud, arriving at the Cardiff Exhibition, June 27th, 1896.[13]

The exhibition was given in a specially arranged marquee erected in the grounds of Marlborough House. At that time Marlborough House was supplied with electricity by two different electric light companies, by the St James's and Pall Mall with continuous current (DC), and by the City of London with alternating current (AC), both at about 100 volts. The DC supply was the one chosen for the performance as this was considered to give better results with the Ross-Hepworth carbon arc-lamp used in the projector. Direct current provided a steadier and brighter light and had, we are told, the added merit of being silent.[14]

The film of the royal visit to Cardiff had its public première at the Metropolitan Music Hall in Edgware Road, London, on 25 August. During the performance 'the orchestra played "God Bless the Prince of Wales," and at the close the audience loudly cheered the operator and his work'.[15] The man responsible for the presentation was Lewis Sealy. Sealy seems to have had a special working arrangement with Birt Acres as regards the commercial exhibition of the Kineopticon (or Royal Cinematoscope), probably owing to Acres's reluctance to undertake the role of showman himself which, one senses, he felt was

beneath his dignity. He therefore left this side of the business to a professional and preferred to remain in the background.

The royal film performance certainly influenced the future exploitation of the Kineopticon. We have already noted how the name of the apparatus was changed to the Royal Cinematoscope under Sealy's management, and how the royal films were advertised to boost the future sales of the projector. Even so, the Kineopticon never seems to have been quite successful in the commercial field and the lack of information concerning its construction remains a mystery.

The events connected with Princess Maud's wedding, on the day after the Royal Command Film Performance, were also filmed by R.W. Paul, but since no cameras could operate inside the Abbey, even had they been allowed to, the public had to be content with watching the 'Procession of Life Guards and State Carriages leaving Marlborough House'.[16]

Queen Victoria herself had always shown a keen interest in still photography and no doubt she was also curious about the new animated photography. Among the many official photographers who had taken her portrait was W. Downey of W. & D. Downey of 61 Ebury Street, London.[17] This establishment had already published numerous photographs of the queen and other members of the royal family, and, when the opportunity arose, lost no time in getting the queen to appear before the movie camera. It so happened that a Mr Harrison,[18] 'a valued assistant' who had been with the firm for the past fifteen years, had been employed since June 1896 upon the construction of a cinematograph camera of his own design, most of the work being carried out at the Downey establishment. Shortly after the completion of the camera, Mr Downey's son, a partner in the subsidiary firm of J. & F. Downey of South Shields, received the royal command to attend at Balmoral to take some still photographs of their Imperial Majesties the Emperor and Empress of Russia. It occurred to Mr Downey junior to take along with him the newly completed Harrison camera. After taking the still photographs required, he enquired of the queen whether he might also be permitted to take some animated photographs of the royal assembly. The royal assent being most graciously given, Her Majesty and the royal party withdrew for half an hour to enable Mr Downey junior to complete the necessary preparations. When all was ready, Mr Downey then commenced to turn a series of films of the royal family and their guests.

Among the distinguished personages who appeared in the films were Queen Victoria, the Emperor and Empress of Russia, the Duke and Duchess of Connaught, Prince Henry of Battenberg, the royal children at Balmoral, and Princess Victoria of Schleswig-Holstein, not forgetting some of the queen's favourite dogs. Whether or not these films are still extant is not known, but fortunately sections of the films were reproduced in facsimile, in fifteen strips, complete with perforations. They fill three whole pages of the special Supplement to

the *Lady's Pictorial* published on 5 December 1896 (70).

Naturally, the queen expressed a desire to see these films and accordingly a special performance was arranged to coincide with the tenth birthday of Prince Alexander, eldest son of Princess Harry of Battenberg.[19] The performance took place at Windsor Castle on 23 November. Father and son Downey were both in attendance since two different projectors were to be used during the performance, and the programme of films was shared between them. They were assisted by an able employee of Messrs W. & D. Downey named P.L. Pocock.

The series of films taken at Balmoral the previous month were much larger than the standard Edison gauge and had round perforations, eight to each frame, ie four on either side. They naturally required a special machine to project them and this was also supplied by T.J. Harrison, who had been responsible for the camera. If the account in the *Lady's Pictorial* is to be believed, this projector was completed only on the very morning of the scheduled performance. The other projector was a Paul Theatrograph and this was used to project the other films (nos 5-14) on the programme (45).[20] A series of lantern slides was also included, which were shown during the changeover from the Harrison machine to the Theatrograph, so preventing a tiresome interruption.

The following description of the presentation is quoted from the special Supplement to the *Lady's Pictorial*, which has also been the main source of information for the preceding paragraphs.

> The exhibition of the views at Windsor Castle was held in the Red Drawing Room, in the doorway of which, communicating with the Green Drawing Room (most thoughtfully placed at Mr Downey's disposal) a raised platform and the necessary screen had been erected. Her Majesty was accompanied by Her Royal and Imperial Highness the Duchess of Saxe-Coburg and Gotha, their Royal Highnesses the Duke and Duchess of Connaught and their children, H.R.H. Princess Christian, and H.R.H. Princess Henry of Battenberg with her children. Some forty or fifty of the ladies and gentlemen of the Royal Household were very graciously permitted to be present. The Queen was seated in an armchair with a small table near her, holding her opera-glass. On her Majesty's right hand was the Duchess of Saxe-Coburg, the Princess Henry of Battenberg being on the left. The Duke of Connaught sat immediately behind the Queen.
>
> Her Majesty was delighted with the animated photographs, and sent to know if it were possible to repeat the views, but upon it being explained that a repetition would necessitate a certain amount of preparation, was pleased to withdraw her request.
>
> Before leaving the Red Drawing Room, her Majesty despatched Lord Edward Pelham Clinton to summon Mr Downey to her presence, and in very gracious terms expressed her great satisfaction with the entertainment provided by him.

184

After her Majesty's departure, some of the young Royal children came behind the screen and displayed much curiosity as to the working of the views and the lighting of the same by electric light, and oxy-hydrogen.

The commercial value of royalty was fully appreciated in those days, as now, even by an embryo film industry, and the Downeys were not slow in issuing this advertisement the following week:

Downey's Living Photographs. Under the direction of Messrs. J. & F. Downey. A selection from forty subjects. Including those they had the honour of exhibiting before her Majesty the Queen and Court at Windsor Castle, on Monday, Nov. 23, 1896. Permanent address, 17 & 19, Eldon St., South Shields.[21]

R.W. Paul, whose apparatus and films had formed part of the programme, also cashed in and joined the following rider to his advertisements: 'Exhibited before H.M. the Queen at Windsor Castle'.[22]

Another early pioneer of cinematography in England, C. Goodwin Norton, gave a film presentation for the Empress Eugénie, wife of Napoleon III, on the occasion of her visit to Lord and Lady Pirbright, at Henley Park. Norton was well-known for his spectacular lantern entertainments which were shown with a magnificent triple lantern and comprised a series of dissolving views and other optical effects. He was also the author of a book on the subject entitled *The Lantern and How to Use It*, first published in 1895. It was reprinted several times thereafter, and a fourth, revised edition, appeared in 1912. During the latter half of 1896, Norton began to introduce films into his programmes, and a little later, probably early in the following year, started to make his own films.[23] Referring to the performance he gave for the Empress Eugénie, the *Amateur Photographer* informs us that she showed 'great interest in the films and machine which were explained to her in French by Lord Pirbright, who had previously mastered the details'.[24] Unfortunately, we are not told the make of the projector or the titles of the films shown, but most probably the apparatus used was the Vitagraphe, made by Clément & Gilmer of Paris, since an advertisement of Norton's, published in *The Era* on 23 January 1897 links his name with the apparatus, using the English derivative 'Vitagraph'.[25] His films were probably obtained from the same source.

As the year drew to a close, Birt Acres once more had an opportunity of turning his camera on the Prince of Wales, as *The Era* reported on 26 December:

A very interesting picture of his Royal Highness has been taken by Mr Birt Acres for his Royal Cinematographe, showing the Prince driving up and alighting from his carriage and bowing to the

spectators. The Dramatic and Musical Syndicate has taken this machine up, and it is attracting large houses in the provinces.[26]

Next year was Queen Victoria's Diamond Jubilee, and the cinematographers, whose ranks had by then increased considerably, were able to enjoy a field day. The procession was covered from almost every conceivable angle and even drew cameramen from abroad, who took up their positions alongside such pioneers as R.W. Paul, Birt Acres, David Devant, Alfred Wrench, Philip Woolf, the Fuerst brothers, Cecil M. Hepworth, and a host of newcomers.[27] In those fervent patriotic days, royalty was 'box-office', and the royal family, however inadvertently, played the star role until its place was eventually taken by the screen's own idols. There can be little doubt that royalty played a significant part in popularising the new medium and helped to draw an audience from all walks of life.

12 Film Production

The first films to be seen in England were those exhibited in the Edison Kinetoscope. From press reviews of the opening of the Oxford Street parlour on 17 November 1894 it is possible to establish the titles of some of the subjects which were publicly exhibited for the first time in this country; they include *Annabelle—Serpentine Dance, Barber Shop, Blacksmith Shop, Carmencita, Cock Fight*, and *Wrestling Match*.[1] Since ten machines were in operation, four other films must have been exhibited, but unfortunately their titles do not seem to have been recorded. However, a report in *Chambers's Journal* for 24 November refers to a further subject as a 'gymnast'.[2] This must obviously be one of two films showing Bertholdi, either *Bertholdi—Mouth Support*, or *Bertholdi—Table Contortion*.[3] These, then, were among the very first films ever exhibited in England. In succeeding months, they would have been replaced by other subjects, and with the opening of further parlours, almost the full range of Edison Kinetoscope subjects are likely to have been presented.

The first English films, too, were made for exhibiting in the Kinetoscope—those taken with the Paul–Acres camera in 1895. Some of these were publicly exhibited at the Empire of India Exhibition at Earls Court from 27 May to 26 October, for instance *The Oxford & Cambridge University Boat Race*, filmed on 30 March, and *The Derby* of 29 May.[4] Paul had installed fifteen of his own machines at the exhibition, but it is unlikely that all fifteen were showing the home product. Most probably some were Edison films since some of the latter were included in his early screen presentations.

It has not been possible to determine how many films were made by Paul or Birt Acres for the Kinetoscope, but it is safe to assume that all film production prior to March 1896 was undertaken for Kinetoscope exhibition. Thus when Birt Acres gave his first screen performance on 14 January 1896, he had to rely on films originally intended to be viewed in the Kinetoscope: *Boxing Match, Dancing Girls, The Derby, Rough Sea at Dover*, and *The German Emperor Reviewing his Troops*. The same applied to Paul's first screen projection, where the films shown included *Boxing Kangaroo, Rough Sea at Dover, Actors Rehearsing a Play*, and *Juan Caicedo*.

The chief defect of these early screen performances was that the films had been taken at the normal Kinetoscope speed of about forty or more frames per second and were projected at a considerably slower rate. This is the reason why the actions of the boxers, for example, were regarded by the audience as being too slow. The most successful subjects were those in which the normal movements of the scene could not be so precisely judged, such as sea subjects where the slowing down of the action of the waves tended to enhance the effect rather than detract from it. This accounts for the popularity of a film

such as *Rough Sea at Dover*, which was invariably singled out for praise whenever it was shown. One of the reasons why the Cinématographe-Lumière had the edge over all other machines was the fact that the taking speed was approximately the same as the projection rate. The Lumière films were made solely with projection in mind, and camera and projector were one and the same machine, which was a decided advantage at this stage of the cinema's development and accounts in large measure for the superiority of the Lumière performances.

The discrepancy between the taking and projecting rates did not go unheeded by either Paul or Birt Acres, for as soon as they had each achieved a practical method of screen projection and had abandoned Kinetoscope practice, they each designed cameras operable at rates suited to their projection apparatus. Even so, the old Kinetoscope films were not completely phased out for some time to come and such subjects as the Derby of 1895, for example, still retained a place in their programmes. However, a list published by Paul in November 1896 omitted all films previously made for the Kinetoscope with the Paul–Acres camera. By this time, of course, his output of films had increased considerably and the quality also had evidently much improved. Birt Acres, on the other hand, whose output of films was never large, continued to show the old product.

The construction of a practical cinematograph camera was not the only task which had confronted the English inventors; laboratory practice, too, had to be mastered. Furthermore, a supply of 35mm film had first to be obtained. Fortunately, suitable material was available from the European Blair Camera Co Ltd of 9 Southampton Street, High Holborn, London. By 1895 this firm was already advertising film in rolls and cut sheets, coated with rapid emulsion (71).[5] Blair was thus an obvious source of supply for the English film-makers.

The Blair Camera Company had been founded in America by T.H. Blair, who was born in Nova Scotia. He had started life as a farmer but gave up this occupation when his interests turned to photography. For a time he became a travelling ferrotype or tin-type worker, but growing tired of this itinerant life he set up business as a professional photographer in his home town. He then went to the United States where he took up the manufacture of dry plates in Cambridge, Mass. In 1880 he started making cameras and in the following year organised the Blair Camera Company, with a capital of $7,500. Thereafter the company was engaged in the manufacture of a wide range of photographic goods, which included cameras, lenses, dry plates, film, chemical preparations, etc. In 1893 Blair came to England and set about forming the British company.[6] This was to be known as the European Blair Camera Co Ltd, and was soon destined to play a historic role in the beginnings of the cinema in England.

When Paul and Birt Acres began their first experiments, it was to the Blair company that they turned for their supply of film. 'The

189

Advts.]

BLAIRS

In rolls or cut sheets

FILM

In cut sheets, coated with a **rapid emulsion** by the process which has proved so superior in producing **Blair's Film** in rolls, are now ready.

The base is of the thickness usually employed in making cut sheet fi m, and, to give users a choice, two brands are made – the "Ground Glass Surface Brand" (like **Blair's Film** in rolls), and the "Transparent Brand," which are as transp arent as glass

The following extracts from recent letters will explain the reason of the increasing popularity of our film :

"I may add that during my stay of 5 weeks I had but 7 days in which I could photograph. During these 7 days I made over 200 exposures on your film; of these I have now developed 78, of which only 5 were failures, owing to over-exposure. The rest are all good—some exceptionally so."

"Will you kindly forward me your price list of appliances and films. I have tried your film in a 5×4 camera, and am in every way satisfied with it."

"A friend of mine is loud in the praises of your film and is trying to persuade me to use it. Kindly let me know if you have the film on the roll $3\frac{1}{4}$ wide for $\frac{1}{4}$ plate roll-holder, also length, and price."

Prices from dealers everywhere, or from

The European Blair Camera Co., Ltd.,
9, Southampton Street,
High Holborn, London, W.C.

Continental Agency: 368, Rue St. Honoré, Paris.

European Blair Co., of London,' Acres later recalled, 'supplied me with the films that I used in England; in fact, as the Blair Co. can testify, the very first strip of film they ever cut for this purpose was cut to my order.'[7] A statement of Paul's also confirms the use of Blair film, although he states that Eastman film was also used: 'Film stock, with a matt celluloid base, was procurable from Blair, of St Mary Cray, Kent. For negatives, Kodak film having a clear base was preferred.'[8] Whether Kodak film was in fact used at this time is open to question. Paul's statement certainly refers to the Kinetoscope era,[9] that is during 1895 when he and Birt Acres were producing films for the replica Kinetoscopes which Paul was then manufacturing. But in a letter dated 24 September 1897 and published in the *Amateur Photographer* Birt Acres wrote that he had approached the Eastman Company at the beginning of 1896 and suggested that there was going to be a demand for this class of film, but was informed that it would not be worth their while to manufacture it.[10] Paul's statement concerning the matter was made in 1936, whereas Acres was writing a year or so after the event described. He was, moreover, emphatic about Blair's priority in supplying film for cinematographic purposes in this country, and in the letter just referred to stated: 'I have no interest whatever in the Blair Co., but as priority is considered of importance in all new inventions and applications, I think it only fair that they should take whatever credit is due to them.'

If the Eastman Company considered it not worth their while to manufacture cinematograph film at this period, they had certainly changed their policy by June, as is evident from the following statement which appeared in the *Photographic News* for that month: 'We are informed that the Eastman Company are experiencing a strong demand for the lengths of celluloid ribbons, coated with gelatine emulsion, that are used for making Kinematographic negatives and positives.'[11] Of course, by this time film projection was getting into its stride and film-making had prospects of becoming a lucrative business. Indeed, before the year ended several firms were engaged in the manufacture of cinematograph film. In November Blair were advertising 'Film for animated photographs. Matt for negatives, transparent for positives ... in any length up to 120 feet without joins'.[12] In the same month, Fitch & Co, of Seldon House, Fulwood's Rents, Holborn, were advertising cinematograph film 'ready perforated, Edison gauge ... very perfect and yields strong contrasts, being at the same time exceedingly transparent'.[13] A Swiss film, put out by Dr J.H. Smith & Co of Zurich, was also being advertised in November;[14] whereas the Celluloid Co, of New York, suppliers of the raw stock, were represented in England by S. Guiterman & Co, who advertised 'rollable film, as used in the Cinematograph and similar instruments. 3/1000 in. thickness, 20 and 22 in. wide in lengths of upwards of 500 feet, from 3/- per yard. Transparent and semi-transparent'.[15] Birt Acres, too, became a manufacturer of cinematograph film at his Northern Photographic Works at Hadley,

which he had established in January 1896. An advertisement of November gives the following particulars of the firm's activities:

> Birt Acres' animated photographs. Inventor and manufacturer of noiseless apparatus for photographing, printing, developing & projecting these marvellous photographs . . . also manufacturer of special sensitive film. Guaranteed accurate width; seasoned celluloid, transparent (does not frill) lengths up to 300 ft., without join, perforated or plain.[16]

Although the Kinetoscope had created a need for long strips of sensitised film, it was the coming of film projection which had stimulated its production. The film required for projection needed to be more transparent than that used for the Kinetoscope, but in other respects no changes were necessary and the Edison 35mm Kinetoscope film set the standard for projection. The Kinetoscope also influenced the length of the English films made for the screen. Since film production in England had originally been geared to Kinetoscope exhibition, the Paul–Acres camera was constructed to take lengths of about 40ft, which was the capacity of the standard Edison Kinetoscope machine. Even after the Kinetoscope had been abandoned in favour of projection, films were still being made 40ft long. Paul in particular continued to produce his films in this length, and when a certain subject required additional footage it was increased to 80ft and advertised in his catalogues as 'double length'. All Paul's films up to the end of 1896 were either 40ft or 80ft long and those made in 1897 were never more than triple length, ie 120ft. However, the films made by Birt Acres independently of Paul were said to average 40–60ft.[17]

It is interesting to note that a film measurer dating from this period and now in the Barnes Museum (72) is calibrated to 100ft, this length evidently being considered quite sufficient for measuring the majority of films then in use. Films exceeding this length were being made in France, however, where the number of films being produced was greater than in any other European country. The French product was also considered to be superior in content[18] and it is probably true to say that film production in France was ahead of any other country in the world at this time. Philipp Woolff, who was shortly to become the largest distributor of films in England, issued a catalogue in December which listed about 200 subjects, the majority of which were of French make and averaged about 75ft in length.[19]

In the Kinetoscope, the film was not spooled but was wound in a series of loops over pulley wheels and joined at its ends in an endless loop. Some American projectors (eg Edison's Projectoscope and the Lubin Cineograph) adopted the spool-bank idea, but the method does not appear to have been used with any English-made machine. The short lengths of film were usually rolled and suspended on a horizontal spindle or completely enclosed in a box. Spools were used

only when the film exceeded the normal length, or when several subjects were joined together, but then not all projectors could accommodate such a quantity of film.

We have already had occasion to mention the perforating of the film, and there is little to add to what has been said. It was a most important factor in film production, for upon it depended the successful registration of each frame on the screen. Faulty perforating was the cause of much of the unsteadiness of the picture, a criticism too often levelled at the early film shows. Once the film had been perforated and exposed in the camera, it had to be processed or developed. Paul in his lecture to the British Kinematograph Society outlined the procedure he employed: 'For development the forty feet of film was wound on a birch frame with spacing pegs. Horizontal or vertical troughs held the solutions and washing water. At first, drying was done in festoons, but a little later on light wooden drums.'[20] Talbot gives a more precise description of Paul's method:

He took a light, square wooden frame ... which rested loosely upon two uprights in such a way that it could revolve. The free end of the film was fixed to one side of the frame, and the film was then

72 A 35mm film measurer, c1896. The dial records a maximum of 100 ft, since films at that period rarely exceeded that length. *(Barnes Museum of Cinematography)*

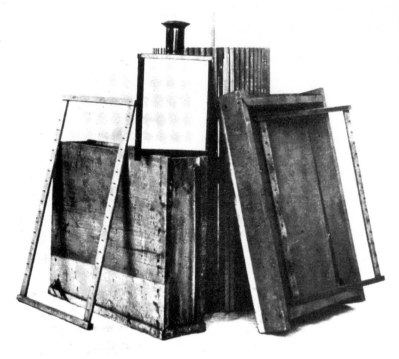

passed from one side to the other, as if being wound upon a wheel, as it was uncoiled from the spool, the inner end of the film being likewise secured to the frame. This rack was dipped first into a vertical tank to soak the film, and then was placed in a flat tank or trough to be developed in the same way as an ordinary glass plate. By this means every part of the exposed surface was developed equally. Development carried to the requisite degree, the frame was withdrawn, washed, and finally immersed in the fixing tank, which was of the same horizontal design. When the image was fixed it was placed in another tank and received a thorough washing, to remove all traces of the fixing solution, as in the ordinary developing process. This task completed, the film was uncoiled from the flat rack to be re-coiled upon a wooden drum, which was suspended from the ceiling in the drying chamber, until the film was dry and hard.[21]

Paul's complete developing and drying outfit is illustrated (73).[22]

After the negative had been processed, a positive print had to be made for projection purposes. With the Cinématographe-Lumière, the same apparatus served as camera, printer and projector, but Paul and Birt Acres both chose to relegate each process to a separate machine. A printer used by Paul in 1896 is now in the Science Museum (11). The action is continuous and is hand driven. The negative and blank film are fed together from their respective spools over a single sprocket-wheel which is rotated by a hand-crank. The

emulsion sides of the film are face to face and pass in close contact behind a small metal printing frame with a narrow slot, situated immediately in front of the sprocket-wheel. When in use, the opening is illuminated by an incandescent gas lantern (not shown in the illustration), the length of exposure depending on the intensity of light and rate of movement of the film. A second spindle is provided by which the machine may be driven at a much slower rate. Paul states that the sprocket was turned by hand at a speed judged by the operator, who inspected the negative as it travelled past a beam of red light.[23]

Birt Acres also had his own developing and printing equipment which he says was exclusively designed by himself and made on his own premises,[24] but no particulars concerning it seem to have been published. Processing and printing were part of the services offered by his Northern Photographic Works which he had established at the beginning of 1896 and which was almost exclusively devoted to cinematographic work.[25] Much of his time must have been expended upon this business and it is hardly surprising that his film-making activities suffered accordingly. His output of films during this period was small. He was also, of course, constantly travelling about the country giving lectures and exhibitions with his Kineopticon. Paul, on the other hand, concentrated his attention on manufacturing equipment as well as film production, but his laboratory work seems to have been confined to his own needs.

13 Conclusion

During this formative period of the film's history, the creative poten-
tialities of the medium were naturally overlooked and the sole pur-
pose of the camera was to record, as faithfully as possible, the action
that appeared before it. Its function was simply to photograph the
scene within the field of view, like a series of still photographs, which
then became animated when subsequently viewed as a series of con-
secutive phases of movement. The term 'animated photographs',
which was commonly applied to these moving pictures, was indeed
most apt, for this is precisely what they were. No attempt was made to
move the camera during shooting or to alter the viewpoint. Each
scene was simply recorded with a static camera. The only movement
was that supplied by the scene itself.

If we examine the content of British films made during the period
1895–6, we find that they all conform to this pattern. The only distinc-
tion which can be drawn between them is that some of the subjects
were specially staged for the camera, whereas others were actual
scenes or events which the camera happened to record. Their merit
relied almost entirely on choice of subject-matter, not on treatment.
The more interesting the subject, the more successful the film. There
was no creative process involved, except that some films were
photographed better than others.

The Edison Kinetoscope films set the pattern in England as far as
staged subjects were concerned, and vaudeville acts supplied the bulk
of this material. The 'Black Maria' production of *The Boxing Cats*
had its counterpart in England in *The Boxing Kangaroo*, and so on.
But the Paul–Acres camera had a decided advantage over the
Kinetograph in that it was more portable. The Kinetograph, because
of its bulk and the fact that it was electrically driven, was chiefly
confined within the 'Black Maria' studio, whereas the English camera
was free to roam the streets or to be set up in the most unlikely places.
This was one of the reasons why *Rough Sea at Dover*, when presented
at Coster & Bial's Music Hall in New York, was so refreshing to
American audiences, who until then had witnessed nothing but
staged acts usually derived from the vaudeville theatre.

The English film-makers certainly concentrated more on 'ac-
tualities' than on 'made-up' films, but in this respect they were follow-
ing the French. It cannot be denied that the Lumière films in par-
ticular had a marked influence on British film production, and some
of the more successful of their films were imitated. For example
Arrivée d'un Train en Gare obviously prompted Paul to set off on an
excursion to film a similar subject. As the *Photographic News*
reported: 'Last Sunday [May 1896] he was to have made a special
journey to Calais for the purpose of getting a train subject. English
railway stations, being more or less covered in, are difficult to take at
the comparatively rapid exposures required.'[1] The resultant film was

Arrival of the Paris Express at Calais (Maritime) and passengers disembarking. Birt Acres, too, was equally influenced and his film called *A Surrey Garden* was virtually a remake of the famous *L'Arroseur Arrosé* in which a boy steps on the garden hose and releases it just as the head-gardener is peering into the nozzle, with the inevitable consequences.

It would be wrong to suppose that the English film-makers had nothing to contribute of their own. As regards film reportage they were probably in the forefront. Topical events such as the Boat Race, Derby, Lord Mayor's Show and events connected with royalty were consistently covered, and the speed with which the Derby of 1896, for example, was made available for public exhibition within twenty-four hours of the event was remarkable and presaged the birth of the news film. The variety of subject-matter is also noteworthy, as a glance at the film titles appended to the present work will testify. There was also an awareness of the value of such films to future generations and there was talk of providing a repository, or film archive, for preserving them. On this topic *The Era* published the following paragraph:

Mr R.W. Paul began his experiments in animated photography in a scientific spirit, and was, maybe, a little surprised to find himself plunged into the vortex of professional life. He still hopes to give the animatographe a value apart from its entertaining quality, and offered the authorities of the British Museum a series of films recording events of to-day, which he thought would be greatly appreciated a century hence. The suggestion was received with delight by the museum authorities as a body. Then arose a question as to the particular authority concerned. The film was neither a print nor a book, nor—in fact, everybody could say what it was not; but nobody could say what it was. The scheme was not exactly pigeon-holed. The real trouble was that nobody could say to which particular pigeon-hole it belonged![2]

According to a report in the *Amateur Photographer* for 19 February 1897, it was ultimately decided that films should go to the Print Room of the British Museum.[3] Could it be that somewhere in the store-rooms of the British Museum a hoard of forgotten film negatives lies awaiting discovery? Frankly, it seems unlikely. Paul himself later disclosed the fate of his own negatives:

By 1910 the expense and elaboration necessary for the production of saleable film had become so great that I found the kinematograph side of the business too speculative to be run as a sideline to instrument making. I then closed it down and destroyed my stock of negatives, numbering many hundreds, so becoming free to devote my whole attention to my original business . . .[4]

Another interesting proposal was to use film in place of painted

197

scenery in the theatre, to which the *Amateur Photographer* replied: 'All we can say is that until a somewhat less noisy machine has been invented than those at present in use we hardly think Sir Henry Irving is likely to entertain the idea.'[5] But the idea was not quite so far-fetched as it may seem, and something on these lines was attempted in the theatre before long. A case in point was the 1899 Drury Lane production, *Hearts are Trumps*.[6]

There were some who regarded the new animated photographs as a passing fad and could see no future in the invention. A consistent propagator of this point of view was a professional lanternist who was soon to become a prominent British film producer, Cecil M. Hepworth. He wrote:

> That the present boom in these animated palsy-scopes cannot last for ever is a fact which the great majority of people seem to be losing sight of altogether, yet it is only common sense that it will not be very long before the great British Public gets tired of the uncomfortably jerky photographs. Living photographs are about as far from being things of beauty as anything possibly could be, and they ought not to be expected to be joys for ever.[7]

After several similar tirades against the new medium, which need not be quoted, Hepworth finally admitted his mistake. In his regular column for the *Amateur Photographer* he was at last forced to write:

> More than once I have aired the opinion in this column that animated photography is getting played out. That I was utterly and hopelessly wrong in so soliloquising is now proved—or nearly proved. A few days ago a new company was brought out under the title of 'Paul's Animatographe, Limited,' with a capital of £60,000. The profits on the business which the company have brought over for the period from March, 1896, to the same month in the present year [1897] were £12,838 15s. 4d. and the estimated profits for a similar period in the future are £15,000 per annum! So, you see, animated photography is *not* played out by any means.[8]

Before this volte-face, Hepworth had supposed that the high cost of films would be a contributing factor to the ultimate demise of animated photography:

> If the living photographs do not die a natural death the thing that will kill them will be the price of the films. At the present writing, the very lowest at which a kinetoscopic film can be bought is £3, and from their nature it is hardly likely that this cost will ever be very materially reduced.[9]

These words appeared in November 1896 and at that time films were bought outright. No one had yet come up with the idea of a film

renting system. Such a scheme still lay in the future, and before that came about, films, as they increased in length, were to be sold at so much per foot. But during the period under discussion the general practice was to sell the complete film at a set price. Hepworth's figure of £3 seems to have been the normal rate for films of about 40ft. The *Photographic News* for 22 May reported that 'Mr R.W. Paul, we believe, charges £100 for his Theatrograph, and £3 apiece for the pictures.'[10] Despite Hepworth's forebodings, Paul managed to do very nicely according to the figures quoted above, even if the price of his films was considered by Hepworth to spell disaster. Hepworth was obviously still thinking in terms of ordinary still photography and overlooked the fact that a few films could soon recoup their cost, in addition to making a handsome profit by being exhibited time and again to paying audiences until each film virtually reached the end of its practical life.

If the name of Paul seems to have dominated these pages, it is because he was far and away the most important figure in the early history of the cinema in England. His inventive genius supplied him with the tools of his trade, and his imagination and foresight enabled him to lay the foundations of the British film industry. In August 1896 he was able to boast of his Theatrograph that 'during the last five months no other apparatus (except Lumière's Cinématographe) has stood the test of appearing at a London Hall'.[11]

Robert William Paul was born at Highbury, London, in 1869, and educated at the City of London School and at Finsbury Technical College. Before starting business on his own in 1891, he had worked in the electrical instrument shop of Elliott Brothers in the Strand, where he obtained a practical knowledge of instrument-making. Apart from his cinematographic work, he specialised in electrical measuring instruments and in 1903 invented a moving-coil galvanometer in which the coil was supported at its centre of gravity on a single pivot. He called it the 'Unipivot' and its sensitivity was far beyond that of any pivoted galvanometer then in existence. Remarkable as were his achievements in the field of cinematography, he seems to have regarded this side of his business as of only secondary importance. His main concern was producing instruments to meet the ever-growing demands of the electrical industry, and in this he was remarkably successful. In 1920 his business was amalgamated with Cambridge Scientific Instruments Ltd which still flourishes. He died on 28 March 1943, at the age of 74. In his will he left industrial shares valued at over £100,000 to form a trust to be known as the R.W. Paul Instrument Fund administered by the Institution of Electrical Engineers, of which he had been a continuous member since 1887. The income from the fund was to be used primarily for the provision of instruments of a novel or unusual character to assist physical research.[12]

Next to R.W. Paul the name of Birt Acres is dominant in the pages of this history. He was quite a different character from Paul, and

although he did not possess Paul's genius he nevertheless made a significant contribution to the British film. His attitude to films was rather that of the amateur and it is hardly surprising that his most successful technical achievement was the Birtac which was specifically designed for amateur use. His place in the history of the British cinema is assured, however, for he has the distinction of being the first in England to achieve screen projection, and was, besides, England's first cameraman.

Birt Acres was born on 23 July 1854, in Virginia, USA, of English parents, and came to England in the 1880s.[13] He showed an early interest in photography and was for a time the manager of Elliott & Son, of Barnet, manufacturers of the well-known photographic dry plates. In 1892 he was elected a member of the Royal Photographic Society and was admitted a Fellow in 1895. He was thus an experienced photographer before his attention was directed to cinematography through his association with Paul. Paul supplied the technical knowledge and Acres the photographic expertise and together they produced England's first films. Following in their footsteps came the other pioneers whose names and achievements have been recorded in this book.

Appendix 1

British Films 1895–6*

The only previous attempt to catalogue the British films for the years 1895 and 1896 was made by Denis Gifford in his monumental work *The British Film Catalogue 1895–1970*. Here, however, he confined himself to 'entertainment films', by which is meant those subjects specially enacted for the camera. Without in any way wishing to denigrate such an admirable work, it is necessary to point out that my own list is sometimes at variance with Mr Gifford's. This is not to imply that my own is free from error or omissions, but rather to point out that this early period of the film's history is still open to serious study. Unfortunately, the necessary material required to complete such a task is for the most part scattered, lost, or non-existent, and it therefore seems very unlikely that every film made during the period under discussion will ever be traced, or accurately dated. The films themselves have rarely survived, although a few are preserved in the National Film Archive and are listed in Parts 1–3 of the published catalogue. Here, however, there is some confusion regarding the classification of subjects and there is need for a more rigid definition of terms. The National Film Archive Catalogue is divided into three parts: Silent News Films, Silent Non-Fiction Films, and Silent Fiction Films. In several instances, one finds a particular film listed in one or other of the parts to which it clearly does not belong. To take an example, *Visite sous-marine du 'Maine'*, a film made by Georges Méliès in 1898, is listed as a non-fiction film, whereas it is obviously a studio-made film in the Méliès style, enacted against painted scenery. The fact that it supposedly represents an actual incident in Cuba surely does not qualify it for inclusion in the non-fiction class. There are more than twenty-five similar instances in this part of the catalogue alone. Some agreed classification system is thus called for, and I offer the following definitions for consideration:

NEWS FILM	A cinematographic record of a particular historic event, happening at a precise time and date irrespective of the camera's presence. The term 'news film' is itself inadequate; maybe 'chronicle' would be better.
NON-FICTION FILM	A film using as its subject actual scenes, events, or processes of a general kind, which have not been expressly devised for recording on film. Perhaps 'actuality' would be a better term.
FICTION FILM	Subject-matter expressly devised for the purpose of the film, even if the subject is based on an actual event.

There should be a separate class for scientific films.

In the list below, each film has been classified according to these definitions and designated with the appropriate letters in square brackets, thus: [N] news film; [N-F] non-fiction film; [F] fiction film. It should be noted that films at this period carried no main title, and the titles under which the films are listed are therefore arbitrary.

* The majority of the films listed in this appendix are more fully described in the text; the reader is referred to the index for the appropriate pages.

Paul-Acres

Listed under this category are the films made with the Paul–Acres camera. Most, if not all, were turned by Birt Acres, but in other respects they may be regarded as the joint production effort of R.W. Paul and Birt Acres. These films were specifically made for Kinetoscope exhibition and accordingly were each approximately 40ft long and photographed at the rate of about forty frames per second. It has not been established how many films were shot with this camera, but the twelve listed below probably represent the more important of them. It is reasonable to assume that all were made during the period February–June 1895, and were probably first publicly exhibited in Paul's Kinetoscopes at the Empire of India Exhibition, Earls Court, between May and October of that year. Many were subsequently used for screen projection, and the fact that both Acres and Paul included them in their performances is a fair indication that they were indeed made with the Paul–Acres camera.

1 *Cricketer Jumping over Garden Gate* (February) [F]
Trial film. Section preserved in the Will Day Collection, item No 300.
2 *Incident Outside Clovelly Cottage, Barnet* (March) [F]
First successful Kinetoscope film made in England. Sample strip enclosed with letter sent by Paul to Edison, dated 29 March 1895; now in the Edison Museum.
(Illustrations 6, 8 and 74)

74 *Incident Outside Clovelly Cottage, Barnet,* the first successful Kinetoscope film made in England, photographed with the Paul–Acres camera in March 1895. *(Kodak Museum, Harrow)*

3 *Oxford and Cambridge University Boat Race* (30 March) [N]
According to Paul, this was their first saleable Kinetoscope film.
4 *The Derby* (29 May) [N]
Clearing the course; preliminary canter; race and crowd surging over course.
(Illustration 75)

5 *The Boxing Kangaroo* (month uncertain) [F]
 Boxing bout between a kangaroo and a man.
6 *Boxing Match* (month uncertain) [F]
 Boxing bout in which each competitor is floored.
7 *Carpenter's Shop* (month uncertain) [F]
 With one of the thirsty souls taking a pull at a pewter.
8 *Dancing Girls* (or *Skirt Dancers*) (month uncertain) [F]
9 *London Street Scene* (?) (month uncertain) [N-F]
 One or two street scenes may have been taken, but no specific subject
 has been identified.
10 *Rough Sea at Dover* (month uncertain) [N-F]
 Waves breaking over Admiralty Pier.
 Negative and print in the Science Museum, South Kensington.
 (Illustration 24)
11 *Tom Merry, Lightning Cartoonist, Sketching Bismarck* (month
 uncertain) [F]
12 *Tom Merry, Lightning Cartoonist, Sketching Kaiser Wilhelm II* (month
 uncertain) [F]
 Original negative in the Science Museum, South Kensington.
 (Illustration 23)

Birt Acres

Sometime in June 1895 Birt Acres parted company with Paul and
embarked on an independent course of film production, equipped with his
own Kinetic Camera. During the next twelve months, this camera obviously
underwent several modifications and it seems almost certain that he
replaced the unsatisfactory intermittent mechanism of the original with a
more practical device borrowed from some other source. The original

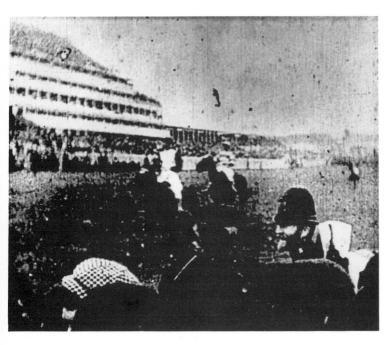

75 Unidentified film of the
Derby, possibly the Derby of
1895, photographed by Birt
Acres with the Paul–Acres
camera. *(National Film
Archive)*

76 *The Kiel Canal:* frame enlargements of two sections of the film made by Birt Acres in June 1895. Note the abrupt change in the position of the head of the man in the right-hand section, showing that the film was taken at a slower speed than the optimum sixteen frames per second required for normal motion and an indication of the inadequacies of the Kinetic Camera used by Birt Acres at this time. *(National Film Archive)*

Kinetic Camera appears to have been a hit-or-miss affair, since he seems to have managed to take only one reasonably successful film with it, *The German Emperor Reviewing His Troops.*

After the break with Paul, Acres's film production practically ceased until March of the following year. Even then, his output of films was sporadic and it was not until June that a more regular supply of films began to appear. The weather, of course, may account for a slackening off of production during this period, but it seems probable that the cause was equally the need for a more practicable camera.

No catalogue of Birt Acres's films appears to have been published, but the titles of many of them are to be found in various reviews and printed programmes. Although his output of films was less than Paul's, his subjects are just as varied. He seems to have been the first in England to attempt a simple dramatic photoplay, with his film *Arrest of a Pickpocket*, which was probably made during March 1896. He also made at least two comedies, *Golfing Extraordinary*, and *A Surrey Garden*. However, he seems to have been more concerned with recording the topical events of the day, with a penchant for royalty. Exact dating of many of his films is not possible from the available evidence, and in some cases the month cited must be regarded as tentative. The earliest known reference to the film is the one given. Unless otherwise stated, the length of each film averages 40–60ft.

1895
1 *The Kiel Canal* (June) [N]
 Opened 20 June by Kaiser Wilhelm II.
 Original negative in the Science Museum, South Kensington. Print in the National Film Archive (N3).
 Ref *British Journal of Photography*, 13 March 1896, p 173.
 (Illustrations 25 and 76)
2 *The German Emperor Reviewing his Troops* (June/July) [N]
 Filmed during the ceremonies attendant on the opening of the Kiel Canal.
 Ref *Amateur Photographer*, 24 January 1896, p 75.

3 *Arrest of a Pickpocket* (March) [F]

The first dramatic photoplay made in England.

Ref *British Journal of Photography*, 27 March 1896, p 202.

4 *Street Scene (?)* (March) [N-F]

This may be one of the London street scenes made in 1895 with the Paul–Acres camera.

Ref *British Journal of Photography*, 27 March 1896, p 202.

5 *A Visit to the Zoo* (March) [N-F]

Ref *British Journal of Photography*, 27 March 1896, p 202.

6 *The Derby* (3 June) [N]

Clearing the course; the preliminary parade; the race; Persimmon wins, the rush, intense enthusiasm, waving hats, etc.

Ref *Photographic News*, 7 August 1896, p 503.

7 *T.R.H. The Prince and Princess of Wales Arriving in State at the Cardiff Exhibition* (27 June) 80ft. [N]

Ref *The Era*, 25 July 1896, p 14.

8 *Henley Regatta* (7-9 July) [N]

Showing the river crowded with boats.

Ref printed programme in the National Film Archive.

9 *Children Playing* (June/July) [N-F]

Romping with two nurses.

Ref *Photographic News*, 7 August 1896, p 503.

10 *Great Northern Railway—Departure of the East Coast Express* (June/July) [N-F]

Ref *Photographic News*, 7 August 1896, p 503.

11 *Highgate Tunnel, with the Passage of a G.N.R. Luggage Train* (June/July) [N-F]

Ref *Photographic News*, 7 August 1896, p 503.

12 *The Capstone Parade—Ilfracombe* (June/July) [N]

Ref *Photographic News*, 7 August 1896, p 503.

13 *Yarmouth Fishing Boats Leaving Harbour* (June/July) [N-F]

The boats are towed by tugs, leaving in their wake a mass of foam.

Ref *Photographic News*, 7 August 1896, p 503.

14 *Yarmouth Sands* (June/July) [N-F]

Ref printed programme in the Will Day Collection, item No 464.

15-21 *Military Tournament* (June/July) [N]

Approx. 1,000ft. Comprising the following subjects:

15 *Sword v. Sword*

16 *Sword v. Bayonet*

17 *Boxing Match*

18 *Cleaving the Turk's Head*

19 *Mounted Mule Battery*

20 *Maypole Dance*

21 *Mounted Quadrille*

ref *Cardiff Evening Express*, 3 September 1896.

22 *Boxing Match, or Glove Contest* (June/July) [N]

Two rounds between Sergeant-Instructor F. Barratt and Sergeant Pope. Possibly one of the films taken at the Military Tournament: No 17 *Boxing Match*.

Ref *Photographic News*, 7 August 1896, p 503.

23 *Lancers on Horseback* (June/July) [N]
Dancing the 'Lancers' on horseback.
Possibly one of the films taken at the Military Tournament: No. 21
Mounted Quadrille.
Ref *Barnet Times*, 30 October 1896.

24 *Golfing Extraordinary—Five Gentlemen* (June/July) [F]
Golfing comedy.
Ref *Photographic News*, 7 August 1896, p. 503.

25 *Tom Merry, Lightning Cartoonist, Sketching Gladstone*
(June/July) [F]
Ref *Photographic News*, 7 August 1896, p 503.

26 *Tom Merry, Lightning Cartoonist, Sketching Salisbury* (June/July) [F]
Ref *Photographic News*, 7 August 1896, p 503.

27 *Princess Maud's Wedding* (22 July) [N]
Departure of the bride from Marlborough House; return to
Marlborough House after the wedding; departure of the bride and
bridegroom for Sandringham.
Ref *The Era*, 12 September 1896, p 18.

28 *Cycling in Hyde Park* (August) [N-F]
Ref *The Era*, 5 September 1896, p 28.

29 *A Surrey Garden* (August) [F]
Comedy. Reminiscent of Lumière's *L'Arroseur Arrosé.*
Ref *The Era*, 12 September 1896, p 18.
A film in the National Film Archive, called *A Joke on the Gardener*,
may be the same film, although ascribed in the Catalogue to Bamforth, and
dated 1900.

30 *A Corner of Barnet Fair* (August) [N-F]
Showing roundabouts in operation and people moving about.
Ref *Barnet Times*, 30 October 1896.

31 *Finsbury Park Station* (October) [N-F]
Ref *Barnet Times*, 30 October 1896.

32 *Pierrot and Pierette* (October) [F]
Ref *The Era*, 31 October 1896, p 18.

33 *Brighton Beach* (?) (October) [N-F]
Attribution uncertain.
Ref *Lady's Pictorial*, 7 November 1896, p xviii, advert.

34 *Scrambling Urchins* (?) (October) [N-F]
Attribution uncertain.
Ref *Lady's Pictorial*, 7 November 1896, p xviii, advert.

35 *The Lord Mayor's Show* (9 November) [N]
Ref *Photographic News*, 27 November 1896, p 769.

36 *H.R.H. The Prince of Wales* (December) [N]
Driving up and alighting from his carriage and bowing to the spectators.
Ref *The Era*, 26 December 1896, p 17.

Robert W. Paul

With the departure of Birt Acres in June 1895, and the general decline in
Kinetoscope business, Paul seems to have momentarily lost interest in film
production. His thoughts turned instead to the idea of screen projection and
in October he suggested its use in a novel form of entertainment based on
H.G. Wells's *The Time Machine*. Shortly thereafter, news reached him of
the success in Paris of the Cinématographe-Lumière and he at once turned

206

his attention to the invention and construction of a film projector. This materialised as the Theatrograph. His repertoire of films at this time included the few turned by Birt Acres with the Paul–Acres camera, and two or three Edison Kinetoscope films. The immediate need was for a regular supply of new films for projection, and Paul set himself the task of constructing a more practicable camera than the one formerly made with the help of Birt Acres. This new camera (13) was probably completed sometime in April 1896, and it was during that month that Paul commenced film production on his own account. His first films went into the programme at the Alhambra Theatre in late April or early May, and by the end of the year the bulk of British film production was of Paul's manufacture. He was the first in England to attempt a simple comic photoplay *(The Soldier's Courtship)*, and was also responsible for the first serious travelogue *(Tour in Spain and Portugal)*. It can also be claimed that he was the originator of the news film, when his film of the Derby was shown the evening of the next day. In fact, his output of films covers a wide range of subjects which includes comedies, dramas, variety acts, actualities, travel and news items.

Paul issued a list of his films under the title: *List of Films or Subjects for the Theatrograph*. Although undated, internal evidence shows it to have been published sometime in November 1896. This was probably the first catalogue Paul produced. The exact whereabouts of an original copy is unknown to me, but I believe one exists in a public library in New Zealand. The National Film Archive has a poor photostat copy, and what appears to be a photograph of the original is reproduced in Jacques Deslandes, *Histoire comparée du cinéma*, vol 2, but without acknowledgement. Forty-six films are listed, out of a possible total of more than seventy. Among the titles not included are *Morris Cronin, American Club Manipulator*, and the series of films comprising the *Tour in Spain and Portugal*. The latter was the subject of a special leaflet published by Paul at the end of October 1896. A copy of the original leaflet is preserved with the Paul catalogue just mentioned, since a photostat in the National Film Archive shows it to have the same library reference number (Group B 1444).

Unfortunately, Paul's catalogue is not arranged in chronological order. I have therefore attempted to do this in drawing up the list printed below. The exact date of production of many of the films is not always ascertainable, so in some cases the month cited must be taken as tentative. The earliest known reference to the film is the one given. I have added Paul's catalogue number and his own description of the film. Unless otherwise stated, all films are 40ft long.

1896

1 *A Crowd in the City* (?) (April) [N-F]
Exact title and location unknown.
Apparently not listed in Paul's catalogue.
Ref *The Era*, 25 April 1896, p 17.
(Illustration 77)

2 *On Westminster Bridge* (?) (April) [N-F]
Possibly the same as Cat No 9, *Westminster*, see No 16 below.
Ref *The Era*, 25 April 1896, p 17.

3 *A Rush-Hour Record on London Bridge* (?) (April) [N-F]
Attribution uncertain.
A copy of this film is in the National Film Archive (N7).
(Illustration 78)

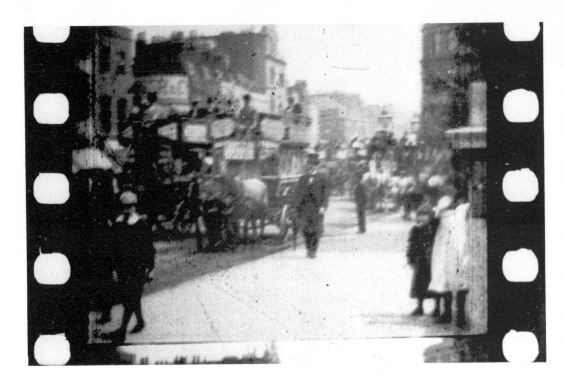

77　*A Crowd in the City* (?);
possibly one of the London
street scenes photographed by
R.W. Paul in April 1896.
(Kodak Museum, Harrow)

4　*The Soldier's Courtship* (April/May) [F]
　Cat Nos 41 and 42, *Soldier*. 80ft
　'A very comic scene, meeting of soldier and sweetheart, arrival of third
　party who attempts to crowd them, but is thrown off the seat by the
　soldier. (Double length)'
　Ref *The Era*, 16 May 1896, p 16.
　(Illustration 40)
　Subject of the Filoscope in the Barnes Museum. A second version of this
　film was made in 1898, called *Tommy Atkins in the Park* (Paul List No
　15, August 1898, p 10.)

5　*Up the River* (April/May) [F]
　Cat No 28, *Up the River*.
　'Steam launch, from which one of the passengers drops a child, which is
　promptly rescued by a swimmer from the bank.'
　Ref *The Era*, 16 May 1896, p 16.

6　*Rough Sea at Ramsgate* (1) (May) [N-F]
　Cat No 7, *Sea No. 1*.
　'Rough Sea at Ramsgate, May, 1896, showing Waves breaking in the
　open sea.'
　Ref *The Era*, 16 May 1896, p 16.

7　*Rough Sea at Ramsgate* (2) (May) [N-F]
　Cat No 8, *Sea No. 2*.
　'Rough Sea at Ramsgate, breaking over stone Steps.'
　Ref *The Era*, 16 May 1896, p. 16.

78 *A Rush Hour Record on London Bridge;* possibly one of the London street scenes photographed by R.W. Paul in April 1896. *(National Film Archive)*

8 *Arrival of the Paris Express* (May) [N-F]
 Cat No 12, *Train*.
 'Arrival of the Paris Express at Calais (Maritime) and passengers disembarking.'
 Ref *The Era*, 16 May 1896, p 16.
9 *Costermonger* (May) [N-F]
 Not listed in Paul's catalogue.
 Coster girl and Guardsman.
 Ref *Standard*, 26 May 1896.
10 *Hampstead Heath on Bank Holiday* (25 May) [N]
 Cat No 6, *Hampstead*.
 'Scenes on Hampstead Heath on Whit-Monday, 1896, showing Swings, Children Skipping, and other amusements.'
 Ref *The Era*, 8 August 1896, p 25.
11 *The Derby* (1) (3 June) [N]
 Cat No 10, *Derby*.
 'The Finish of the great Race of 1896, showing the victory of the Prince of Wales' horse "Persimmon" and the crowd commencing to sweep over the Course.'
 Ref *The Era*, 6 June 1896, p 16.
 (Illustrations 37 and 41)
 Subject of the Filoscope in the Barnes Museum.
 (Copy in the National Film Archive (N.13), and Science Museum (1947-324)
12 *The Derby* (2) (3 June) [N]
 Cat No 10a, *Derby*.
 'A continuation of the above, showing thousands of persons rushing on to the Course. (Can be joined to No. 10 to form one picture).'
 Ref *The Era*, 6 June 1896, p 16.

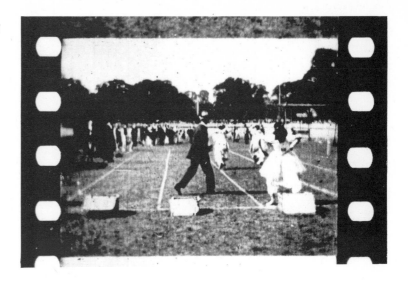

13 *Henley Regatta* (1) (7-9 July) [N]
Cat No 23, *Henley.*
'Scene on the River Thames at Henley Regatta, 1896, showing crowd of
small Boats moving.'
Ref *Reynolds's Newspaper*, 12 July 1896.
14 *Henley Regatta* (2) (7-9 July) [N]
Cat No 24, *Crew.*
'Landing of the Trinity Hall Crew at Henley after a Race.'
Ref *Reynolds's Newspaper*, 12 July 1896.
15 *A Comic Costume Race* (14 July) [N]
Cat No 22, *Sports.*
'A Comic Costume Race at the Music Hall Sports, July 14th, 1896.'
Held at Herne Hill, London.
Ref *The Era*, 8 August 1896, p 25.
A similar film was taken at the Music Hall Sports held on 5 July 1898
(Paul List No 15, August 1898, p 20).
A copy of one or other of these films is in the National Film Archive.
The indications are that it is the earlier event which is recorded on the
Archive print (186).
(Illustration 79)
16 *Westminster* (July) [N-F]
Cat No 9, *Westminster.*
'Street Traffic near the Houses of Parliament, with passing Omnibusses
[*sic*] and Carriages.'
Ref *The Era*, 8 August 1896, p 14.
17 *Children at Play* (1) (July) [N-F]
Cat No 29, *Children No. 1.*
'Children and Dogs at play in the field.'

Ref *The Era*, 8 August 1896, p 14.
18 *Children at Play* (2) (July) [N-F]
Cat No 30, *Children No. 2.*
'Two Children playing, accompanied by Parents.'
Ref *The Era*, 8 August 1896, p 14.
(Illustration 80)

210

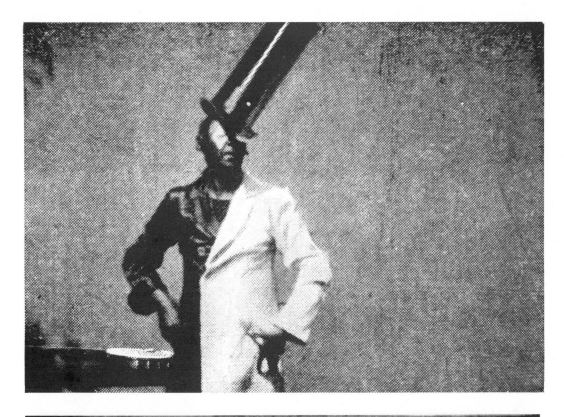

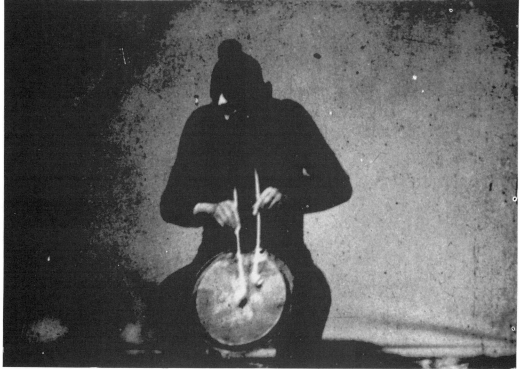

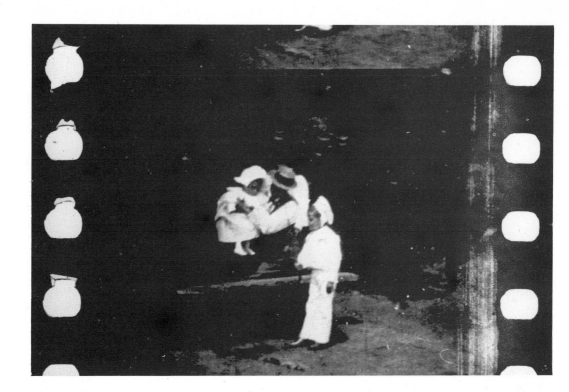

19 *The Tea Party* (July) [F]
Cat No 21, *Tea Party*.
'Showing a Party of Ladies and Gentlemen at Tea, the table being upset
by one of the Party.'
Ref *The Era*, 8 August 1896, p 25.

20 *David Devant: the Mysterious Rabbit* (July) [F]
Cat No 15, *Devant (Rabbit)*.
'Conjuring Séance by DAVID DEVANT of the Egyptian Hall; Rabbits
taken from a Hat &c.'
Ref *The Era*, 8 August 1896, p 25.

21 *David Devant: the Egg Laying Man* (July) [F]
Cat No 16, *Devant (Egg)*.
'Do. with Eggs appearing from the Head and Arms.'
Ref *The Era*, 8 August 1896, p 25.
(Illustration 81)

22 *David Devant: Objects Produced From Paper* (July) [F]
Cat No 17, *Devant (Paper)*.
'David Devant, who forms very rapidly a large number of familiar
objects from a large sheet of paper.'
Ref *The Era*, 8 August 1896, p 25.

23 *Chirgwin (Hat)* (July) [F]
Cat No 18, *Chirgwin (Hat)*.
'Amusing Scene by the White-Eyed Kaffir.'
Ref *The Era*, 8 August 1896, p. 25.
(Illustration 82)

82 *(top left) Chirgwin (Hat),*
by R. W. Paul, 1896. *(Barnes
Museum of Cinematography)*

83 *(bottom left) Chirgwin
(Pipes),* by R. W. Paul, 1896.
(Kodak Museum, Harrow)

84 *(above) Mr Maskelyne:
Spinning Plates and Basins,* by
R.W. Paul, 1896. *(Barnes
Museum of Cinematography)*

24 *Chirgwin (Pipes)* (July) [F]
Cat No 19, *Chirgwin (Pipes)*.
'Do. showing the Sword-Dance executed by Tobacco-Pipes.'
Ref *The Era*, 8 August 1896, p 25.
(Illustration 83)

25 *Mr Maskelyne Spinning Plates and Basins* (July) [F]
Cat No 25, *Maskelyne*.
'Plate-spinning by Mr. Maskelyne of the Egyptian Hall.'
Ref *The Era*, 8 August 1896, p 25.
(Illustration 84)

26 *On the Calais Steamboat* (July) [F]
Cat No 11, *Steamer*.
'Scenes on the S.S. "Victoria" from Dover to Calais, showing Mons.
Jacobi, Mdlle. Yvette Guilbert, and incidents.'
Ref *The Era*, 8 August 1896, p 25.

27 *On Brighton Beach* (July) [F]
Cat No 20, *Beach*.
'Landing of a Party from a small Boat in the surf on Brighton Beach,
with comic incidents.'
Ref *The Era*, 8 August 1896, p 25.

28 *The Engineers' Shop at Nelson Dock* (July) [N-F]
Cat No 1, *Engineers*.
'Blacksmiths, Engineers and Machinery at work at Nelson Dock,
London.'
Ref *The Era*, 8 August 1896, p 25.

29 *Blackfriars Bridge* (July) [N-F]
Cat No 14, *Blackfriars*.
'Scene on Blackfriars' Bridge, London, with passing Traffic and
Pedestrians.'
Ref *The Era*, 8 August 1896, p 25.

30 *Princess Maud's Wedding* (1) (22 July) [N]
Cat No 26, *Wedding*.
'Procession of Life Guards and State Carriages leaving Marlborough
House.'
Ref *The Era*, 8 August 1896, p 25.

31 *Princess Maud's Wedding* (2) (22 July) [N]
Cat No 27, *Wedding*.
'Do. (continuation of No. 26).'
Ref *The Era*, 8 August 1896, p 25.

32 *The Gordon Highlanders* (1) (August) [N-F]
Cat No 32, *Highlanders*.
'The Gordon Highlanders marching out of Maryhill Barracks,
Glasgow.'
Ref *The Era*, 22 August 1896, p 29.
Copy in the National Film Archive (225).
(Illustration 85)
Subject of a Filoscope in the Science Museum.

33 *The Gordon Highlanders* (2) (August) [N-F]
Cat No 33, *Highlanders*.
'Do. (continuation) may be joined to the above to form one film.'
Ref *The Era*, 22 August 1896, p 29.

214

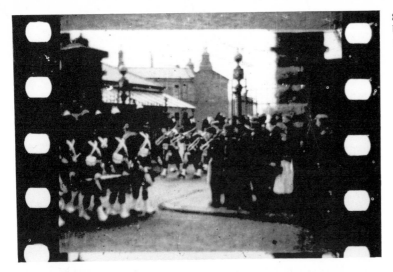

85 *The Gordon Highlanders,* by R.W. Paul, 1896. *(National Film Archive)*

86 *The Twins' Tea Party,* by R.W. Paul, 1896. *(National Film Archive)*

34 *The Gordon Highlanders* (3) (August) [N-F]
Cat No 34, *Highlanders.*
'Do. (continuation) may be joined to the above to form one film.'
Ref *The Era*, 22 August 1896, p 29.
35 *SS Columba* (August) [N-F]
Cat No 37, *S.S. Columba.*
'The Passenger Steamer "Columba" leaving Rothesay Pier.'
Ref *The Era,* 25 September 1896, p 18.
36 *Passengers Disembarking from SS Columba* (August) [N-F]
Cat No 38, *Disembarking.*
'Passengers leaving the Steamer at Rothesay Pier.'
Ref *The Era*, 25 September 1896, p 18.
37 *Argyle Street, Glasgow* (August) [N-F]
Cat No 40, *Glasgow.*
'Scene in Argyle Street, Glasgow.'
No other reference to this film has been found. Presumably it was taken
on the same trip as the other Scottish subjects.

38 *The Arrest of a Bookmaker* (August/September) [F]
Cat No 5, *Bookmaker.*
'Struggle of a Betting Man with the Police, and his arrest.'
Ref *The Era*, 25 September 1896, p 18.

39 *The Twins' Tea Party* (August/September) [F]
Cat No 35, *Twins' Tea Party.*
'Two Infants at Tea laughing, playing and crying.'
Ref *The Era*, 25 September 1896, p 18.
Copy in the National Film Archive (F.528).
(Illustration 86)
A second version of this film was made in 1898 (Paul List No 15, August 1898, p 18.)

40 *Two a.m., or the Husband's Return* (August/September) [F]
Cat No 36, *2 a.m.*
'Comic Scene by Mons. Paul Clerget and Miss Ross Selwicke, representing the husband's return.'
Ref *The Era*, 25 September 1896, p 18.

41 *Morris Cronin, American Club Manipulator* (September) [F]
Not listed in Paul's catalogue.
Cronin juggling with three Indian clubs.
Ref *The Era*, 25 September 1896, p 18.

42–55. *Tour in Spain and Portugal* (September) Approx. 600ft.[N-F]
Series of fourteen pictures representing a five-week tour in Spain and Portugal.
Photographed by Harry Short.
First shown on 22 October 1896 at the Alhambra Theatre.
Subject of a special pamphlet published by R.W. Paul at the end of October 1896.
Ref *The Era*, 10 October 1896, p 19.
Comprising the following films:

42 *Lisbon—the Fish Market*
Scene in the fish market at Lisbon, showing women bringing in sardines.

43 *Madrid—Puerto del Sol*
Street scene in the Puerto del Sol, Madrid (two views).

44 *The Bathers*
Sea Bathing at Cascaes, near Lisbon.

45 *Cadiz—the Square*
Scene in the Plaza del Cathedrale, Cadiz.

46 *Seville—Bull Fight*
Procession of bull-fighters in the ring at Seville; The Bull Fight (Part 1); The Bull Fight (Part 2).

47 *Andalusian Dance*
Two persons performing the Andalusian dance.

48 *Seville—Leaving Church*
Men and women leaving church of San Salvador, Seville.

49 *Portuguese Game of Pau*
Two men actively engaged in the national game of pau.

50 *The Fado*
Unique Spanish dance, performed by one man and two women (the Fado Dance).

51 *Lisbon—Praca do Municipio*
Street Scene in the Praca do Municipio, Lisbon.

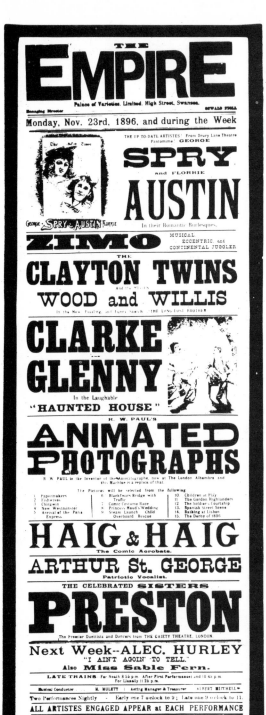

87 Playbill of the Empire Palace of Varieties, Swansea, for the week beginning 23 November 1896, advertising R.W. Paul's 'animated photographs'. *(Kodak Museum, Harrow)*

52 *Lisbon—Praca dom Pedro*
 Street Scene in the Praca Dom Pedro, Lisbon.
53 *Portuguese Railway Train*
 The Arrival of a Train at Caes do Sodre, bringing Bathers to the Coast.
54 *A Sea Cave Near Lisbon*
 A Very striking and artistic photograph of a large cave on the Atlantic
 Coast, into which waves dash with great violence. 80ft.
 (Illustration 42)
55 *Seville—the Triana*
 View in the Triana, Seville.
 Refs *The Era,* 5 December 1896, p 30; Paul List No 15, August 1898.
 Only two of these films stood the test of time and were to be included in
 Paul's catalogues as late as June 1903. These were Nos 47 and 54. The
 remainder were stated as being 'not recommended for general
 exhibition' in Paul's List No 15, issued in August 1898.
56 *New Westminster* (September) [N-F]
 Cat No 31, *New Westminster.*
 'Street Scene near Westminster Bridge with bus and traffic outside St.
 Thomas' Hospital.'
 Ref *The Era*, 3 October 1896, p 18.
57 *Turn-out of a Fire Brigade* (October/November) [N-F]
 Cat No 44, *Fire Brigade.*
 'A Turn-out of the Newcastle Fire Brigade.'
 Ref *The Era*, 16 January 1897, p 18.
58 *A Football Match* (October/November) [N]
 Cat No 46, *Football.*
 'A Football Match at Newcastle-on-Tyne.'
 No other reference to this film has been found.
59 *Feeding Pelicans at the Zoo* (October/November) [N-F]
 Cat No 43, *Pelicans.*
 'Feeding the Pelicans at the Zoological Gardens, London.'
 Ref *The Era*, 19 December 1896, p 18.
60 *Petticoat Lane* (October/November) [N-F]
 Cat No 39, *Petticoat Lane.*
 'Sunday Morning Scene in Wentworth Street, Whitechapel.'
 No other reference to this film has been found.
61 *The Lord Mayor's Show* (9 November) [N]
 Cat No 45, *Show.*
 'The principal features of the Lord Mayor's Procession, Nov. 9th, 1896,
 passing the Bank of England.'
62 *Papermakers* (?) (November) [N-F]
 Ref playbill of the Empire Theatre, Swansea, for 23 November 1896.
 (Kodak Museum, Harrow, illustration 87)
63 *Hyde Park Bicycle Scene* (?) (November) [N-F]
 Ref Windsor Castle programme, 23 November 1896, reproduced in the
 Lady's Pictorial Supplement, 5 December 1896.
 Although this list probably includes the more important of Paul's films, it
is obviously incomplete. Sixty-three films are accounted for out of a
possible total of more than seventy. This is apparent from a statement
published in September 1896 which says: 'Since the first exhibition of the
Animatographe at the Alhambra on March 25th, last, over seventy different
scenes have been successfully photographed and introduced in the series
nightly exhibited.' (Ref *The Era*, 5 September 1896, p. 18.)

Others

There were a number of films made in England during 1896 by makers other than Birt Acres or Paul, but very few can now be traced. We have noted several names in the text who are said to have been engaged in film production, but rarely is a particular film described. Many of them must have been local scenes or simple actualities, for the most part photographed with the one or two French cameras which are known to have been on the market in England during the latter half of the year. Possibly some of the subjects were noted in the local press, and until such time as a thorough examination of these sources is undertaken, little will be known of these forgotten film-makers. The few films that have been traced are listed below under the names of their producers:

W. and D. DOWNEY and J. and F. DOWNEY
Arrival of Her Majesty the Queen and TIMs the Emperor and Empress of Russia at Mar Lodge (October) Approx. 120ft [N]
Ref Windsor Castle programme, 23 November 1896; reproduced in the *Lady's Pictorial* Supplement, 5 December 1896.
Her Majesty the Queen and TIMs the Emperor and Empress of Russia, TRHs the Duke and Duchess of Connaught, H.R.H. Princess of Battenberg and Royal Children at Balmoral (October) Approx. 120ft [N]
Ref as above.
Ditto (October) Approx. 120ft [N]
Ref as above.

These three films were approx. 70mm wide, with round perforations, the stock supplied by Eastman and the Blair Camera Co.
Ref the *Lady's Pictorial* Supplement, 5 December 1896.
(Illustration 70)

B. DOYLE
Traffic on the Thames (July) [N-F]
Ref *The Era*, 25 July 1896, p 21.
ESME COLLINGS
The Lord Mayor's Show (9 November) [N]
Ref *British Journal of Photography*, 11 December 1896, pp 797, 810.
The Broken Melody (November) [F]
Based on the play by James Tanner and Hubert Keene; with Auguste Van Biene and wife.
Ref *British Journal of Photography*, 11 December 1896, p 797.
LUMIÈRE
Outside of the Empire (July) [N]
Lumière Cat No 250, *Entrée du Cinématographe, Londres.*
Showing cabs arriving and departing, with Dundas Slater, the acting-manager of the theatre, and other members of the staff.
Probably taken by Felicien Trewey with the Empire's Cinématographe.
Ref *The Era*, 1 August 1896, p 16.
Change of Guard at St James's Palace (July) [N-F]
Probably taken by F. Trewey.
Ref *The Era*, 1 August 1896, p 16.
This film is possibly one or other of two films listed in the Lumière catalogue: 257, *Garde montante au palais de Buckingham* and 258, *Garde à cheval.* The Lumière catalogue, which was published in 1897, lists the titles of thirteen films taken in London, but I have been able to find English references to only two films for 1896.

Appendix 2

Chronology

1892

Autumn W.K-L. Dickson achieves the first practical method of
cinematography with his invention of the Kinetograph and
Kinetoscope.

December 1892–January 1893 'Black Maria' under construction. This was
the world's first studio specifically built for motion-picture production.

1894

14 April Opening of the world's first Kinetoscope parlour at 115
Broadway, New York.

17 October Opening of the first Kinetoscope parlour in England, at 70
Oxford Street, London.

November/December R.W. Paul begins manufacturing replicas of the
Edison Kinetoscope.

1895

February Experimental work begun on the Paul–Acres camera.
Film stock supplied by the European Blair Camera Co.

13 February Cinématographe-Lumière patented in France.

March Completion of the Paul–Acres camera. A successful perforator,
printer and processing plant are also constructed.

29 March Paul sends Edison a sample strip of the first successful
Kinetoscope film made in England.

8 April Cinématographe-Lumière patented in England.

27 May Birt Acres patents his Kinetic Camera.

29 May Birt Acres films the Derby with the Paul–Acres camera.

May/October R.W. Paul exhibits his Kinetoscopes at the Empire of India
Exhibition, Earls Court. Some of the first British films exhibited.

June/July Birt Acres films ceremonies attendant on the opening of the Kiel
Canal.

24 October R.W. Paul takes out a provisional patent for a screen
entertainment based on H.G. Wells's *The Time Machine*, and suggests
the use of intermittent screen projection.

28 December Cinématographe-Lumière commercially exhibited at Le
Grand Café, 14 Boulevard des Capucines, Paris.

1896

14 January Birt Acres gives the first screen performance in England at a
meeting of the Royal Photographic Society held at 12 Hanover
Square, London.

February R.W. Paul publishes details of his first film projector, the
Theatrograph.

20 February Cinématographe-Lumière first publicly exhibited in England,
at the Marlborough Hall, Regent Street, under the management of
Felicien Trewey. R.W. Paul's first projector, the Theatrograph,
exhibited at the Finsbury Technical College.

2 March R.W. Paul patents his second film projector, the Theatrograph
No 2, Mark 1.

9 March Cinématographe-Lumière exhibited at the Empire Theatre, Leicester Square. This was the first time that films were included in an English music-hall programme.

19 March David Devant exhibits Paul's Theatrograph at the Egyptian Hall, Piccadilly.

21 March Paul's Theatrograph exhibited at Olympia.
Birt Acres's Kineopticon first commercially exhibited, at 2 Piccadilly Mansions, Piccadilly Circus.

25 March Paul's Theatrograph exhibited at the Alhambra Theatre, Leicester Square, under the name Animatographe.

28 March Carl Hertz sails for South Africa with a Paul Theatrograph No 2, Mark 1.

6 April Rigg's Kinematograph first exhibited at the Royal Aquarium, Westminster. This was the third English projector to be commercially exhibited in England.

8 April Paul exhibits hand-coloured film at the Alhambra Theatre.

April Paul's Cinematograph Camera No 1 constructed. This was the first camera designed by Paul after his association with Birt Acres ended. Paul commences film production on his own account. *The Soldier's Courtship* filmed on the roof of the Alhambra Theatre.

23 April Edison–Armat Vitascope receives its première at Coster & Bial's Music Hall, New York. The Paul–Acres film *Rough Sea at Dover* is one of the films included in the programme.

3 June Paul films the Prince of Wales's horse 'Persimmon' winning the Derby.

4 June Paul's film of the Derby shown at the Alhambra Theatre.

27 June Birt Acres films the Prince and Princess of Wales arriving in state at the Cardiff Exhibition.

21 July First Royal Command Film Performance given by Birt Acres at Marlborough House.

October First official film of Queen Victoria, taken in the grounds of Balmoral Castle.

22 October *Tour in Spain and Portugal* first shown at the Alhambra Theatre.

23 November Royal Command Film Performance at Windsor Castle, given by W. & D. and J. & F. Downey, for Queen Victoria and other members of the royal family.

24 December Randall Williams exhibits films at the World's Fair, held in the Royal Agricultural Hall, Islington. This was the cinema's first connection with the English fairground.
By the end of the year, the cinema had established a temporary home in every major music-hall in the country.

Notes

1 The Kinetoscope

1 W.K.-L. Dickson (1860–1935) was born at Minihuc-sur-Rance in Brittany. His mother was of Scottish descent and his father English. For a more detailed biographical sketch, see Gordon Hendricks, *The Edison Motion Picture Myth* (Berkeley, Calif: University of California Press, 1961), Appendix A.

2 Cf Jacques Deslandes, *Histoire Comparée du Cinéma* (Tournai: Casterman, 1966), vol 1, p 219.

3 Verified in the present work.

4 A. Lomax gives the following data respecting the speed and duration of pictures in the Kinetoscope: 'The pictures move at an average speed of 30 per second (though this is sometimes very much increased), and one revolution of the shutter moves the film by the distance of one picture. The slit in shutter is one-tenth, and the mean diameter 10 inches. The picture is only visible to the eye about the 310th part of the time it takes to move from picture to picture, and each part of the picture is only visible to the eye about the 9,300th part of a second, the whole picture being visible about the 1,240th of a second.' (*Optical Magic Lantern Journal*, vol 7, no 87 (August 1896), p 133.) Lomax was considered somewhat of an authority on Kinetoscopes, having had, we are told, a great deal to do with them. At one time he was the sole agent for Great Britain for the Kansas Phonograph Company, and had offices at 28 Caunce Street, Liverpool (ibid, p 122).

5 Gordon Hendricks, *The Kinetoscope* (New York: 1966).

6 Antonia and W.K.-L. Dickson, 'Edison's Invention of the Kineto-Phonograph', in *The Century Magazine* (New York: The Century Co; London: T. Fisher Unwin; vol 48, no 2 (new series vol 26), June 1894), pp 206–14.

7 *Cassell's Family Magazine* (September 1891), pp 575–6.

8 *Chambers's Journal of Popular Literature, Science and Art*, vol 11, no 536 (28 April 1894), p 269.

9 *The Daily Graphic,* 18 October 1894, p 8; *The Times,* 18 October 1894, p 4.

10 Hendricks, *Kinetoscope,* pp 111–12. For further details of Maguire and Baucus, the reader is again referred to Hendricks, who has done so much valuable research into the beginnings of the cinema in America.

11 The only known copy of the pamphlet in this state is in the Barnes Museum of Cinematography. For a detailed examination of the original, see Hendricks, *Kinetoscope*, p. 25, illus 38.

12 *The Times,* Thursday 18 October 1894, p 4.

13 *The Daily Graphic,* Thursday 18 October 1894, p 8, column one.

14 *Photographic Work,* vol 3, no 132 (9 November 1894), p 534.

15 Hendricks, *Kinetoscope,* pp 13–14.

16 Leslie Wood, *The Romance of the Movies* (London: 1937), p 25; Maurice F. Speed, *Movie Cavalcade* (London: 1942), p 17; Egon Larson, *Inventor's Scrapbook* (London: 1947), p 27; Leslie Wood, *The Miracle of the Movies* (London: 1947), p 94; J.H. Bird, *Cinema Parade* (Birmingham: 1946), p 35. All these are popular works and of no consequence to the serious student of film history.

17 Frederick A. Talbot, *Moving Pictures: How they are Made and Worked* (London: Heinemann, 1912).

18 Ibid, preface.

19 Ibid, pp 33–4.

20 Terry Ramsaye, *A Million and One Nights: The History of the Motion Picture* (New York: Simon & Schuster, 1926).

21 In the Post Office London Directory for 1895 they are listed as: Tragidis & Georgiades, Edison's kinetoscopes, 95 Queen Street, EC.

22 The London trade directories of the period list no such establishment at this address. However, the Post Office London Directory for 1896 lists the 'Continental Commerce Co, sales agents for Edison's kinetoscopes' at 9 New Broad St, EC, where they occupied premises on the ground floor of Dashwood House, having apparently moved from their former place of business at 70 Oxford St. Either the existence of the parlour in Old Broad St was of short duration or Ramsaye has confused the address with that of the Continental Commerce Co in New Broad St, close by. See also note 21 above.

23 Ramsaye, op cit, pp 147–8.

24 Henry William Short was a pioneer of cinematography in his own right and was the inventor of the Filoscope. His work is discussed in Chapter 7

25 Paul was probably echoing Ramsaye when recalling this address. See note 22 above.
26 *Proceedings* of the British Kinematograph Society, no 38 (3 February 1936), p 2.
27 Hendricks, *Kinetoscope*, pp 64–5, 115.
28 *The Era,* 25 April 1896, p 17: 'A Chat with Mr Paul'. The Empire of India Exhibition was held at Earls Court from 27 May to 26 October 1895.
29 R.W. Paul in a letter to Edison dated 29 March 1895 wrote of 'the sundry attempts now being made to copy your films'. See p 20.
30 Charles Pathé, *De Pathé Frères à Pathé Cinéma* (Lyons: Premier Plan, 1970), p 24.
31 Acquisition no 16535-E.26.
32 Raoul Grimoin-Sanson, *Le Film de Ma Vie* (Paris: 1926), pp 64–5.
33 Hendricks, *Kinetoscope*, p 11, note 6.

2 The Paul–Acres Camera

1 The 'Black Maria' was the studio on the Edison lot constructed specially for the production of Kinetoscope films. The name derives from its tarred exterior.
2 For example, Paul's advertisement in *The Era* for 1 August 1896 (p 24) states: 'My films are only supplied to purchasers of my apparatus'. Similarly, the Birt Acres films taken at the royal wedding at Marlborough House are advertised by the agents, the British Toy and Novelty Co Ltd, as follows (ibid, p 24): 'N.B.—The Royal Films will only be Supplied to Purchasers of the Kineopticon'.
3 French pat no 245032, 13 February 1895, A. and L. Lumière.
4 Letter book E 1717 7/31/94—7/1/97. cf. Hendricks.
5 Hendricks, *Kinetoscope*, pp 133–4.
6 Talbot, *Moving Pictures,* illustration facing p 36.
7 *Proc* BKS, no 38 (3 February, 1936), p 3.
8 The Kodak Museum, Harrow, has a small portion of this film. It appears to be an earlier print than the one sent to Edison, since the perforations have obviously been hand-punched (see illustration 74).
9 Hendricks, *Kinetoscope*, p 134.
10 *Proc* BKS, no 38 (3 February 1936), p 3.
11 Will Day, *Illustrated Catalogue of the Will Day Historical Collection of Cinematography and Moving Picture Equipment* (London: undated), p 34, item 300.
12 *Catalogue of the Will Day Collection,* item 132.
13 Science Museum acquisition nos 1930-289 and 1913-551.
14 Talbot, *Moving Pictures,* pp 36–7.
15 As Hendricks has already pointed out (*Kinetoscope*, p 134), this was the date on which Paul wrote to Edison. I think this is an error on Paul's part. In trying to recall an exact date he selected the wrong one. I am not inclined to believe that it has any other significance.
16 Ramsaye, *A Million and One Nights,* pp 149–50.
17 *Proc* BKS, no 38 (3 February 1936), p 3
18 C.W. Ceram, *Archaeology of the Cinema* (London: Thames & Hudson, 1965).
19 Deslandes, *Histoire Comparée du Cinéma,* vol 1, p 252.
20 Sidney Birt Acres, 'A Pioneer of the Cinematograph' in *Amateur Photographer,* 18 April 1956, p 303.
21 This print is now in the possession of Mrs Sidney Birt Acres. The man in the immediate foreground has been identified as Lord Derby, and the man seated on the platform in the middle as Lord Marcus Beresford.
22 *Strand Magazine,* vol 12 (August 1896), p 134.
23 The success of this type of intermittent mechanism would depend on the absolute minimum of film shrinkage.
24 *Proc* BKS, no 38 (3 February 1936), p 3.
25 Patent nos 18689 of 1889 and 23670 of 1893.
26 At the Stanley Cycle Show held at the Agricultural Hall, Islington, 18-26 November 1892, 'a photographic enlargement from a whole plate negative, by Birt Acres, of Elliott & Son, was the subject of an admiring crowd. It measured 7 feet long by 5 feet high'. (*Optical Magic Lantern Journal,* vol 3, no 43 (1 December 1892), p 155.)
27 Talbot, *Moving Pictures,* p 40.
28 *Amateur Photographer,* vol 26, no 678 (1 October 1897), p 277.

29 Ibid, vol 24, no 627 (9 October 1896), p 298.
30 Cf SidneyBirt Acres, 'Kinematography and the Kiel Canal', in *Cinema Studies*, vol 1, no 6 (December 1962), p 130.
31 Henry V. Hopwood, *Living Pictures: Their History, Photo-Production and Practical Working* (London: 1899), pp 97–8.
32 The original house has been almost entirely demolished and rebuilt in a different style.
33 Birt Acres is in error regarding the Friese-Greene patent. The apparatus was quite impractical and the pictures far from being evenly spaced. Furthermore, its claims to being the master patent were never upheld. Cf Brian Coe, 'William Friese Greene and the Origins of Kinematography', in *Photographic Journal*, March and April 1962.
34 *British Journal of Photography*, vol 43, no 1871 (13 March 1896), pp 173–4.
35 Ibid, vol 43, no 1873 (27 March 1896), pp 206–7.
36 Ibid, vol 43, no 1875 (10 April 1896), p 239.

3 Paul's Time Machine

1 *Strand Magazine*, vol 12 (August 1896), p 134.
2 It was first published in 1895.
3 Quoted from William Rose Benet, *The Reader's Encyclopedia*, 2nd edn (London: A. & C. Black, 1965).
4 *The Era*, 25 April 1896, p 17.
5 Ramsaye, *A Million and One Nights*, pp 155–7. Paul's patent specification received provisional protection only and was not printed. The Patent Office informs me that the original document has since been destroyed. I have therefore been obliged to rely on Terry Ramsaye for the above transcription. It is appalling that an historical document can be destroyed at the whim of some shortsighted civil servant.
6 Raymond Fielding, 'Hale's Tours: Ultra-Realism in the pre-1910 Motion Picture', in *The Smithsonian Journal*, vol 3 (1968–9), p 101.
7 The reader is referred to an article in *The Kinematograph Weekly* (1 October 1908, p 481), where a description and illustration of Hale's Tours in Oxford St will be found and which was overlooked by Professor Fielding in his excellent history referred to above.
8 A copy of this film is in the National Film Archive. See my note on the film in the National Film Theatre Programme Notes, *Pioneers of the British Film*, May 1968.

4 The Theatrograph

1 *The Era*, 25 April 1896, p 17.
2 It so happened that Paul was forestalled not by Lumière but by his former collaborator, Birt Acres.
3 *The Era*, 25 April 1896, p 17: 'Paul is now one of a very small group of manufacturers who devote themselves exclusively to the production of the most delicate scientific instruments. He will turn you out a machine for the measurement of the sun's heat, and mechanically assist you in every other department of difficult research ...'
4 *The English Mechanic and World of Science*, no 1613, 21 February 1896, p 11; and *Reynolds's Newspaper*, Sunday 23 February 1896, p 4, column six. *The English Mechanic* was published on Friday of each week.
5 *The Era*, 25 April 1896, p 17.
6 For a discussion of the Lumière performances in France, see Deslandes, *Histoire Comparée du Cinéma*, vol 1.
7 *English Mechanic*, no 1613, 21 February 1896, p 11.
8 The editor has substituted the word 'photograms' here, this being a pet word often used by this journal. That Paul used the word 'photographs' in his original description is established from other published extracts.
9 *The Photogram*, vol 3, no 28 (April 1896), p 103.
10 *Photographic News*, vol 40, no 9, new series (Friday 28 February 1896), p 142.
11 *British Journal of Photography*, vol 43, no 1869 (28 February 1896), p 143.
12 *English Mechanic*, no 1615 (6 March 1896), pp 51–2.

13 *Optical Magic Lantern Journal,* vol 7, no 83 (April 1896), pp 71–2. At this period the journal was published on the 1st of each month.
14 *Amateur Photographer,* vol 23, no 597 (13 March 1896), pp 225–6.
15 This claim had been pursued ever since the journal had published the first account of Friese-Greene's apparatus (pat no 10131 of 1889) in the issue for 15 November 1889, p 44, under the heading 'A Startling Optical Novelty: Photoramic and Phono-Photoramic Effects'.
16 Brian Coe, 'William Friese Greene and the Origins of Kinematography', in *Photographic Journal,* March and April 1962.
17 *Amateur Photography,* vol 23, no 597 (13 March 1896), pp 225–6.
18 Several early projectors were subsequently designed to be used in this way. Wray's Kineoptoscope projector could be fitted into the slide stage of an ordinary magic lantern in the same manner as a mechanical lantern slide; see pp 143-4.
19 *Proc* BKS, no 38 (3 February, 1936), p 3.
20 *English Mechanic,* no 1613 (21 February 1896), p 11.
21 Ibid, 6 March 1896, p 51; *Amateur Photographer,* vol 23, no 597 (13 March 1896), p 226.
22 *Optical Magic Lantern Journal,* vol 7, no 83 (April 1896), p 72.
23 Jacques Deslandes erroneously assigns this patent to the first model; see *Histoire Comparée du Cinéma,* vol 1, p 51.
24 *The Era,* 28 March 1896, p 18.
25 'Mr R.W. Paul . . . has shown a neat piece of apparatus called 'The Theatrograph', in the library of the Royal Institution, with some success, but it must be owned that in its present condition the registration of the pictures on the screen is not so perfect as in Lumiere's arrangement.' (*Amateur Photographer,* vol 23, no 597 (13 March 1896), p 226.)
26 *The Era,* 16 May 1896, p 16.
27 It has already been established that this film was shot with the Paul–Acres camera; see Chapter 2.
28 References for each of these first performances at the venues named are given in Chapter 7.
29 The nomenclature of these early film performances is often confused. We know that it was the Theatrograph, not the Lumière machine, that was being used from a Paul advertisement in *The Era* (9 May 1896, p 16): 'Canterbury.—The Theatrograph by R.W. Paul, at 10.40. Sensation of London.' See also the issue for 6 June (p 16): 'Canterbury.—a most important feature of the bill, the Theatrograph, which was far from perfect on the opening night, now answers admirably.'
30 *The Era,* 2 May 1896, p 16.
31 The original model is preserved at the Conservatoire National des Arts et Métiers, Paris (Inv 16966—E.1942). Examples of the modified version are to be found in several collections, including the Science Museum, South Kensington, and the Kodak Museum, Harrow.
32 *Proc* BKS, no 38 (3 February 1936), p 4.
33 The segmented drum shutter became a feature of several later projectors of other makes, L. Kamm's projector of 1918 for instance, an example of which is in the Barnes Museum of Cinematography.
34 *Proc* BKS, no 38 (3 February 1936), p 3.
35 *The Era,* 25 April 1896, p 17.
36 Carl Hertz, *A Modern Mystery Merchant: The Trials, Tricks and Travels of Carl Hertz* (London: Hutchinson, 1924).
37 The catalogue entry wrongly states that this was the first projector constructed by R.W. Paul.
38 The Will Day Collection has since been acquired by the Cinémathèque Française.
39 *Strand Magazine,* vol 12 (August 1896), p 134.
40 Acquisition no 1913-549.
41 This illustration is taken from Talbot, *Moving Pictures,* facing p 60.
42 *The Photogram,* vol 4, no 46 (October 1897), pp 306–7; *Optical Magic Lantern Journal,* vol 8, no 96 (May 1897), p 185.
43 Acquisition no 1913-550.

5 The Kinetic Camera and Kineopticon of Birt Acres

1 For an account of these Kiel ceremonies see Sidney Birt Acres, 'Kinematography and the Kiel Canal', in *Cinema Studies*, vol 1, no 6 (December 1962), pp 130–1. The article is of little value to the historian as no references are quoted.

2 *Amateur Photographer*, vol 23, no 590 (24 January 1896), p 70.

3 Ibid, no 591 (31 January 1896), p 90.

4 Inv 1946-310.

5 British pat no 24457, 19 December 1893.

6 *Amateur Photographer*, vol 23, no 590 (24 January 1896), p 75.

7 *Photographic Journal*, vol 20, no 5 (31 January 1896), pp 123–4.

8 *British Journal of Photography*, vol 43, no 1863 (17 January 1896), p 43.

9 *The Photogram*, vol 3, no 27 (March 1896), p 68.

10 *British Journal of Photography*, vol 43, no 1869 (28 February 1896), p 138.

11 *Photographic News*, vol 40, no 4, new series (24 January 1896), p 61; *British Journal of Photography*, vol 43, no 1864 (24 January 1896), p 61.

12 A notice of the proposed demonstration appeared in *Amateur Photographer*, vol 23, no 593 (14 February 1896), p 138: 'London & Provincial P.A.—Feb. 20th, The Kinetoscope [*sic*] with demonstration by Mr Birt Acres.'

13 *British Journal of Photography*, vol 43, no 1869 (28 February 1896), p 138.

14 *Optical Magic Lantern Journal*, vol 7, no 83 (April 1896), p 71.

15 *British Journal of Photography*, vol 43, Monthly Supplement 6 March 1896, p 17.

16 *Amateur Photographer*, vol 23, no 596 (6 March 1896), p 193.

17 Ibid, no 597 (13 March 1896), p 226.

18 *British Journal of Photography*, vol 43, Monthly Supplement 3 April 1896, p 26.

19 *The Optician*, vol 10 (19 March 1896), p 358.

20 *British Journal of Photography*, vol 43, no 1873 (27 March 1896), p 202.

21 *Photographic News*, vol 40, no 13 (27 March 1896), p 194.

22 *The Optician*, vol 10 (23 April 1896), p 79.

23 *Amateur Photographer*, vol 23, no 603 (24 April 1896), p 355.

24 These were the Cinématographe-Lumière, Paul's Theatrograph, Acres's Kineopticon and Rigg's Kinematograph.

25 *British Journal of Photography*, vol 43, Monthly Supplement 1 May 1896, p 33.

26 Even at Olympia the Theatrograph was only one attraction among many in a vast complex of entertainment.

27 Annotation made by Birt Acres in his personal copy of Talbot, *Moving Pictures*, p 40.

28 *South Wales Echo*, 6 May 1896.

29 *Western Mail*, 6 May 1896.

30 *Evening Express*, Thursday 3 September 1896.

31 *British Journal of Photography*, vol 43, no 1906 (2 October 1896), pp 630–2; *Photographic News*, vol 40, no 39 (25 September 1896), p 610; *Amateur Photographer*, vol 24, no 627 (9 October 1896), p 291.

32 *Barnet Times and Finchley Telegraph*, Friday 30 October 1896.

33 *Amateur Photographer*, vol 24, no 631 (6 November 1896), p 378.

34 *British Journal of Photography*, vol 43, no 1904 (30 October 1896), p 699.

35 *Amateur Photographer*, vol 24, no 638 (24 December 1896), p 524.

36 *Photographic News*, vol 40, no 48, new series (Friday 27 November 1896), p 769.

37 Unidentified source in the possession of Mrs Sidney Birt Acres.

38 Unidentified and undated newspaper clipping in the possession of Mrs Sidney Birt Acres.

39 *Amateur Photographer*, vol 24, no 631 (6 November 1896), p 378; ibid, no 632 (13 November 1896), p 386; *British Journal of Photography*, Supplement 6 November 1896, pp 86–7.

40 *The Era*, 27 June 1896, p 25, advertisement.

41 Ibid, 1 August 1896, p 24, advertisement.

42 *Amateur Photographer*, vol 26, no 678 (1 October 1897), p 277.

43 Those exhibited by Lewis Sealy, T.C. Hayward and Birt Acres himself; see below.

44 *Amateur Photographer*, vol 24, no 628 (16 October 1896), p 305.

45 *The Era*, 1 August 1896, p 24.

46 Ibid, p 28.

47 Hopwood, *Living Pictures*, p 98.

48 *The Era*, 30 May 1896, p 26, advertisement.

49 Ibid, 20 June 1896, p 21.

50 Ibid, 13 June 1896, p 26, advertisement.

51 Ibid, 15 August 1896, p 16; ibid, 5 September 1896, p 28; ibid, 12 September 1896, p 18.
52 Ibid, 15 August 1896, p 25.
53 Ibid, 27 June 1896, p 25, advertisement.
54 Ibid, 26 December 1896, p 27, advertisement.
55 Ibid, 2 January 1897, p 34, advertisement.
56 Ibid, 15 August 1896, p 16.
57 Ibid, 12 September 1896, p 18.
58 *Photographic News*, vol 40, no 36, new series (4 September 1896), p 561.
59 *Lady's Pictorial*, 7 November 1896, p xviii, advertisement.
60 Ibid, 21 November 1896, p x, advertisement.
61 *The Era*, 12 December 1896, p 18.
62 Ibid, 30 January 1897, p 18.
63 Ibid, 3 April 1897, p 18.
64 Ibid, 8 May 1897, p 18.
65 Ibid, 15 August 1896, p 25, advertisement.

6 The Cinématographe-Lumière

1 Deslandes, *Histoire Comparé du Cinéma*, vol 1, part 3, ch 1, pp 217-40.
2 *Description of the Cinématographe of August [sic] and Louis Lumière* (Lyons: 1897); copy in the Barnes Museum of Cinematography.
3 From a list printed in the official handbook; see note 2. Explanations in parentheses supplied by me.
4 Hopwood, *Living Pictures*, p 93.
5 Albert A. Hopkins, *Magic: Stage Illusions and Scientific Diversions, including Trick Photography* (New York: Munn & Co, 1897), pp 173-83.
6 Both the printed programmes mentioned are in the Barnes Museum of Cinematography.
7 This and earlier impressions of the pamphlet are in the Barnes Museum.
8 *St Paul's Magazine*, 7 March 1896, p 436.
9 The 'host' referred to could comprise only the apparatus of Birt Acres, R.W. Paul and the Lumière brothers, since no others existed in England at the time.
10 *Optical Magic Lantern Journal*, vol 7, no 83 (April 1896), p 71.
11 *Amateur Photographer*, vol 23, no 595 (28 February 1896), p 174.
12 Ibid, no 597 (13 March 1896), p 226.
13 *British Journal of Photography*, vol 43, no 1869 (28 February 1896), pp 129–30.
14 *The Optician*, vol 10 (5 March 1896), p 331.
15 *British Journal of Photography*, vol 43, Supplement 6 March 1896, pp 17–18.
16 *Photographic News*, vol 40, no 9, new series (28 February 1896), p 142: 'We believe . . . that the apparatus will be on view for about three months.'
17 *British Journal of Photography*, vol 43, Supplement 3 April 1896, p 26.
18 Letter from F. Trewey, published in the Will Day Catalogue, plate 44a.
19 *The Era*, 14 March 1896, p 18.
20 Ibid, 24 July 1897, p 16.
21 What was reported to be the first cinema theatre in London was the Balham Empire, opened in 1907; cf, *Kine and Lantern Weekly*, no 11 (25 July 1907).
22 *The Era*, 14 March 1896, p 18.
23 Ibid, loc cit.
24 Ibid, 28 March 1896, p 16, advertisement.
25 Ibid, 14 March 1896, p 18.
26 *Amateur Photographer*, vol 23, no 601 (10 April 1896), pp 314–15.
27 *The Era*, 1 August 1896, p 16.
28 *Amateur Photographer*, vol 24, no 633 (20 November 1896), p 409. A similar communication was also published in the *British Journal of Photography*, vol 43, no 1906 (13 November 1896), p 729, and in *The Photogram*, vol 3, no 36 (December 1896), p 302. Messrs Fuerst Brothers' other interests are listed in the Post Office London Commercial Directory for 1896 as 'oils, chemicals, drugs, herbs, extracts, drysalteries, photographic plates & chemicals &c., general merchants, import & export'. A report in the *Amateur Photographer*, vol 26, no 690 (24 December 1897), p 513, states that 'Mr Fuerst has presented a Lumiere cinematograph [sic] to the Royal Photographic Society'.

7 Exploitation of the Theatrograph

1 The Cinématographe-Lumière was also being exhibited, of course, in many of the larger cities of Europe.
2 *Proc* BKS, no 38 (3 February 1936), p 3.
3 *Reynolds's Newspaper*, Sunday 23 February 1896, p 4, column six.
4 Ethel M. Wood, *A History of the Polytechnic* (London: MacDonald, 1965), p 61.
5 Ibid, p 72.
6 Paul was a member of the Royal Institution for the last twenty-one years of his life. In the Institution's *Proceedings*, vol 32 (1941–3), p 383, thanks to R.W. Paul are recorded on 7 December 1942 for his gift of a large quantity of electrical and other scientific apparatus and a number of books.
7 *The Morning*, 29 February 1896, p 1, column five.
8 Cf Hendricks, *Kinetoscope*, pp 76–7.
9 Talbot, *Moving Pictures*, pp 39–40.
10 Official programme, dated 25 May 1896; copy in the Barnes Museum of Cinematography. A similar programme for 24 April is in the Westminster Public Library.
11 *Proc* BKS, no 38 (3 February 1936), pp 3–4.
12 Quoted in an advertisement published in *The Era*, 8 August 1896, p 25. (The relevant page is missing from the files of *The Daily Chronicle* at Colindale.)
13 *Daily Chronicle*, 23 March 1896, p 4, column two, advertisement.
14 *Proc* BKS, no 38 (3 February 1936), p 4.
15 *The Era*, 26 February 1898, p 19.
16 Ibid, 10 July, 1897, p 17.
17 Cf *The Era*, 25 April 1896, p 17: 'Mr Moul, the enterprising manager of the Alhambra, was anxious to give a particular identity to the exhibition at the Leicester Square house—hence Animatographe.'
18 *The Era*, 28 March 1896, p 18.
19 Cf Hendricks, *Kinetoscope*.
20 *The Era*, 25 April 1896, p 16.
21 Ibid, 2 May 1896, p 16.
22 Ibid, 3 October 1896, p 18.
23 Ibid, 5 September 1896, p 18.
24 This is obviously the film made by George Méliès called 'Une Nuit Terrible' (Star Film Catalogue no 26), and the film of the Czar, shown in the same programme, was probably the Méliès film no 50, 'Cortège de Tzar au Bois de Boulogne'.
25 *The Era*, 21 November 1896, p 18.
26 Fred Karno is best remembered today as the discoverer of Charlie Chaplin.
27 *The Era*, 5 December 1896, p 18.
28 Ibid, 12 December 1896, p 19.
29 Ibid, 19 December 1896, p 18.
30 *Proc* BKS, no 38 (3 February 1936), p 4.
31 *The Era*, 18 July 1896, p 7.
32 Ibid, 25 April 1896, p 17.
33 *Proc* BKS, no 38 (3 February 1936), p 4.
34 *The Era*, 16 May 1896, p 16.
35 At the Science Museum, South Kensington, the Kodak Museum, Harrow, and the Barnes Museum of Cinematography, St Ives. The Paul films reproduced are *Gordon Highlanders, Street Scene,* and *The Soldier's Courtship*. Another Filoscope in the Barnes Museum shows the Prince's Derby of 1896.
36 *Proc* BKS, no 38 (3 February 1936), p 4.
37 *Strand Magazine,* August 1896, pp 137–40.
38 *The Era*, 6 June 1896, p 16.
39 Ibid, loc cit.
40 *Proc* BKS, no 38 (3 February 1936), p 4.
41 *The Era*, 10 October 1896, p 19.
42 Ibid, 31 October 1896, p 19.
43 Catalogue of Paul's films for June 1903. Copy in the Barnes Museum of Cinematography.
44 *The Era*, 11 April 1896, p 19.
45 Ibid, 25 April 1896, p 17.
46 Ibid, 2 May 1896, p 17.
47 *The Optician*, vol 10 (30 July 1896), p 267.

8 Independent Exhibitors of the Theatrograph

1 *Proc* BKS, no 38 (3 February 1936), p 4.
2 *The Era*, 18 July 1896, p 7.
3 Ibid, 23 May 1896, p 25; ibid, 31 October, p 30; ibid, 5 December, p 31: advertisements.
4 For a history of this company, see George A. Jenness, *Maskelyne and Cooke: The Egyptian Hall, London, 1873–1904* (Enfield: the author, 1967).
5 Jasper Maskelyne, *White Magic: The Story of the Maskelynes* (London: Stanley Paul undated), pp 81–2.
6 *The Era*, 21 March 1896, p 16, advertisement.
7 Ibid, 18 April 1896, p 16.
8 *Proc* BKS, no 38 (3 February 1936), p 4.
9 *Optical Magic Lantern Journal*, vol 8, no 99 (August 1897), pp 127–9: 'Prominent Men in the Lantern World No. X—Mr C.W. Locke'.
10 Ibid, vol 7, no 90 (November 1896), p 173.
11 *The Era*, 1 August 1896, p 24, advertisement.
12 Ibid, 28 November 1896, p 30, advertisement.
13 William J. Hilliar, *Novel Hand Shadows* (London: 1900), pp viii–ix.
14 David Devant, *My Magic Life* (London: Hutchinson, 1931), pp 70–2.
15 *The Era*, 1 August 1896, p 24, advertisement; quoted on p 118 above.
16 Devant, *My Magic Life*, p 74.
17 Ibid, p 73.
18 Hertz, *A Modern Mystery Merchant*, pp 139–40.
19 *The Era*, 28 March 1896, p 19.
20 Hertz, *A Modern Mystery Merchant*, pp 139, 141; *Proc* BKS, no 38 (3 February 1936), p 4.
21 Peter Germishuys, 'Flickering Past', in *South African Panorama*, vol 8, no 5 (May 1963), p 5. The photograph reproduced in this article and captioned 'View of the first film projector used in South Africa by Carl Hertz' shows a machine presented by R.W. Paul to the Science Museum, South Kensington, not the machine used by Hertz which is in the Will Day Collection.
22 G.H. Chirgwin (1855-1922), minstrel and music-hall artiste known as the White-eyed Kaffir; he appeared in two films for Paul.
23 *The Era*, 31 October 1896, p 19.
24 *New York Herald*, 4 April 1896; quoted by Ramsaye, *A Million and One Nights*, p 228.
25 *New York Herald*, 24 April 1896; original cutting reproduced in *International Motion Picture Almanac 1936–1937*, p 22.
26 Raff and Gammon were the American agents for the Edison Kinetoscope and films and had secured the sole rights to the Vitascope.
27 *Journal* of the Society of Motion Picture Engineers, vol 24 (March 1935); reprinted in Raymond Fielding, *A Technical History of Motion Pictures and Television* (Berkeley and Los Angeles, Calif: University of California Press, 1967), p 19.
28 *The Era*, 3 October 1896, p 28, advertisement.
29 Ibid, 22 August 1896, p 24, advertisement.
30 Ibid, 3 October 1896, p 28, advertisement.
31 Ibid, 27 June 1896, p 27, advertisement.
32 Ibid, 5 December 1896, p. 31, advertisement.
33 Ibid, 28 November 1896, p 20.
34 For a discussion of the Harrison apparatus, see p 149.
35 *Lady's Pictorial*, Supplement, 5 December 1896.
36 *The Era*, 19 December 1896, p 30, advertisement; ibid, 26 December 1896, p 26, advertisement.
37 Ibid, 29 August 1896, p 28, advertisement.
38 Ibid, 19 September 1896, p 29, advertisement.
39 Ibid, 29 August 1896, p 28, advertisement.
40 Ibid, 31 October 1896, p 30, advertisement.
41 Ibid, 24 October 1896, p 19.
42 During May R.W. Paul's theatrical agent, Tom Shaw & Co, 86 Strand, London, advertised an engagement at the Paddington Theatre, Liverpool; see *The Era*, 23 May 1896, p 25, advertisement.
43 *The Era*, 8 August 1896, p 25, advertisement.

44 Ibid, 29 August 1896, p 28, advertisement.
45 Ibid, loc cit.
46 Ibid.
47 Ibid, 22 August 1896, p 24, advertisement.
48 Ibid, 29 August 1896, p 28, advertisement.
49 Ibid, 19 September 1896, p 29, advertisement.
50 Stanley Chadwick, *The Mighty Screen: The Rise of the Cinema in Huddersfield* (1953), pp 14–15.
51 *The Era*, 3 October 1896, p 28, advertisement.
52 Original poster, Kodak Museum, Harrow.
53 R.W. Paul publicity brochure (Group B1444); photocopy in the Barnes Museum of Cinematography. Whereabouts of original unknown.
54 Ibid.
55 Ibid.
56 Original poster, Kodak Museum, Harrow.
57 Original printed programme, National Film Archive.
58 Original printed programme, National Film Archive.
59 *The Era*, 5 December 1896, p 31, advertisement.
60 Ibid, loc cit.
61 Ibid.
62 Original printed programme, National Film Archive.
63 *The Era*, 5 December 1896, p 31, advertisement.
64 Ibid, loc cit.
65 Ibid.
66 Ibid.

9 Other Inventors and Exhibitors

1 Charles Pathé, *De Pathé Frères à Pathé Cinéma*, p 21. See also Charles Pathé, *Souvenirs et Conseils d'un Parvenu* (Paris: 1926), p 68.
2 *Optical Magic Lantern Journal*, vol 8, no 93 (February 1897), p 37.
3 *The Era*, 4 April 1896, p 17.
4 Ibid, p 14, advertisement.
5 Ibid, 15 August 1896, p 16.
6 *Optical Magic Lantern Journal*, vol 8, no 93 (February 1897), p 37.
7 Inv 1953-181.
8 A publicity sheet of 1898 refers to him as 'Prof. C. Conrad, Cinematographist and Illusionist. 4½ years Stage Manager with Louis Tussaud's New Exhibition from London . . . has given Exhibitions of animated photos in all the principal towns in England and Wales . . .' (Science Museum).
9 *Optician*, 10 September 1896, p 350.
10 Hopwood, *Living Pictures*, p 117.
11 *Optical Magic Lantern Journal*, vol 8, no 93 (February 1897), pp 37–8.
12 *The Photogram*, vol 4, no 38 (February 1897), p 81.
13 Ibid, loc cit.
14 Ibid, vol 4, no 37 (January 1897), p 28.
15 *Optical Magic Lantern Journal*, vol 8, no 92 (January 1897), p 2.
16 *The Photogram*, vol 4, no 39 (March 1897), p 81.
17 Pat no 14455, 30 June 1896.
18 *Amateur Photographer*, vol 25, no 644 (5 February 1897), p 106.
19 *The Era*, 25 July 1896, p 21, advertisement.
20 Ibid, 5 December 1896, p 28, advertisement.
21 *Optical Magic Lantern Journal*, vol 9, no 107 (April 1898), p 66.
22 Ibid, Almanac 1898-9, p 97, advertisement.
23 *The Era*, 25 July 1896, p 21, advertisement.
24 Ibid, 5 December 1896, p 28.
25 Ibid, 21 November 1896, p 30, advertisement.
26 *The Optician*, vol 11 (30 July 1896), p 271.
27 *Optical Magic Lantern Journal*, Almanac and Annual 1896–7 (August 1896), pl. xix, advertisement.
28 *Photographic News*, vol 40, no 21, new series (22 May 1896), p 322; *Optician*, vol 10 (4 June 1896), p 163.
29 *Optical Magic Lantern Journal*, vol 7, no 85 (June 1896), p 93.

30 Ibid, July 1896, p 119. A similar communication was published in *The Optician*, 11 June 1896, p 178.
31 A special price of £24 was quoted to wholesale dealers; see *Optician*, vol 10 (6 August 1896), p 281.
32 *Optical Magic Lantern Journal*, vol 7, no 88 (September 1896), p 138.
33 Ibid, vol 7, no 90 (November 1896), p 175.
34 Ibid, Almanac 1897–8, p 125.
35 Ibid, vol 7, no 89 (October 1896), pp 168-9.
36 *The Optician*, vol 12 (26 November 1896), p 138.
37 Ibid, 3 December 1896, p 149.
38 Ibid, vol 12 (17 December 1896), p 175, advertisement; *The Era*, 26 December 1896, p 25, advertisement.
39 *Amateur Photographer*, vol 24, no 638 (24 December 1896), p 521.
40 Hopwood, *Living Pictures*, p 156.
41 *British Journal of Photography*, Almanac 1897 (November 1896), p 1063.
42 This letter is filed at the National Film Archive, Berkhamsted.
43 The letter is addressed to the Director of the *Observer* Film Exhibition (London, 1956) and offers the document for display.
44 *The Era*, 9 May 1896, p 18.
45 *Optical Magic Lantern Journal*, vol 7, no 87 (August 1896), p 132.
46 *The Era*, 3 October 1896, p 28, advertisement.
47 *Optical Magic Lantern Journal*, vol 7, no 89 (October 1896), p 162.
48 Ibid, Almanac 1897–8, p 120.
49 *Journal* of the Motion Picture and TV Engineering Society of Japan, no 218 (1970), pp 1, 3, 69–73. The camera described and illustrated in this journal is in the Barnes Museum.
50 *The Optician*, vol 10 (2 January 1896), p 214.
51 *Amateur Photographer*, vol 23, no 599 (27 March 1896), p 287.
52 Ibid, vol 24, no 636 (11 December 1896), p 480.
53 *Optical Magic Lantern Journal*, vol 7, no 90 (November 1896), pp 194–5.
54 *The Optician*, vol 12 (19 November 1896), p 128.
55 *Photographic News*, vol 41, no 53, new series (1 January 1897), pp 13–14.
56 Cecil M. Hepworth, 'A Review of Some Present Day Machines', in *Amateur Photographer*, vol 26, no 677 (24 September 1897), p 267.
57 *British Journal of Photography*, Almanac 1897 (November 1896), p 278.
58 *The Era*, 5 December 1896, p 28, advertisement; ibid, 19 December 1896, p 28.
59 *Optical Magic Lantern Journal*, Almanac 1897–8 (October 1897), pp xcvii–ci, advertisement. Twenty-one Méliès films are listed under the heading 'Robert Houdin'; a list of the Lumière films could be had on application.
60 Ibid, vol 8, no 108 (May 1898), p 71.
61 *British Journal of Photography*, vol 43, no 1905 (6 November 1896), pp 715–16.
62 Ibid, 4 December 1896, p 784.
63 *Optical Magic Lantern Journal*, Almanac 1897–8, facing p xlix.
64 *The Photogram*, vol 4, no 42 (June 1897), p 178.
65 Ibid, July 1896, p 214.
66 *The Era*, 7 January 1899, p 26, advertisement.
67 Ibid, 23 January 1897, p 18, advertisement.
68 *Amateur Photographer*, vol 25, no 658 (14 May 1897), p 405.
69 Inv 1936-68.
70 *Amateur Photographer*, vol 25, no 661 (4 June 1897), p 464.
71 Ibid, vol 26, no 677 (24 September 1897), p 267.
72 *British Journal of Photography*, vol 44, Supplement 5 February 1897, p 16. See also *Amateur Photographer*, vol 25, no 646 (19 February 1897), p 147.
73 Jasper Maskelyne, *White Magic*, p 83.
74 German pat no 88599, 1 November 1895.
75 Hopwood, *Living Pictures*, p 244.
76 Brian Coe, 'William Friese Greene and the Origins of Kinematography', in *Photographic Journal*, March/April 1962.
77 Inv 1930-755. Presented by J.A. Prestwich & Co Ltd.
78 *British Journal of Photography*, vol 43, no 1910 (11 December 1896), p 797.
79 Erroneously stated to have been taken by Messrs Wrench & Sons; see *British Journal of Photography*, vol 43, no 1911 (18 December 1896), p 810, for correction of this error.
80 The Barnes Museum has two opal portraits by Esme Collings signed and dated Brighton 1892 and 1894.

81 Ray Allister, *Friese-Greene—Close-up of an Inventor* (London: Marsland, 1948), p 34.
82 *The Optician*, vol 12 (26 November 1896), p 137.
83 *British Journal of Photography*, vol 43, no 1910 (11 December 1896), p 797.
84 Ibid, loc cit.
85 Ibid, 18 December 1896, p 810
86 Ibid, 11 December 1896, p 797.
87 I am indebted to Denis Gifford for data respecting this film. See his *British Film Catalogue 1895–1970* (Newton Abbot: David & Charles, 1973).
88 *The Era*, 15 August 1896, p 25, advertisement.
89 Ibid, 31 October 1896, p 28, advertisement.
90 *Optical Magic Lantern Journal*, vol 7, no 91 (December 1896), p 199.
91 *Photographic News*, vol 40, no 40, new series (2 October 1896), p 625.
92 *The Era*, 25 April 1896, p 7, advertisement.
93 *Amateur Photographer*, vol 26, no 677 (24 September 1897), pp 266–7.
94 *The Era*, 9 May 1896, p 23.
95 Ibid, p 28, advertisement.
96 Ibid, 2 May 1896, p 27, advertisement.
97 Ibid, 9 May 1896, p 28, advertisement.
98 Ibid, 30 May 1896, p 26, advertisement.
99 Ibid, 6 June 1896, p 16.
100 Ibid, 13 June 1896, p 26, advertisement.
101 Ibid, 20 June 1896, p 21.
102 Ibid, 27 June 1896, p 27, advertisement.
103 Ibid, loc cit.
104 Ibid, 3 October 1896, p 18, advertisement.
105 Ibid, 23 May 1896, p 19.
106 We know that the Theatrograph was shown at the Paddington Theatre, Liverpool, the following week, from an advertisement of Tom Shaw & Co, R.W. Paul's booking agents, though the machine is referred to as the Cinematographe. This name was perhaps more familiar to theatre managers than Theatrograph. See *The Era*, 23 May 1896, p 25, advertisement.
107 *The Era*, 16 January 1897, p 29, advertisement.
108 Ibid, 12 September 1896, p 28.
109 Ibid, 8 and 29 August 1896, p 28 in each issue, advertisements.
110 Ibid, 1 and 22 August 1896, pp 17 and 16 respectively.
111 Ibid, 5 December 1896, p 31, advertisement.
112 Ibid, 11 September 1897, p 18.
113 Ibid, 19 September 1896, p 19, advertisement.
114 Ibid, 31 October 1896, p 18.
115 One of the few recorded fairground shows was Edwin Lawrence's at the Great Glasgow Fair in August 1897. Cf *The Era*, 7 August 1897, p 16.
116 *The Era*, 19 December 1896, p 16, advertisement.
117 Ibid, 26 December 1896, p 18.
118 Cf *Merry-Go-Round: The Magazine of the Friendship Circle of Showland Fairs*, founded in 1940.
119 Jim Connell, *Islington Landmarks* (Islington Public Library: undated).
120 Quoted in Rachael Low and Roger Manvell, *The History of the British Film*, vol 1 (London: Allen & Unwin, 1948), p 118.
121 *The Era*, 20 June 1896, p 25, advertisement.
122 Examples of the Eragraph are in the Science Museum, South Kensington, and the Barnes Museum.
123 *The Era*, 22 August 1896, p 24, advertisement.
124 *Islington Gazette*, 3 December 1965, p 11.
125 *The Era*, 22 August 1896, p 24, advertisement.
126 Ibid, 21 November 1896, p 30; see also ibid, 12 September 1896.
127 Ibid, 18 April 1896, p 25; ibid, 2 May 1896, p 25; ibid, 6 June 1896, p 25; ibid, 1 August 1896, p 25.
128 Ibid, 23 May 1896, p 25; ibid, 6 June 1896, p 25; ibid, 25 July 1896, p 21.
129 Ibid, 1 August 1896, p 25; *British Journal of Photography*, Almanac 1897, p 1292.
130 *The Era*, 17 October 1896, p 28; ibid, 12 December 1896, p 28.

10 Apparatus from Abroad

1 Ramsaye, *A Million and One Nights,* p 236.
2 Ibid, p 240.
3 Ibid, p 275.
4 *British Journal of Photography,* Supplement 5 June 1896, p 41.
5 US pat no 673992.
6 Ramsaye, op cit, p 311.
7 *Photographic News,* vol 40, no 47, new series (20 November 1896), p 753.
8 *The Era,* 24 October 1896, p 29, advertisement.
9 The American Biograph had its English debut in March at the Palace Theatre, London; see *The Era,* 20 March 1897, p 18.
10 First introduced into England by Maguire and Baucus, late in 1897 (Cf *Amateur Photographer,* vol 26, no 691 (31 December 1897), p 550). The word 'Bioscope', like so many names given to cinematographic apparatus, stems from the Greek. The *Oxford English Dictionary* defines the meaning as 'a view of life; that which offers such a view'; but it was probably owing to the popularity of the Urban Bioscope that the word subsequently came to be used as a general term for cinema. In Holland and South Africa the cinema is still referred to as the Bioscope, though in England the word is more often applied to the fairground cinema booth. An early use of the word is to be found in the title of a book by Granville Penn, *The Bioscope, or Dial of Life* (London: Murray, 2nd edn, 1814).
11 *The Era,* 16 May 1896, p 15, advertisement.
12 W.G.S. Tonkin, *Showtime in Walthamstow* (Walthamstow Antiquarian Society: 1967), p 7.
13 *Walthamstow Guardian,* 5 June 1896.
14 *The Photogram,* vol 3, no 32 (August 1896), p 201; *Photograms of the Year 1896,* p xxxv; *British Journal of Photography,* Almanac 1897 (November 1896), pp 1362–3.
15 *Amateur Photographer,* vol 24, no 634 (27 November 1896), p 440.
16 *The Optician,* 1 October 1896, p 47, advertisement.
17 British pat no 6503, 24 March 1896.
18 *British Journal of Photography,* Almanac 1897 (November 1896), pp 1364–5.
19 Ibid, p 1365.
20 *Photographic News,* vol 40, no 47, new series (20 November 1896), p 7531; *Optical Magic Lantern Journal,* vol 7, no 91 (December 1896), p 200. Mr Brian Coe, the curator of the Kodak Museum, informs me that A.W. Rider entered the Eastman Dry Plate and Film Company soon after the first office opened in Soho Square in 1885 as book-keeper/cashier. He became Company Secretary of the Eastman Photographic Materials Company when it was formed in December 1889, remaining in that position until January 1896 when he went to Australia to promote the new range of cameras. He left the company's employment on 28 October 1896.
21 *British Journal of Photography,* vol 43, no 1889 (17 July 1896), p 461.
22 Inv 1935-112.
23 *British Journal of Photography,* vol 43, no 1909 (4 December 1896), p 779; *Photographic Journal,* vol 20, no 5 (30 January 1897), p iii, advertisement.
24 *The Optician,* vol 10 (17 December 1896), p 176.
25 *British Journal of Photography,* vol 43, no 1911 (18 December 1896), p 807.
26 *The Era,* 19 September 1896, p 29, advertisement; ibid, 3 October 1896, p 28, advertisement.
27 Oskar Messter, *Mein Weg mit dem Film* (Berlin: 1936), pp 9–10.
28 I am indebted to Adriaan Briels for information concerning Messter and for kindly bringing the matter to my notice.

11 Royal Film Performances

1 *Proc* BKS, no 38 (3 February 1936), p 4.
2 *Amateur Photographer,* vol 24, no 617 (31 July 1896), p 87.
3 *Cardiff Western Mail,* 26 August 1896.
4 *The Globe,* 31 August 1896; see also *Photographic News,* vol 40 (11 September 1896), p 585.
5 Ibid.

6 It was known as the Ross–Hepworth Arc Lamp (Pat no 11892, 19 June 1895). This was one of the first hand-feed arc-lamps to appear and was manufactured by the optical firm of A. Ross & Co. Hepworth subsequently became one of the most important of early British film producers.

7 *The Era*, 25 July 1896, p 14.

8 *Optical Magic Lantern Journal*, vol 7, no 88 (September 1896), p 138.

9 The cause of the mirth was apparently the Prince scratching his head, which was to arouse hostile comment from some quarters of the press when the film was publicly shown.

10 The 'disc' refers to the illuminated area thrown on the screen by the projector, and does not mean that the pictures themselves were circular. The term had been carried over from old-type magic-lantern shows when the painted slide area was invariably circular and was shown on the screen as such.

11 *Amateur Photographer*, vol 24, no 617 (31 July 1896), p 87.

12 *British Journal of Photography*, vol 43, no 1891 (31 July 1896), p 490, and *Photographic News*, vol 40, no 32, new series (7 August 1896), p 503.

13 *Photographic News*, 7 August 1896, p 503.

14 Ibid, 11 December 1896, p 587.

15 *Cardiff Western Mail*, 26 August 1896.

16 R.W. Paul, 'List of Films or Subjects for the Theatrograph' (undated: *c* November 1896).

17 In the opinion of Mr Downey, Queen Victoria was the greatest patroness photography had ever had. The possibility of photographs fading made her insist upon portraits being printed in carbon and platinotype, while special photographs had to be enamelled. Downey also reported that she was an excellent sitter and knew exactly what was required, aiding the photographer as much as possible to obtain the required effect. (*Lady's Pictorial*, Supplement 5 December 1896.)

18 I have already established (p 149) that this was in fact Thomas James Harrison, co-patentee of the Grand Kinematograph, the apparatus used at Balmoral and Windsor Castle.

19 *The Era*, 28 November 1896, p 20.

20 For a discussion of this part of the programme, see p 126.

21 *The Era*, 5 December 1896, p 31, advertisement.

22 Ibid, 19 December 1896, p 30, advertisement.

23 One of his films dating from this period is preserved in the National Film Archive. It shows a boy pasting a poster on to a shop window, to the annoyance of the shopkeeper who rushes out and gives him a good hiding. The poster advertises 'Animated Photographs by C. Goodwin Norton'.

24 *Amateur Photographer*, vol 24, no 624 (18 September 1896), p 225.

25 *The Era*, 23 January 1897, p 28.

26 Ibid, 26 December 1896, p 17.

27 *The Photogram*, vol 4, no 43 (July 1897), p 214.

12 Film Production

1 *The Times*, 18 November 1894, p 4.

2 *Chambers's Journal of Popular Literature, Science and Art*, vol 11, no 543 (24 November 1894), p 752.

3 Hendricks, *Kinetoscope*, p 112.

4 *Proc* BKS, no 38 (3 February 1936), p 2.

5 J. Pike, *Lantern Slides: Their Production and Use* (London: 1895), advertisement.

6 *The Photogram*, vol 1, no 5 (May 1894), p 113.

7 *Amateur Photographer*, vol 26, no 678 (1 October 1897), p 277; see also ibid, vol 23, no 590 (24 January 1896), p 70.

8 *Proc* BKS, no 38 (3 February 1936), p 3. St Mary Cray, Kent, was the site of the Blair factory.

9 Ibid, pp 2-3. The section in which Paul's statement appears is headed 'Making Kinetoscope Films'.

10 *Amateur Photographer*, vol 26, no 678 (1 October 1897), p 277.

11 *Photographic News*, vol 40, no 26, new series (26 June 1896), p 401. Mr Brian Coe informs me that, according to the company's records, Kodak's cinematograph trade began in April 1896. This was of material made specifically for cine use. Most materials used previously had been the conventional material used for the Kodak cameras but not very suitable for use as cinematograph film for positives.

12 *British Journal of Photography*, Almanac 1897 (November 1896), p 1188.

13 Ibid, p 1033.

14 Ibid, p 1376.

15 Ibid, p 1288.

16 Ibid, Almanac 1897, p 610.

17 *Photographic News*, vol 40, no 4, new series (24 January 1896), p 61; *British Journal of Photography*, vol 43, no 1864 (24 January 1896), p 61.

18 *Amateur Photographer*, vol 25, no 639 (1 January 1897), p 15.

19 *Optical Magic Lantern Journal*, vol 8, no 92 (January 1897), p 2.

20 *Proc* BKS, no 38 (3 February 1936), p 3.

21 Talbot, *Moving Pictures*, pp 77–8.

22 This illustration is reproduced from Talbot, *Moving Pictures*, p 70; the photograph had previously been published in *Cassell's Popular Science* (London: 1903), p 249.

23 *Proc* BKS, no 38 (3 February 1936), p 3.

24 *British Journal of Photography*, vol 43, no 1875 (10 April 1896), p 239.

25 *Photographic News*, vol 40, no 4, new series (24 January 1896), p 50.

13 Conclusion

1 *Photographic News*, vol 40, no 21, new series (22 May 1896), p 321.

2 *The Era*, 17 October 1896, p 19.

3 *Amateur Photographer*, vol 25, no 646 (19 February 1897), p 142.

4 *Proc* BKS, no 38 (3 February 1936), pp 6–7.

5 *Amateur Photographer*, vol 24, no 627 (9 October 1896), p 286.

6 In Act I, Scene iv ('The Stage of the Frivolity Music Hall') the American Biograph was used. (Printed programme in the Barnes Museum.)

7 *Amateur Photographer*, vol 24, no 361 (6 November 1896), p 371.

8 Ibid, vol 25, no 657 (7 May 1897), p 374.

9 Ibid, vol 24, no 631 (6 November 1896), p 371.

10 *Photographic News*, vol 40, no 21, new series (22 May 1896), p 321.

11 *The Era*, 8 August 1896, p 25, advertisement.

12 *Proc* of the Institution of Electrical Engineers, vol 89, part 1 (1942), pp 540–1, obituary notices; and *Report of the Council for 1944–5*, vol 92, part 1 (1945), p 195.

13 H. Tummel, 'Birt Acres, an almost forgotten English pioneer of cinematography', in *Cinema Studies*, vol 1, no 7 (June 1963), p 157.

Acknowledgements

I wish to thank all those who have been of assistance to me in assembling the material for this book, and in particular my gratitude is extended to the following: Carmen de Uriarte Barnes, my able assistant at the Barnes Museum; my brother William Barnes for his part in acquiring vital source material and for improvements to the text; Mr Brian W. Coe, Curator, Kodak Museum, for contributing the Foreword and for his unstinted help with illustrations and other material; Mrs Sidney Birt Acres for allowing me access to her collection of material relating to Birt Acres, and for her hospitality during my visit to her home; Mr Adriaan Briels for information on R.W. Paul's Theatrograph in the Netherlands; Mr Harold Brown, Preservation Officer of the National Film Archive for providing extracts from Paul's films; Mr Roger Holman, Head of the Cataloguing Department of the National Film Archive, who kindly put at my disposal the related material filed at Berkhamsted; Mr John Ward, Senior Museum Assistant at the Science Museum, for his kind help during my examination of various apparatus in the museum; Mr G.L. Young, Information Officer, Cambridge Scientific Instruments Limited, for kindly bringing to my notice the original printing blocks used by R.W. Paul and for the use thereof; Mr Leo J. De Freitas, Librarian, the Royal Photographic Society; Mrs I.M. McCabe, Librarian and Information Officer, the Royal Institution; Miss Wendy Lloyd, Deputy Librarian, the Institution of Electrical Engineers; Mr Colin Sorensen, Assistant Keeper, the London Museum; Mr Peter Williams for information relating to his great-grandfather, Randall Williams, 'King of Showmen'; Miss Brenda Davis, Head of the Information Department of the British Film Institute, and to Miss Betty Leese; Mrs P.A. Eddy, Librarian, the Public Library, St Ives; Mr Gordon Hendricks, the premier historian of the early American cinema, whose books are indispensable to any historian writing about the beginnings of the cinema; and to Mrs B.M. Barrow. I also wish to acknowledge the following corporate bodies for services rendered: British Film Institute; British Museum; British Museum Newspaper Library, Colindale; Cambridge Scientific Instruments Limited; Cinémathèque Française, Paris; Conservatoire National des Arts et Métiers, Paris; Finsbury Public Library; Greater London Council, Photograph Library; Guildhall Library; Institution of Electrical Engineers; Islington Central Library; Kodak Museum, Harrow; London Museum; National Film Archive; Patent Office; Public Library, St Ives, Cornwall; Royal Commission on Historical Monuments; Royal Institution; Royal Photographic Society; Science Museum, and Science Library, South Kensington; Science Reference Library (British Library); Shoreditch Public Library; United States Department of the Interior; Westminster Central Reference Library; and Westminster Public Library.

Items from the Barnes Museum were photographed by Ander Gunn.

236

Film Index

237

General Index